THE COMPLETE
Drawing & Painting
COURSE

Sterling Publishing Co., Inc.
New York

The Complete Drawing and Painting Course

Library of Congress Cataloging-in-Publication
Data Available

10 9 8 7 6 5 4 3 2

Published in 2003 by Sterling Publishing Co., Inc.
387 Park Avenue South
New York, NY 10016
Originally published in Spain under the title *Curso Completo de dibujo y pintura*
by Parramón Ediciones, S.A.
Gran Via de les Corts Catalanes, 322-324
Barcelona, 08004

© 2002 by Parramón Ediciones, S.A.
Distributed in Canada by Sterling Publishing
C/o Canadian Manda Group
One Atlantic Avenue, Suite 105
Toronto, Ontario, Canada, M6K 3E7

Printed in China

Sterling ISBN 1-4027-0568-9

Contents

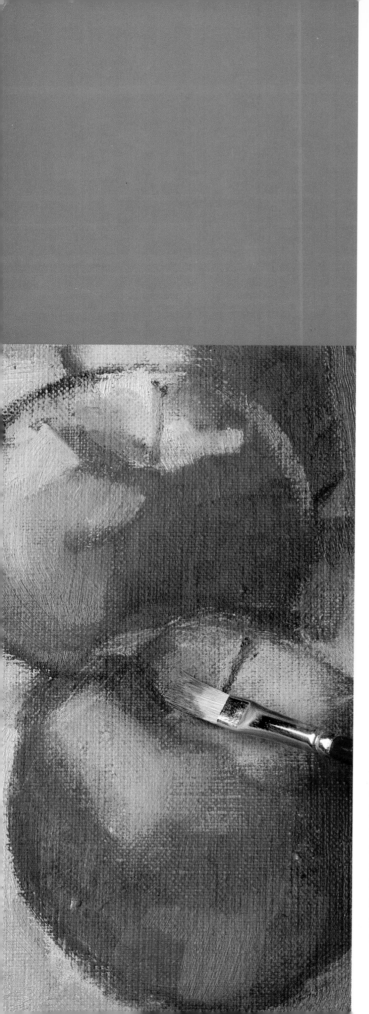

THE COMPLETE
Drawing & Painting
COURSE

Introduction

The Complete **Drawing and Painting Course** combines in one book many detailed lessons and instruction about drawing and painting, giving the reader all the means possible to develop his or her artistic ability. This book truly is the most extensive collection of teaching that the art enthusiast can find on the market. Relying on teaching, theory, and practice, The Complete Drawing and Painting Course does not require or expect that the reader have any previous art knowledge or skill, making it an excellent teaching guide. At the same time, however, it is also an invaluable manual for the artist and art professional.

To be truly useful, an art book should clearly explain and illustrate each aspect of its subject. This is the basis behind The Complete Drawing and Painting Course: a short, detailed summary of each topic, the processes involved, and the technique. The three underlying criteria used throughout this book are (1) presenting all the materials involved in drawing and painting along with detailed explanations on how to use them; (2) teaching art theory; and (3) demonstrating everything through examples and practice. Every drawing and painting material has its own section, from pencils and drawing paper to oil and watercolors.

The various media, theories, and processes are explained in a clear and easy-to-understand manner. As each topic is presented, a step-by-step drawing, painting, or illustration by a professional artist demonstrates and puts into practice what is being taught, enhancing the reader's understanding in a practical way.

We begin in **Chapter 1** with an elementary overview of the different tools and basic techniques used in artistic drawing. The reader should become familiar and comfortable with these before proceeding to more elaborate and complex chapters. Aspects such as how to use pencils, line and stroke techniques, calculating proportions, and composition are the firm bases of every artistic medium.

In **Chapter 2** we will tackle the big drawing techniques of representing light and shade, contrast, perspective, creating a rough outline, and others. Again, we cannot stress enough that the reader does not need any prior experience or knowledge of these techniques—everything he or she must learn will be thoroughly explained.

A book about drawing and painting should give special attention to color theory, as it is one of the most important aspects in every art form. For this reason, **Chapter 3** is dedicated solely to color. Principal color theories, obtaining colors by mixing primary and secondary colors, the chromatic color wheel, and color harmony are explained. All are important lessons to know before beginning any type of artwork. Practical examples illustrate the theoretical explanations so that the reader can immediately see results.

We then move on to **Chapter 4** where the human figure is studied in detail. Although artists express themselves through many different means, none can ignore the significance of the human figure in drawing and painting. The law of proportions of the human figure and its outline on paper are broken down into partial studies: the head, face, facial features, hands, feet, etc. All of them are accompanied by anatomical explanations of the bones and muscles, and understanding of which is essential if one is to represent the human body with realism.

Chapter 5 deals with the principal drawing and painting processes along with detailed explanations of their respective tools and techniques. Diagrams and illustrations by a team of dedicated professionals and artists accompany each process so that the reader can follow each step carefully in order to fully understand what is being taught, which—in our opinion—is the best way to learn.

To conclude our book, we have supplied a complete glossary of art terms with clear definitions.

CHAPTER I
Materials

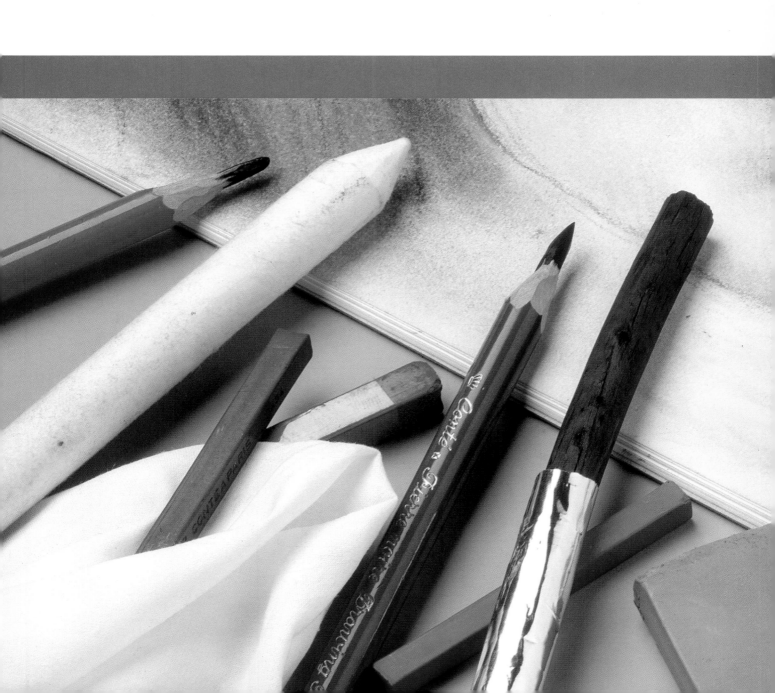

Materials

*T*he great painter Henri Matisse once said, "The simplest media allow the artist to express himself the best." There could not be a better epigraph for this section, which describes the different basic materials and tools for drawing. Pencils, paper, and erasers, although very basic tools, have just as many creative possibilities as even the most sophisticated of painting materials of the fine arts. The following section will also introduce the basic techniques of drawing such as calculating measurements and rough outlining.

Materials, tools, and techniques of drawing ■

Ingres, the great French painter, once said: "How you paint depends on how you draw." We could expand this quotation by adding that "knowing how to paint and draw depends on knowing the materials best suited to each technique."

We will look at the pencil, for example, at the different types, at their respective hardnesses, at the line produced by each, and at the various makes on the market. We will also look at types of paper—some smooth, some heavily textured—papers of different weights, different makes and quality, and at the results obtained from each type.

Equally, we will investigate practical and interesting aspects such as using the eraser, prolonging the life of your pencils, and the various ways of sharpening them. As you will see immediately, we will not just give you bald facts about concrete makes, but also simple, useful, practical exercises to underscore the information contained in the text. So, for example, if the line drawn by a particular pencil is described, an illustration of this line will be included.

We suggest that you do not just look at these illustrations, but also that you learn to do what you see in them! Try out the tonal possibilities of the 2B pencil and compare them with those of the HB; learn to differentiate between paper textures through practical experience: Look at them, draw on them, until you can tell them apart by touching them.

Get used to the idea that it is not always important to stick rigidly to our guidelines. As you improve through imitating our examples, you should also experiment on your own with materials and techniques, so that you can envisage with greater accuracy and confidence the effect you can expect from each when adapting them to your own projects. After all, one of the most exciting things about learning how to draw and paint is the constant discovery of new methods and new tricks of the trade, which, little by little, enrich your creative powers.

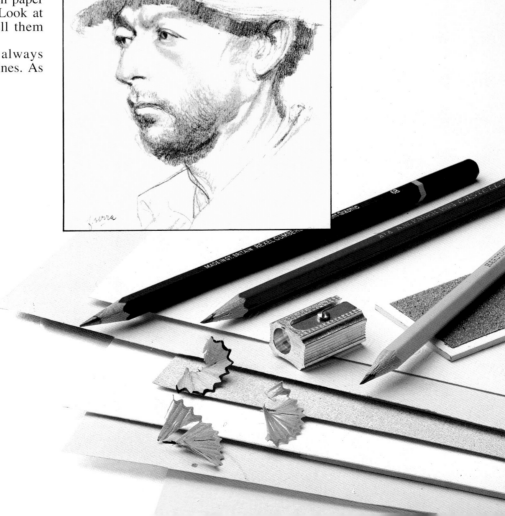

MEDIUM PENCIL (HB)

MEDIUM PENCIL (2B)

SOFT PENCIL (6B)

PRINCIPAL MANUFACTURERS OF SUPERIOR QUALITY PENCILS		
Country Of Origin	**Manufacturer**	**Make**
France	Conté	Castell
Germany	A.W. Faber	Carbonit
Germany	J. S. Staedtler	Negro
Czechoslovakia	Koh-i-noor	
Switzerland	Caran D'Ache	
United Kingdom	Cumberland	
United States	Faber	Mongol

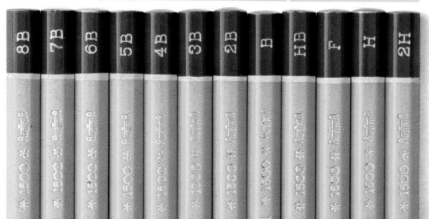

Using a hard pencil, however hard you press on the paper, you will never manage more than a mid tone of gray. The hard lead is not easily worn away and can never produce the broad strokes sometimes required in an artistic drawing. However, hard and very hard pencils are excellent for line and technical drawing or, occasionally, for works demanding an extreme softness of tone.

What tools do I need for drawing?

It is a question we have all asked at some stage and, perhaps, one you are asking at this very moment. If we were to limit ourselves to the minimum, we could say that a normal No. 2 pencil—or a good-quality HB, paper, an eraser, and a clip-board or piece of backing board as a support are all we need to start drawing. Of course, going on from this list, we could add anything our personal tastes or needs demand: A harder or softer pencil, white or tinted paper, different types of pencils (lead, charcoal, sanguine, etc.). Every new possibility is a way of broadening your potential for expression and developing a style of your own. However, none of these considerations affects the basic fact that all you need for drawing are a pencil and a piece of paper. And because we have referred already to normal pencils and superior quality pencils, take note that:

Pencils classified by numbers are normal pencils, in everyday use.
Superior quality drawing pencils are categorized by letters.

In the illustration on the right you can see that the difference between a hard and a soft pencil stroke is really significant. The soft pencil allows a wide range of grays and (the very soft ones) for intense blacks. Soft pencils are useful for gradation of tone ranging from pale gray to almost jet black.

The "koh-i-noor" type offers a wide range of pencils for artistic and technical use. So do the other makes mentioned. Naturally, you will not need the whole range to produce good drawings but to be able to choose the right grade for each particular drawing is an obvious advantage.

Pencils to suit all tastes

In this landscape, an H pencil has been used for the lightest areas of the background and the building.

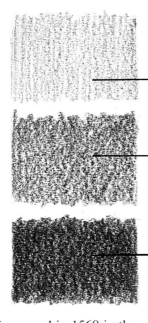

With a 2B pencil (perhaps the grade most used by the professional) the medium tones of the drawing have been established.

For the foreground blacks and interior spaces, an 8B pencil was used. These blacks emphasize depth.

Graphite is a mineral discovered in 1560 in the mines of Cumberland, England. Mixed with greater or lesser quantities of clay, it is the material that makes up pencil lead. Today, manufacturers offer many different grades and qualities of pencils:

Superior quality pencils. Soft pencils, indicated with a B, are best for artistic drawing (B, 2B, 6B, 8B, and so forth). Hard pencils are recommended for technical drawing and are indicated with the letter H (H, 2H, 5H, 7H, and the like). HB and F lie between hard and soft.

Classroom-type pencils. Numbers 1 and 2 correspond to 2B and HB in the softer range; 3 and 4 are the equivalents of H and 3H in the harder range.

In all, there are nineteen different grades of superior quality pencil and just four classroom-type pencils. Individual pencil leads are very useful but must be used with a clutch pencil; these are also available in different grades and qualities. We recommend the 2B pencil for general use. This grade is able to produce a fairly dark gray but can also produce paler, fine lines. It is also useful to have a 4B and an 8B for quick sketches and filling in dark areas. Really, any soft pencil can offer a wide tonal range and which one to choose depends on the subject and the artist's personal tastes.

KOH-I-NOOR PENCILS
Grade table

Soft grade	Medium grade	Hard grade	Extra-hard grade
(Artists')	(Everyday use)	(Technical)	
7B	2B=1	H=3	6H
6B	B	2H	7H
5B	HB=2	3H=4	8H
4B	F	4H	9H
3B		5H	

The thickness of the lead relates to its grade. The softer the pencil, the thicker the lead will be.

How to sharpen a pencil

It is important to sharpen your pencil correctly, though it may not seem so to the beginner. You must try not to break the lead, but to shape it into a smoothly tapering point that will be a delight to work with.

These days, many professionals refuse to use the traditional sharpener, which gives the pencil a point that is short and impractical. A razor blade, or more particularly a scalpel, is much more effective (see the illustration on the left). Make firm, deliberate movements, paring off fine shavings of wood (cedar is the best kind). To sharpen the point, there is nothing more useful than a specially designed metal scraper; but beware of sharpening the point too much because it will break easily.

Pencil holders and clutch pencils

Drawing with a pencil that is too short is an awkward business and hinders the creation of confident, loose strokes. To lengthen the life of the pencil there is an ancient but extremely useful device known as the pencil holder. This allows you to enjoy your friend of wood and graphite to the limit of its useful life and to save money in the bargain.

Metal clutch pencils appeared some years ago as a practical alternative to the traditional pencil. These days, the range of leads of different grades and thicknesses on the market is very wide indeed. Naturally, for the thicker, softer leads, wider clutch pencils are available.

We are going to allow ourselves to be a little traditional and to say that, although clutch pencils can produce the same results as ordinary pencils and in spite of their practicality (you don't need to sharpen them), we prefer the old-fashioned wooden variety for artistic drawing. They are warmer to the touch, you can create your own point and, finally, they are more enjoyable to use.

It is important to have a big container for your pencils, always storing them with their leads pointing upright.

Left. Point obtained with a pencil sharpener. Compare this with the point produced using a scalpel or razor blade (right).

Below. When sharpening with a scalpel, make lots of small cutting movements—and take care! The scalpel is a dangerous tool.

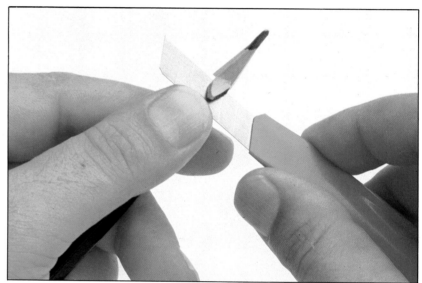

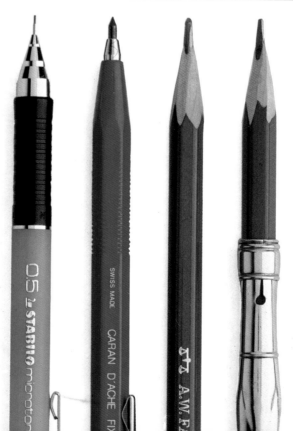

From left to right. A clutch pencil for hard leads, another for soft leads, a normal pencil and a pencil in a holder to make it last longer. There are many different makes of clutch pencils on the market for different lead thicknesses.

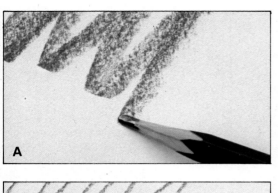

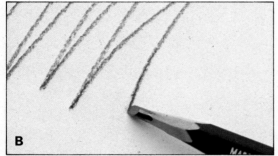

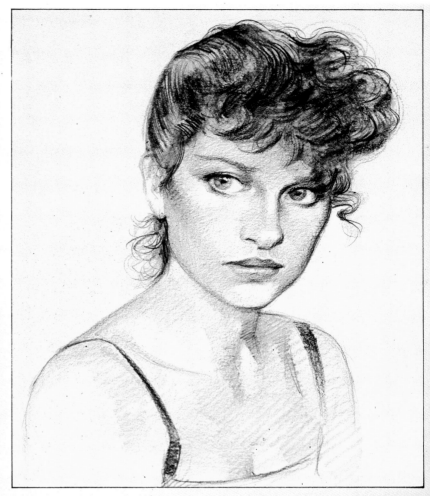

Above. *The drawing on the right has been produced using different types of pencil strokes: Type **A**, with the lead applied flat, cut in a wedge shape for wide strokes and type **B**, with the same shaped lead turned on its back, for sharp outlines.*

As you can see from the illustrations above, the strokes a graphite pencil can produce vary enormously.

With the lead sharpened to a wedge shape, for example, we can produce wide strokes by applying it flat against the paper, and fine strokes by turning it on its back, as seen in diagram *B*. But mistakes will happen, so we will need, alongside the pencil, a good eraser for rubbing out, as well as for other purposes.

It should be clearly stated at this point that ideally the eraser should be used only for opening up highlights, for sharpening outlines, and so on. It is better to start a new drawing than to damage the surface of the paper with a lot of rubbing. The most suitable eraser for use with the lead pencil is the soft, bread crumb eraser and the plastic or rubber eraser that is denser but equally effective. The modern kneadable or putty eraser should also be mentioned; it can be molded into any shape you require.

13

Drawing paper

Any paper, more or less, with the exception of plastic and metallic varieties, is suitable for drawing. Great artists have created great works on packing paper. However, we should distinguish between normal, everyday types of paper made from wood pulp using mechanical processes for mass production, and the high-quality papers made from textile fiber (high rag content), using more traditional methods with much greater quality control. These are expensive, so the same manufacturers often produce medium-quality papers as well. Let's look at some of the finishes and textures of various types of paper.

Smooth or glossy paper. Hot-pressed, this has almost no "grain," or texture. It is used for drawing with pen and ink and also with a lead pencil, in both cases providing smooth gradations and shading.

Fine-textured paper. This also produces velvet-smooth shading and gradations and is perfect for drawing in soft graphite pencil, wax crayons, or colored pencils.

Medium-textured paper. Used for pastels, sanguine crayons, chalks and, to a limited extent, watercolors.

Íngres paper. White or colored, this is one of the most traditional papers on the market. Its special texture is clearly visible if held against the light; it is the standard paper for drawing with charcoal, sanguine crayons, or pastels.

Cartridge paper, white or colored. This is a widely used paper with a rough texture on one side and a medium texture on the other. Its texture and sized surface make it a very versatile paper, used with charcoal, sanguine crayons, pastels, chalks, and colored pencils.

Watercolor paper. Various textures and qualities are available, ranging from hot-pressed (fairly smooth) through cold-pressed (semi-rough) to rough. Each is intended for a particular kind of watercolor painting, although all are occasionally used for pencil drawing.

Other papers in less frequent use are rice paper, for instance, which is used for exquisite washes, and various types of coated paper for pen and ink, as well as other flock or cloth-lined papers. You will certainly find something to cater to whatever your particular need might be.

PRINCIPAL MANUFACTURERS OF QUALITY PAPERS

Arches	France
Canson & Montgolfier	France
Daler	United Kingdom
Fabriano	Italy
Grumbacher	United States
Guarro	Spain
RWS	United States
Schoeller Parole	Germany
Whatman	United Kingdom
Winsor & Newton	United Kingdom

Above. A list of some of the best professional papers on the market. Below. Drawing paper —especially watercolor paper—comes in pads that are sometimes gummed on all four sides.

Paper: Appearance, weights, and measurements

Weight and format

Paper is generally sold in reams (500 sheets), and comes in different weights, such as 16, 20, 40, 50, and 90 lb.

As for formats, Fine Art paper comes in various sizes, the most popular being 9 × 12, 11 × 14, 14 × 17, and 19 × 24 in.

Some papers are sold mounted on board and even in rolls. The most normal presentation is in pads of individual sheets. Watercolor pads are sometimes gummed on all four sides. Except for certain heavily textured papers, all watercolor papers are perfectly good for drawing with pencils, charcoal, sanguine crayons, chalks, and pastels.

Good papers are expensive and easily identified. They are stamped or watermarked with the name of the manufacturer in one corner: Arches, Canson, Schoeller and Fabriano and many others do this.

The most frequently used paper

If we had to decide which type of drawing paper is most frequently chosen from all those on the market, we would probably go for the medium-quality, medium-textured cartridge paper that gives excellent results with all types and grades of pencil. It is quite another matter if you are undertaking a specific project or an exhibition of your drawings, in which case it is worth paying the price for high-quality paper of the type best suited to the work in question. Each manufacturer produces different textures and weights within each paper type, including hand-made papers that have the characteristic uneven edges distinguishing them from other papers.

These are some of the best brands of drawing paper, listed in each case with the corresponding manufacturer's trademark. Observe the different textures or grains of each sample.

The pencil *par excellence*

When we ask in a vague sort of way for "a pencil," we assume that we will be given one with a graphite lead and of a medium grade—a No. 2, for example. The graphite or lead pencil is the pencil par excellence and, just as we looked earlier at the most frequently used paper, before starting to look at the art of drawing itself we should refer to the possibilities of the medium of graphite.

Essential to the art of drawing, the lead pencil offers an unlimited range of creative possibilities. From the simplest sketch to the most beautifully studied still-life; landscapes, portraits, nudes—the pencil is usually the medium first used when exploring these areas.

A drawing on smooth paper made with a 2B pencil produces soft, even shading and gradation; the same drawing made using the same pencil but on a medium-grained paper gives a more textured efffect. By blending the pencil strokes with the fingertips, an infinite range of exquisitely subtle gradations can be achieved, especially on very smooth, high-quality paper.

Another effective combination is that of pencil and white chalk on colored paper, such as Ingres paper. In portraits, where the strokes can be blended and gradated, the pencil produces some wonderful results.

Graphite sticks ("all-lead" pencils) are also useful tools. By applying them with flat strokes, you can achieve wide, even areas of shading. The combination of pencil and graphite stick produces some fascinating effects. Try also combining a 2B and an 8B pencil on very smooth paper; play with the white of the paper itself and you will discover some lively contrasts.

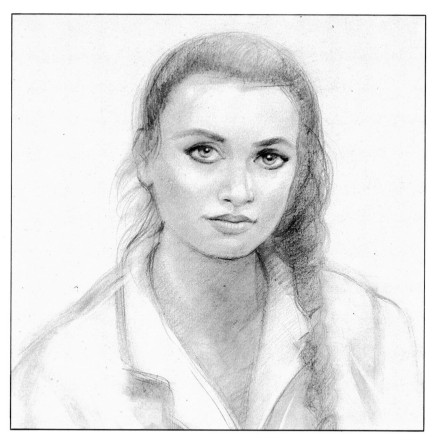

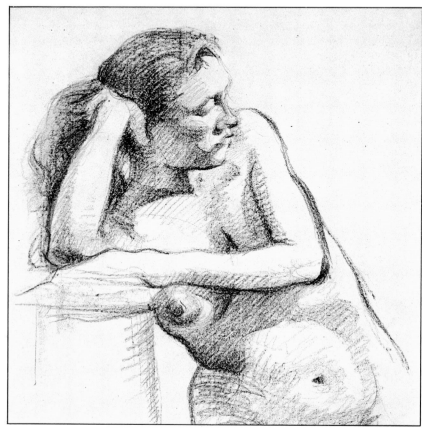

Here are two beautiful examples showing the versatility of the graphite pencil.

Above, *a drawing on very smooth, good-quality paper; some strokes have been softly blended with the fingers.*

Below, *a lively drawing on a medium-grained paper using spontaneous, unblended pencil strokes.*

Training the hand ■

You enjoy drawing, but you say that you don't know how, and yet you must have signed your name hundreds of times over the years. We would like to point out that every time you sign your name, you *are* drawing, in a way. The same training that in your childhood taught your hand to produce the wavy, straight, and broken lines that make up your name, is now going to help you begin your apprenticeship in drawing.

You should start by practicing what we might call the ABC's of drawing, until you can produce a series of basic pencil strokes as confidently as if you were writing the letters of the alphabet: Straight lines, circles, parallel lines and cross-hatching, wavy lines, spirals—all of which you will be able to apply later in your artistic creations.

The preliminaries

These may be summed up under the following three points:

• **Sit correctly.** Sit comfortably at an angled drawing table or a board rigged up at an angle on a standard table, so you can see the whole drawing paper at a single glance.

• **Make sure the light is good.** Whether natural or artificial, the light should always come from the left—if you are right-handed, that is. If it does not, disconcerting shadows may fall across your drawing. Your own hand can also create some strange shadows.

• **Hold the pencil properly.** For drawing, the pencil is held a little higher up than for writing. An additional tip: To avoid damp or greasy marks on your drawing, place a piece of paper under your working hand. Remember also that, whenever possible, the area you are working on should be directly in your line of vision to prevent any distortion.

Three steps to a pencil drawing. 1. First sketch with simple lines. 2. Add more lines to obtain more detail and build up tone. 3. After combining lines and gradations, the drawing appears real.

1

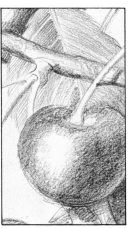

2

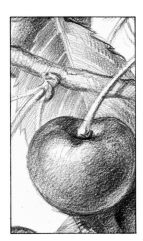

3

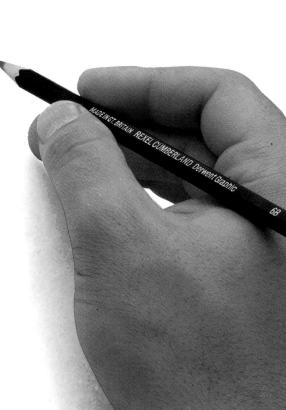

In this illustration, notice how you should hold the pencil when drawing. Make sure that your hand does not touch the paper at all. Place a piece of paper underneath your hand to avoid any pencil smudges from perspiration and oil.

◼ The basic strokes

Diagonal straight lines

These are continuous, uninterrupted strokes, made by moving not only the hand, but the whole arm, across the paper. Trace these lines diagonally, slowly at first, then gradually more rapidly, trying always to keep them the same distance apart. In other words, draw sloping, parallel lines. Practice also drawing lines sloping the other way.

Vertical and horizontal lines

Following the same principle as before, without lifting the pencil from the paper and keeping the same distance between strokes, draw a series of horizontal lines first and then (without turning the paper around) a row of vertical ones, to form an area of cross hatching as even as possible.

Curves and loops

To start out on curved lines, begin by drawing a row of boxes and trace a circle inside each one. Try to produce these using two firm lines: One to form the left-hand side and the other, the right. When you have mastered this technique, you can start drawing a series of the letter " S " using loops and curves. They should be made in a single stroke, taking care with proportions and harmony of form. Fill up as many sheets of paper as needed to produce the strokes shown on this page without difficulty.

Your pencil strokes should always be continuous and confident, made without any hesitation. Although these are elementary exercises, try to give the different strokes on your paper a sense of proportion and composition.

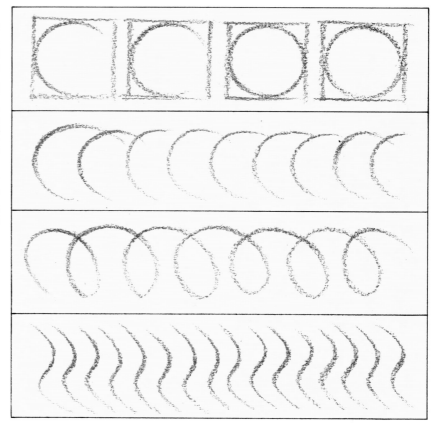

Shading and gradation

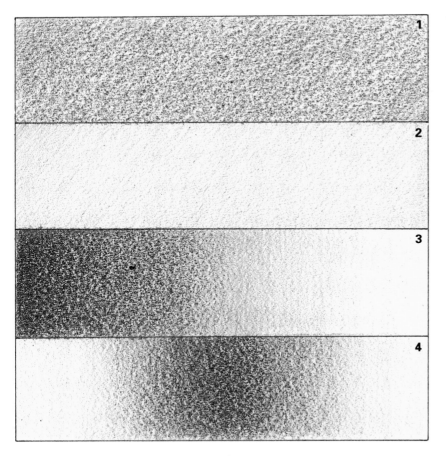

These exercises in shading and gradation should be carried out holding the pencil firmly. First, practice shading with a 2B pencil using diagonal strokes. Try to maintain an even pressure and speed of movement across the paper.

Carry out the same exercise again, but this time using an H pencil, much harder than the 2B. Study the difference between the two pencils when used on the same paper.

Practice vertical gradations using a 6B pencil, one of the softest, and an H, blending them together to highlight the differences more clearly. The H pencil blends in with the gradation where the shading of the 6B pencil becomes less intense.

Finally, produce a vertical gradation using an H pencil, spreading outwards from the center and reinforced in the central area with a 6B. These four exercises have all been carried out on a fine-textured paper.

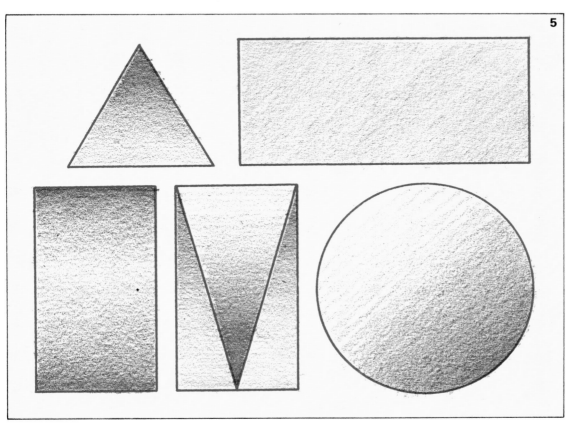

And now for something a little more interesting as a complement to the previous exercises: The same shading and gradations as above, produced inside different shapes. First, draw squares, rectangles, or whatever shape you like, and then fill them in using shading or gradation. This will teach you how to work within predetermined dimensions.

Gradation using circular strokes
Using a 2B pencil for dark areas and then an HB pencil for the lighter parts, draw a gradation using small, rapid, circular strokes. The wrist and arm should move simultaneously.

Gradation using elongated curves
Cover a pre-determined area with a gradation produced by superimposing increasingly dense layers of elongated curves. Notice the "textured" look this creates.

Uneven horizontal strokes
Now fill in this shaded area with uneven horizontal lines. Move your wrist and arm in a rapid, even rhythm.

Horizontal parallel strokes, leaving a space
With the HB pencil, make horizontal, parallel strokes on both sides of an area contained by a curved line, as if each stroke passed behind the white area. Do not draw in the outline of the shape: Your drawing should look like the one on the left.

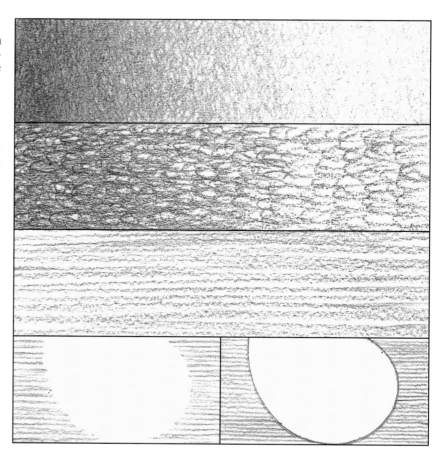

Shading a sphere
Here you can apply what you have learned from the exercise on uneven, horizontal lines. Reproduce the sphere on the top left by building up layers of strokes with the HB pencil, then by intensifying the tone with the 2B. Notice how, in this example, the direction of the strokes follows the lines of the sphere's surface (see the sketch, bottom right). This contributes greatly to the sense of form. However, it is perfectly possible to turn a circle into a sphere with just horizontal strokes (above, right) or vertical strokes, by means of gradations of tone.

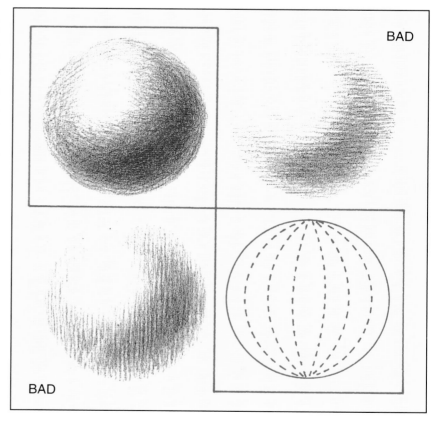

Applying the basic strokes

Cleanliness is vital

With this and every drawing, a lot of attention should be paid to keeping things clean; this can affect the appearance of the finished work. The drawing needs to be protected from your hand and anything else that might dirty the paper surface. It is also important to be neat during the drawing process: The white of the paper, as well as the gray tones, can be marred by being smudged by a clammy hand. Always work with a sheet of paper under your hand, changing it regularly so it won't begin to dirty your drawing instead of keeping it clean.

Now we are going to apply the previous exercises on basic pencil strokes to the drawing of a specific theme that we have set for you. However, before starting, remember that all our lessons and exercises need to be augmented by your own ideas in order for your learning process to be complete.

Look for and draw other simple subjects to which you can apply the same techniques as in our exercise.

Tonal evaluation

Let's look at our subject: Some cherries hanging from the branch of the tree. It is a subject that has no large areas of uniform tone but, rather, small spaces of considerable tonal diversity. Each leaf, each cherry, contains within itself a wide range of tones.

Look at the tonal analysis we produced in the adjacent illustration based on a scale of grays. The reference numbers indicate the scale value of specific areas of the drawing. This lesson in observation will help you avoid one of the most common mistakes made by beginners in drawing: Using too much dark tone. Making the dark areas too strong creates a false tonal value in which shadows become nothing but dark patches.

Our finished drawing (see page 27) has been carried out on paper with a fine grain using three pencils: HB, 2B, and 6B.

If you study our subject, you will notice that the highlights are pure white. At the bottom of the illustration you can see the numbered scale of grays representing the tonal values of different areas of the drawing.

The direction of strokes

The direction of pencil strokes contributes greatly to the sense of depth and volume. It is especially important when representing forms contained within curved lines and also when we decide not to use the technique of blending strokes together—in other words, when we decide to work with nothing but the pencil (and an eraser, of course).

As a general rule, we should direct our strokes as if we were tracing the pencil lead over the surface of whatever we are drawing. Take a look at this pen and ink version of our subject and you will see how this principle has been applied. The lines follow the curves of the different surfaces. Now you should do the same with the pencil.

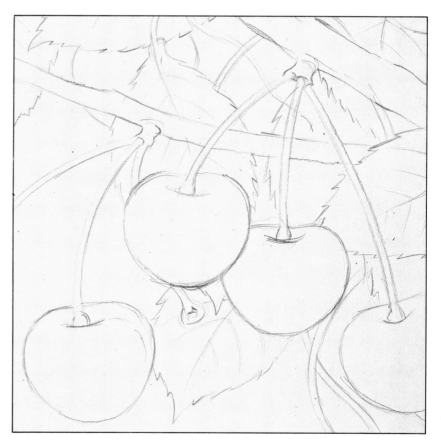

General outline

With an HB pencil, first situate and then outline the different forms that make up the subject, being as accurate as you can about the size and location of each. Make a few tentative lines, without pressing too hard, until you have decided where each element is to go. In this first exercise, we are leaving everything to your intuition. On later pages we will go into outline drawings and proportions. Just as we teach our hand to manage the pencil, we have to educate our eye to capture the shapes of objects and their proportions in relation to one another.

Look at our outline drawing and try to reproduce it on a piece of paper of approximately 8 × 10 in.

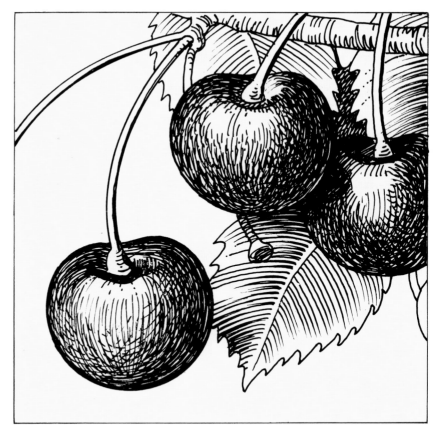

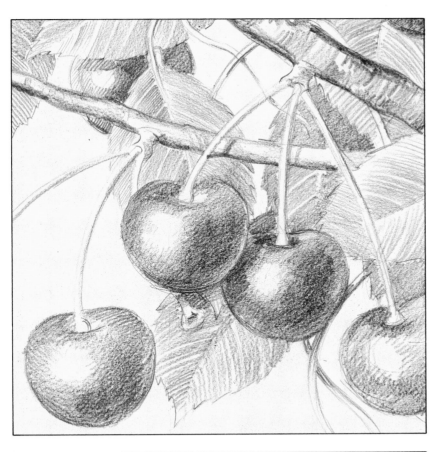

Setting the tone

Block in each part of the drawing using the appropriate base tone. Do this with an HB pencil without "using up" the blacker range of tones or allowing them to dominate at this early stage. Don't forget that the object of this exercise is to apply the basic strokes we studied in theory earlier. Notice, especially on the leaves, how the strokes are parallel and follow the curve of the surface.

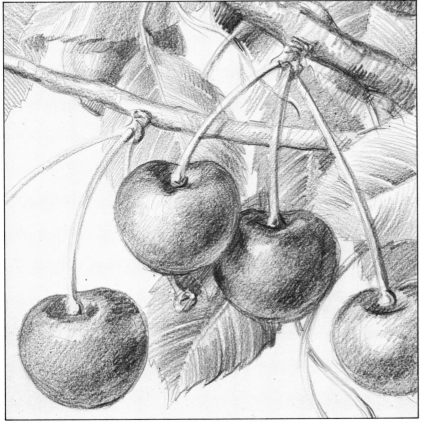

General build-up of tone

Using an HB and 2B pencil in combination, touch up any imperfections and correct the tonal values. Use the point of the pencil or its flat edge as required. Make use of the eraser too, harmonizing shading and gradations, frequently studying and comparing the different tonal intensities and adjusting them accordingly. Making your pencil (guided by your hand) obey orders from your brain (don't forget that drawing is an act of intelligence) is not something that happens immediately. With this in mind, if you are in doubt, stop for a moment and practice on a separate sheet, to find out if the position and pressure of your pencil and the direction of your strokes are the right ones for this drawing.

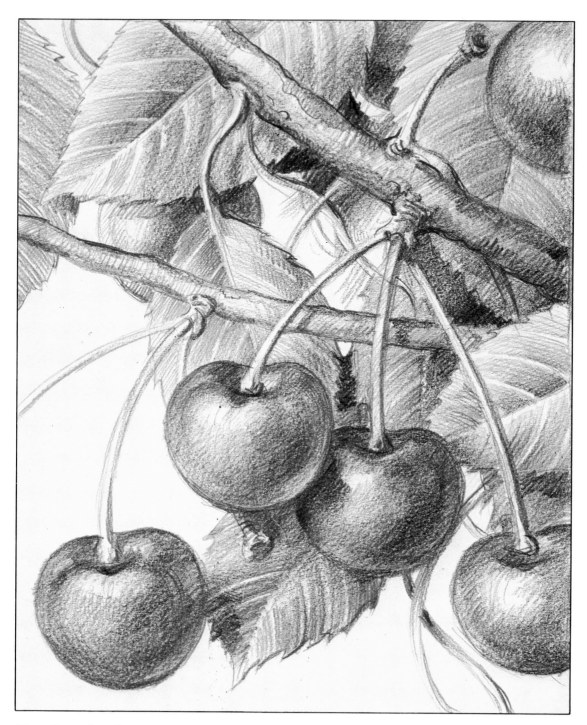

Tonal evaluation

Enhance the black areas with a 2B pencil, without overdoing the effect. Come to grips with the intense black of the shadows, extending and gradating them and bringing them into harmony with the other tonal values. This is a particularly enjoyable moment; it looks as though the drawing has been varnished, suddenly brought to life.

Heighten all the tones simultaneously, always seeing the drawing as a finished whole, at any stage in its production. Draw successive layers of strokes, progressively enhancing tones and contrasts as required, until you achieve exactly the right shade of gray.

The final touches have been added using a 6B pencil. These little details are always left until the very end: A highlight here, an outline there. Before applying a fixative to your drawing, leave it for two or three days, in case some last-minute alteration is needed. Once these have been made, you can go ahead and sign your first "work of art."

Every artist, and especially the beginner, often feels real terror when confronted by a blank sheet of paper.

The amateur takes one look and wonders, "What do I do next? Where do I start? I have the model in front of me, but what do I do first?" This amateur artist may have heard about the outline sketch and that the secret lies in looking at the objects as if they were blocks placed inside boxes, and developing the real shapes from this starting point. But the doubts continue: "How do I draw these boxes? Where? How big?"

If you are in this situation, allow us to explain that the key to this problem lies in convincing yourself that a drawing, especially in its early stages, is never the result of chance or magical inspiration. A drawing is the product of your own intelligence. In order to draw you must apply reason. Simple reasoning, but absolutely logical, enables you to produce on the white paper the first strokes indicating the position and dimensions of the elements in your subject. Look closely at the example on the right and ask yourself:

"Where is the vertical axis of the picture?"

"How high up the bottle do the other elements of the composition reach?"

"How tall is the teapot in relation to the total height of the bottle?"

"How far from the vertical axis are the farthest width limits of the teapot and the cup?"

With the answers to these questions it is easy to set up "boxes" defining the height and width of the elements in the composition. The outline sketch is no more than the result of putting in some thought before beginning a drawing, a process that breaks down the barrier of anxiety caused by the blank page.

More than five hundred years ago, Leonardo da Vinci encouraged his pupils to exercise their "eye" to calculate the true dimensions of objects and then to compare them to establish simple arithmetical relationships between them.

We are going to look into this, so that in no time at all you will be able to cut a cake into twelve identical pieces, or set up a sketch of any object or composition of objects with four quick and accurate strokes. In short, we are going to take a lesson from the great Leonardo.

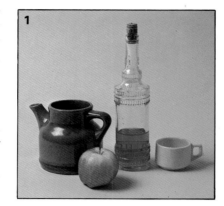

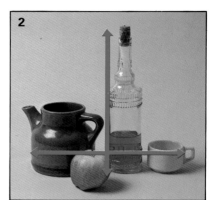

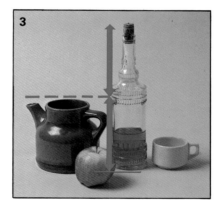

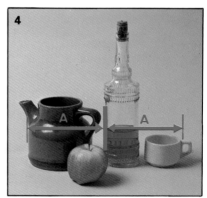

Calculating distance

Making a mental calculation

Look at this illustration. It is an uncomplicated subject that will provide a good introduction to making mental calculations of distances.

Notice, for instance, that the distance between the base of the door and the lintel over the balcony may be divided into five equal parts, the lengths of which coincide with the height of the balcony rail. This observation allows us to establish all the basic height measurements of our subject as well as the widths, if we bear in mind that C (the width of the balcony door) is the same as the unit of height, A; as a consequence, B is equal to 2A.

With every subject it is possible to find measurements that relate to one another and can be compared in this way, whether they be whole parts, halves, or quarters. This task of analyzing a subject, checking measurements, and making an initial sketch, is essential before undertaking the definitive drawing.

Logically, there will be certain measurements that do not fit exactly within the pattern we begin to work out for a particular subject, but it will not be difficult to estimate these.

No doubt you will be asking yourself, "So, will I have to go through this measuring business every time I draw?" The answer is yes and no. Yes, because there is no outline sketch that does not require a certain amount of calculation of the basic measurements and proportions of the subject; and no, because, as your eye grows accustomed to gauging distances, you will become more confident using the pencil, reducing the need to "pause for thought." The time will come when your eye will be able to spot equal distances without needing to go through the whole mental process.

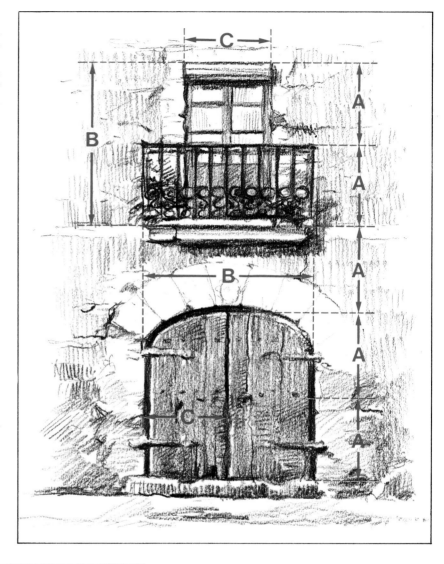

THE MENTAL CALCULATION OF DIMENSIONS CONSISTS OF:

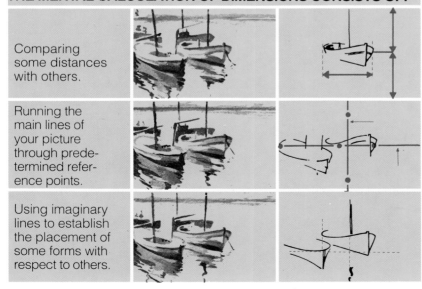

Comparing some distances with others.

Running the main lines of your picture through predetermined reference points.

Using imaginary lines to establish the placement of some forms with respect to others.

Above. In this illustration it can be seen that, by comparing distances, related proportions are discovered that allow key measurements to be established in a drawing.

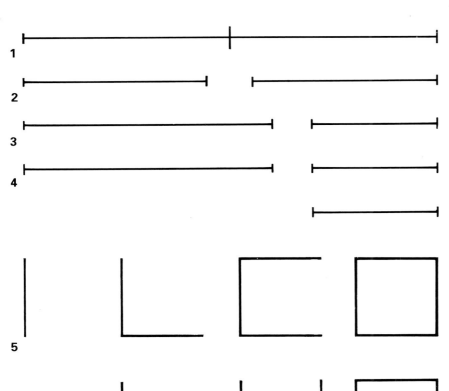

The ideas on this page are only a small sample of the great variety of possible exercises on this subject. The type of paper and pencil you use here is not too important. The important thing is to work on a drawing board, situated a short distance from you. Work with your arm extended and with a firm grip on the pencil.

Draw on fairly large pieces of paper (a good-sized piece of packing paper, for instance) and remember that the harder the exercise, the sooner you will become adept at visually calculating distances. Repeat these exercises again and again—and any others you care to invent for yourself—until you can do them perfectly.

1. Draw a horizontal line about 8 in. (20 cm) and, using your eye, to find its center, divide it in two.

2. Draw a horizontal line and, beside it, another of the same length.

3. Draw a horizontal line about 6 in. (15 cm) and, beside it, another half its length.

4. Draw a horizontal line and, beside it, two parallel lines both half the length of the first.

5. Draw a square following the sequence shown in the illustration.

6. Draw another square, this time cut in half, following the sequence shown.

7. Draw a vertical line, then an "X" with the line passing through its center, and finally draw a square using the "X" as its diagonals, as shown in the illustration.

THE IMPORTANCE OF A MILLIMETER

These two drawings are both aimed at producing a likeness of Winston Churchill. Study the two results and see the effect that a distance of just one millimeter can have in any drawing. On the left, Churchill has been drawn with errors of distance between the eyes and between his nose and mouth. It's not Churchill anymore, is it? In the drawing on the rigth, the distances have been corrected.

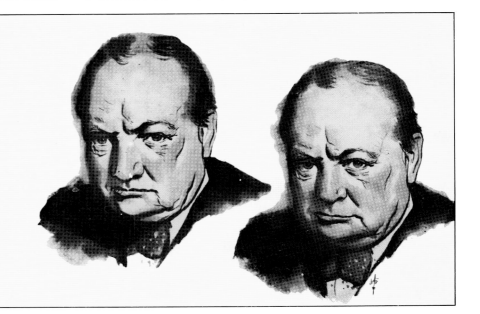

Using the pencil for measuring proportions

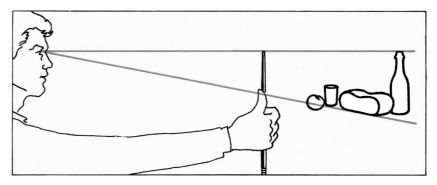

There will be few occasions when the real measurements of a model will be the same as when reproduced in a drawing. It is most likely that the objects will be drawn much smaller or, very occasionally, bigger than in reality. But the proportions of the model will indeed remain the same in most drawings.

When copying a drawing or a photograph, it is common to use a grid. This is a method well known to school children and even professionals use it from time to time. But what about establishing the proportions of a real life model? The most frequently used system revolves around a simple pencil, or paintbrush handle, or ruler. The precise tool is up to you. Look at the illustrations: Raise the pencil to the level of your eyes, extend your arm (return to this position every time you take a measurement) and situate the pencil in front of the part of the model you wish to measure. Move your thumb up and down until the visible part of the pencil coincides with the measurement of your model. Translate this measurement onto your paper and continue to use the pencil to measure the remaining proportions.

Compare distances frequently. Work meticulously, correcting proportions, relating them to one another, and indicating points of reference. Suddenly, without noticing it, you will find that your mind is working in a totally logical way.

Remember to calculate horizontal measurements as well as vertical ones, without ever altering the distance between your arm and the subject. To begin with, use this system for calculating the distances and proportions of simple objects, then go on to larger projects.

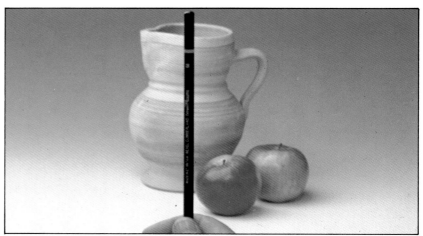

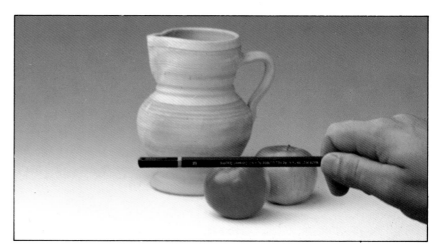

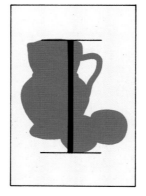

In these illustrations you can see how a pencil—or other, similar object— may be used to establish the dimensions of a chosen subject. Notice how the pencil is held and how to compare measurements of width and height. In this example, is the height greater? Or the width? Or are they the same?

USE OF THE GRID

If a grid had been used (always assuming the subject was a photograph, of course), these errors in depicting the relative size of the apple would not have happened. But since, in this example, the artist was drawing from nature, he only had his eye to work with—which in this case let him down!

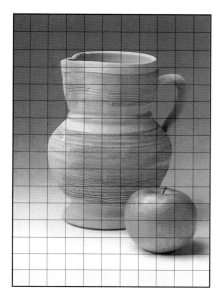

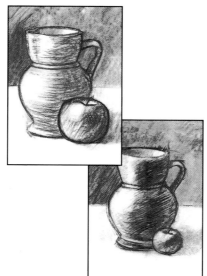

It is very important to know how to set up the proportions of a picture. To illustrate this, on the right we have two sketches of the same subject, a jug and an apple, in which the correct proportions between the two elements have not been observed even though they could easily have been established.

The photograph shows our subject. On the right (above) it has been drawn on a smaller scale, but making the mistake of reproducing the apple on a similar scale, so that it seems proportionately much bigger than in reality. The other sketch shows the same subject with the apple drawn on too small a scale. These drawings show the effects of badly judged proportions.

In the same way, we see figure drawings in which the head seems out of proportion in relation to the body. This problem was resolved by artists in Ancient Greece who created formulas for the depiction of the human body, through which a basic unit of measurement was used to make simple calculations regarding proportions.

DÜRER'S INVENTION

Albrecht Dürer (1471—1528), German draftsman, painter, and engraver, invented various devices to help resolve the problem of dimensions and proportions of his chosen subjects. As we can see in the engraving, one of these devices consisted of a sheet of glass divided into squares and set in a frame, which the artist placed between himself and his model. He traced out a grid on a sheet of paper with the same number of squares—perhaps larger or smaller, but always the same number—and, maintaining a constant viewpoint, he translated the lines and curves of his model onto the paper, using the grid.

This system undoubtedly worked, however basic it might seem. After all, it is no more than a system of applying the "trick" of the grid to a real life model. But these applications of elementary geometrical principles (in this case, one of the criteria of proportionality) that so preoccupied Renaissance man, have never been able to replace the vision and mastery of form that the artist must have, both intuitively and as a result of training his own eye.

An engraving from the era. Alberto Durero is seen drawing with the help of a grid. Observe the reference situated in front of his eyes, the purpose being to always obtain the same point of view.

What is an outline drawing?

Cézanne used to say that "all the elements of nature can be seen in terms of cubes, spheres and cylinders."

It is true. Look around you: Everything you look at could be broken down into square, rectangular, or spherical forms—a table, an orange, a jug, a glass. Everything can be sketched out in an initial drawing that simplifies the graphic representation of its basic dimensions, its length, breadth, and height.

A rough outline, though, is not the same as constructing a frame into which the whole subject will fit. The artist must know how to identify the most important basic shapes to be included in this outline drawing. Look at the illustrations on the left and see how convenient it can be to calculate dimensions by means of an initial sketch consisting of cylinders, rectangles, or spheres.

So, to sum up, if you can draw a cylinder, a cube, or a sphere, you can draw anything, as long as you can calculate and compare distances and are able to draw the basic shapes that make up the proportions of your model.

Now imagine that you are carrying out the following exercise direct from life.

Take a pencil and paper and get ready to "think" along with us:

1. You are going to draw a balcony, complete with Venetian blind; you have already drawn the basic rectangle, observing the height-width ratio of the model.

2. You have noticed that the bottom of the blind comes to just below the half-way point of the rectangle and you have drawn this line.

3. Using the pencil system, you have calculated the thickness of the projection of the balcony (distance A-B) and have drawn a horizontal line passing through A.

4. The same distance A-B, taken from the left-hand vertical, also happens to bring you to the left limit of the blind. Draw in the two verticals and you now have your blind in the drawing.

5. You have noticed that the "unit" A-B can also help you establish the height of the balcony rail: the total height is A-B, plus C (which is half of A-B), plus another unit A-B.

6. To situate the bars of the railing, its entire width has been divided first in two, then in four, and finally into twelve equal parts. A few more details complete the perfect sketch.

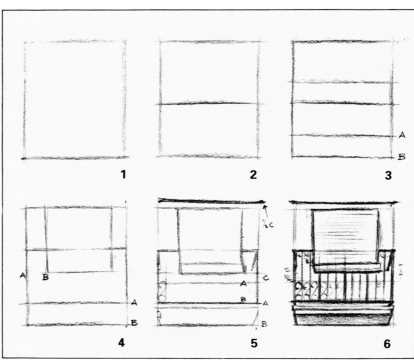

Does this person on the right look familiar? Yes, it's Humphrey Bogart, one of the great legends of the silver screen. We have decided to draw his portrait, not for you to copy it (it might be a little soon for that), but to show you how important it is to train the eye to analyze a model, especially with a subject as involved as a portrait, in which the calculation of distances is critical. The likeness can often be lost by being a millimeter off (remember Churchill on page 30).

On this occasion, then, we are not asking you to draw—at least not immediately. Of course, if you want to copy our drawing, that's fine, but for now all we ask is that you follow the thought process of a professional artist who has drawn Bogart's portrait from the adjacent photograph.

First steps

Our artist has used a 2B pencil, an eraser, and a sheet of medium-textured cartridge paper about 8 3/4 × 12 in. (22 × 30 cm).

But before his pencil touches the paper, he spends a good while just analyzing the model. He notices that the vertical and horizontal axes of the photograph will be a useful reference for situating the parts of the face; they will help him to calculate distances. So he has drawn in these references—that is, the vertical and horizontal axes that divide the rectangle of the picture symmetrically.

"The ear, the chin, the left cheek, and the hat band define the edges of a sloping rectangle in which I am going to draw the face," says the artist.

In the same way, he points out that the hand and the telephone fit into a square in the bottom right-hand corner of the picture, also sloping at an angle (which he calculates by eye) to both axes. The artist has set up both these quadrilaterals within the drawing and, in doing so, has completed the first stage of the drawing. Naturally, this *definitive* stage will sometimes follow an earlier stage, rubbed out by the artist because it did not correspond to his idea of reality.

The definitive sketch

Now the different elements of the face are placed. The eyes, the nose, the ears, the mouth.

The artist continues: "The tip of the ear and the pupils of the eyes suggested to me a line sloping from the top left quarter of the picture to the intersection of the horizontal axis on the right edge of the picture. This line is parallel to the upper (hat band) side and the lower (chin) side of the rectangle containing the face. Also, the bridge of the nose forms a vertical line that cuts through exactly a third on the horizontal axis."

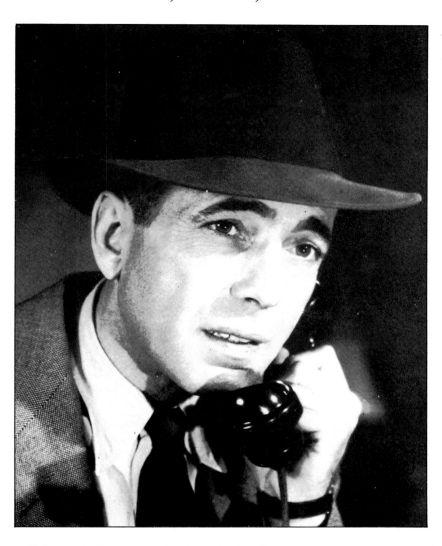

Using a similar approach, the artist has broken the face down into small parts to place the mouth, eyes, eyebrows, fingers, and so on.

Remember that any model, however complex it seems, may be analyzed as if it were a puzzle. All you need is to find and separate the series of pieces that, when joined together, make up the whole.

It is a matter of simplifying shapes, establishing proportions, and situating them in the picture; of identifying very simple forms in more and more detail, until eventually we reach the stage of defining more complicated ones—all of which, of course, is much easier to talk about than to do. But let's get back to Bogart and his portrait.

The estimate of distance begins when we try to see the most convenient methods for dividing the image. This can be done in limited segments by reference lines that simplify the measurements and permit us to place all the elements of the model on the exact spot on the paper.

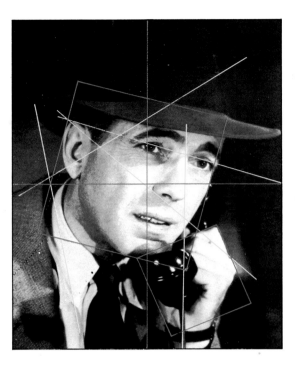

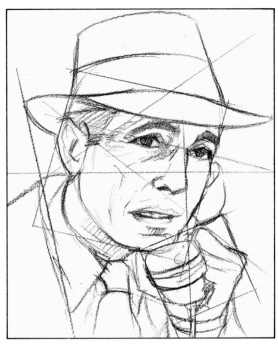

Final stage

The artist has sketched in the position of the fingers and the arrangement of the hand. He has firmly defined the lines of the clothing and has carefully darkened the shaded areas.

This is the moment when, just as the drawing is about to be built up strongly, it is worth going away from it altogether for a few minutes.

When you return to your drawing after a short while you will discover and be able to correct any errors with confidence.

We will take advantage of this little pause to remind you that you need not limit yourself to this portrait of Bogart. Look for another portrait that you would enjoy doing and apply the same analytical process to your own drawing: Situate your axes, draw in boxes for the different parts of your sketch, positioning lines for the eyes, nose, mouth, chin, and so on.

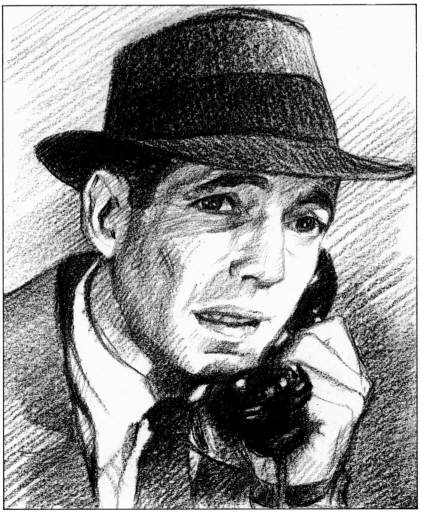

Light, Shade, and Perspective

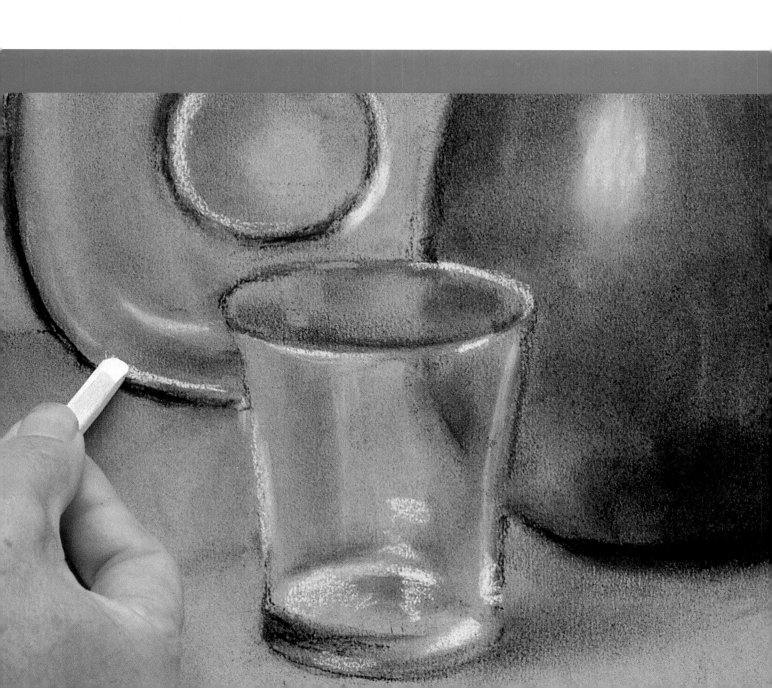

Light, Shade, and Perspective

*T*he following pages deal with the basic themes of artistic representation: light and perspective. Light and perspective are the two factors that determine a work's depth and vision. It could be said that knowing how to represent light and shade and projecting the drawing's dimensions correctly within the given space will truly bring a piece of work to life. The theories of light, shade, and perspective are essential to your practice with shading and creating depth with perspective.

Light and shade

Edouard Manet said in 1870: "The main personality in any painting is light." Manet, like all the Impressionists, was very aware that color is light. Light and shade is what we are going to study now and, by way of an introduction, we are going to take a look at three theoretical aspects of light that might be of interest to the artist.

The direction of light

Basically, a model can be illuminated by:

Front light. Lighting from directly in front of the subject produces hardly any shadow.

Angled-front light. This is light from one side hitting the subject at a 45-degree angle. It creates an even balance between illuminated and shaded areas.

Side light. This is light from one side that leaves the opposite side in shadow. It makes the subject more dramatic and is used to create special emphasis or contrasts.

Back light. In this case the main light comes from behind the subject. As a result the foremost planes of the subject are in total shadow. Back light or semi-back light creates interesting possibilities when painting landscapes.

Light from above. This is usually sunlight coming from an opening in the roof of the studio. It is ideal for life drawing or painting.

Light from below. This is only used in very special circumstances to achieve a dramatic effect.

The quantity of light

This will affect the tonal contrasts the subject offers and that, as a consequence, the artist can recreate in his drawing.

A subject illuminated by an intense light will present marked shadows. Conversely, a weak light will diminish contrasts and create an overall evenness of tone.

The quality of light

By quality of light, we mean whether or not it is natural and the conditions under which it falls on the subject. For example:

Natural light. Light from the sun.

Artificial light. Light produced by electric lamps or other methods.

Direct light. Light hitting the subject directly either from a natural or an artificial source.

Diffused light. Natural light on a cloudy day, or light coming through a window or doorway, hitting the subject indirectly after bouncing off a wall, ceiling, floor, and so forth.

The vocabulary of light

When artists talk about light, in the context of drawing and painting, they use certain words and expressions, the meanings of which do not always coincide with their scientific definitions. Here are a few:

Light areas. Directly illuminated areas of the subject not affected by reflections.

Highlight. The effect created by contrasting a white area with a darker area beside it.

Shade. The shaded areas on the object itself.

Shadow. The area of shade projected by the shape of the subject onto adjacent surfaces (the floor, wall, other objects, and so forth).

Half light. Area of medium tone between an illuminated and a shaded area.

To sum up: When a subject is illuminated, areas of light, half light and shade are produced. At the same time, the illuminated body projects its own shadow onto nearby surfaces and objects. The shade and shadows are themselves affected by the reflected light from adjacent surfaces.

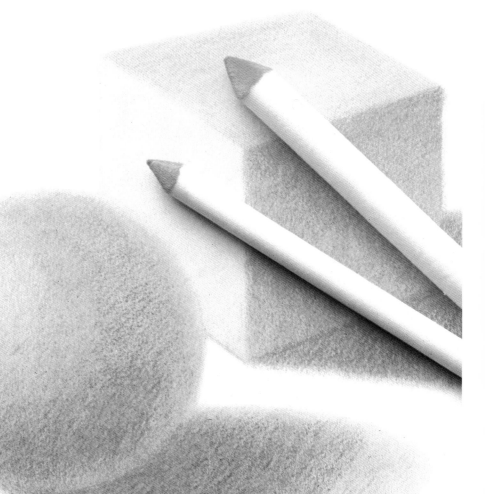

Shading with the finger or torchon

The effects of light and shade in a drawing depend on the correct application of various uniform and gradated areas of tone. In view of this, we believe that the following exercise, which consists of creating different types of shading with a sanguine crayon, will be very useful in teaching you how to convey shadow, to represent in a drawing the effects of light and shade.

First of all, carefully cover a predetermined area with sanguine crayon, applying the strokes very close together. Blend this area with the fingertip, using circular or zig-zag movements, until a uniform tone has been achieved over the whole area.

Now apply another layer of sanguine crayon and blend it in again, this time gradating the color at the same time by spreading the pigment towards the right to create a pale area that will enhance the dark-to-light effect of the gradation. As a complement to this exercise, draw another layer of sanguine crayon, blending it with the finger and creating a uniform tone with the aid of a torchon. Also, discover for yourself how you can draw with an eraser; practice bringing out different whites by using it on plain, shaded backgrounds.

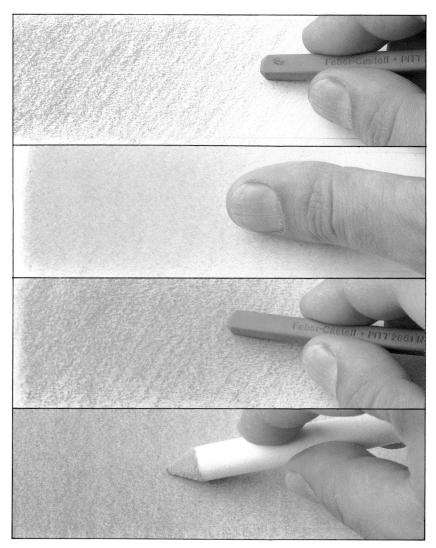

Left. Here you can see how effective your own hand can be in creating shading and gradations. Don't forget the lower palm of the hand, which is useful for blocking in large areas of uniform tone.

Right. Paradoxically, the eraser is also a drawing tool, useful for opening up highlights, defining angles, and sharpening edges. Here we have used a normal eraser on the gradation.

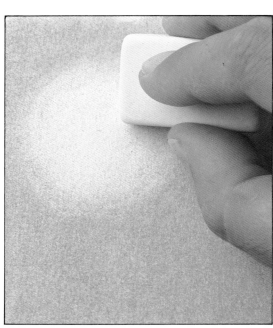

Light and shade. Elementary study

1
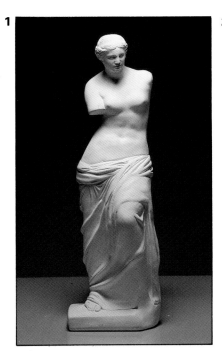

2
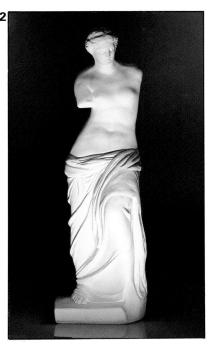

3
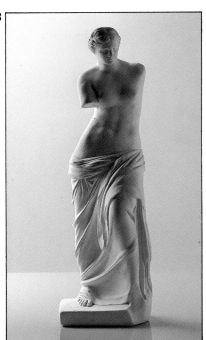

4
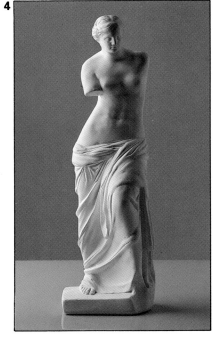

The direction and quality of light

We are going to give you an exercise to demonstrate the effects of light and shade in which, as always, the direction and quality of light are highly influential. This is why, before starting the exercise, we would like you to see for yourself how the appearance of a subject is greatly affected by varying the direction and quality of light. We have already said that light can come from above, below, beside, or behind a subject—indeed, from any direction imaginable!

To illustrate our point, look at these four extremes and the effects they produce on a plaster cast reproduction of the famous Venus de Milo.

1. Light from above. This produces distinct shaded areas (provided the light is intense enough, of course) that emphasize the volume of the model, giving it an unusual appearance.

2. Light from below. The shadows extend upwards. The resulting effect is almost unearthly.

3. Back light. The light comes from behind, leaving the foremost areas of the model in shade, while a characteristic halo of light can be seen around the outline of the figure.

4. Side light. The light is coming entirely from one side, so that at least half the model is in the shade. This emphasizes volume and depth.

In each case, the perfect sense of depth is achieved in a drawing when a balance of tone accurately conveys the contrasts between areas of light, shade, and half light, and when these areas are successfully blended into one another.

Effects of light and shade on a white sphere and cylinder

It is easy to build a cylinder from white card and, as for the sphere, you can buy a little ball of cork or any other material and cover it with matte white paint.

Place both objects on a white background and light them artificially from the side. Then, using an HB pencil, an eraser, and a smooth paper, do the following exercises:

1. Draw lines dividing the cylinder and the sphere into equal parts and, beginning with the line where you think the half-tone starts, build up bands of tone, ranging from the palest through to the darkest gray.

Notice that on the shaded side, the figures show a thin line of reflected light. Don't forget about it!

2. Repeat the exercise, working in bands, but this time without drawing in dividing lines beforehand.

3. Repeat the previous exercise and blend the grays together, so that the transition from light, to half light and shade is smooth and continuous.

4. This time spread the gradation, extending the areas of half tone, to create an effect more like that produced by diffused light, as opposed to example 3, which is created by a more intense light source. The eraser is useful for cleaning up highlighted areas and for defining areas of shade. Notice the clearly visible area of half light around the edges of the projected shadows.

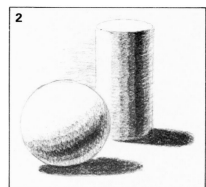

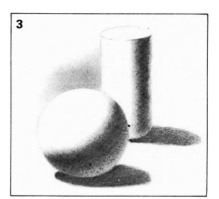

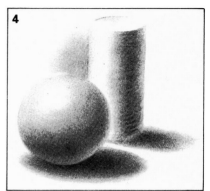

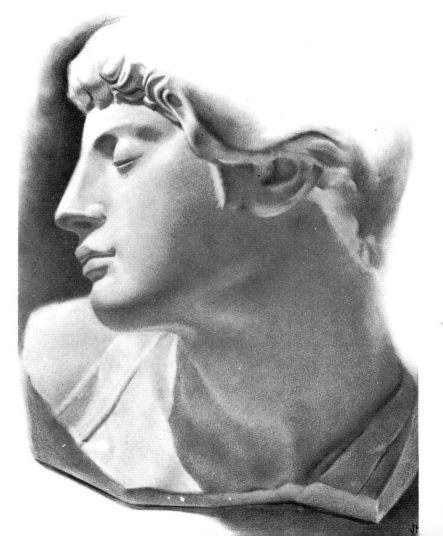

Right. A sample of how an incredible sense of light and depth can be created through the technique of blending light and shaded areas. This magnificent study was produced with a 2B graphite pencil on cartridge paper.

O ne morning in 1909, Pablo Picasso was painting a portrait of Ambroise Vollard, a famous art dealer and friend of most of the famous painters of the era. Picasso was looking through half-closed eyes, detecting angles, quadrilaterals, and cubes in the face of Monsieur Vollard. This was the beginning of the cubist period of the genius from Málaga.

"Let's rest for a while," said the artist, noticing that the subject was looking tired.

Vollard stood up, walked to the window and, while observing the hubbub of the city, remarked, "I was remembering poor Cézanne." (Cézanne had died three years earlier.) "He also painted my portrait, as you are doing now. Cézanne, Monet, Renoir, Sisley...!" Vollard's eyes grew misty with nostalgia. "The most famous group of painters France has ever seen!" he pronounced.

"Yes, but Cézanne ended up turning his back on all of them," Picasso replied, preparing a new mixture of color.

Vollard seemed not to hear this caustic remark. Resuming his position in front of the canvas, he said "He was a very special character: I can almost hear his voice with his rough, Provençal accent, shouting: *Boys, the trick is to reduce everything to cubes, cylinders, and spheres!*"

He smiled at his own clever impersonation, and Picasso started to show signs of impatience.

"Shall we continue, Monsieur Vollard?"

The subject contained the avalanche of reminiscences hovering over his thoughts and adopted the pose Picasso suggested. For the next few minutes, all that could be heard in the studio was the scratching of the paintbrush on the canvas. Suddenly, Picasso's voice broke the silence.

"Cézanne was right!" he said emphatically.

And he continued trying to find new angles, quadrilaterals, and cubes in the face of his friend, Ambroise Vollard.

Cézanne's words are the perfect introduction to our discussion of perspective, which we are going to explore.

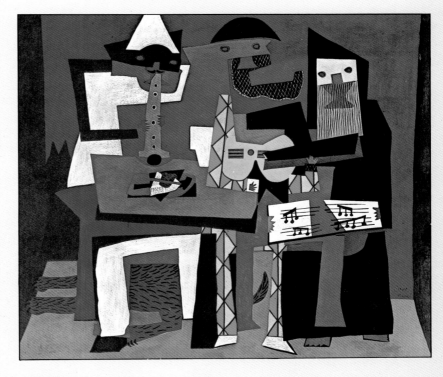

"The Three Musicians", Pablo Picasso, 1921, oil on canvas. Museum of Modern Art, New York. A significant example of Picasso's cubist period, with all the logical geometric qualities.

Parallel perspective of a cube

	Segment The part of a straight line between two points.		**Diameter** Segment cutting through the center of the circumference. Half of the diameter is the radius.
	Parallels Equidistant lines that never meet.		**Angle** Portion of a plane contained within two converging lines.
	Converging lines Those which meet at the same point.		**Arc** Part of the circumference defined by an angle, measured in degrees, minutes and seconds.
	Vertex The point where two or more lines converge.		**Perpendicular** Line forming a right angle with any other line.
	Zig-zag lines Lines made up of many individual segments.		**Oblique** Straight line forming an angle of anything but 90 degrees with another straight line.
	Circle Part of a plane contained within a circumference.		**Acute angle** An angle less than a right angle and, therefore, less than 90 degrees.

Yes, unfortunately, it is necessary to go into the cold and exact science of geometry if we wish to draw perspective correctly. We must begin by clarifying a few definitions. These are concepts that appear constantly in any perspective drawing.

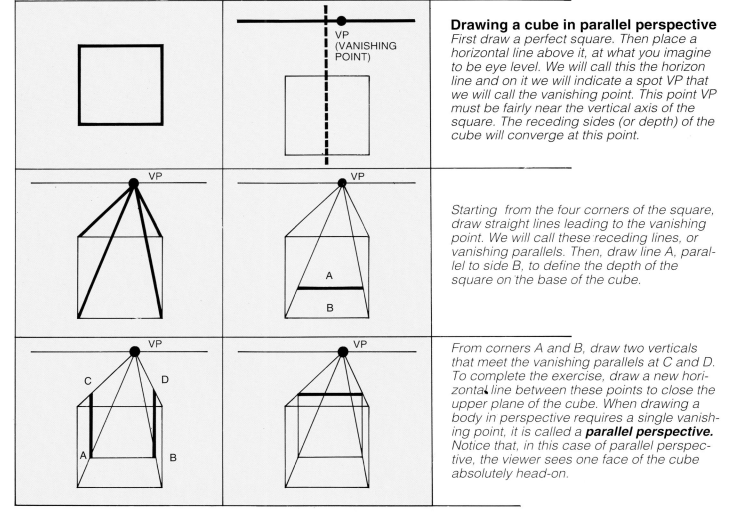

Drawing a cube in parallel perspective
First draw a perfect square. Then place a horizontal line above it, at what you imagine to be eye level. We will call this the horizon line and on it we will indicate a spot VP that we will call the vanishing point. This point VP must be fairly near the vertical axis of the square. The receding sides (or depth) of the cube will converge at this point.

Starting from the four corners of the square, draw straight lines leading to the vanishing point. We will call these receding lines, or vanishing parallels. Then, draw line A, parallel to side B, to define the depth of the square on the base of the cube.

*From corners A and B, draw two verticals that meet the vanishing parallels at C and D. To complete the exercise, draw a new horizontal line between these points to close the upper plane of the cube. When drawing a body in perspective requires a single vanishing point, it is called a **parallel perspective.** Notice that, in this case of parallel perspective, the viewer sees one face of the cube absolutely head-on.*

Oblique and aerial perspective of a cube

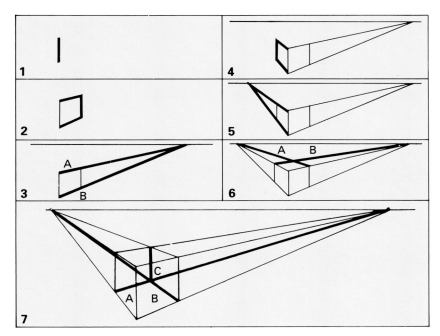

We are now going to draw a cube in perspective when none of its sides completely face the artist. The consequence of this is that we have not just one set of vanishing parallels, but two, with corresponding vanishing points on the horizon.

Cube in oblique perspective

1. Draw the side of the cube closest to you.
2. Draw, in perspective, the foremost face of the cube, bearing in mind that the edges of each plane, seen in perspective, must run to a vanishing point on the horizon.
3. Extend sides A and B to their vanishing points and draw in the horizon line.
4. Now draw the face of the cube that forms an angle with the first.
5. Mark in the second vanishing point.
6. Draw the lines A and B that define the upper face of the cube.
7. To create the effect of a glass cube, draw in sides A, B, and C.

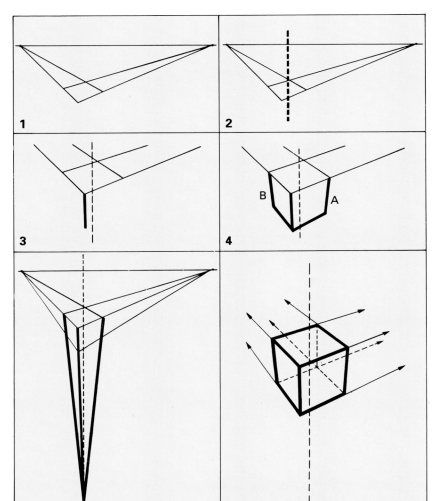

Aerial or three-point perspective of a cube

1. Draw a square in oblique perspective, with a fairly high horizon line.
2. Draw a vertical that passes through the center of the first square.
3. Draw the side of the cube nearest to you. Bear in mind that when this side is extended downwards, it will run to a vanishing point on the vertical line at a level that depends on the height from which the cube is viewed. The higher the view-point, the nearer the base of the cube this third vanishing point will be.
4. Draw the most visible face of the cube. Side A will run to the same vanishing point on the vertical that we just mentioned.
5. Make sure that the slope of these vertical parallels brings them to meet at the third vanishing point on the line perpendicular to the horizon.
6. Draw in the "invisible" lines of the cube as if it were made of glass if you find this helpful, and make any necessary adjustments.

■ The circle in perspective

Drawing a circle in parallel and oblique perspective.

To draw a free-hand circle, follow this method:
1. Draw a square in which to construct your circle.
2. Trace its diagonals.
3. Draw in the vertical and horizontal axes of the square.
4. Divide one half of a diagonal into three equal parts at A, B, and C.
5. Starting at point A, draw another square inside the first. By doing this, you have now created eight reference points on which to build your circle.
6. Draw the circle free hand, making it pass through the eight points you have established.

So, to draw a circle in perspective, you have to start by drawing a square in perspective.

Imagine that, after drawing a geometrically perfect circle, you place it on the floor and walk a few paces away from it. You will, naturally, see it in perspective: In parallel perspective, if it is situated so that you are looking head-on at one of the sides of the square in which it was framed (as in the picture on the left), and in oblique perspective if you are not.

Everything depends on drawing a square in perspective and then following this process:

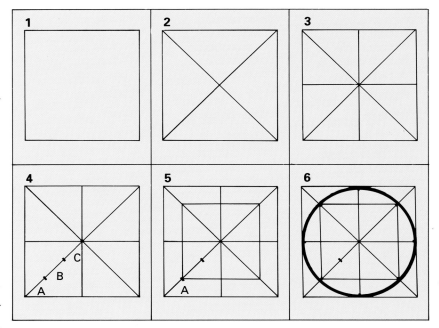

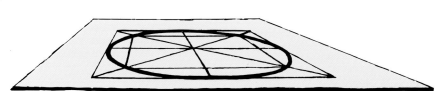

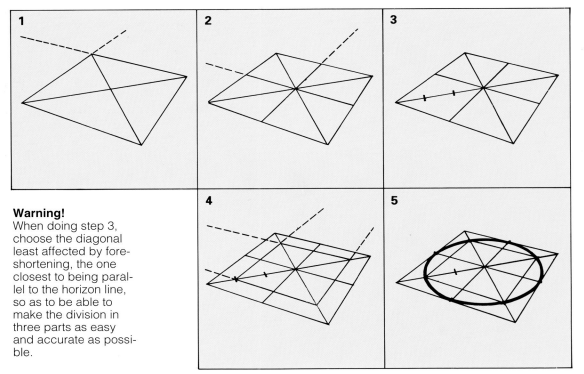

1. Draw the diagonals of the square.
2. Draw the cross through the center with the lines running to their respective vanishing points.
3. Divide one half of a diagonal in three parts.
4. Draw a new square inside the first, starting from the first "third" from the edge.
5. Draw in the circumference by hand, using the eight reference points as a guide.

Warning!
When doing step 3, choose the diagonal least affected by foreshortening, the one closest to being parallel to the horizon line, so as to be able to make the division in three parts as easy and accurate as possible.

Perspective of geometric forms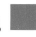

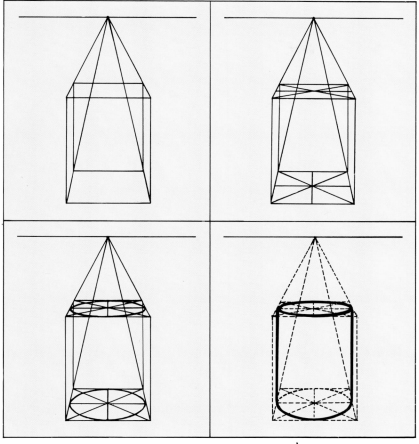

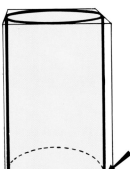

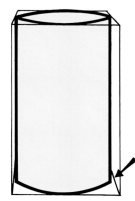

Parallel perspective of a cylinder

Being able to produce, free-hand, the basic geometric shapes in perspective (cube, prisms, cylinder, pyramid, cone, and sphere) is essential if we wish to construct complex compositions. Still life drawings, landscapes, seascapes, interiors, and even figure drawing, can be reduced to these forms at the stage of composition and making an outline sketch.

Look at the four stages of producing a cylinder in parallel perspective shown on the right.

To draw a cylinder in oblique perspective, you will have to draw the prism containing it with two vanishing points, as in the example of the cone on the next page.

Whenever you want to draw a figure with a circular base, you will first have to construct in parallel or oblique perspective, depending on your requirements, the square-based prism in which you think it will fit, and then trace in perspective the circles of the upper and lower planes.

Above. *The cylinder on the left is distorted because its vanishing point is too far away.*

Right. WRONG: The base of the cylinder is not true, because the perspective has been incorrectly drawn.

Left. RIGHT: The trick of the "glass" cube has contributed to a perfect construction.

Common mistakes in drawing cylindrical forms in perspective

We mentioned earlier, when we were drawing the cube in parallel perspective, the importance of keeping the vanishing point close to the visual center of the cube.

When drawing cylinders from the side, we discover the importance of following this same recommendation. Parallel perspective implies seeing the object from in front (B), not from the side, as in example A. The distortion of this first cylinder happens because, in reality, the figure would be well outside the normal field of vision, so that to see it we would have to change our position or draw it in oblique perspective.

To avoid imperfections when drawing in perspective, always imagine that the figures you are drawing—in this case a cylinder—are transparent and that the invisible lines passing through them are visible. It is a trick many professionals use to set up or adjust the perspective of their compositions.

Drawing a pyramid and a cone in oblique perspective

Now that you know how to draw a cube in perspective, this exercise will not be difficult. It involves drawing in oblique perspective the cube or prism that contains the figure you wish to draw: In this case a pyramid with a square base and a cone. The diagonals of the upper and lower squares are drawn and their intersection joined by a vertical line that ensures the cube is correctly constructed. All that remains now is for the corners of the lower square to be linked to the central point of the upper square, and you have your pyramid.

Do this exercise several times, varying the position of the cube. As for the cone, it is produced by drawing a cube with a circle on its base; the center of the upper square is again found by drawing diagonals; this central point is then linked to the outline of the circle forming the face of the cone.

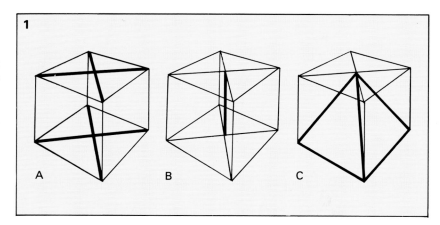

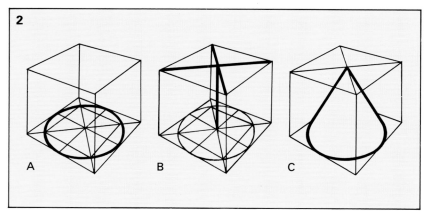

Perspective of a sphere

In practice, when an artist needs a sphere to form part of a composition (an orange for a still-life, an architectural adornment, and so forth), he tends just to draw a circumference with the appropriate diameter, and that's it! In creative drawing we work on the basis that a sphere always looks "round" whichever way you look at it. However, it is worth knowing that the sphere does have its own perspective and that, in theory as well as in practice, its poles, its meridians, and its parallels are situated and seen in a different way depending on your viewpoint.

So it is worth looking at the perspective of the sphere formed by combining the perspectives of different circles we could describe as its equator and its meridians, as shown in the drawings on the left.

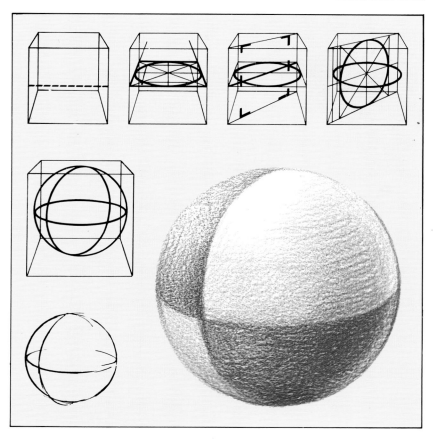

Cubes, prisms... buildings!

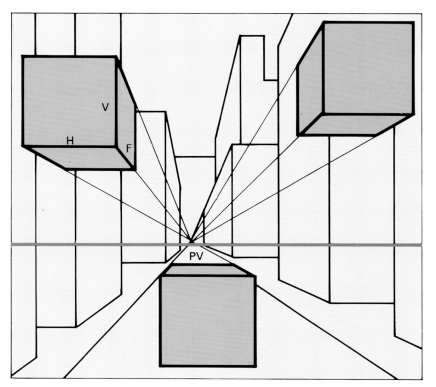

Below. *Typical example of oblique perspective, with the vanishing points outside the picture. Notice that all the lines on the subject, which are parallel in reality, run to the same point on the horizon. In this building, seen in oblique perspective, we have two sets of vanishing parallels that converge, respectively, at one point situated off to the right and another off to the left. Notice also how the perspective of these simple structures can be reduced to the perspective of cubes and prisms.*

Left. *This diagram is a good example of parallel perspective: It shows a single vanishing point that is, at the same time, the center of vision. Three important things are clear here: The sides (or lines) of the buildings in reality are vertical (e.g. line V in the drawing) and when seen in perspective continue to be vertical; they never meet.*

Horizontal lines, in reality horizontal and parallel to the horizon line (e.g. line H), remain horizontal.

Finally: Lines which are in reality horizontal and perpendicular to the picture plane (e.g. line P) are, in a perspective drawing, vanishing parallel lines that converge on the center of vision (CV).

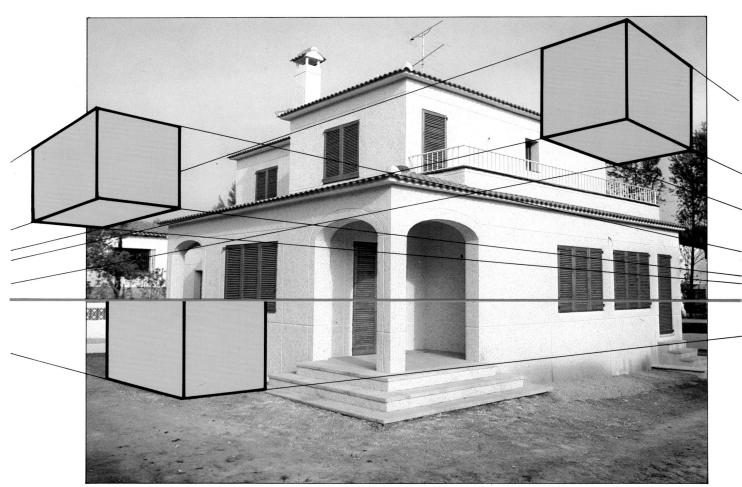

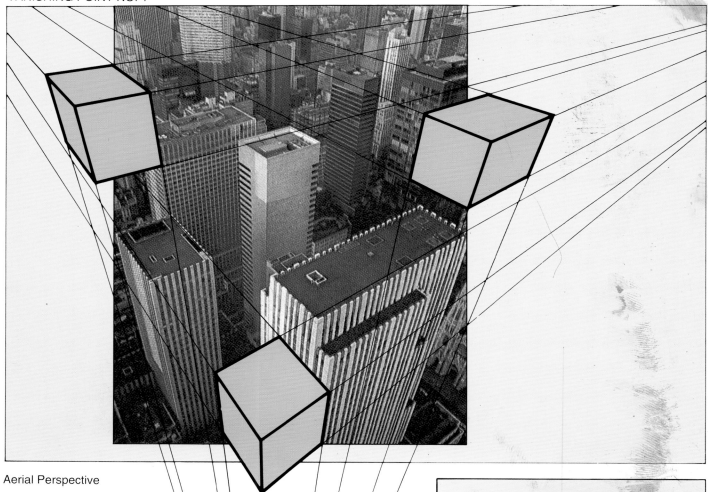

Aerial Perspective

To conclude, here is a very unusual form of perspective, only occurring when things are seen from way above (or way below) the horizon, giving us three vanishing points.

Two different sets of lines run to vanishing points one (left) and two (right) on the horizon. But there is also a third set of lines converging on vanishing point three, down below, but which could be way above the horizon if we were looking up at the building from the pavement.

VANISHING POINT NO.3

Using perspective in the outline sketch ■

I f we seem to be laboring the point that drawing is based on geometric shapes, it is not because we enjoy theorizing, but because it is quite true and has an undeniable practical value.

Find out for yourself: analyze the structure of any object you see, whether you are indoors, in the street, or in the countryside; whether it be a chair, a car, a flower pot, or a tree. You will see that all these structures can be reduced to spheres, cubes, and cylinders.

So, in theory, if we can draw these three things, we can draw anything!

Well, don't get carried away—unfortunately this is only in theory. In creative drawing, indefinable factors like personality, sensitivity, good taste, and emotion play a vital role. What is undeniable is that an awareness of theory (including perspective) gives the artist something on which to base his or her first efforts and also to help the artist apply reason (or common sense) when evaluating later work.

We will now demonstrate how helpful our early lessons in perspective can be when setting up a drawing and adjusting the angle of this or that line so it runs to the right vanishing point. Look at the example on this page: Even the freshest beginner can see that the general shape of the coffee grinder fits perfectly inside a cube seen in oblique perspective, from our point of view. A circle seen from the same viewpoint and forming the base of the hemisphere is the lid—do you see? A few more curved strokes (not forgetting your perspective) will give you the handle of the machine.

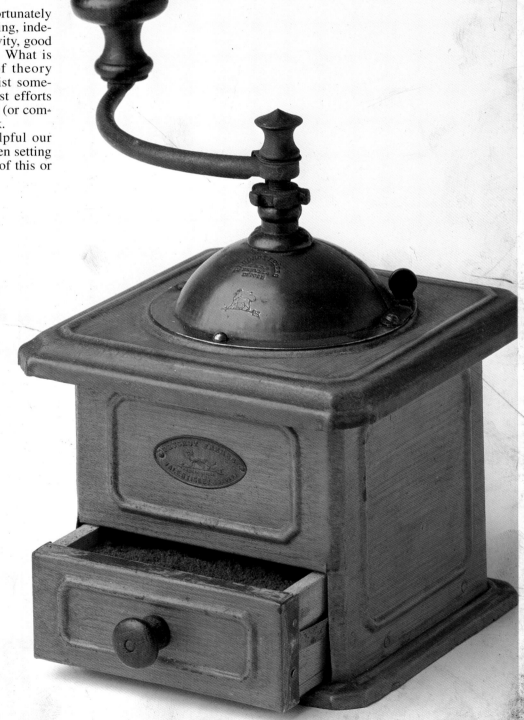

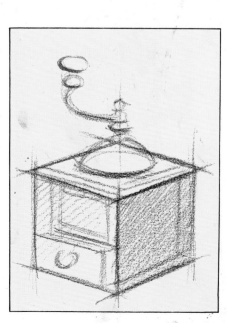

Examples of perspective and the outline sketch

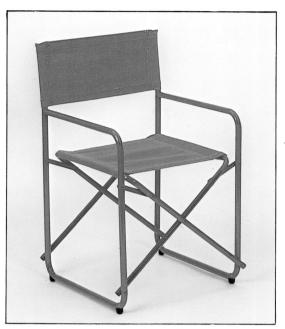

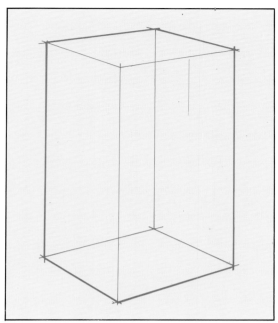

This chair and the coffee grinder on the previous page confirm that all objects really can, just as Cézanne said, be based themselves on a cube, a rectangular prism, a cylinder, a pyramid, a cone, or a sphere. Try it out with lots of examples that, like our chair, require the construction of squares at different heights, parallel to the base of the main prism. Don't forget that all vanishing parallel lines will run to a single horizon.

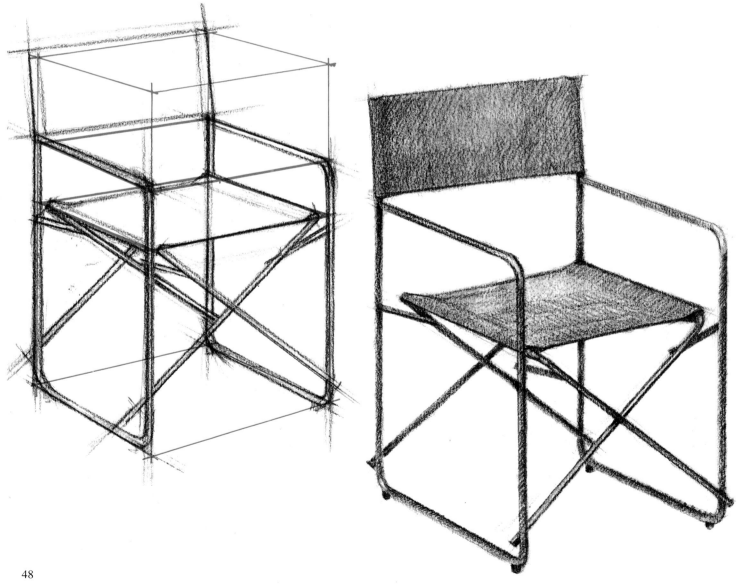

Describing the basic form of this jug has involved the assembly of various geometric lines with which we will need to become familiar if we want to construct any-thing with a round or cir-cular shape. Once we have mastered these tech-niques, which mainly consist of constructing, in perspective, a cube, a cylinder, or a sphere from a square base, we can begin to work free-hand.

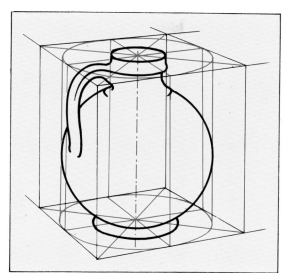

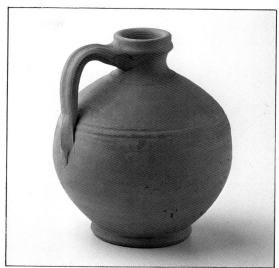

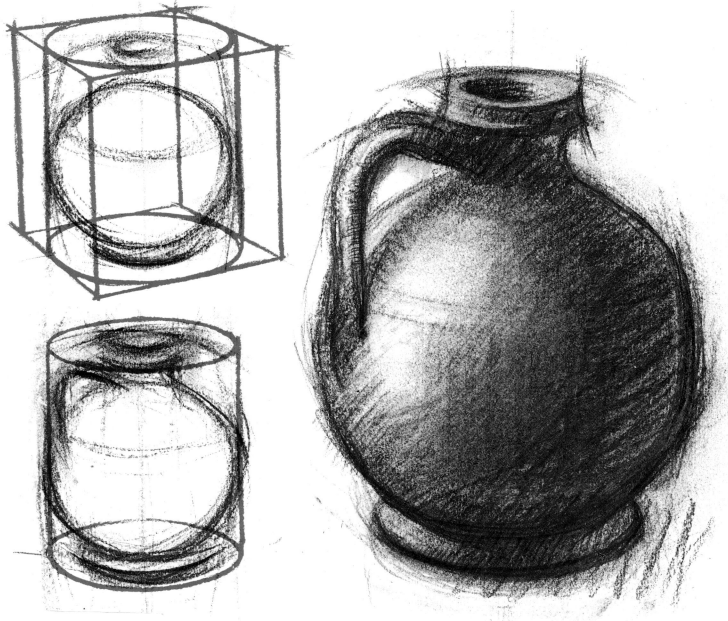

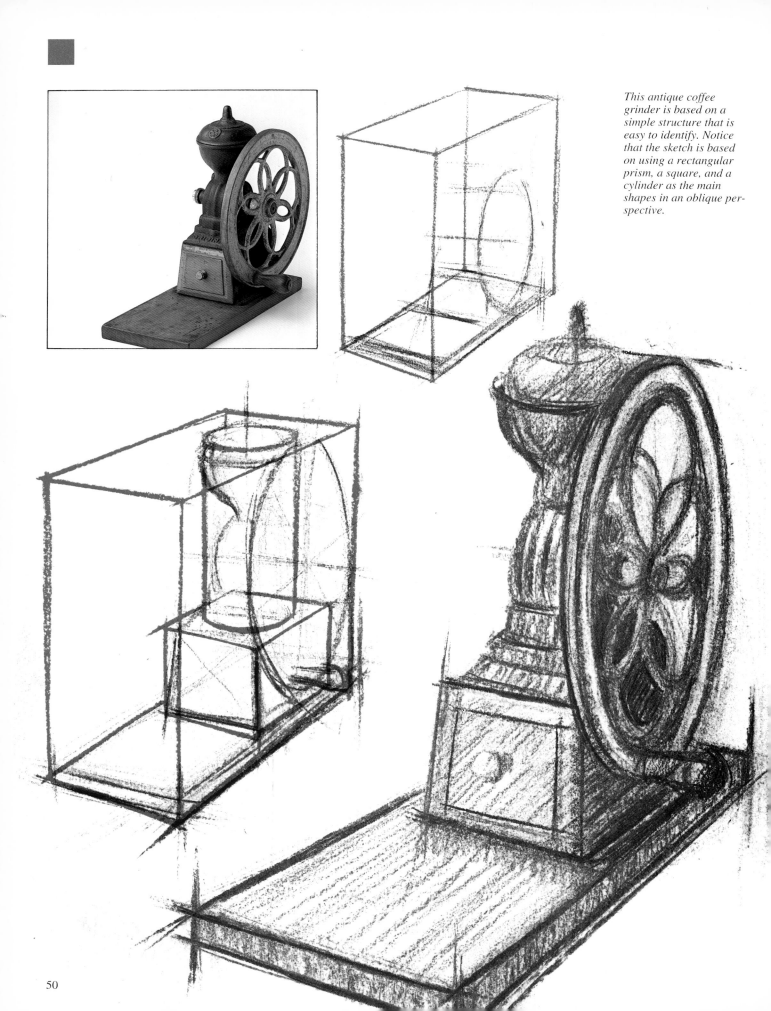

This antique coffee grinder is based on a simple structure that is easy to identify. Notice that the sketch is based on using a rectangular prism, a square, and a cylinder as the main shapes in an oblique perspective.

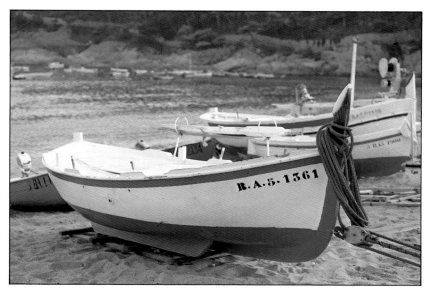

This picture, with the lively, familiar lines of the boat, is a perfect subject to demonstrate the use of basic forms in setting up a drawing— as is the example of the antique gas-lamp on the next page.

Notice how a prism in oblique perspective establishes not only the proportions of the object, but also the direction of its principal lines. The keel coincides with the line dividing the prism in half (in perspective) and the port and starboard sides of the boat are curves at a tangent to the sides of the prism.

Obviously, we can indicate on the basic prism as many point and construction lines as we like to help us set up the outline sketch of our subject. This is something the experienced artist often does along the way, at those moments when he needs to back up his intuition with a little theoretical know-how.

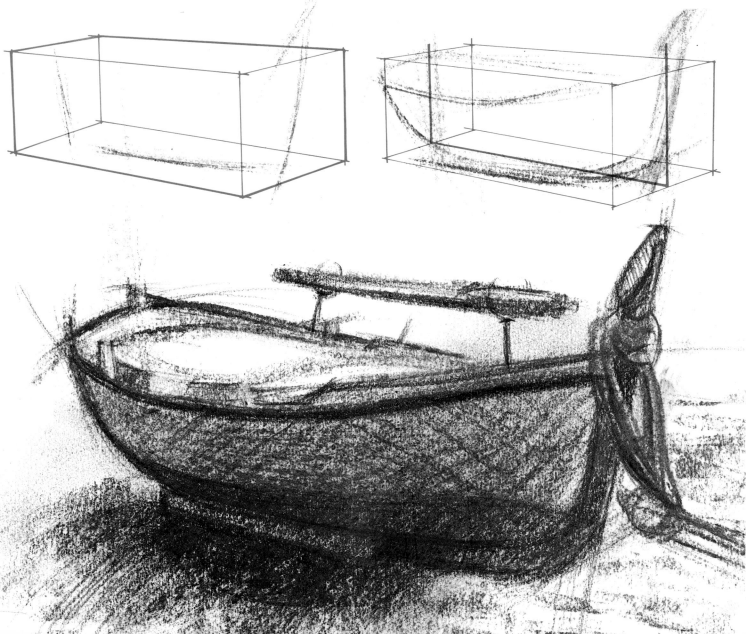

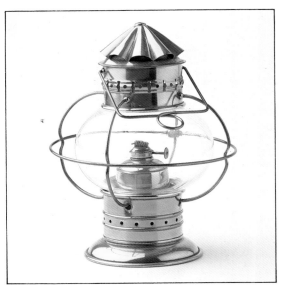

This gas lamp with its sparkling reflections, is made up of forms such as a cone, cylinder, a circle, and so forth. In conjunction, these create a structure that can be contained within a square prism. In the example, it is drawn in parallel perspective. Once the prism in parallel perspective is drawn, its center is found. Squares at various heights are drawn in perspective, within which are situated the circular forms that will give us the cylindrical shapes. On top of this sketch, some early lines are then roughed in to give us a clearer vision of the basic structure of the lamp.

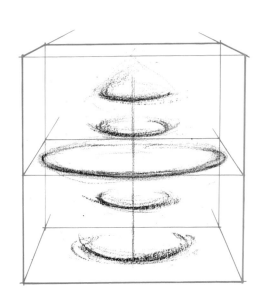

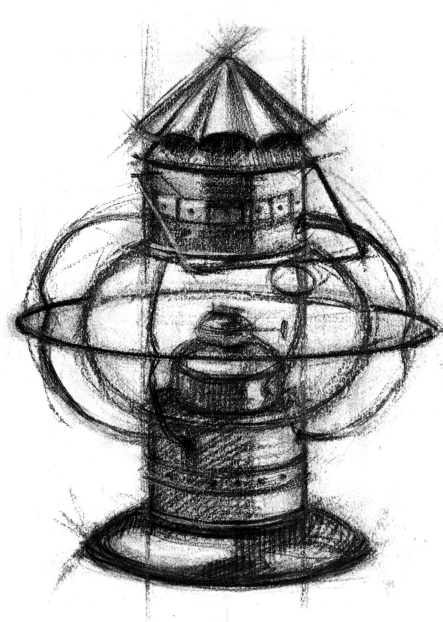

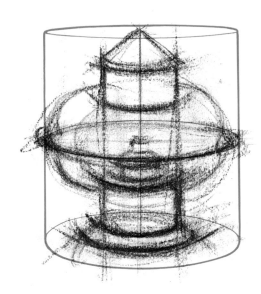

Calculating depth in perspective

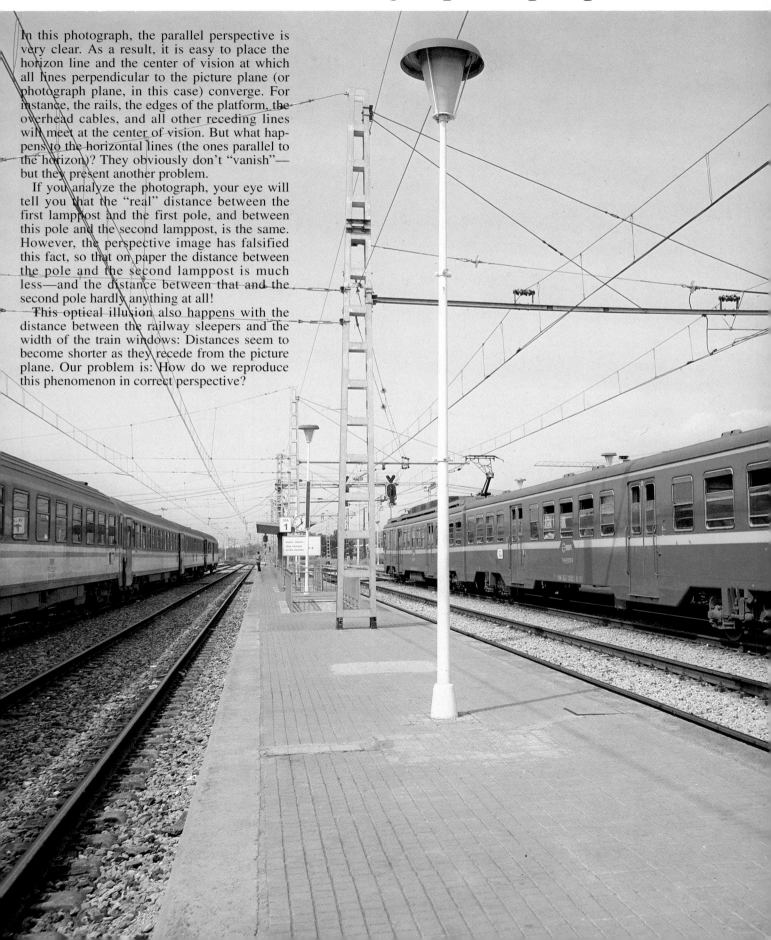

In this photograph, the parallel perspective is very clear. As a result, it is easy to place the horizon line and the center of vision at which all lines perpendicular to the picture plane (or photograph plane, in this case) converge. For instance, the rails, the edges of the platform, the overhead cables, and all other receding lines will meet at the center of vision. But what happens to the horizontal lines (the ones parallel to the horizon)? They obviously don't "vanish"—but they present another problem.

If you analyze the photograph, your eye will tell you that the "real" distance between the first lamppost and the first pole, and between this pole and the second lamppost, is the same. However, the perspective image has falsified this fact, so that on paper the distance between the pole and the second lamppost is much less—and the distance between that and the second pole hardly anything at all!

This optical illusion also happens with the distance between the railway sleepers and the width of the train windows: Distances seem to become shorter as they recede from the picture plane. Our problem is: How do we reproduce this phenomenon in correct perspective?

Calculating depth in perspective

How to represent equal distances in perspective

Let's take a situation that typifies the problem we are facing: We have to represent, in perspective, the apparent separation between the columns in the upper gallery of these cloisters. In this and similar cases (telegraph poles, equidistant trees, and so forth) the following system is very useful:

1. Once you have situated the horizon and the most important receding lines, draw in, using your eye for measurement, vertical lines representing the first two columns, as if these defined the depth of a vertical rectangle drawn in parallel perspective. When you feel the distance AB is accurate, draw the diagonals of your rectangle AA'BB' in perspective and a vanishing parallel that passes through the intersection of these diagonals. This vanishing parallel will intersect the axis of the second column at point 1.

2. From A, draw a straight line passing through point 1 to create C. This straight line is, in fact, the diagonal of a rectangle whose depth, AC, is twice AB. Therefore, the distance BC is equal to AB—in perspective, of course. What next? Simply continue the process drawing diagonals that successively determine points D, E, F, and so forth, representing the axes of the different columns.

3. Look at the more finished version of the drawing and consider how such an elementary perspective construction has enabled us to produce an accurate impression of the space between equidistant objects.

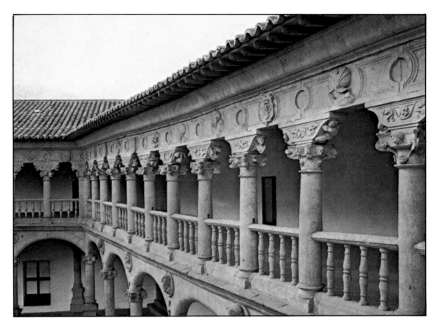

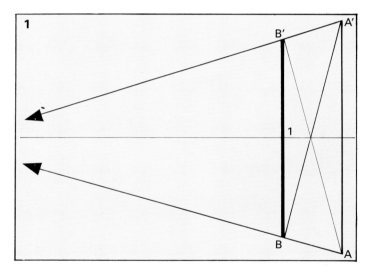

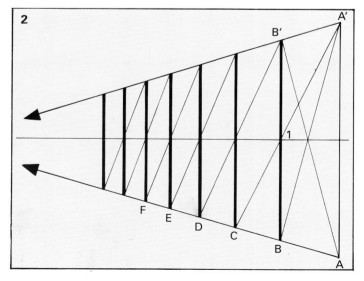

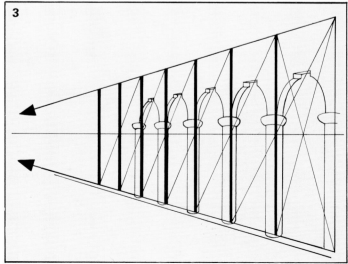

A grid in perspective

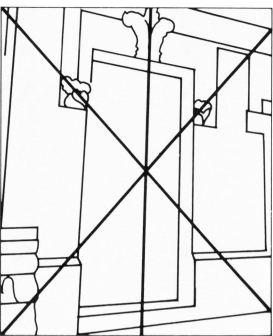

Left. The most practical way of finding the line that divides a rectangle or square in half in perspective, is to draw in the diagonals.

Below. Study by Leonardo da Vinci for "The adoration of the magi." The plan traced on the ground plane allowed this old master to know, at any given moment, at what level of depth each element of his complex composition was situated.

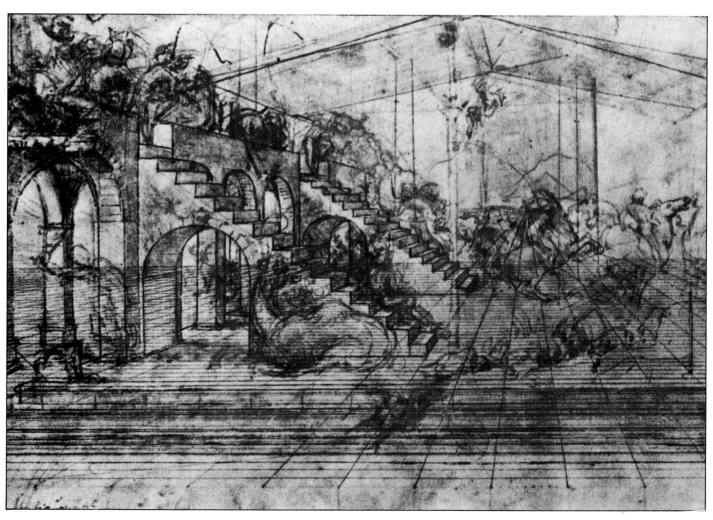

A grid in perspective

In parallel perspective

The width of the individual squares is indicated on the front edge of the grid. From these points, vanishing parallels lead to the center of vision. In the right-hand corner, the depth of a square with sides measuring "three-by-three" units is determined. The extended diagonal of this square cuts through the vanishing parallels at points 1, 2, 3, 4, and the like, which establish the depth of the successive rows of squares. This process could be continued ad infinitum.

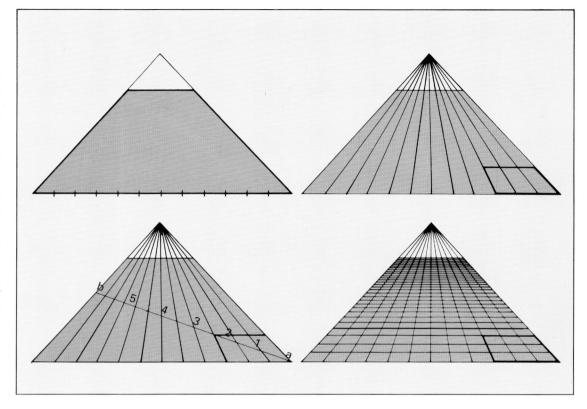

In oblique perspective

A. A measuring line is drawn with a series of divisions equal to the measurements of the segments. A diagonal **D** is drawn to point **d**, which marks the vanishing point for the diagonals. Vanishing parallels are taken to a point off to the left allowing us to establish depth scales at 1, 2, 3, and 4.

B. From these points vanishing parallels are traced to a point off to the right and extended forwards to complete a square of four-by-four segments.

C. Another diagonal drawn in perspective indicates new depth lines for parallels vanishing to the left, which cut through diagonal **D**, creating new marks for parallels vanishing to the right. In this way the grid is built up.

D. Continue the process until you reach the required depth of grid.

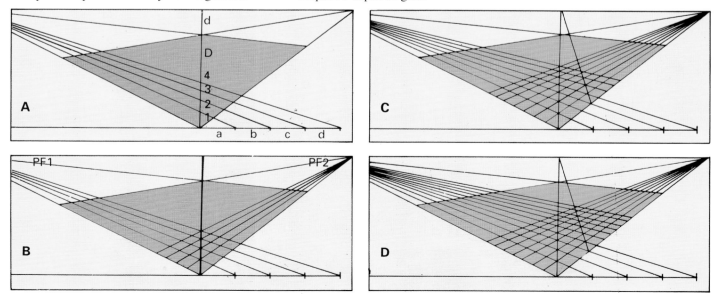

Regular and irregular shapes in perspective

Drawing a grid is a useful exercise whenever we need to place anything in perspective, whether it be a regular geometric figure or a totally irregular shape or form. In every case, the problem can be reduced to let us see how to place in perspective the relative depth of different parts of the subject. Two typical cases are those illustrated on this page: A mosaic with triangular forms and a completely irregular shape (a flower) that, without the help of the perspective grid, would be very hard to describe in terms of depth.

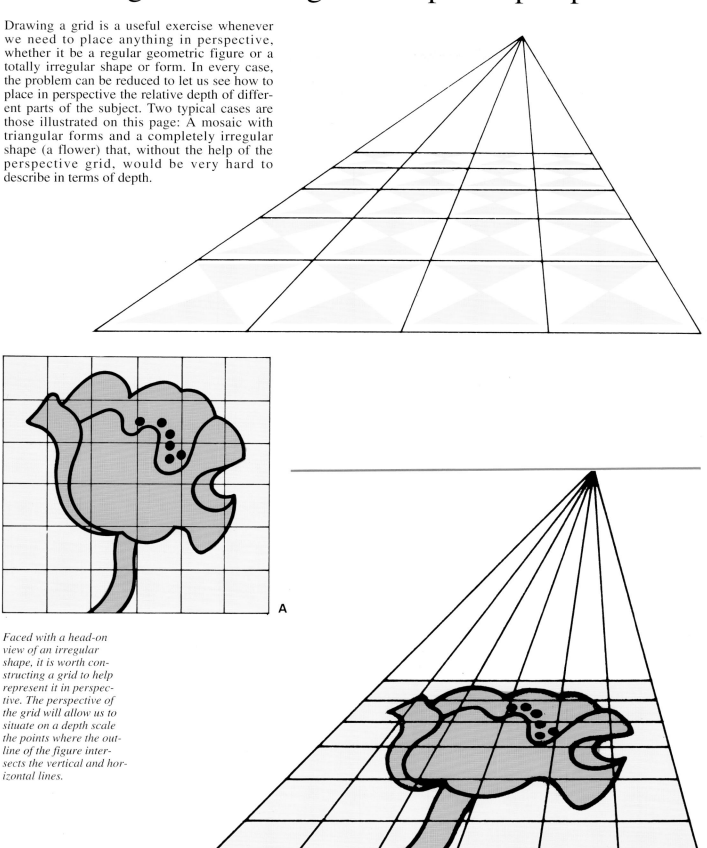

Faced with a head-on view of an irregular shape, it is worth constructing a grid to help represent it in perspective. The perspective of the grid will allow us to situate on a depth scale the points where the outline of the figure intersects the vertical and horizontal lines.

A

B

A practical example

Let us conclude these notions of perspective with an example that sums up all the elements we have studied until now. Study carefully the line drawings on top of which, in red, we have placed the horizon line and the vanishing parallel and construction lines that guided the artist in producing these perspectives. It would be interesting to trace this drawing to show that all lines that in reality are parallel really do run to the same point on the horizon—except, of course, for the vertical lines, which remain vertical and the lines parallel to the horizon, which do not have a vanishing point.

Drawings like these, produced in ink with watercolor wash, are frequently produced in architects' and interior design studios. The perspective drawing allows the architect or designer to show clients what their proposed designs will look like (a villa, in our example) before they have actually been built.

Below: In this diagram the measuring lines showing the distance between verticals can be seen, as can the lines receding to vanishing points VP1 and VP2. Note also that sloping lines A and B, which are parallel to one another, run to one point on the vertical that passes through VP2; VP2 is the vanishing point for horizontal lines on the plane comprising the lines in question.

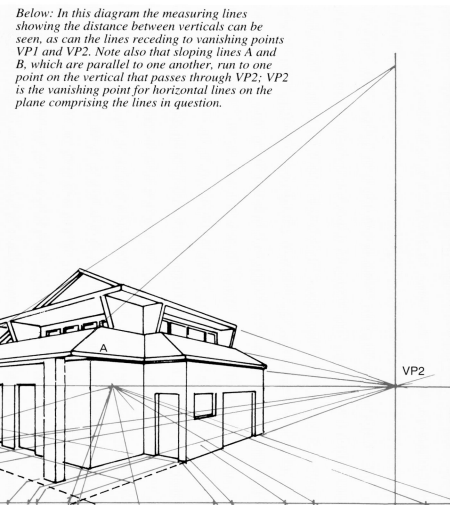

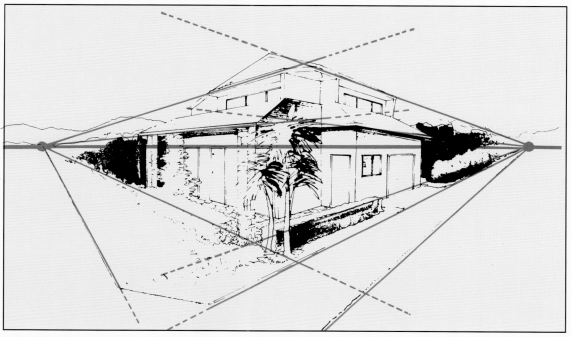

On top of the pen and ink drawing we have superimposed the horizon line—which indicates to us that we are looking at the villa from a fairly elevated position—and the vanishing points. They are appropriate to an oblique perspective drawing on which the two sets of parallel horizontal lines converge on either side of the viewpoint.

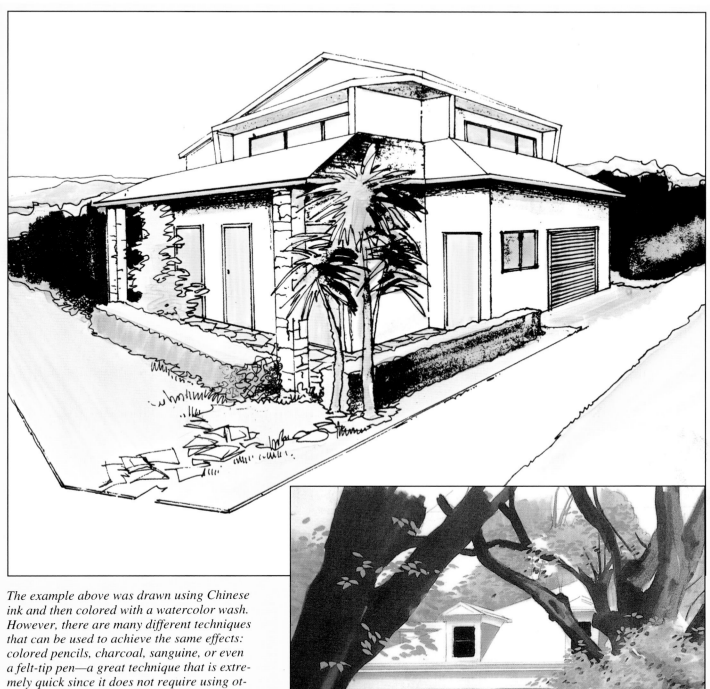

The example above was drawn using Chinese ink and then colored with a watercolor wash. However, there are many different techniques that can be used to achieve the same effects: colored pencils, charcoal, sanguine, or even a felt-tip pen—a great technique that is extremely quick since it does not require using other tools or materials.

To the right is a magnificent example drawn with a felt-tip pen. The applied perspective enables a client to see what his or her building will look like when it is completed.

Two examples

Above. In this imaginary neoclassical construction, the perspective artists confronted and resolved practically every problem that a parallel perspective might present. This is quite a display.

Below. A cloister in Barcelona Cathedral; reed pen drawing by M. Ferrón. In this oblique perspective, the depth has been established by diagonals applied free-hand or by trial and error, with the prior knowledge that accuracy would be relative. Absolute precision, in creative drawing, is of only limited importance.

— CHAPTER III —
Color

Color

*T*he problem of color and its representation continues to intrigue artists and scientists alike. In the following pages we will delve deeply into the essential aspects of color theory, the most important of which is the ability to obtain every color by only using three tones. After learning these basics, you will clearly understand the logic that governs color and how the artist can use it to his or her best advantage.

The theory of color

First Isaac Newton established a principle that all artists today accept as indisputable fact: Light is color. Newton reached this conclusion by shutting himself in a dark room and allowing just a little light to filter in through a window. Then he placed a triangular glass prism in the ray of light; the result was that the glass split the white light into the six colors of the spectrum, which became visible when they fell on an adjacent wall.

Some years later, Thomas Young, an English physicist, carried out the same experiment in reverse. First, through his investigations he established that the six colors of the spectrum can be reduced to three basic colors: Green, red, and deep blue. Then he took three lamps and projected the beams of light through filters of these three colors, focusing them on the same spot; the green, red, and blue beams became white. In other words, Young *recreated* light.

So white light, the light that surrounds us, is made up of six different colors of light; when these fall on any object, that object absorbs some of the colors and reflects others. Let's emphasize this point:

All opaque objects, when illuminated, reflect all or part of the light directed at them

To understand this phenomenon more easily, let's say that, for example, a red tomato absorbs green and blue light and reflects red and that a yellow banana absorbs blue and reflects the colors red and green which, added together, allow us to see the color yellow.

We are going to devote a few pages to studying the theory of color, and we are going to do it as artists; that is to say, *not painting with light* (with colored light) but *painting light* with colored substances that we call pigments. Using the popular medium of colored pencils, we will show you how to study a wide range of colors based on the theories of Newton and Young, but applying them from the artist's point of view.

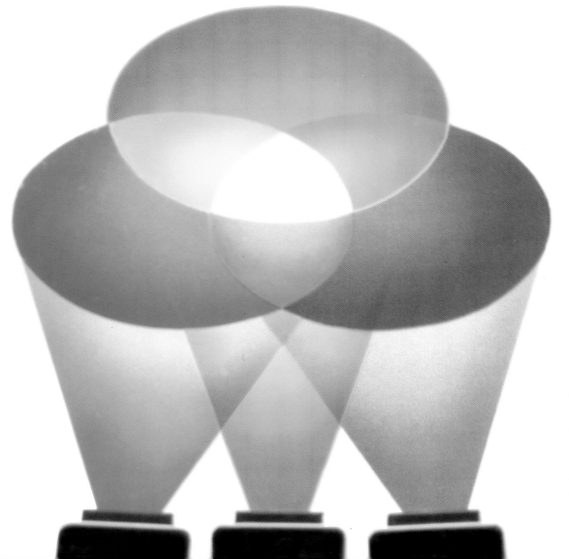

Three beams of light, passing through green, red, and bright blue filters—the primary colors of light—recreate white light. By projecting them two at a time, you obtain the three secondary colors of light—yellow, cyan blue, and magenta.

Colors of light and pigment colors

In the chromatic circle, or color table, which appears below left, the primary colors have been indicated with a P and the secondaries with an S. Everything we have said up until now has pointed to certain conclusions:

• Artists paint using pigments with which they can reproduce the colors of light, or spectrum colors.

• Given that colors of light and palette colors coincide, it is easy for the artist to imitate the effect of light on objects and, therefore, to reproduce exactly all natural colors.

• Theories of light and color show us that the artist can paint all natural colors using only the three primary colors which, as pigments, are yellow, cyan blue*, and magenta.

• However, an understanding of the use of complementary colors considerably broadens the expressive potential of the artist's "palette" when capturing shades and quality of light and color and, as we shall see later on, when trying to achieve perfect harmony in a picture.

*Cyan blue does not exist in artists' color charts. It is mainly used in graphic design and color photography. The term has been used in the theory of color to define primary blue (very similar to Prussian blue oil paint mixed with a little white).

Green, red, and blue, primary light colors.

Cadmium yellow, cyan, and magenta, primary pigment colors.

Illustrated in this chromatic circle are the three primary light colors (P) that create the secondary colors (S) when mixed. The secondary colors then create the tertiary colors (T) when mixed.
The mixture of the three primary pigment colors (cyan, magenta, and yellow) create black while the light colors (red, green, and blue) create white.

RANGE OF SPECTRUM COLORS
Newton broke down the colors of light and established the six colors of the spectrum. Young recreated light and classified the colors of the spectrum as primaries and secondaries.

PRIMARY colors of light:
red, green, deep blue
SECONDARY colors of light:
Blue light + green light = cyan blue
Red light + blue light = magenta
Green light + red light = yellow

So a complementary color is a secondary color that only requires a primary color to complement it to recreate white light, or vice versa.

COMPLEMENTARY colors of light:
Deep blue complements yellow
Red complements cyan blue
Green complements magenta

Above is the spectrum that Newton created: violet, blue, green, yellow, orange, red.

PIGMENT COLORS

Primaries:
Yellow
Cyan blue*
Magenta

Secondaries:
Green
Red
Deep blue

Tertiaries:
Orange
Carmine
Violet
Ultramarine blue
Emerald green
Light green

LIGHT COLORS **PIGMENT COLORS**

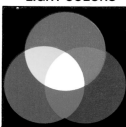
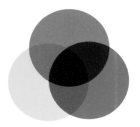

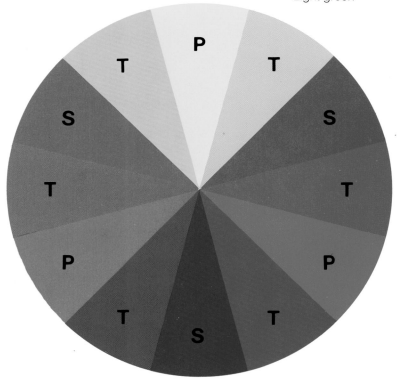

Complementary colors

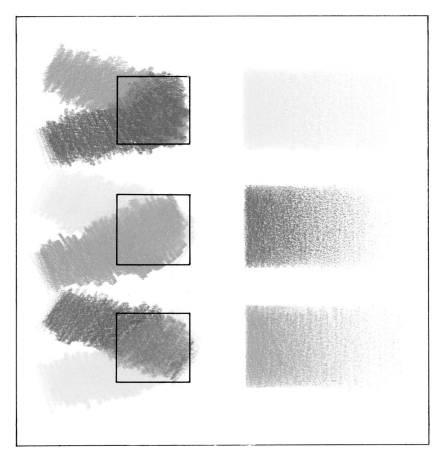

In this chromatic circle we have shown only the primary and secondary colors, the central arrows indicating complementary colors.

In this chromatic circle we have shown only the primary and secondary colors, the central arrows indicating complementary colors.

Below, *a small sample of the effect achieved by juxtaposing complementary colors to create maximum contrast.*

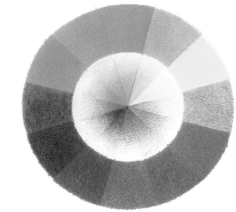

As we can see in the chromatic circle on the previous page, complementary colors are pairs situated opposite one another. Using this principle, we can find the complementary pairs of tertiary colors. For example:

Orange	**Ultramarine blue**
Carmine	**Emerald green**
Light green	**Violet**

It is easy to demonstrate (see the examples at the bottom of the page) that complementary colors are those that offer the greatest contrast. Carmine and emerald green, for instance, have an extraordinary impact side by side in a painting—and look at deep blue next to yellow!

Once the theory and practical application of complementary colors have been mastered, the rendering of shade and shadows will hold no secrets for the painter. In shade portions of the object itself, or in its projected shadow, you will always find the color complementary to that of the object. An example will illustrate this point more clearly: In a green melon's shadow—which is a dark green such as tertiary emerald green—the complementary color carmine will appear.

Great Post-Impressionist painters such as Matisse, Derain, Vlaminck, Dufy, Braque, and Friesz adopted the use of complementary colors as a style of painting in its own right, called *fauvism.* There could be no more useful and definitive lesson than studying paintings by these masters of the palette; the colors of their paintings are veritable explosions of light, intensity, and contrast. The examples offered on this page and the next five have been produced using colored pencils, but they could just as easily have been created in oils or any other medium. The theory of color applies to them all.

Above. *The secondary deep blue—a mixture of the primaries blue and magenta—is the complement of primary yellow, and vice versa.*

The secondary red—a mixture of the yellow and magenta primaries—is the complement of primary blue, and vice versa.

The secondary green—a mixture of the primaries blue and yellow—is the complement of primary magenta, and vice versa.

Creating colors by mixing primaries

The "neutral" green range

This is a series of greens of increasing intensity, in which there is some magenta. They may be described as "neutral" because they are subdued by the presence of a third color that alters the pure green which consists only of blue and yellow. These greens can be regarded as being produced by yellow when added to a violet base, as opposed to a base of blue. Study the amounts of each color required to achieve the same shades as those appearing in our six examples.

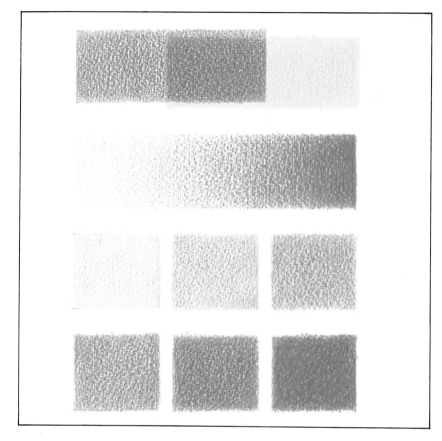

The bluish-gray range

You now will have the opportunity to find out the extent to which the greater or lesser presence of a primary in a mixture affects the final color. We are going to create a range of bluish-grays.

The initial mixture of blue and magenta will give us more or less the same violets produced in the blue range as in the section above, and that, in the previous example, led us to neutral greens. To this violet mixture we will add a moderate amount of yellow, without intensifying the color too much. The difference between these mixtures and the neutral greens results entirely from the lesser amount of yellow applied.

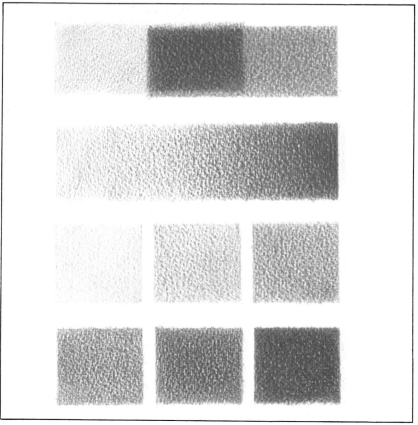

Creating colors by mixing primaries

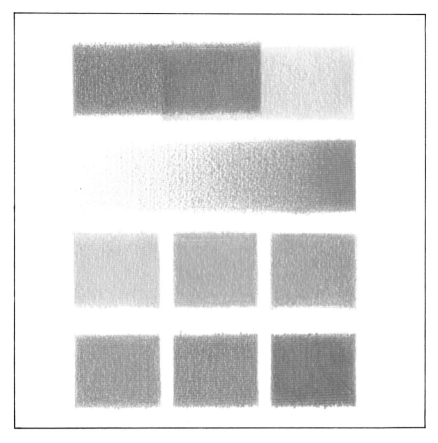

The orange-red range
If yellow is added to an area of deep magenta (see the upper example), you get a deep red. However, if your objective is to achieve colors in the orange-red scale, the quantity of both magenta and yellow must be carefully controlled. In our examples you can see a gradation produced with the magenta pencil, on which we have superimposed another gradation in yellow. This has created, from left to right, the transition from the white of the paper to a deep red, passing through orange-reds of increasing intensity.

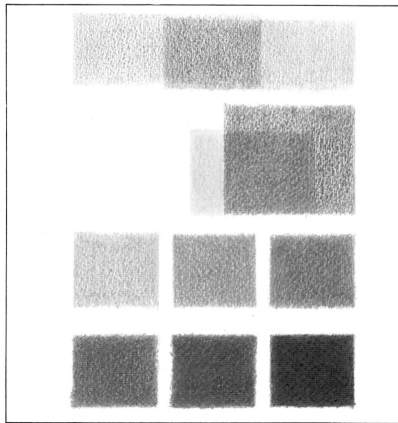

The range of ochres and earth colors
Using a medium violet made from magenta and blue (see the top example), it is possible to achieve an extensive range of colors ranging from yellow ochre, through the siennas, to burnt ochre. To do this, you add yellow to the different violets created from the other two primaries. As always, you must practice altering the quantity of each color according to the result you wish to achieve. It is obvious, for instance, that in the first three examples of the range, there is much less blue than in the three samples underneath, in which magenta and blue dominate the yellow.

Now we are going to combine in a single chart of 36 colors the information we have accumulated through studying each range separately. Bear in mind the following tips:

• Use a sheet of good quality, semi-rough watercolor paper.
• Assuming that your pencil box contains two blues and two reds, use only the bright blue (cyan) and the magenta or carmine, in addition to the yellow.
• Keep a protective sheet of paper under your drawing hand.
• Hold the pencil in the usual way, but slightly higher than for writing.
• Before starting on the definitive version, practice on separate pieces of paper of the type you will be using for the exercise.
• To produce the first set of gradations, start on the left (or on the right if you are left-handed). Without exerting pressure with the pencil, and keeping the lead at a bevelled angle, apply the color with vertical strokes, shifting your hand to the right as necessary, making the strokes stronger and closer together as you go, trying to achieve a regular gradation.
• Finally it is possible that parts of the scale might require some touching up; by all means do this, but without losing sight of the color range as a whole.

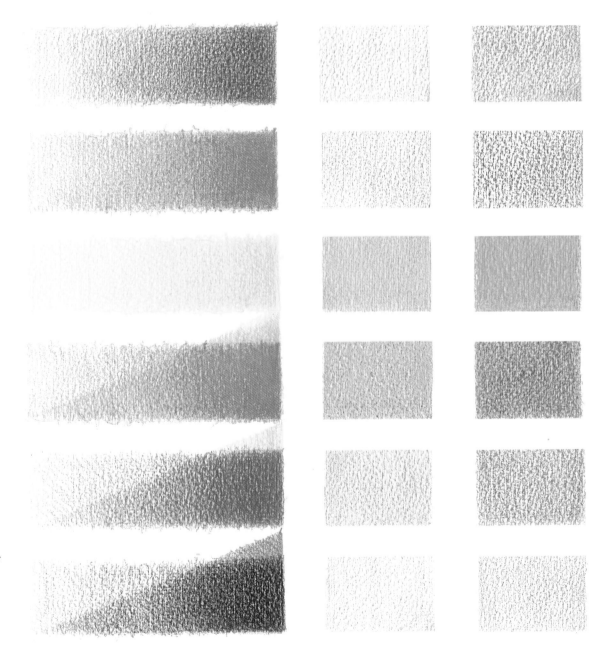

Binary mixtures. Notice how mixing two of the primaries together gives us reds, greens, and violets.

Consider, alongside the binary mixtures, the chart of 36 different colors you have to create, using just three colors: Blue, carmine or magenta, and yellow.

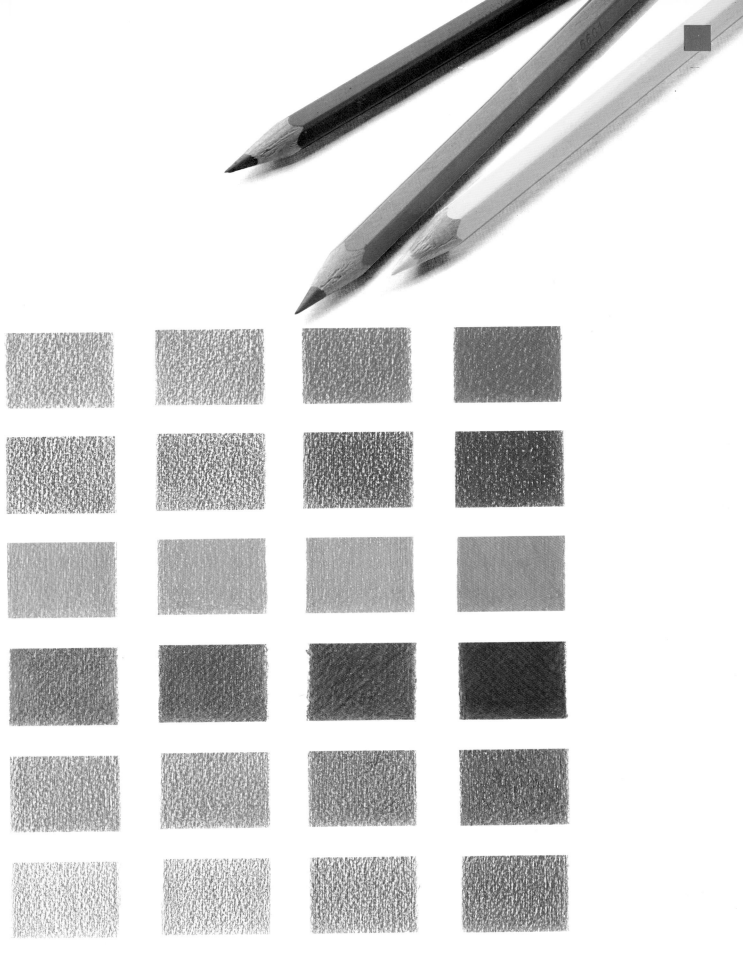

We suggest that you discover for yourself how to obtain any color using only blue, magenta, and yellow—that is, the primary colors. You will need only three colored pencils (one of each primary color) and a good quality, semi-rough watercolor paper, ideal for our goal of creating a color chart of 36 colors, obtained by superimposing two or three primary colors.

But let's take it stage by stage. Start by individually coloring the different color ranges that will make up the complete chart. Using pieces of paper no larger than the boxes containing our examples, and good quality pencils, do the following:

Creating the green color range
Greens are made by mixing blue and yellow. The first color you should apply is blue, yellow being added later. Try to achieve a smooth gradation starting with the palest tint and moving towards the final, darkest tones.

The blue range
Note that the darkest blues have been obtained by mixing magenta and blue, the magenta being laid down first.

Be careful with magenta. It is a very intense color and it should be used sparingly.

To make these dark blues, blue has been laid on top of magenta. You can really take the plunge with both these primaries and experiment, changing the order in which you apply the color, superimposing magenta onto blue. This way can be useful if you want to darken a blue-colored area; notice the intensity of the color in the bottom righthand corner.

Color harmony

When we study the works of the great masters, we realize that they did not limit themselves to copying the colors they saw in their subjects. We can see that they planned their colors, starting with the observation of their subject and then moving through a range of tones and colors chosen to achieve the color harmony that was first created in the artist's imagination. The blending of colors is a very important exercise in the art of painting, an art within an art. This blending can be highly individualistic, so we sometimes refer to "the color" of such and such an artist.

Does blending color imply inventing it? That question does not really have a clear answer. You can see in any subject you like that although many colors are present, it is still possible to see a color *tendency,* or a dominant tone. At one time the reds will dominate, at another the yellows, and so on. Usually, though not always, the artist decides what range of colors he will use—his *palette,* as it is sometimes called. Within this range, the color tendency will be the dominant note that creates the color harmony of the painting. A painting with a tendency to reds, for example, will achieve its harmony from a range of warm colors (not excluding the counterpoint provided by some cool colors). Then there are paintings in which the dominant color is less obvious, in which the colors are grayed down. In such cases, the harmony comes from a range of broken colors, applied in short strokes.

Now let us look at two paintings by Parramón and one by Ferrón to see the range of colors the artist has used in each one to achieve a perfect balance. Then take your colors, your palette, and your brushes and try to reproduce each and every one of the colors in the three ranges on the following pages.

Harmony with warm colors

What colors would you use to achieve this blend of warm colors? José M. Parramón reveals the secret of his palette. He used only three colors in addition to white: cadmium yellow medium, alizarin crimson, and Prussian blue.

Above. "La Plaza Nueva, fiesta de San Roque," by José M. Parramón. Oil on canvas. Private collection.

Below. Warm range of colors used by Parramón in this painting, mixed as follows:

1. *Yellow, white, and a bit of crimson*
2. *The same mixture with additional crimson*
3. *Yellow with very little white and crimson*
4. *Yellow, a touch of crimson, and no white*
5. *The same mixture with a bit more crimson*
6. *Yellow, crimson, and a touch of blue and white*
7. *Yellow and crimson with no blue or white*
8. *The same mixture with more crimson*
9. *The same mixture with more crimson and a touch of blue*
10. *Crimson with some blue*
11. *Yellow and white with a little crimson and blue*
12. *Crimson, white, and yellow*
13. *Crimson, white, and just a touch of yellow*
14. *Yellow, blue, and crimson*
15. *The same mixture with more crimson and blue*

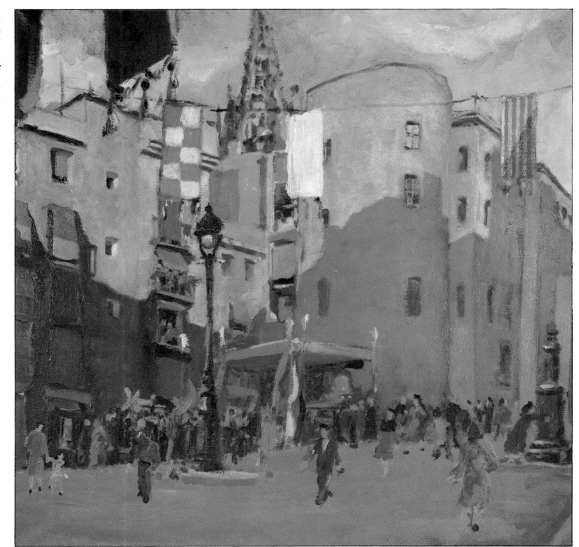

Harmony with cool colors

Left. *The cool colors used by Parramón to paint a seascape:*
1. *Yellow, white, a little crimson, and a touch of blue*
2. *The same mixture with more crimson and a bit more blue*
3. *White, blue, and crimson, mixed to get a greenish earth tone*
4. *The same mixture with yellow and more blue*
5. *The same mixture with more yellow and blue*
6. *White and a little blue*
7. *The same mixture with more blue and a touch of yellow*
8. *The same mixture as 6 with more blue and a touch of crimson*
9. *The same mixture with more blue and crimson*
10. *The same mixture with more blue and a bit of yellow*
11. *White, blue, and a little crimson and yellow*
12. *The same mixture with additional white and a bit more blue*
13. *The same mixture with more yellow and a bit more crimson*
14. *A mixture of crimson and yellow, with blue added bit by bit to achieve this earth tone*
15. *Blue with a little crimson*

Below. *"Fornells" by José M. Parramón. A clear example of harmony using cool colors.*

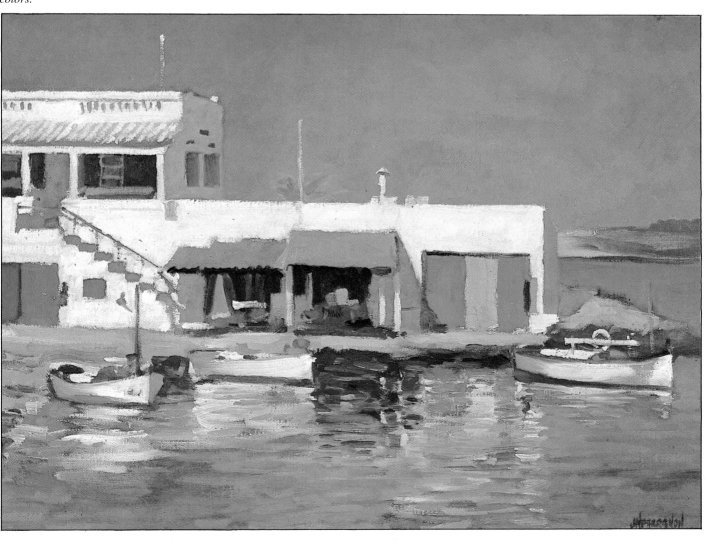

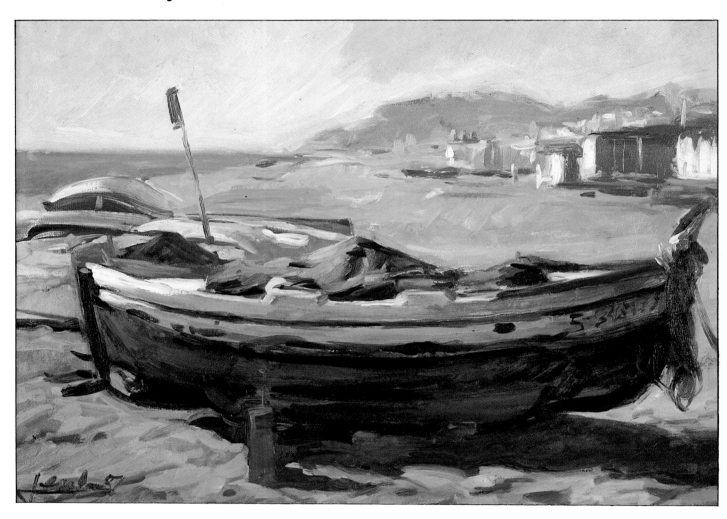

This seascape by Miguel Ferrón is a good example of harmony achieved by a range of muted colors. Here the cool colors are "broken" by the presence of warm tones, and the warm tones in turn are broken by the presence of cool colors. If we put it more colloquially, we can say that a muted color is a color that has been "dirtied" by an excess of a color of the opposing temperature.

Test your feeling for color. Try to reproduce the muted range you see on this page.

Above. *"Calella Beach" by Miguel Ferrón. Oil on canvas.*

Right. *A chart of the colors used in the painting above, created with mixtures of yellow, Prussian blue, crimson, and white.*

A rural landscape: harmony with warm colors

In this photograph of the landscape we are going to paint, you can see that there is a clear color tendency—ochre tones predominate. This makes it logical for us to plan to work in a range of warm tones. In addition, we will give the painting an *imprimatura* of the dominant hue, yellow ochre.

We will use a 16-inch by 20-inch stretched canvas, preprimed.

Get yourself set up, and follow, step by step, the process used by our artist, Juan Sabater.

Imprimatura

Put a good quantity of yellow ochre on your palette and, using a wide flat brush, thin the paint with turpentine and a few drops of varnish. Proceed to cover the canvas with this thin ochre glaze, using parallel brush strokes, always in the same direction. The finished coating should be transparent.

Once you have finished, place the canvas on a flat surface to dry. Before you go on to the next step, be sure this undercoat is completely dry.

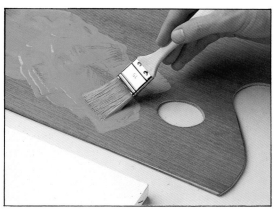

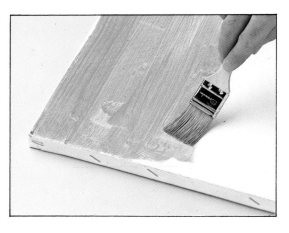

The canvas with an undercoat of ochre, laid down with brush strokes parallel to the shorter side of the canvas.

The sketch

Once the undercoat is completely dry, use a sanguine pencil or chalk to sketch in the scene. Use this sketch, as Sabater has, to draw, in broad outline, the major tonal areas. Spray the sketch with fixative, using an atomizer or a spray can.

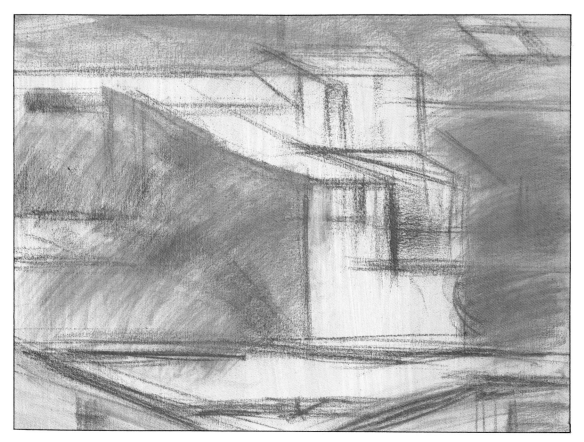

The first touches of color

Keeping the paint well diluted, establish the basic colors of the major areas of the painting. Here the artist has used a mixture of ochre and crimson, with a large amount of white, for the roofs. The same mixture, with the addition of still more white, produces the rose color of the walls.

With a bristle brush, the artist rubs white over the upper façade to lighten it. He then uses a mixture of ochre and Prussian blue, with touches of crimson and white, in varying proportions to establish the different green shades.

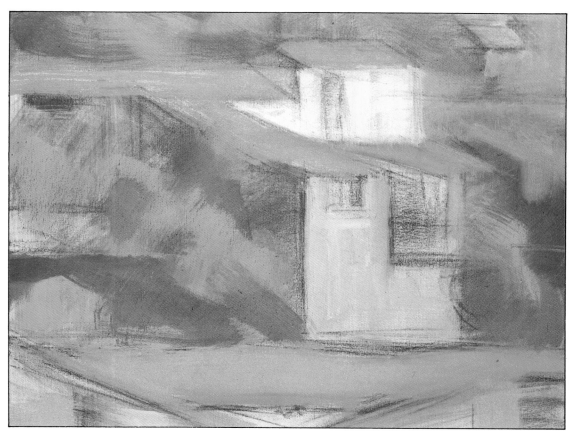

A rural landscape: harmony with warm colors

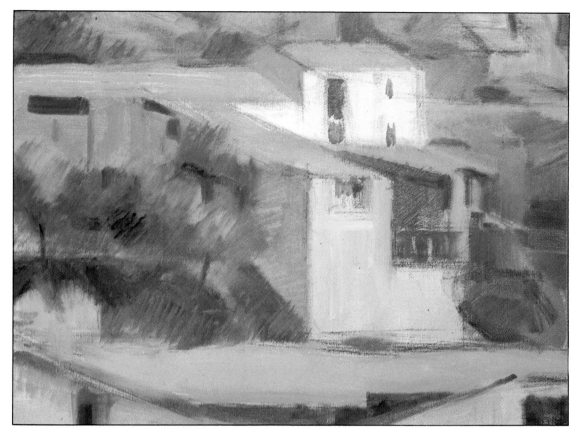

Shading and definition

Without discarding the mixtures we used for the first layer of color, we now give more definition to the different elements in the scene. The artist uses burnt umber to unify the shaded planes, and mixes this same color with Prussian blue to create contrast in the darker areas of the painting. He uses this same "dirty" shade to create shadows and contrasts in the green areas.

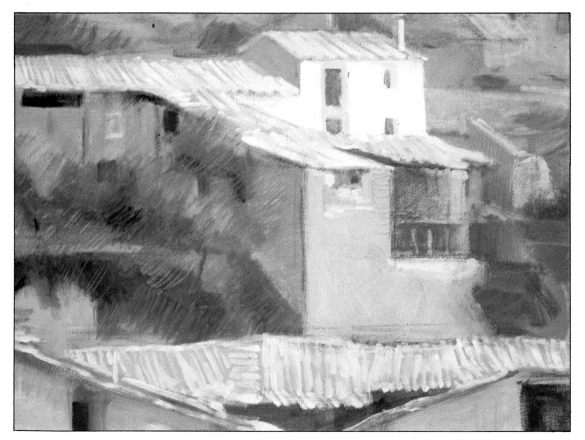

The first details

Over the range of tones already established, whitened ochres and purpled blues are used to bring out certain parts of the painting. Using loose brush strokes, the artist has suggested the bright sunlight on the roofs and a bluish light in other areas. The white façade now seems much cleaner and the central walls more luminous. The walls of the ruins off to the right have been given definition by a layer of ochre mixed with plenty of white.

The final touches

To achieve a greater sense of light on the rooftops, the artist decides to change their basic color. In the picture to the left, you can see that they look very rosy, especially next to the yellows. In the finished painting (below), new brush strokes of ochre, with the addition of varying quantities of white and yellow, give greater impact. The sense of light is heightened by the strokes of purple (yellow's complementary color) added to the walls in shadow. The greens seem most luminous in those areas where the color is mixed with plenty of cadmium yellow, offering a counterpoint to the dominant warm tones of the painting and creating an overall sense of harmony.

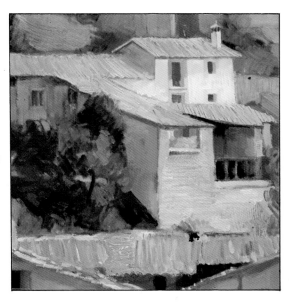

Below. Sabater's finished work. Observe the strategic placement of the purple tones, which provide a contrast that heightens the harmony of warm tones established by the very first brush strokes.

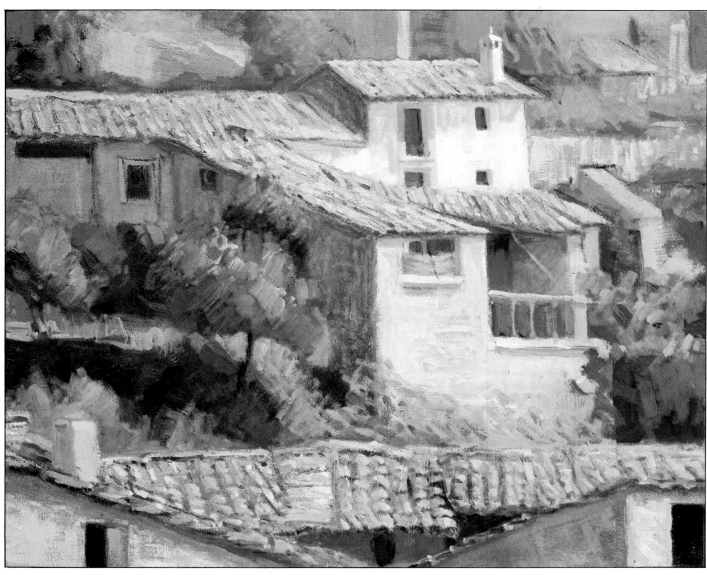

CHAPTER IV
The Human Figure

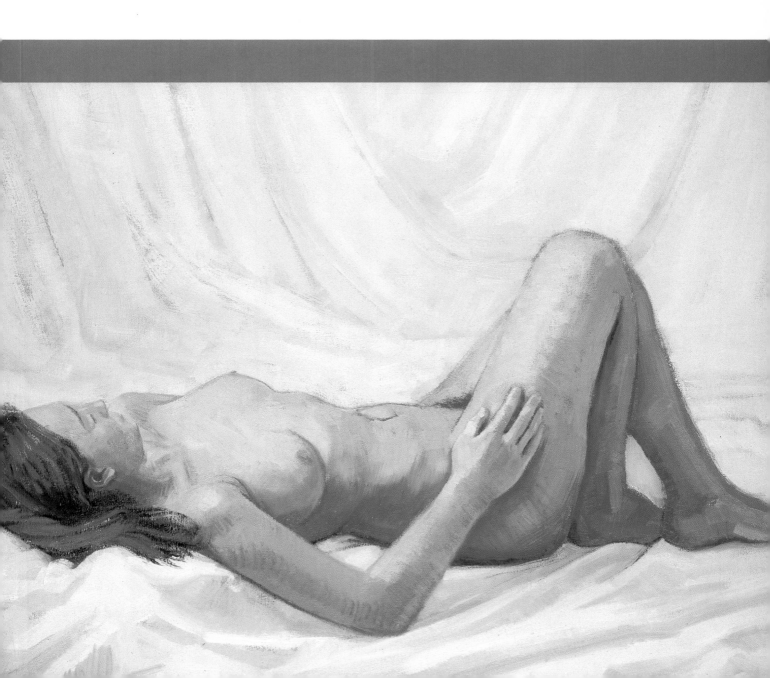

The Human Figure

*C*aptured in one form or another, alone or accompanied,
static or in movement, idealized or deconstructed, the human figure
has been represented throughout every period of history, an infinite
language for all that man seeks to express. We begin with the head
and face—considered a harmonious pair—by using a universal rule
of proportions. Basic muscular and bone anatomy is also examined
in this chapter in an easy, applicable format.

Study of the human head

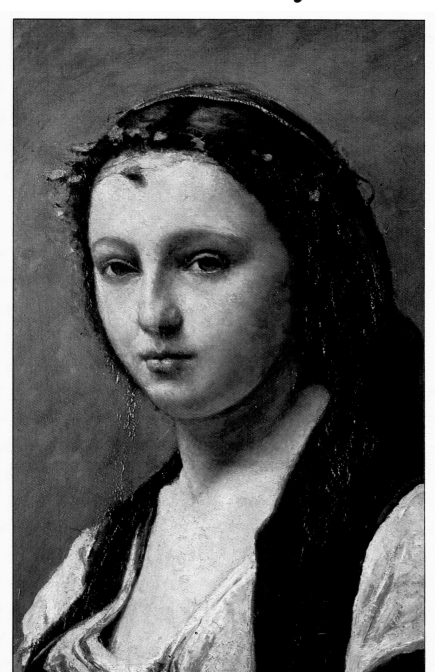

"Young woman with a pearl ring" by Jean-Baptiste Camille Corot. Oil on canvas (21 1/4 × 27 1/2 in.(54 × 70 cm) The Louvre Museum is home to this magnificent portrait (somewhat reminiscent of the Mona Lisa) in which, apart from a wonderful mobility of technique, we can also observe the almost total application of the rule we have been studying.

The word "rule" is synonymous with a law or precept. To establish a rule for drawing the human head implies fixing the conditions that must apply for the head to be correctly drawn. Of course, certain generic norms may be established, but we should never expect them to be universally applicable. The rule relating to the proportions of the human head, for instance, provides a reliable guide for drawing imaginary faces or for setting down the first few lines of a portrait. But clearly in many cases this rule cannot be mathematically corroborated.

The currently accepted law (there have been many) dictates that the distance between the upper part of the skull (without the hair) and the lowest point of the chin is equal to three and a half times the depth of the forehead, which is regarded as the basic unit of measurement under this rule. All the proportions are calculated by means of further subdivisions. Notice (see next page) that an adult head, seen from the front, is three and a half units high and two and a half wide. The first unit comprises the depth of the forehead down to the base of the eyebrows and the second reaches to the base of the nose. It is clear that the space between the eyebrows, the nose and the mouth form the vertical axis of this scale, while the eyes are situated on the horizontal scale. Within this formula there are many facts to observe and memorize. For example:

• The depth of the ear measures one unit and its extremes coincide with the line of the eyebrows (C) and the base of the nose (E).
• The distance separating the eyebrows from the center of the eyes (C-D) is 1/4 of a unit.
• Halving the distance E-G (one unit) gives us a line F that coincides with the bottom of the lower lip.

Although it is true that the average head will not conform to these rules in every respect, it is interesting to note that certain proportions are nearly always applicable.

For example: The distance between the two eyes is almost always that of another eye and, almost invariably, the first three vertical units, consisting of the distance between the nose and the chin, the nose itself, and the forehead, are equal.

The nose and the ear also tend to be of equal proportions.

The rule of proportions

Right. *Diagrams defining the proportions of the human head.*
A. *Scale showing the height and width of the head, based on a unit of measurement.*
B. *The vertical and horizontal axes seen from the front.*
C. *Guidelines for the outer extremes of the nose and the eyes and line showing the level of the lower lip.*

Below. *Showing the depth of the different elements of the face:*
A. *Upper extent of the skull.*
B. *The hair-line.*
C. *The line of the eye-brows.*
D. *The level of the eyes.*
E. *The base of the nose.*
F. *Base of the lower lip.*
G. *Lower extent of the chin.*

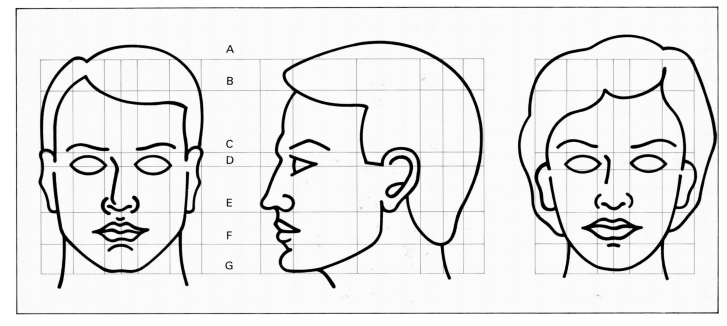

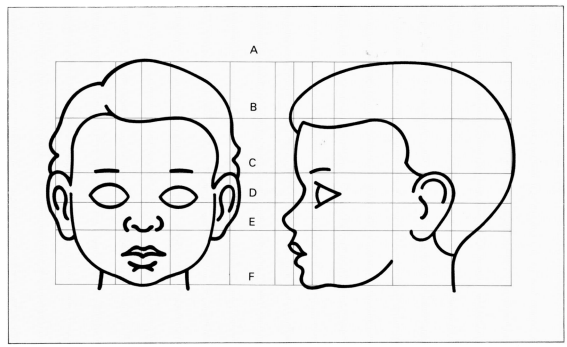

Left. *Rule relating to the head of a child (two to five years), is quite different from that of an adult. The most obvious difference is that the eyebrows, rather than the eyes, mark the half-way point in the depth of the head. The distance between the eyes is greater than in the adult. The forehead is broader and there is generally less hair at the top and sides. The nose is turned up and the ears are bigger, the chin rounder, and so on.*

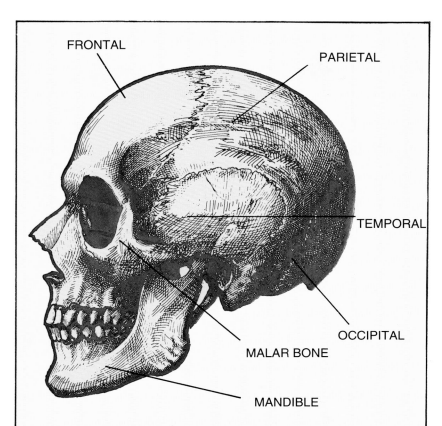

FRONTAL

PARIETAL

TEMPORAL

OCCIPITAL

MALAR BONE

MANDIBLE

The framework of our body is the skeleton and our physical characteristics depend, primarily on the shape of our bones. This is particularly obvious with the shape of the head. The skull is a bony structure with a very slight surrounding musculature. With the head, you can really "see the bones," something that does not happen elsewhere in the body where the skeleton supports a heavier layer of muscle. Because of this, without trying to memorize every bone, it is worth it for the artist to have a clear idea of the structure of the human skull, which constitutes the basic structure of the head of each individual. For the artist, the formation of the skull should provide the basic structure for any drawing of the head.

An analysis of the skull leads us to conclude that the head is made up of a sphere that encompasses the skull area and a more or less triangular appendage comprising the two jawbones. This singularity can be clearly seen in a profile view of the head. Seen from the front the sphere looks flattened on both sides, indicating the areas that, in the living person, are occupied by ears.

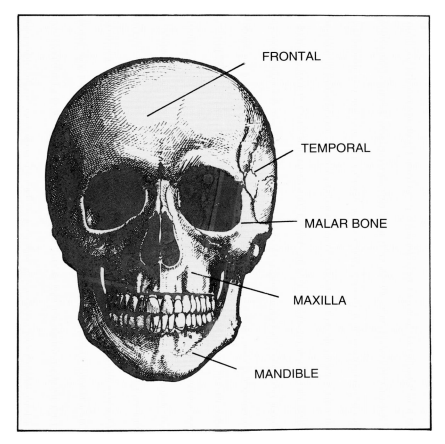

FRONTAL

TEMPORAL

MALAR BONE

MAXILLA

MANDIBLE

Below. *In the form of the skull we have a good base for an outline drawing of the head. These diagrams illustrate the details described above. Observe how the three units of the rule of proportions relate to the shape of the skull. It is important to know how to reduce the skull in your mind to a sphere-shape to draw a head in any position.*

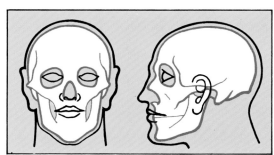

Construction of the head, based on a sphere

Although this explanation is valid for any position of the head, we will refer to the three most frequently described positions: Looking down at an angle, up at an angle, and directly upwards (seen from the front).

1. First, we have to imagine that the sphere of the skull has an axis running through it.

This axis, which would coincide more or less with the line of the neck, is enough to give us an idea of the position adopted by the head we are about to draw. Sphere **A** corresponds with a head looking downwards at an angle; **B** corresponds with a head looking upwards at an angle; and **C** shows a head looking upwards, seen from directly in front.

2. Now we will describe three perpendicular circles (in perspective) around our sphere (which we will imagine to be transparent) in such a way as to determine the meridian **E** that symmetrically divides the face; the equator **G** that corresponds to the line of the eyebrows; and another meridian **F** that divides the skull into a front (face) half and a rear, or occipital, half. As you can see, it is vital to bear in mind the perspective of the circle and the sphere. Look at the three circles **E**, **G**, and **F** seen in relation to the perspective of positions **A**, **B**, and **C** of the head.

3. Remember that, in reality, the sphere of the skull doesn't exist. The ear areas are, themselves, individual circular planes. We have pointed out the diameters of these circles with an arrow. From point **J**, at the intersection of circles **E** and **G**, we have drawn a line straight downwards, parallel to the axis **A** of the sphere. This straight line is clearly the axis dividing the face symmetrically, seen in perspective.

4. Look at the various axes: Axis **A**, for right to left movement; axis **H**, for up and down movement; and axis **I** for lateral movement, or tilting the head sideways from right to left. These axes are a guide when constructing a drawing but, as you will have guessed, do not correspond to the anatomical movements of the head that, in life, are dependent upon the "atlas" and "axis" vertebrae at the base of the occipital bone.

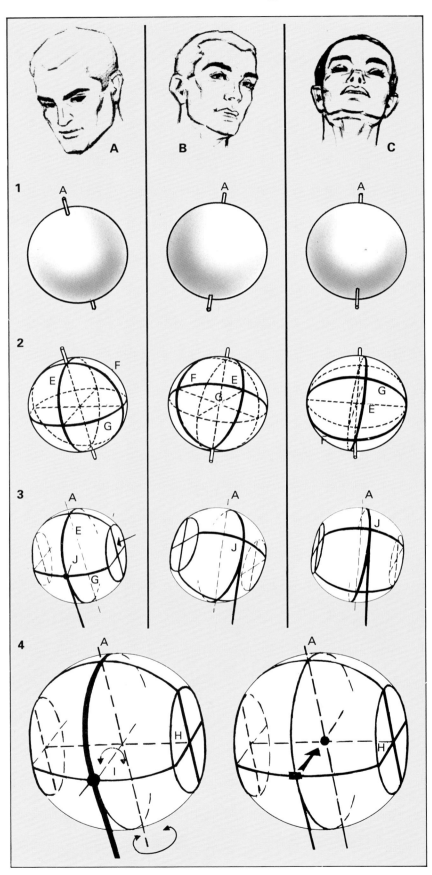

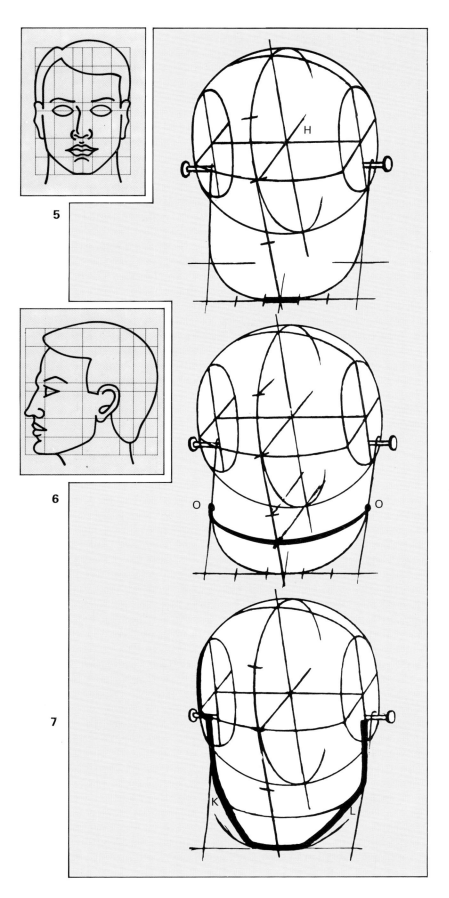

Let's continue with the construction of the head. Obviously, our next stage consists of marking out the three main units across the axis that divides the facial features.

5. The lower jaw is put in place. We have envisaged it as a kind of horseshoe revolving around two pivots situated a little below axis **H**. Anatomically speaking, these pivots would be the "masseters," or muscles controlling the movements of the lower jaw. Notice that the width of the chin, equal to the distance between the eyes, is a fifth of the overall width of the head. In our diagram we have indicated it with a bolder line.

6. Next, the level of the mouth is established. The lower lip, as we know, is located at the middle point of the third unit, between the chin and the base of the nose. If we were to pass another circle in perspective through this point, we could also determine the maximum width of the lower jaw, at points **O**.

7. The construction of the jaw can be completed with just a few more strokes. Two straight lines are drawn, down through the pivots at point **O** on each side and then two sloping lines, defining the lateral limits. By now you might be asking yourself if it is really necessary to go through this entire process every time you draw a human head. The answer to this is, "It depends." It depends on the skill and experience of each artist and, above all, on the type of work being produced. With a portrait, it is quite possible that these principles will not be considered, or perhaps only superficially considered. However, when drawing an imaginary head (or drawing from memory), the rules become more important. Indeed, in certain situations where the attitude of the head requires us to depict a pronounced foreshortening effect, they may well prove indispensable.

Right. We have repeated two drawings, the first set of three in this section, so that you can compare the vertical and horizontal lines defining the units of measurement with the circles corresponding to the perspective drawing.

8. Without completely losing the circles that correspond to the divisions of each unit, or the one we have used to locate the mouth, we can begin to outline the more definitive features. For instance, we can sketch in the ear, trace the line of the mouth more precisely, define the angle of the hollow of the eyes between the curves of the brow and the cheekbone, and so on. We can also indicate the thickness of the hair.

Finally, we have all the features of the head drawn in proportion as indicated by the rules. The construction lines have defined the location of the different parts of the face, which we can now begin to draw in properly. Notice that, in the first and third diagrams illustrating section 8, the lines of the mouth and the profile of the nose have been suggested.

When drawing the eyebrows (on the line cutting the sphere in half), remember that they do not form part of a perfect circumference, but, in fact, consist of a slightly inward sloping straight line and a much shorter curve, sloping slightly downwards. This can be seen in the illustrations on previous and later pages.

We know that the eyes are situated at a third of a unit below the line of the eyebrows. We should also pay careful attention to their position in relation to the ears and the nose, whatever the angle of the head.

We recommend that you not start drawing "finished" human heads until you have produced a number of outline sketches like those on the left. For the time being, don't worry about finishing. The important thing is to produce sketches in which the circles of the eyebrows, the nose, and the mouth are perfectly situated. Details can wait until later.

8

Applying the rules

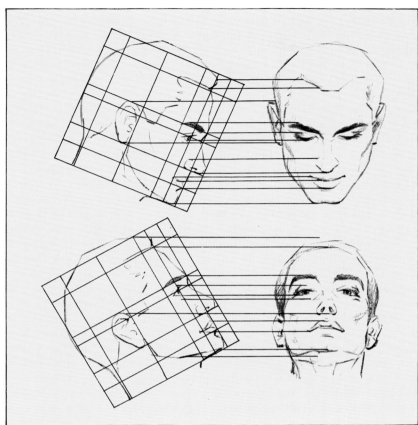

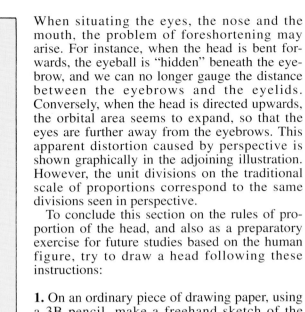

When situating the eyes, the nose and the mouth, the problem of foreshortening may arise. For instance, when the head is bent forwards, the eyeball is "hidden" beneath the eyebrow, and we can no longer gauge the distance between the eyebrows and the eyelids. Conversely, when the head is directed upwards, the orbital area seems to expand, so that the eyes are further away from the eyebrows. This apparent distortion caused by perspective is shown graphically in the adjoining illustration. However, the unit divisions on the traditional scale of proportions correspond to the same divisions seen in perspective.

To conclude this section on the rules of proportion of the head, and also as a preparatory exercise for future studies based on the human figure, try to draw a head following these instructions:

1. On an ordinary piece of drawing paper, using a 3B pencil, make a freehand sketch of the sphere of the skull, with a diameter of approximately 6 in. (15 cm). Indicate the angle of the cranial axis (A).

2. Indicate the planes of the ears and draw the circle corresponding to the level of the eyebrows. From the center of the sphere, marked K, establish the point K', and through this point draw the axis dividing the face into symmetrical halves (the line running between the eyebrows).

3. On this axis, mark the levels corresponding to the base of the nose, the chin, and the mouth (lower lip).

Begin to erase the construction lines as you build up the distinct elements of the face.

4. Making any necessary adjustments along the way, prepare your drawing for the first areas of shading. On this occasion, we suggest that you go no further than a simple indication of the principal areas of light and shade.

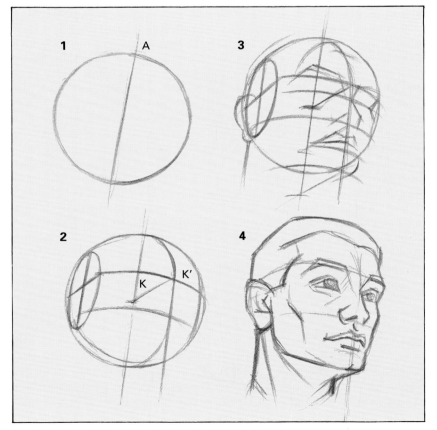

Follow our instructions to the letter and you will discover that—using these rules as a starting-point, and the infinite number of perspective versions (one for every conceivable position)— drawing the shape of a head is not as difficult as it might seem. Try to achieve a result similar to the one in this illustration, onto which, for the sake of clarity, we have superimposed the principal construction lines in red.

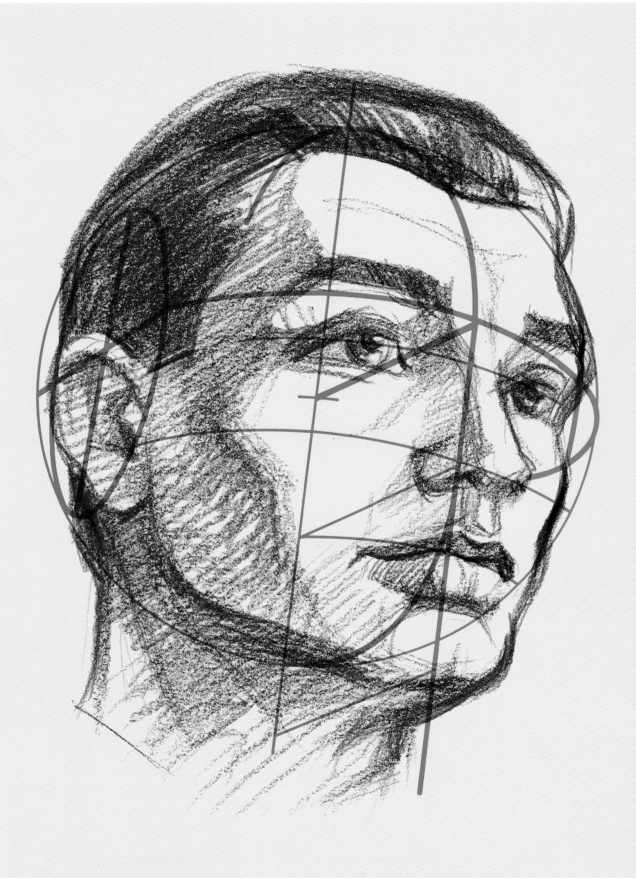

An understanding of the rule of proportions we just studied helps us to draw the human head (real or imaginary) with all the elements correctly situated: Eyebrows, eyes, nose, and ears in particular. Our new objective is to explore the form of these facial elements and to learn how to draw them.

Strangely enough, the parts of our fellow creatures seen most often, and of ourselves as we look into the mirror each day, are the parts we notice the least. Rarely do we stop and study the shape of the nose or eyes or eyebrows of those we live with. And if we cannot picture them in our own minds, how can we begin to describe them on paper?

The study we are about to undertake uses archetypal features as its points of reference, as well as generalized examples and observations. However, we recommend that you try to apply these lessons to your own features. Sit in front of a mirror and look carefully at yourself: First directly, then with the head a little to one side, then looking slightly up or downwards. Try and discover how your own features are a modification of the standard forms we are going to demonstrate.

We think it is fair to say that the task of the portrait artist is, fundamentally, this: To demonstrate his understanding of the formal elements of the human face through the specific features of his own models.

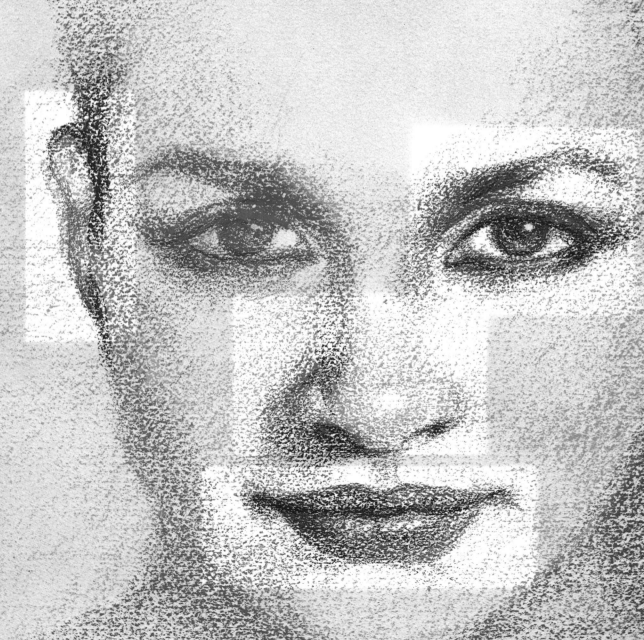

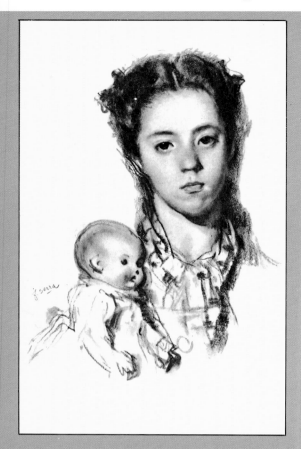

Left. *Pencil portrait by Alfred Opisso. Even in this angled pose, the rules of proportion have been observed. It would be an interesting exercise to demonstrate this by tracing this face and comparing it with our study based on the rules of proportion.*

Above. *Two pencil portraits by Francesc Serra. Serra's mastery of this genre is indisputable. What we wish to point out is that two such apparently different faces display almost identical proportions. It is not the proportions that distinguish them, but rather the individual features: The eyes, nose, mouth...*

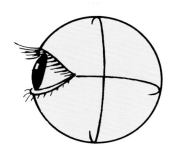

The eyes

The form of the eyes is spherical

This is the first important observation: The eyes are in the shape of a sphere and, to be more precise, a sphere with a little spherical cap that corresponds to the lens.

We can imagine this sphere with its little cap seen from in front (1a), in semi profile (1b), in profile (1c), or looking down at an angle (1d); from these diagrams you can see the basis for drawing the visible part of the eyeball and the shape of the eyelids.

Imagine (2) that this sphere is covered with an elastic substance 1/3 in. thick and that we make a small, transverse cut just above the cap. If we open this cut like a buttonhole, we will have a shape similar to that of the eyelids, of which (and this is important) we will always see one of the edges. Springing from the outside of these edges are the eyelashes. Taking the pupil of the eye as an approximate center, each eyelash follows a radial direction from the center of the lens. Look at diagram 3, a,b, and c. Now we can see the external form of the eye region. Containing it on the upper side are the eyebrows, straight and slanting slightly upwards at first, then arching downwards at the outer edges. Immediately below the eyebrow is the upper eyelid. When the skin is taut, the eyelid follows the spherical shape of the eyeball, a shape lost beneath the fold of skin when the eyebrow is lowered (4b and 4c). It is worth noting that the eye opens and closes almost exclusively through movement of the upper eyelid. The lower one hardly does a thing. This observation should remind you that, when the eye is open, the curve of the upper lid is much more accentuated than that of the lower lid, which is more like a horizontal line passing through the lachrymal duct. In other words, the "almond" of the eye is not horizontally symmetrical. Notice this in diagram 5a and don't forget it when you come to draw the outline of the human eye.

Another thing to remember is that the eyelids open over a curved surface, so that you will almost always be able to see the thick edge of one of them. Also, the eye is never symmetrical. Look at diagrams 6a and 6b. Finally, bear in mind the "radial trajectory" of the eyelashes so you will be able to draw them from any angle.

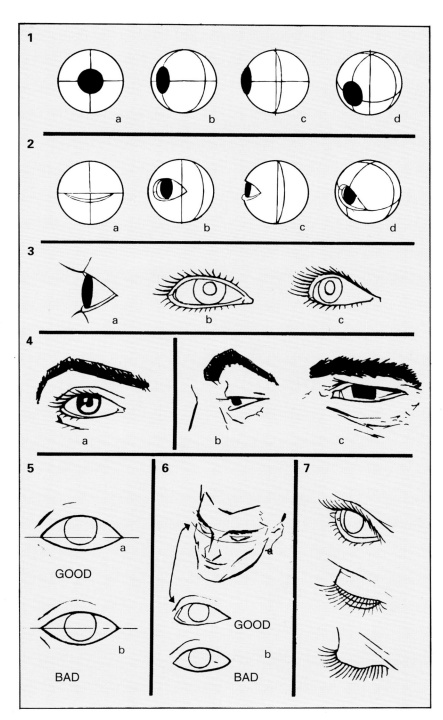

1

a　　　　b　　　　c　　　　d

2

a　　　　b　　　　c　　　　d

3

a　　　　b　　　　c

4

a　　　　b　　　　c

5

a

GOOD

b

BAD

6

a

GOOD

b

BAD

7

The diagram above illustrates the different parts of the eye, eyebrow, and eyelid. Keep it near you as you practice since facial elements create extremely important characteristics in your drawings of people.

Moving on from this diagrammatic approach, we will now consider the tonal values of the region around the eye. We will assume that our drawings are clear enough to save us too much detailed explanation. Among artists, pictures paint a thousand words.

1. The soft pencil lines have situated the eyebrow that encloses the top of the eye cavity, providing a good guide to the structure and location of the eye. These faint strokes will be strengthened later.

2. Continue the logical building up of outlines. This is the time to adjust the initial sketch and to prepare the drawing for the addition of light and shade. Notice that the line of the lower lid, which curved downwards too much in the first drawing has been altered.

3. The pencil has begun to describe depth, darkening the folds of the eyelids and emphasizing the curve through gradated shading on the right half. The left part of the hollow

of the eye has been darkened, with the lachrymal duct at its deepest point. The iris and other details have also been more clearly defined.

4. Notice that the final stage has consisted mostly of completing the work begun in the previous phase. However, it is worth noting the following points:

•There is a shadow, on the eye itself, projected by the upper eyelid and the eyelashes.
•The spherical shape is conveyed by the shading in the white of the eye.
•The thickness of the eyelids can be seen clearly.
•The "twinkle" in the eye, expressed through a spot of white on the edge of the pupil, is very important.

Naturally, the tone and shading of the eyes depends on the lighting. Different lighting produces different effects but, in every case, the lines and curves to be drawn will be similar. For instance, imagine this same eye, lit strongly from the right hand side. The light and dark areas would be reversed, wouldn't they? Why not try to draw it yourself?

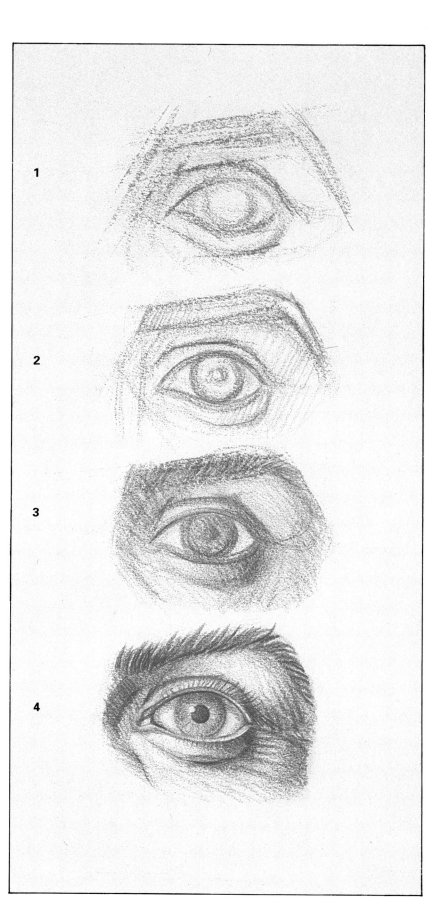

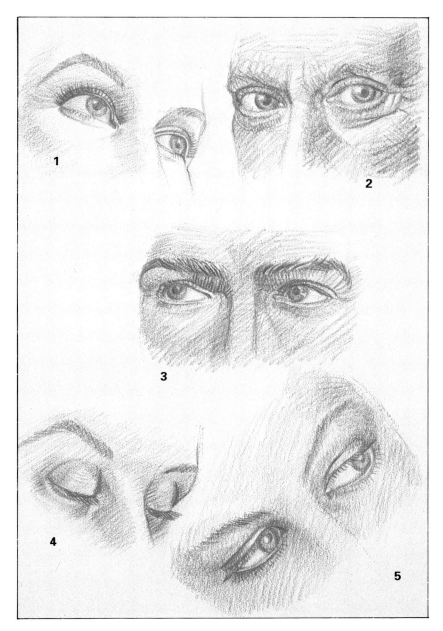

The direction of the gaze

Up until now we have been analyzing the form of the eye. But there are two eyes and we usually have to draw them both. If you already find drawing one eye difficult, then having to draw two will only add to the problem. Why is this? Firstly because the face is constructed on a curved surface and the eyes, which are spherical, are "embedded" in individual hollows on this surface. Because of this, we will only see both eyes in the same way when seeing the face from directly in front. In every other case (in the majority of cases), one eye will be seen more in profile. This fact becomes obvious in sketches 1 and 4 in the series of illustrations shown here.

In sketches 2, 3, and 5 we have tried to show another problem: The fact that the eyes we draw really "look" and have their own expression. In this situation, the direction of the gaze is very important, conveyed partly by the openness of the eyelids and also by the "attitude" of the eyebrows.

The eyes, the eyebrows, and the mouth are the main factors in the expression of the face.

As well as expression, the gaze indicates direction and, when drawing a face, we must be careful to show both eyes looking the same way; otherwise we will end up with squinting or a cross eyed look.

The eyes look up or down simultaneously, as if they revolved around a single axis (see the diagram below) and when looking to the right or left they move as if controlled by a mechanism similar to that which drives a car.

In truth, these problems have just one solution: Careful observation of the model to try to understand what his or her eyes are "saying," when drawing from life and, when working from the imagination, trying to imagine mobile spheres operating inside their hollows and half covered by the eyelids.

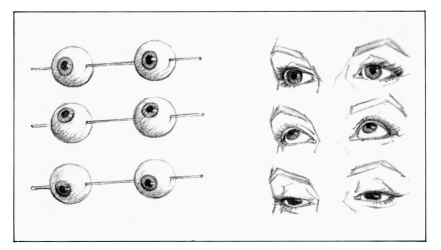

The eyes move up or down together, as if they were both fixed to a horizontal axis.

The ears, the nose, and the lips

However young you are, you will have seen countless noses in your life. However, would you be able to give an accurate description of the shape of a nose? Or an ear or a mouth, for that matter? The fact is, we often hardly notice what we have in front of us every day. You might say we look without seeing.

This is a luxury the artist cannot afford. The artist must look, not only at a nose, a mouth or an ear, but at the precise shape of that nose, that particular mouth or ear. The drawings on this page can be a good starting-point for getting to know these forms. They may be taken as prototypes you should copy until you can reproduce them from memory, using them as a base from which to analyze the characteristics of other, specific models. We have not attempted to go into details of form. Sometimes there is a tendency in drawings to exaggerate descriptive details that are often more subtle, especially in a woman's face.

Move on from these prototypes, and try to make some studies from life. Draw your own nose or mouth, from directly in front or at an angle. Ask your family to pose for you so you can practice drawing these elements so vital to the art of portraiture.

Study the shape of the lips, the hollows at the corners of the mouth where an upwards or downwards curve shows so much about the mood of a person. Explore the difference in tone between the upper and lower lips, caused by the fact that one of them (usually the lower) is in more direct light. Notice also that, generally speaking, a woman's lips are darker than a man's; they are shinier and also show more clearly the little furrows, characteristic of the skin on the lips. We stress again that you should copy these drawings over and over again, until they are engraved forever on your brain.

Practice using different media: Lead pencil, sanguine crayon, charcoal, and so on.

In these drawings, the ears, nose, and mouth are seen from different points of view. Study these prototypes and begin to draw them. Then look at your lips, nose, and mouth carefully in a mirror. Try to draw them. After that, practice drawing other people's lips, nose, etc.

Pencil drawing of a female face

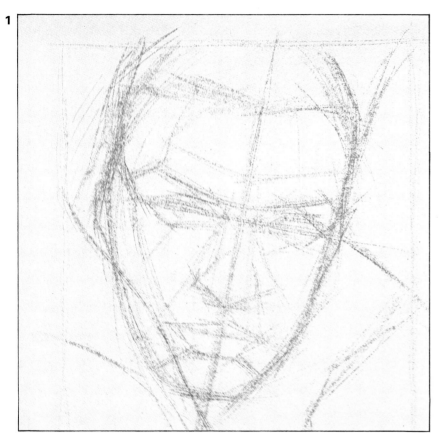

With the detailed study of the proportions of the human head and the following analysis of the features (eye, nose, mouth, and ears) still fresh in your memory, we think it is time you start to explore the art of portraiture. We recommend that you work from photographs in the beginning so you become familiar with different features and expressions. It is a good way to gain experience before working with a living model. Exercises like the one we have illustrated on these pages can be broken down into three phases, each one bringing its fair share of trial and error, alterations and irritations, all of which are part and parcel of the creative process.

1. As always, the pencil describes the first lines of your drawing, guided by intelligence and not by magic: The line of symmetry, the line of the eyes, of the mouth, and so on, all in accordance with the rules of proportion. Then the oval of the face and the situation of the features can be adjusted to the characteristics of your model.

2. Between the previous stage and the end of this second phase, there is a lot of work to be done. The features continue to be built up by means of new, tentative strokes, further observation, and comparison between the drawing and the model; the initial tone is laid down, which helps to define the contours of the face. At the end of this stage there should be a definite, visible likeness. However, anyone who cannot see the original photograph of our model may be wondering if it is a man or a woman.

3. Here we have the finished drawing. There is no longer any doubt that the model is a woman. How have we gone from phase 2 to a real portrait of a particular person? We had already defined the features in the previous stage but the change is largely due to the effective use of light and shade to soften areas that were previously quite harsh, and to describe form more precisely and decisively: The eyebrows, the folds of the eyelids, the lines around the eyes, the lips, and so on.

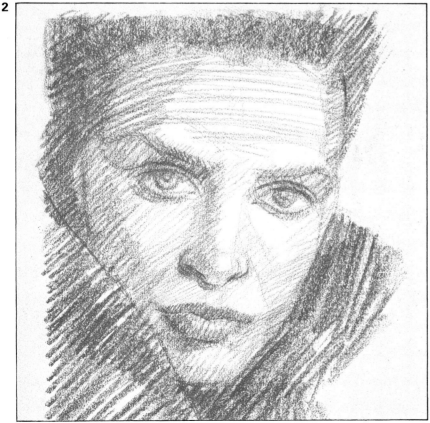

The illustrations on this page and the next of a female face were drawn from the steps we have explained. It is an exercise that you, too, should try. If at first your final result is not what you expected, do not despair. This is normal when using these types of measurement and dimension. With a little patience and some perseverance, everything will soon come together.

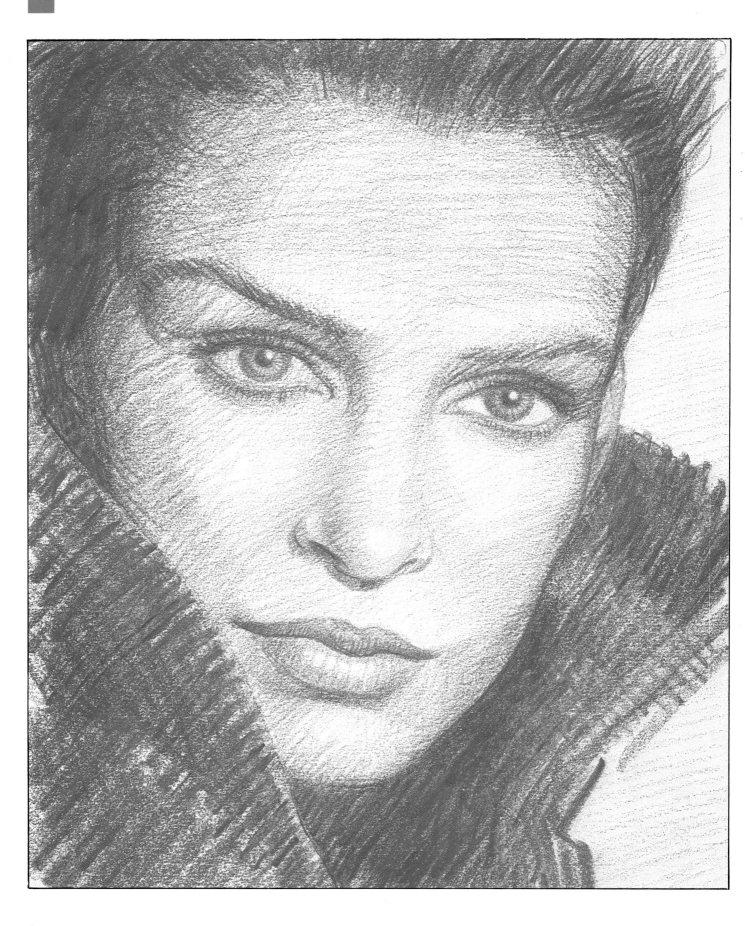

The human figure

Great artists have been preoccupied with the expression of Beauty and, when attempting to convey it through the medium of the human body, have turned their attention to formulating a law of proportions: that is, a series of mathematical relationships that, based on one simple proportion, determines all the other measurements of the ideal human form.

The two best-known and most widely accepted formulae are a legacy of the influence of greco-roman culture and were provided by two ancient Greek artists. These are known as the law of Polycletus (5th Century BC) and the law of Lysippus (4th Century BC).

The most representative of Polycletus' work is the statue known as "The Doryphoros." In this sculpture, all the measurements of the body conform to certain simple mathematic relationships, based on a single precept: *the total height of the body is equal to seven and a half times that of the head.*

The law of Lysippus defines a slightly more slender version of the human body as the ideal form. His initial precept is that *the total height of the body is equal to eight times that of the head.*

Once a rule of proportions goes beyond that of eight heads as equaling the total height of the human body, we enter the realm of heroes and demigods rather than ordinary men and women. Such is the case of the famous Apollo Belvedere, attributed to Leocares, a statue that follows the rule that the body measures the height of eight and a half heads. In any case, knowing and applying a law will help you to respect proportions in your drawing. Finally, bear in mind that in our sketches we have confined ourselves to looking at the most significant proportions relating to the levels and heights of certain parts of the body without going into so many details as to inhibit your spontaneous creativity.

Below, from left to right. "The Doryphoros" of Polycletus and "the Apollo Belvedere," attributed to Leocares. Over each photograph we have indicated the divisions corresponding to the relationship between the head and the total height of the body.

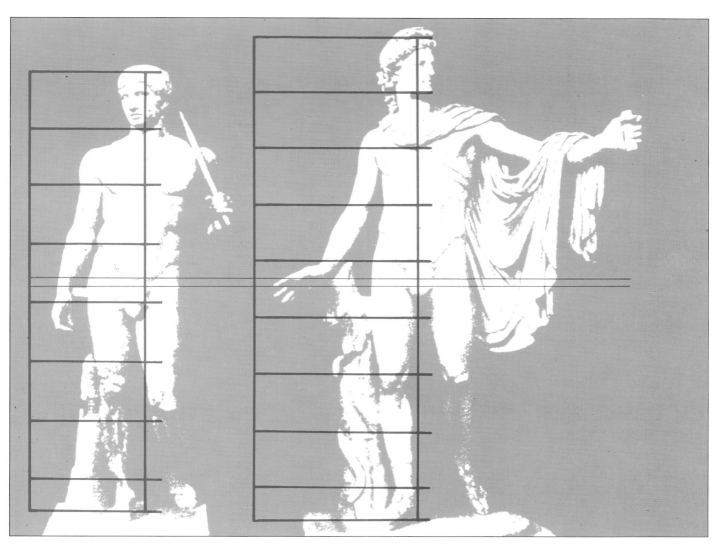

Law of proportion

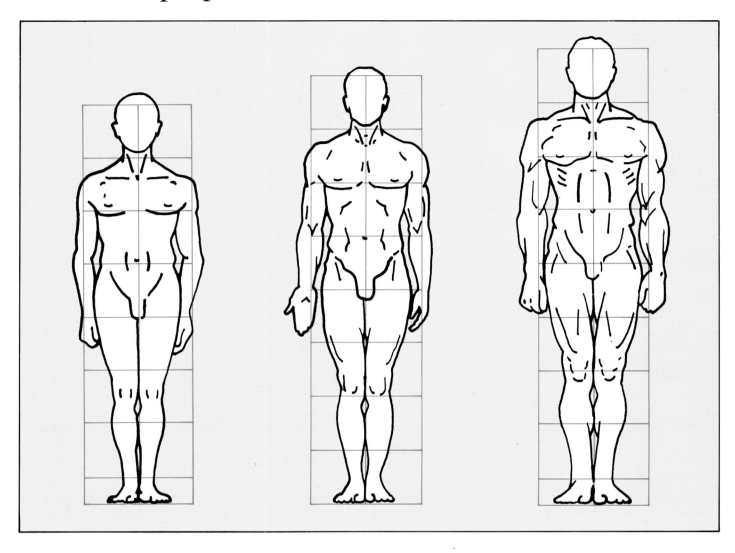

Of course, the classical laws leave no loose ends: Every measurement you care to consider within the human body has its own relationship with the unit of proportion—that is, with the height of the head.

From left to right, you can see diagrams representing three male bodies that base themselves, respectively, on the law of seven and a half heads, eight heads and eight and a half heads. Look at the differences of form and structure resulting from the adoption of one or other of these laws.

These days, it is safe to say that the average man obeys the law of Polycletus (seven and a half heads), although in the last few generations there has been a tendency towards the ideal human form described by Lysippus in the 4th Century. The human race does seem to be evolving towards a more slender form.

As artists, we can obviously choose whichever law best suits the physical type of a particular model but, in general, when the physical type is not immediately evident, the law most appropriate to the aesthetic considerations of the times we live in is that of eight heads to the body: It produces elegant, slender figures, without falling into the exaggeration of the Apollo Belvedere (unless, of course, we are trying to create the image of a superman). For now, it is worth noting that the fundamental differences between the three laws begin at the fourth division: The legs (from the groin area) of the first figure measure three and a half units, those of the second figure, four units, and the legs of the third measure four and a half.

Above. *Diagram showing the three versions of the law of proportions to which we have referred, based on seven and a half, eight, and eight and a half heads. The most widely used formula is that of Lysippus (eight heads), with eight and a half reserved for the representation of heroic figures.*

Law of proportion based on "eight heads"

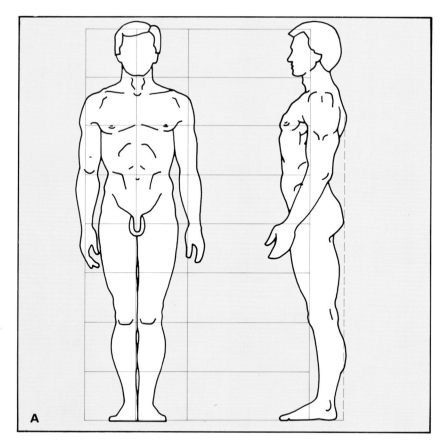

A

B

We are now going to look a little more closely at the laws of proportion of the human figure. We have included the laws relating to both men and women on the same page so we can compare them.

General view. The front and rear view of the human body can be situated inside a rectangle of the following proportions:
Base: measuring two "head heights."
Height: Eight "head heights." The rectangle is divided vertically by an axis of symmetry and horizontally by seven lines producing eight equal units of one "head height."

In the male figure:
• The shoulders are situated at one third of a unit below the first horizontal unit.
• The nipples are located on the lower line of the second unit.
• The distance between the nipples is equal to one unit.
• The navel appears just below the lower line of the third unit.
• The elbows and the bend of the waist are situated on the lower line of the third unit.
• The pubic bone coincides with the exact center of the body, or on the lower line of the fourth unit.
• The knees are situated a little above the bottom of the sixth unit.
• The fold of the glutaeus muscles (the buttocks) is located approximately a third of a unit down from the horizontal line that is level with the pubic bone.
• Seen in profile, the calf muscle touches the vertical that passes through the shoulder blade.
In the female figure, although people often believe the contrary, the proportions are not very different. The structural differences between the two sexes can be summed up in these details:
• In general, the female body is shorter than the male, by about 4 in.
• Women's shoulders are narrower.
• The breasts are situated somewhat below the bottom of the second unit.
• The navel is a bit lower than in the male body.
• The waist is narrower.
• The hips, on the other hand, are wider.
• In profile, the buttocks go beyond the vertical that passes through the shoulder blade and the calf muscle.

Law of proportion for children and adolescents

When a beginner tries to draw a child or an adolescent, there is a tendency to draw a "little adult." This is because the proportions of the human body most familiar to us are those of an adult. The proportions of the body of a child or an adolescent are more elusive; they correspond to various stages of development and we do not pay much attention to them. This should not be the case.

Our first observation should be that the head is the part of the human body that grows the least. We are born big headed, pot bellied and short legged. A quarter of a baby's height is made up of the head; its chest and belly make up almost two more quarters, so that the arms and legs appear very short by comparison. On the left (1), is a diagram representing the approximate proportions of a human being of eight to twelve months old.

In height, the most significant development occurs with the extremities. Between eighteen months and two years (diagram 2), the scale of units increases from four to five, with the legs already occupying two of them, as do the arms alongside the elongated chest and abdomen.

We know that not all children grow at the same rate but, on average, between two and six years of age, their bodies develop enough (always taking the head as one unit) to be defined in a scale comprising six units (3). The lower part of the body, as you can see, is the main area of growth.

The well-formed adolescent body conforms to a scale of seven "heads." Thoracic development and the growth of the extremities (the legs already occupy three complete units) have almost reached adult proportions. In reality, many adults never grow beyond seven head heights. It could be said that between puberty and maturity, the major development takes place in the legs, which grow from three to four units. In terms of proportion, the real difference between the adolescent and the adult lies in the relative length of the legs. Because the greatest difficulties seem to arise when drawing very small children, we have reproduced an enlarged version of our second diagram for you, as it is one of the most frequently used in the entire history of art: Consider sculptor Luca della Robbia's "children" (15th Century) or Murillo's little angels (17th Century), for example.

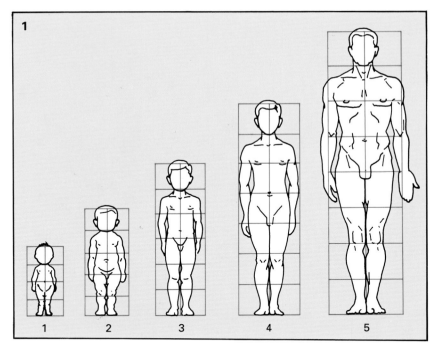

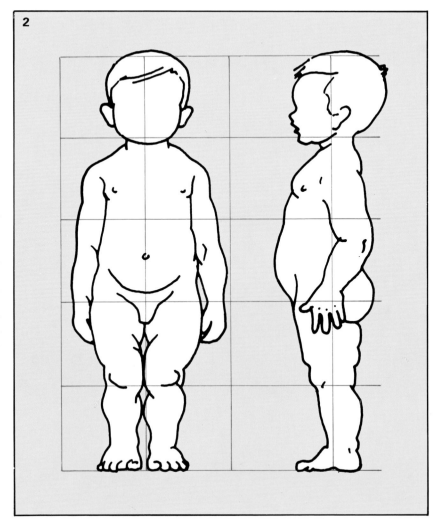

inspire you to carry out a more detailed study of artistic anatomy.

Each artist, within his own limitations, should follow the example of Leonardo da Vinci the great pioneer of the systematic study of human anatomy as applied to art.

Lower right. Studies in anatomy by Leonardo da Vinci. They are surprisingly clear and precise.

Lower left. Anatomical study of human muscles, by the Florentine artist Alesandro Vallari.

In order to draw "something," it is necessary to know what this "something" is like. Elementary, you may think. However, beginners to drawing are often unaware of this fact. Even with subjects as complex as the human figure, they tend to rely on intuition without carrying out a preliminary analysis of form, even though all great artists agree that real mastery of the human form is achieved only through study of the anatomy of the male and female body.

From the Renaissance on, artistic anatomy has been considered an essential discipline in the preparation of the artist. We advise you to look carefully into this subject which, for obvious reasons, we can only touch upon in these pages; naturally, we cannot turn our course into a treatise on artistic anatomy.

There are some very good books available that can help you to understand the human form, to know the whys and wherefores of the contours of the body; unless we have this knowledge, when drawing from life, we end up reproducing what we see, without knowing why it is there.

Understanding the inner reason for the forms of the human body is the only way to interpret them correctly. Since this knowledge begins with the study of our bone and muscle structure, we will confine ourselves to offering you a summary of the main bones and muscles (the most superficial layer) that make up the human body, in the hope that this overall view will

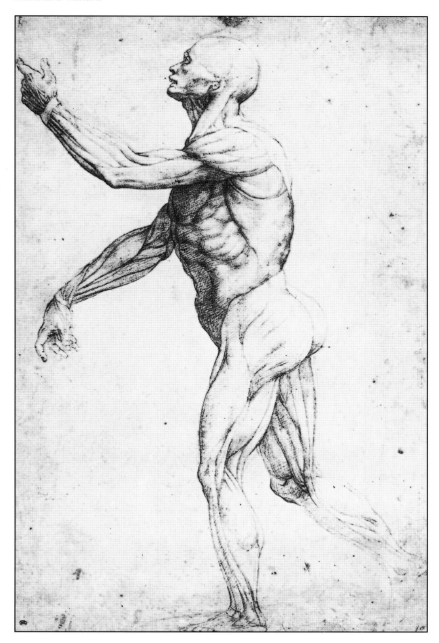

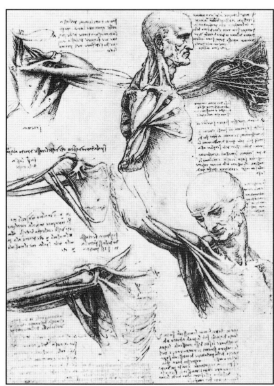

The skeleton

The skeleton is the solid, articulated framework that supports the soft parts of the body (the muscles and internal organs) and that, thanks to the rigidity of the bones, maintains a stable structure. The skeleton could also be considered as a "collection of levers," driven by the muscles, that both facilitate and restrain the movements of the body. The joints are the focal point of interest when describing a particular pose and play a large role in the representation of foreshortening. This is evident in Michelangelo's "David," the famous statue we have described in a pen drawing. All the details of the pose are seen to be present in the underlying skeleton.

In the skeleton, all the details of the pose and the arrangement of the joints that determine the outline and proportions of the drawing can be clearly seen.

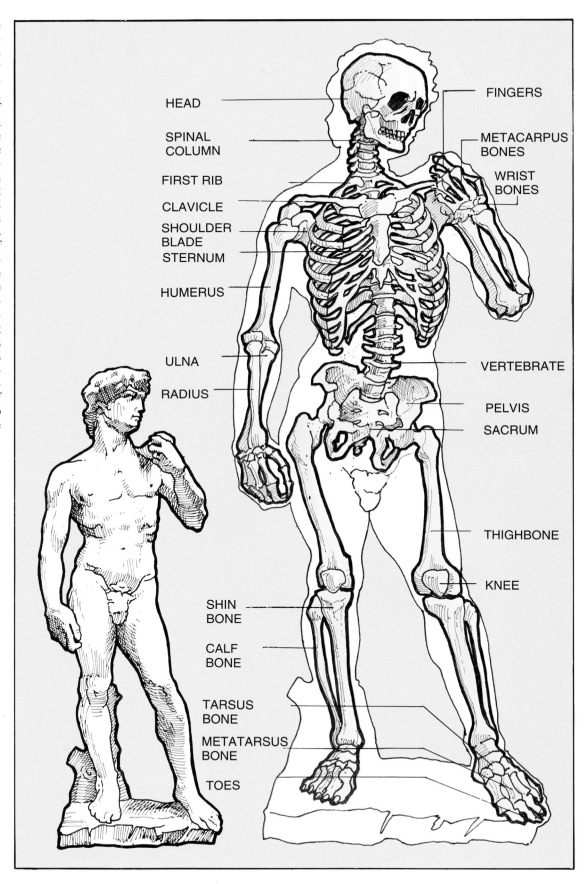

HEAD

SPINAL COLUMN

FIRST RIB

CLAVICLE

SHOULDER BLADE
STERNUM

HUMERUS

ULNA

RADIUS

FINGERS

METACARPUS BONES

WRIST BONES

VERTEBRATE

PELVIS

SACRUM

THIGHBONE

KNEE

SHIN BONE

CALF BONE

TARSUS BONE

METATARSUS BONE

TOES

The muscles

The study of the musculature of the human body can obviously be carried out on various levels, but from the artistic point of view, special emphasis should be placed on the areas of muscle that most affect the external form. In reality, the contours of the body that we see are the result of the volume of the muscles—even the more internal ones—although obviously the ones just beneath the surface of the skin are the ones of greatest interest to the artist. On these pages we show you a front and back view of the superficial musculature of the human body, indicating the name of each muscle. We have based these diagrams, as with the skeleton, on the pose of Michelangelo's "David." It is important to take note of each of the muscles shown here and to try to identify them in your individual model when drawing from life.

Front view

Head muscles: 1. Frontal. 2. Temporoparietal. 3. Masseter. 4. Orbicularis oris. 5. Triangular of the lips. Platysma.

Neck muscles: 6. Sternomastoid. 7. Sternohyoid muscle. 8. Trapezius.

Thorax muscles: 9. Pectoralis major. 10. Serratus lateralis.

Abdominal muscles: 11. Obliquus abdominis externus. 12. Rectus abdominis. 13. Linea alba.

Arm muscles: 14. Deltoid. 15. Biceps brachii. 16. Triceps brachii. 17. Flexor carpi radialis 18. Brachioradialis.

Leg muscles: 19. Tensor fasciae latae. 20. Sartorius. 21. Quadriceps (rectus femoris). 22. Vastus medialis. 23. Vastus lateralis. 24. Gastrocnemius. 25. Tibialis anterior. 26. Peronaeus longus. 27. Soleus.

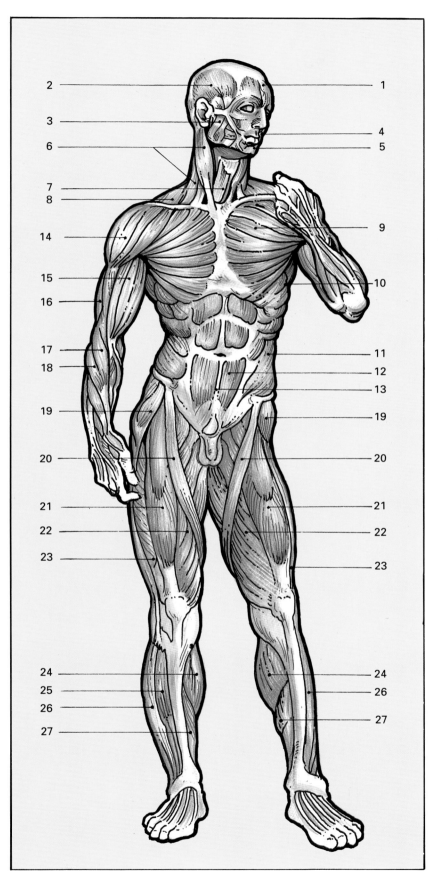

Front view of the superficial muscles of the human body. Try to learn their names in order to identify them in a living model.

Back view

Head muscles: 28. Occipitalis.
Back muscles: 29. Trapezius. 30. Infraspinatus. 31. Major rhomboid. 32. Latissimus dorsi.
Arm muscles: 16a. Vastus interior triceps brachii. 16b. Vastus exterior triceps brachii. 33. Flexor carpi radialis. 34. Flexor carpi ulnaris.
Leg muscles: 35. Gluteus medialis. 36. Gluteus maximus. 37. Biceps femoris. 38. Semitendinosus. 39. Semimembranosus. 40. Triceps surae. 24. Gastrocnemius. 25. Soleus.

As always happens when one is faced with theory of any kind, questions arise about the practical value of studying it. An understanding of the laws of proportion allows us to calculate the measurements of parts of the body in relation to its overall height, or to the basic unit; obviously, it also gives us a solid base for producing a harmonious and slender figure. A knowledge of its anatomy can also help us to situate each joint and muscle in the right place. Naturally, the musculature of the woman's body is exactly the same as that of a man's. The structural differences that we see between the male and female bodies are because of the different development of certain parts of the skeleton. The woman's pelvis, for instance, is broader than that of the man's. The woman also has a more obvious layer of sub-cutaneous fat than the man, which accounts for the greater softness of the contours of the female body, even in the case of gymnasts and sportspersons. A male gymnast has a more angular body than his female counterpart, even if they have both trained to the same level of fitness.

Back view of the superficial muscles of the human body.

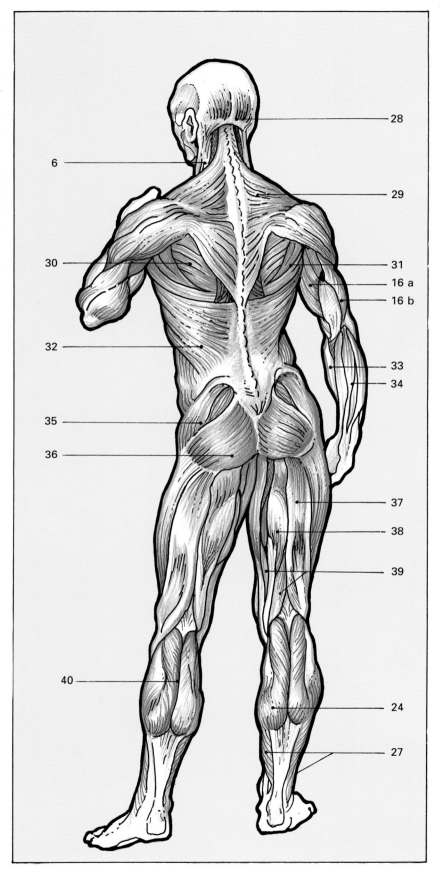

Study of the hands

The expressiveness of the human being (our capacity for expressing feelings and emotions) is mainly transmitted through the facial muscles. However, the eyes are not the only "mirror of the soul," as the saying goes: The hands also have a lot to tell us.

Have you ever analyzed the extraordinary mobility of your own hands? Have you ever watched with curiosity the infinite number of gestures the hands make when we talk to one another, when we are expressing ourselves? All the great artists have understood the expressive potential of the hands and, as a consequence, have carefully studied their anatomical structure and their movements.

Look for examples throughout the history of art, study them attentively and with a certain reverence, and you will be amazed at the beauty and expressive power of this important part of the body.

Drawing a hand (drawing it well, that is) is one of the hardest things an artist has to learn. However, just as with the human face, it is one of the most fascinating subjects there is.

Besides this, it is a subject that is always within reach; if you draw with your right hand, the left is always ready to pose. And of course, the same applies in reverse if you are left handed. So there's no excuse: No one can claim that he doesn't draw hands because a model can't be found. We are going to dedicate the last pages of this book to teaching you how to draw hands... starting with your own!

It is not an easy undertaking, because the hand is not a single form; it is a combination of forms, each capable of independent movement and that we tend to see in acutely foreshortened positions.

The way to resolve the problems arising from this foreshortening effect is to make a thorough analysis of the bone structure of the hand; its joints are the points of reference for calculating all the relevant proportions.

So, prepare yourself—you are going to have to do some hard work.

While one hand is drawing, the other is posing. This is a good way of studying the forms that make up the hand, of getting to know the endless positions it can adopt, and also of acquiring the confidence needed to capture its expressive power.

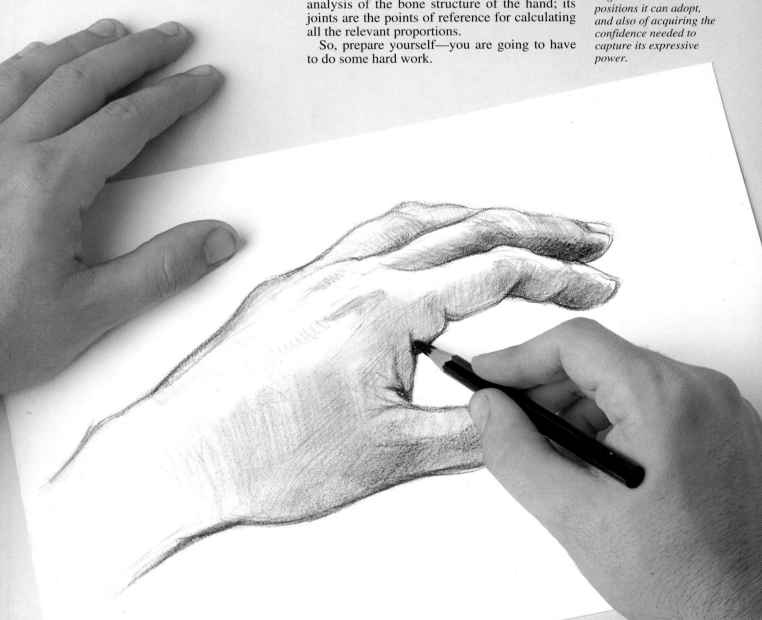

Three examples from old masters

Left. Study of a hand drawn by Bartolomeo Passeritti (1529–1592) with pen and brown ink (Louvre Museum, Paris).

Below, left. Study for the hands of the Virgin and St. Isabel, by Federico Barocci (1528–1612). White and black chalk on blue paper (Staatliche Museum, Berlin).

Below, right. Study of hands by Leonardo da Vinci, in the Royal Library of Windsor Castle. Engraving with highlights on prepared pink paper.

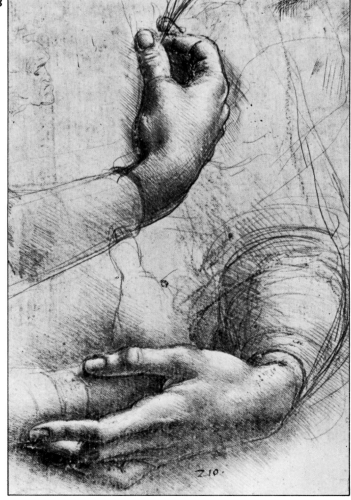

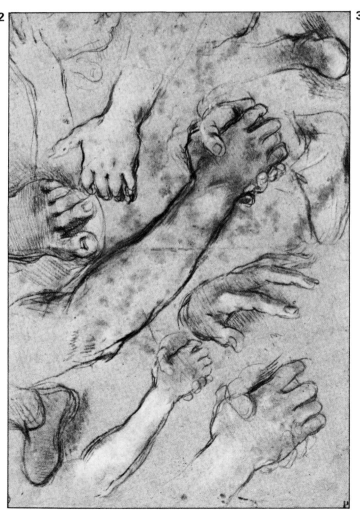

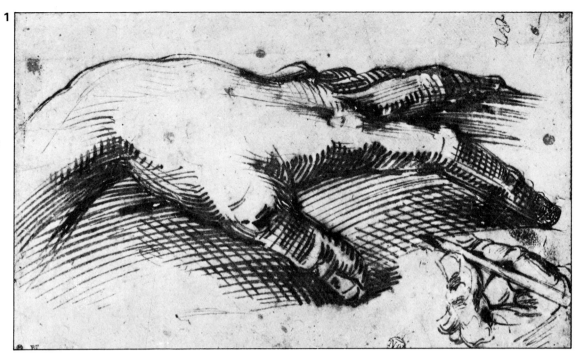

The skeleton

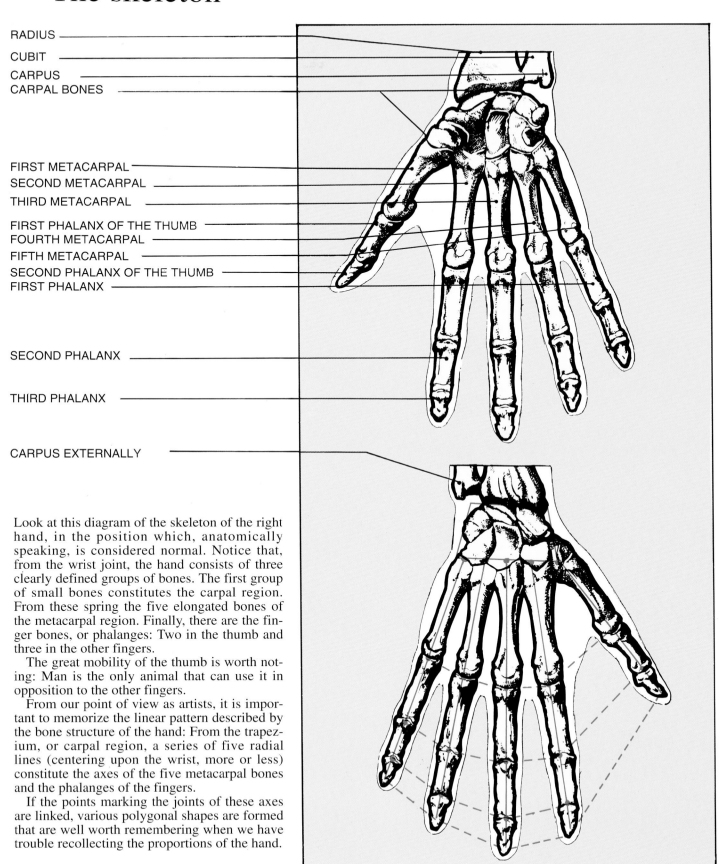

RADIUS

CUBIT

CARPUS

CARPAL BONES

FIRST METACARPAL

SECOND METACARPAL

THIRD METACARPAL

FIRST PHALANX OF THE THUMB

FOURTH METACARPAL

FIFTH METACARPAL

SECOND PHALANX OF THE THUMB

FIRST PHALANX

SECOND PHALANX

THIRD PHALANX

CARPUS EXTERNALLY

Look at this diagram of the skeleton of the right hand, in the position which, anatomically speaking, is considered normal. Notice that, from the wrist joint, the hand consists of three clearly defined groups of bones. The first group of small bones constitutes the carpal region. From these spring the five elongated bones of the metacarpal region. Finally, there are the finger bones, or phalanges: Two in the thumb and three in the other fingers.

The great mobility of the thumb is worth noting: Man is the only animal that can use it in opposition to the other fingers.

From our point of view as artists, it is important to memorize the linear pattern described by the bone structure of the hand: From the trapezium, or carpal region, a series of five radial lines (centering upon the wrist, more or less) constitute the axes of the five metacarpal bones and the phalanges of the fingers.

If the points marking the joints of these axes are linked, various polygonal shapes are formed that are well worth remembering when we have trouble recollecting the proportions of the hand.

A study of proportions

We can establish a rough rule of proportion for the hand, based on two square units that meet at the joints between the metacarpal bones and the first phalanges of the fingers. It is not an exact formula, but it is a guide to the correct proportions of any hand. Notice that each finger is a different length—the differences can be measured approximately in sevenths of a unit. The equal size of the two units is maintained whatever position the hand is in, although they are, of course, seen in perspective. Besides, the second unit (the one containing the fingers) will hardly ever be seen as a single plane. The flexible movement of the fingers will create many individual planes. You have been warned that drawing a hand is not at all easy. So be brave and get drawing right away!

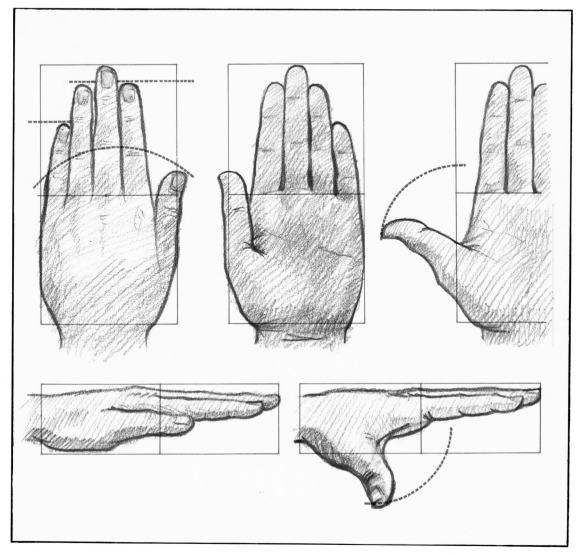

Drawing a hand almost always involves representing the effects of pronounced foreshortening. The joints are a good guide to keeping everything in proportion.

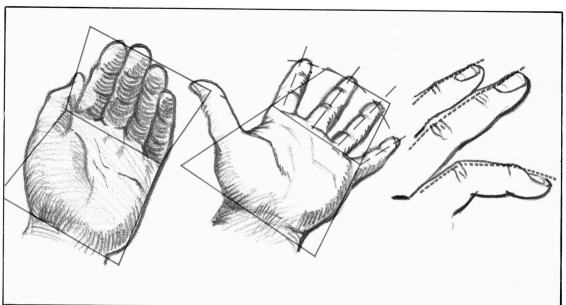

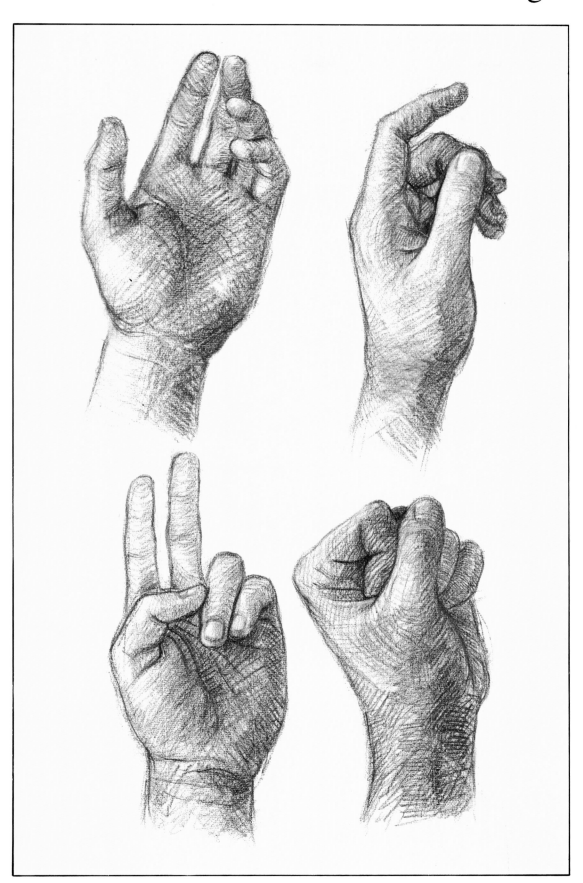

On this page you can see four pencil studies (in 3B and 6B) of a left hand. They show four different poses of the same hand (the left hand of the artist, to be precise) that you should copy, but using your own hand as the model. Notice that in all four drawings, the light is coming from the left, creating quite clearly defined areas of light and shade. Find a light source that does not complicate the drawing, but gives your model a sharp, crisp outline.

Pay attention to the foreshortening of the fingers. Look, for instance, at the ring finger and little finger of the first study and you will see how important the little touches of light are on the fingertips and on the illuminated under-side of the little finger. These highlights contribute greatly to the accurate representation of the fore-shortening effect.

Notice how the effects of foreshortening can some-times be resolved by clever use of highlights.

The objective of the studies on the previous page was to catch the hand in a few of its many fleeting poses.

In this next series of studies, the hands are not just being hands; they are in action. Capturing the effort and the muscle tension in the hands is one of the hardest things. Often, the drawing itself can be correct in terms of form and yet be completely devoid of any quality of expression. The strength of these hands (the sensation that they are strong) has been achieved in this drawing in two different ways: First, the structure has been built up through effective use of light and shade (and considerable tonal subtlety); second, the outlines of the forms themselves have been drawn sharply but sensitively. Sometimes, it is useful to form a concept of volume in your drawing and, as in the first and second studies in this series, to contemplate your subject with the mind of a sculptor.

1

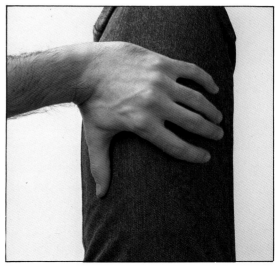

2

Study of the left hand, drawing from life.

Look at the photograph: The artist has rested his left hand on his left leg, so that from above he has a clear, almost frontal view of it. Now do the same, or the opposite if you are left handed. The steps to follow are the same as with any other drawing:

1. With faint lines, draw an outline sketch; you will probably find that the observations made on pages 118 and 119 pay dividends at this point.

2. Once you are happy with the initial sketch, build up the outlines and indicate the main areas of shading (on the fingers and the arm) to create an early sensation of depth. Look closely at the fingers and you will see that the light has created some distinct areas of tone: A darker area around the second and third phalanges of the index and middle fingers, medium tone on the ring and little fingers, and another kind of medium tone on the first phalanges of these same fingers. Defining the upper end of this last plane, a distinctive shadow is caused by the knuckle joints where the first phalanges meet their corresponding metacarpal bones. Finally, the thumb and the contours of the upper palm constitute yet another completely different plane.

Close-up A.
Emphasizing the contours, using line to define volume, that is, to distinguish between the finger itself and the surface it is resting on (the leg). These lines must have a little "life:" Make sure that they vary in thickness and intensity.

Close-up B.
Building up contours with a sanguine crayon. Part of the "personality" of a hand lies in the greater or lesser prominence of the veins on the surface of the upper palm.

A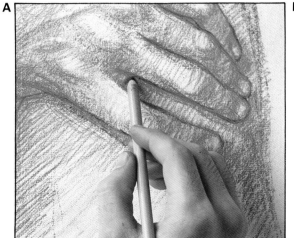

B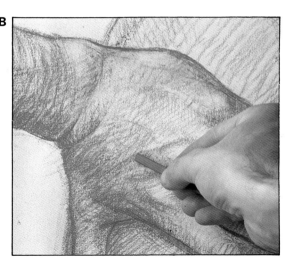

3

3. Build up the tone from the main areas established during stage 2. Study carefully the contours and hollows caused by the anatomical elements beneath the skin: The knuckle joints, the tendons, and veins that, in an adult's hand, can be tremendously expressive. The objective is to achieve, as our artist has done, an image that is a faithful representation of nature, but without lapsing into a labored kind of realism. It is possible to convey the texture of the skin lying on top of certain internal forms, without having to go into minute detail.

CHAPTER V
Techniques and Exercises

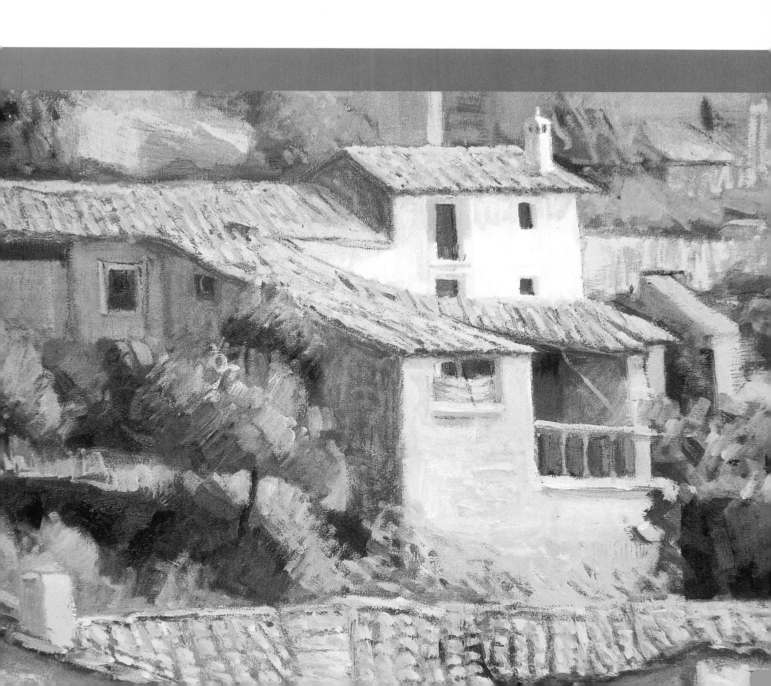

Techniques and Exercises

*I*n this last chapter we will thoroughly review the different drawing and painting processes and put them in practice. From the different media and techniques that follow, you will surely find one that will spark your interest and complement your natural artistic talent. When this happens, our goal has been accomplished: to give you the necessary learning techniques and training to develop and realize your artistic ability.

Colored pencils

Everybody has used colored pencils. It is difficult to imagine meeting anyone who has not used them, even if it was only in their school days. Of course what we have in mind here is more serious: We intend to elevate what were our modest colored drawing pencils to the status of a pictorial medium. Our objective, simply stated, is to be able to paint with colored pencils. Let's begin by getting to know a little more about the tool we will be using.

First, we had better make it clear that when we refer to colored pencils at this level of artistic activity, we mean pencils of a very high quality. The "classroom" type of pencil is of no use to us. We need pencils made of American cedar, exceptionally soft (very easy to sharpen to a good point), but durable enough to provide solid protection for the lead and to withstand pressure from the artist's hand. The lead must be hard and strong, but able to produce an intense color when required, and pale tonal values when attempting half-tones and gradations. An inferior quality lead is easily spotted: It produces little depth of color, its lead feels rough, and it breaks easily.

Colored pencils, when used as part of the picture-making process, have the one drawback that they can only produce a single line; they cannot cover vast areas as a paintbrush can and are therefore not suitable for large works.

However, for works on a small scale, whatever the subject matter, they offer a wealth of possibilities and are capable of producing sophisticated pictures.

All manufacturers of graphite pencils (or almost all) also make colored pencils. Usually they offer an extensive color range and sell pencils individually and in boxed sets of varying degrees of luxuriousness containing 12, 24, 48, or 72 pencils.

The most normal color range, for a box of 12 pencils, consists of two blues, two greens, two reds, two siennas, a yellow, a violet, black, and white; more than enough for the majority of requirements.

As for brand names, it is difficult to recommend one in particular. The big brands all offer high-quality products. Personal tastes and circumstances generally lead an artist to opt for one brand or another. Here are a few of the best-known names: Castell (Faber), Caran d'Ache, Lyra, Staedtler, Stabilo, and Jovi. Finally, we should mention paper. Except for shiny or coated papers, on which the pencil lead slips and can hardly make a mark, almost any matt paper is suitable for drawing on with colored pencils. However, for any special projects, the best choice would be a high-quality, semi-rough watercolor paper.

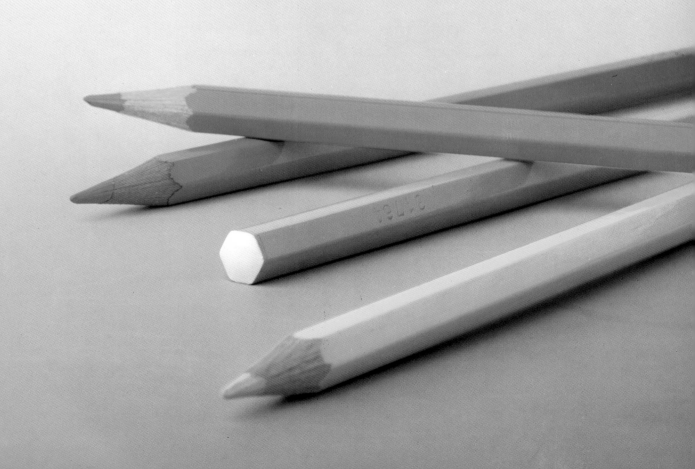

Tools and techniques

The point

To get a good point on the pencil, use a sharpener (it must have a large aperture) when you want a sharp point for detailed work and outlines. Use a penknife if a longer or bevelled tip is required for thicker strokes, such as shading an area or going over a color.

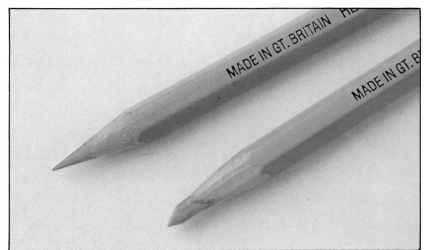

Pencil position

Try not to work with the pencil at too much of an angle. It should be at about 45 degrees from the paper. This decreases the risk of the lead breaking.

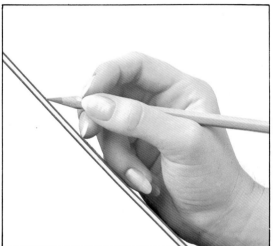

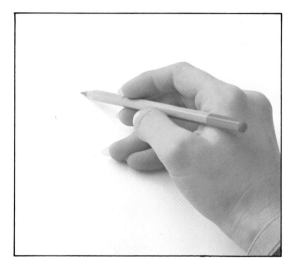

A practical tip

When using colored pencils do not keep taking them in and out of their box or leaving them on the worktop. That is a waste of time, and also exposes them to knocks that can result in broken leads. The best idea is to keep all the colors you intend to use in your left hand or, as in our photograph, to use two containers, one for the warm and one for the cool ranges of colors. It is a practical system and makes it easy to find in an instant the color you need.

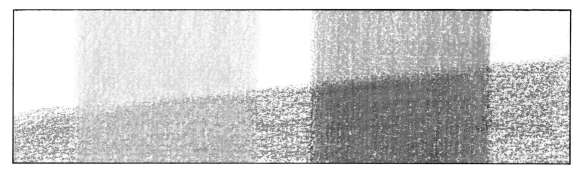

Color mixing

Color mixes with colored pencils are always optical, obtained by superimposing transparent colors. They are not homogeneous mixes of pigment as, for example, with oils and watercolors.

When mixing two colors, it is important to remember that the order in which they are applied will affect the result. Applying blue on top of yellow is not the same as applying yellow on top of blue.

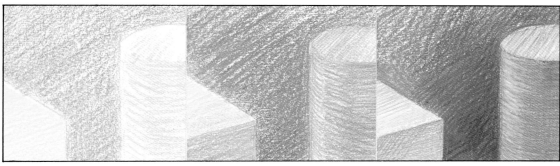

As shown in this short progression, with colored pencils you should work "from light to dark." In other words, intensify color by means of successive layers that build up tonal and chromatic values.

Tinted papers such as cream, pale blue, gray, salmon-pink, and others, provide a good support for colored-pencil work. They provide a tonal base that can harmonize a color scheme and also make it possible to use white.

Water-soluble pencils allow you to produce gradations using a paintbrush. The colors come to life and you can create some really striking transparent effects. However, something of the original pencil mark always remains on the paper.

Exercise with three primaries and black

Initial construction

You are going to copy a seascape from the work of Miquel Ferrón using just three colors and black. In this first stage, creating the initial outline, a blue pencil is used to build up the subject. Use light strokes so you can rub them out if you make a mistake. Keep the surface of the paper clean and in good condition, and erase as little as possible. It helps to produce a perfect outline sketch with as much detail as possible so that later you can work on the picture without having to worry about size and proportion.

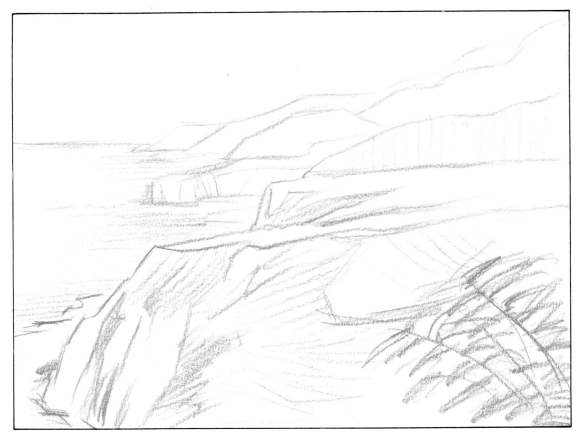

1. First stage: Blue

When drawing with the three primary-colored pencils, with or without black, you normally begin with blue. This makes it easier to mix the other two colors later—magenta and yellow—in order to achieve the desired tones. Notice the areas in which blue has been applied more heavily: in the sea, in the rocky foreground and in the sheer cliff-faces, which will remain in shade in the final picture. Note also the direction of the pencil strokes in each area of the drawing.

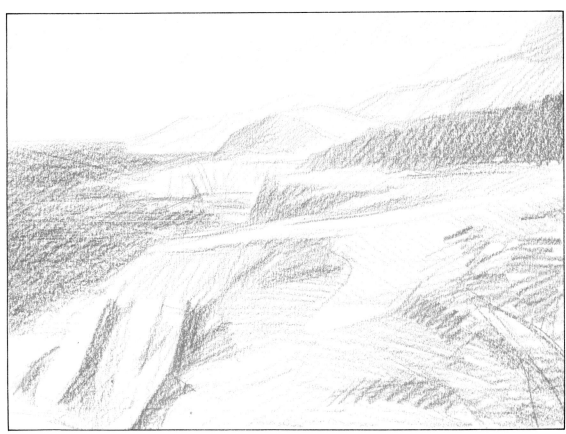

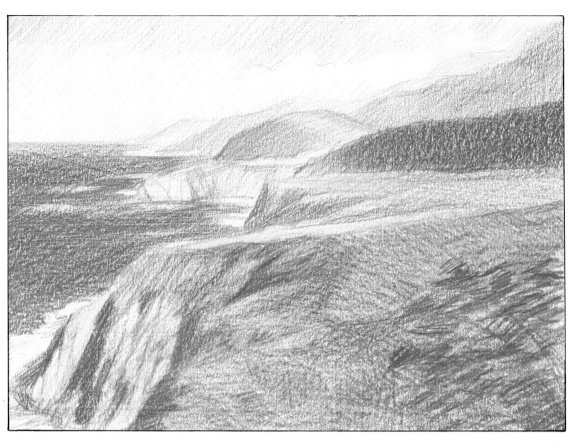

2. Second stage: Yellow

Notice how the appearance of the picture changes dramatically with the addition of yellow. The subject really begins to take shape and it already looks similar to the finished work. Foreground greens appear, along with a few subtle violets in the background where the yellow has just "caressed" the blue. The whole scene has taken on depth and the first contrasts are visible. At the beginning, the artist reserved some white areas in the sea and clouds. Using this method, even the white of the paper becomes a color.

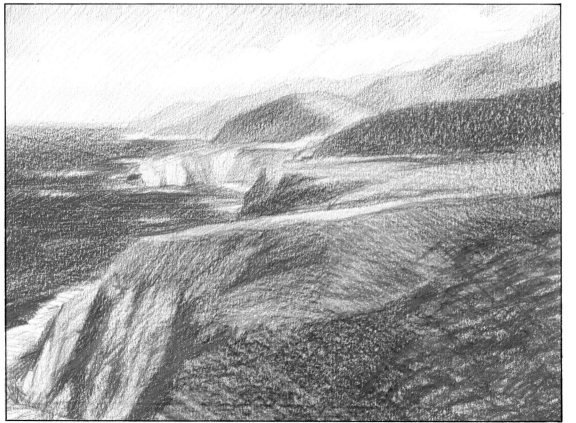

3. Third stage: Magenta

Now we come to lively, intense magenta, the third of the primary colors to be used in this exercise. The artist warns us, "With magenta we must be especially careful how we apply the pencil strokes: softly in some areas and forcefully in others. For example, the vegetation in the foreground and the shadow on the cliffs need a lot of pressure from the pencil. On the other hand, on the distant hilltops you can barely discern a few subtle pencil strokes."

4. Final stage: The finished picture

Before achieving this definitive result, Ferrón used the black pencil in the areas where the tone needed to be brought out, as with the foreground vegetation. But take care; it is easy to get carried away with black. Start by just touching up something here, by reinforcing that outline there, by adding a little shading, and the work ends up looking dusky and dirty. Besides the black, a few last touches of color were applied to enhance the feeling of depth and contrast in the finished illustration. Finally, the strips of adhesive tape around the picture were removed; these ensured that the edges were crisp and clean. Now it is up to you; either copy this seascape, or find a subject of your own and make a picture using three colors with black.

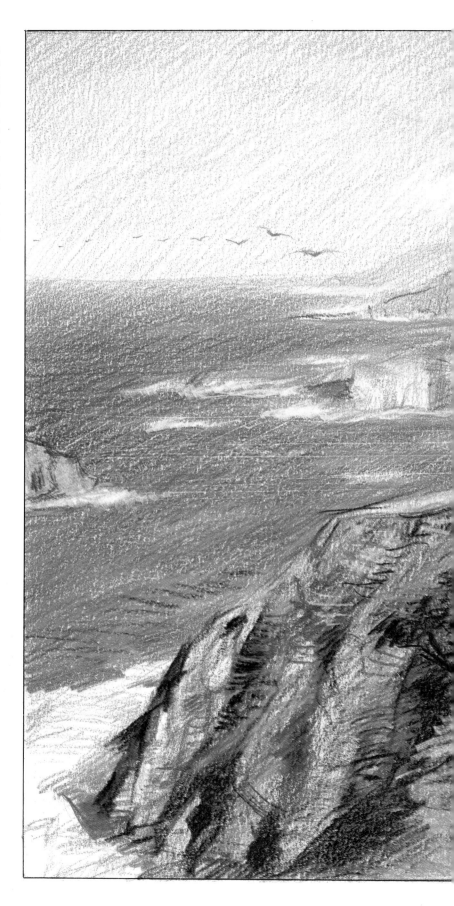

Definitive result of the seascape in pencil in which Ferrón shows us how natural colors can be created using primary colors along with black.

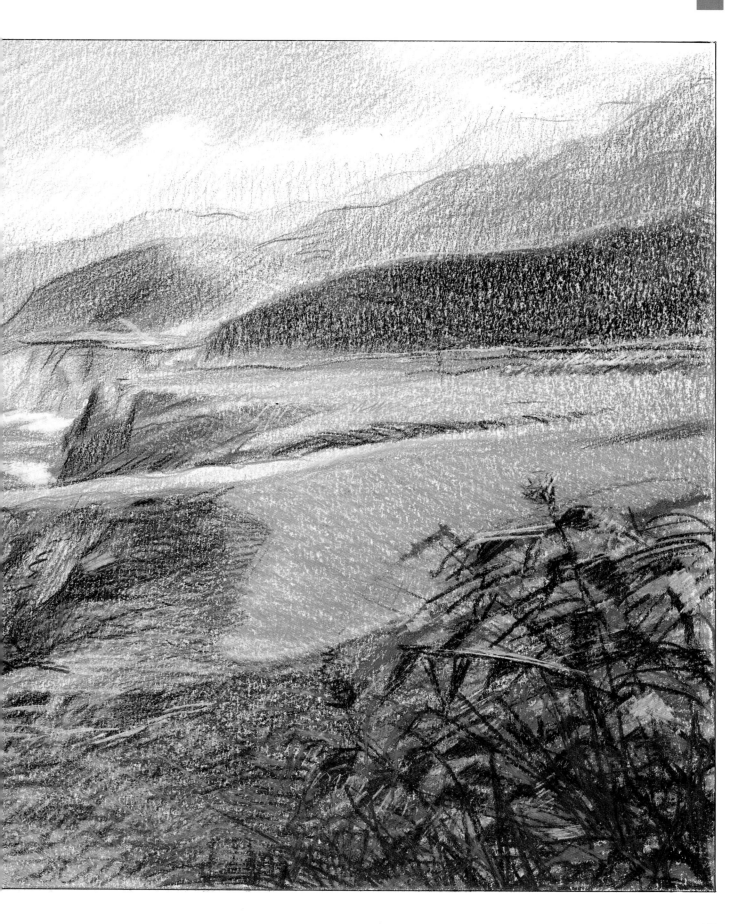

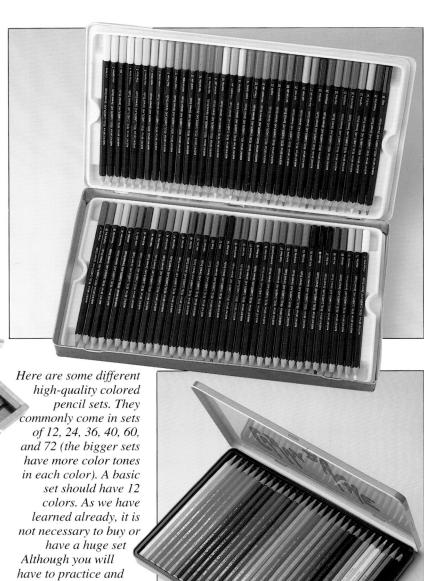

Here are some different high-quality colored pencil sets. They commonly come in sets of 12, 24, 36, 40, 60, and 72 (the bigger sets have more color tones in each color). A basic set should have 12 colors. As we have learned already, it is not necessary to buy or have a huge set Although you will have to practice and experiment a little bit more, try mixing different color tones to obtain your desired color.

Some popular colored pencil brands

BRAND	MANUFACTER	COUNTRY
Derwent Studio	Staedtler	Germany
Rexel Cumberland	Germany	Albrecht Dürer
United Kingdom	Prismalo I and II	Faber-Castell
Polychromos	Caran d'Ache	Germany
Faber-Castell	Switzerland	Mongol
Germany	Lyra	Faber
Staedtler	Rembrandt	United States

Exercise with water-soluble pencils

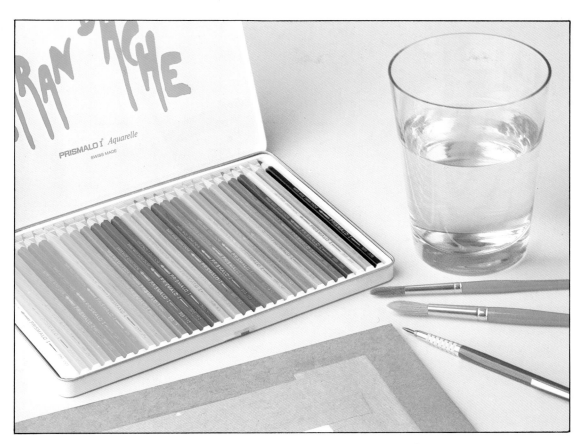

To prepare your water-soluble pencils, take two good-quality paint-brushes, one No. 6 and one No. 12, and a sheet of medium-textured watercolor paper of about 6 × 8 in. (16 × 20 cm).

You will also need clean water. Attach the paper to a base of wood or board with four strips of sticky tape and get ready to follow our steps. You can copy our example or choose another photograph.

The fact that we have used Caran d'Ache pencils does not mean that you cannot use another make.

If you do decide to use a different photograph, make sure that it offers a good balance between warm and cool tonal values. Remember that this is a first exercise and it would be counter-productive to launch into an orgy of color.

Choose the color range best suited to the subject. We have opted for a reduced palette: Emerald green, cinnabar green, yellow ochre, pink madder, burnt sienna—and that's it.

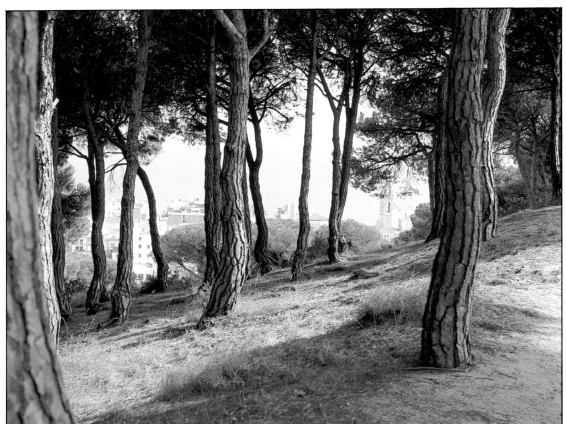

First step

Very lightly, with a dark-blue pencil, make a layout sketch of the subject. Bear in mind that a colored-pencil line is difficult to rub out. You should not make any pencil strokes in your outline sketch too decisive until you are totally sure that you do not want to modify them. If you analyze the dominant color quality of our subject, you will see why we have decided to use dark blue for the sketch: It is obviously the dominant tone in the dark areas of the picture.

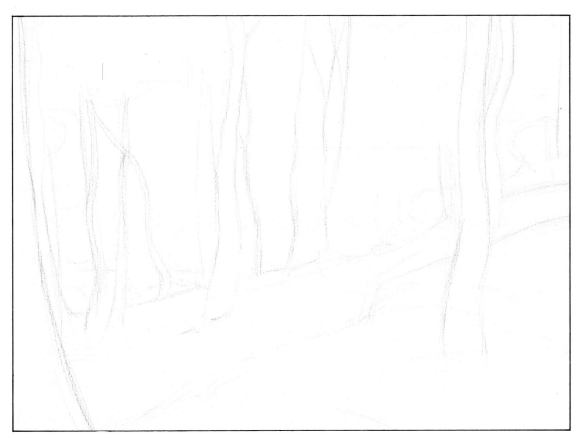

Second step

Our second step has been to establish the overall tonal values of the subject and to hint at the local color in each part of the picture. As you can see, all this has been carried out using very subtle strokes that suggest the color rather than define it. Using the vocabulary traditional to painting, we might say that in this second phase we have *"blocked in"* the picture, establishing a base for its chromatic development.

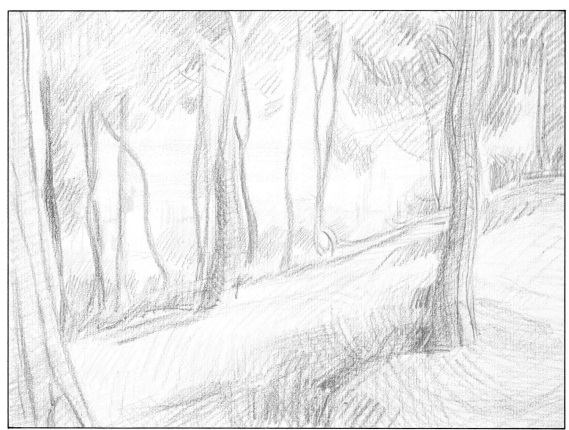

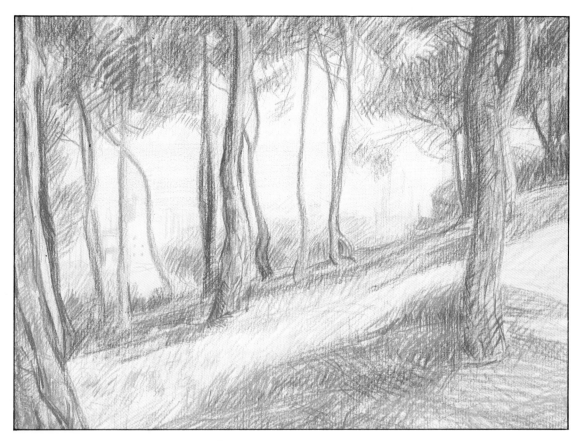

Third step

We continue with the same colors, gradually intensifying them by means of cross hatching and by adding coordinated layers of tone. At this stage, the idea is to leave the picture as a completed pencil drawing but without much color contrast. We must remember that when we carry out the watercolor wash and touch up the final version of the picture, a unity, depth, and general darkening of color will become apparent.

Fourth step: The watercolor wash

Following the method shown in these four close-ups, work on one area at a time. Allow the brush to distribute the water evenly to avoid the colors binding too closely together and to prevent the outlines from becoming blurred. Running a wash over a pencil drawing is not the same as producing a wash in the traditional way with watercolors. Neither the method nor the intention is the same. You do want to blend color—that is certainly the objective—but without sacrificing the characteristic strokes of a colored-pencil drawing.

Fifth step: Final touches

When your watercolor wash is practically dry, but not totally, use the tip of the pencil to highlight certain colors and contrasts, redefining shapes that might have become blurred if the wash caused the colors to blend.

The finished picture

Notice the almost "doughy" texture of the last few touches made by the pencil on areas that still retained some moisture. These strokes, drawn on top of the watercolor wash, give the painting a really appealing character. Try it for yourself: On washes with a greater or lesser amount of color, use the point of the pencil at different stages of dampness and compare the results of each experiment.

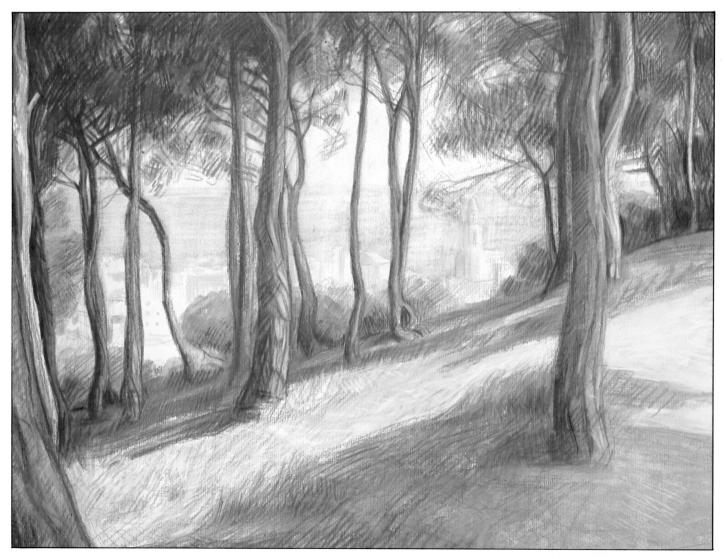

Drawing with charcoal ■

Charcoal is obtained by means of the controlled combustion of small twigs (willow, vine and walnut being the most frequently used). It is, without a doubt, one of the most ancient drawing materials known to man. But it was in the seventeenth century, with the advent of new types of paper better suited to showing the effects of light and shade, that charcoal came into its own as the primary technique used in training future artists.

Charcoal in its ancient and modern form, has many qualities that make it ideal for exploring chiaroscuro (the effects of light and shade). On the right paper (basically Ingres or cartridge papers), it can produce gradations ranging from total black to the white of the paper, passing through every imaginable shade of gray. It can be blended to wonderful effect using the fingers or a torchon or piece of cloth. For blocking in large surface areas with uniform tone, powdered charcoal can be spread evenly with a cloth or rag.

Another great advantage of charcoal is that white areas can be restored quite easily with an eraser; also a drawing can be altered during its creation by dusting off areas with a cloth. During this operation, the drawing does not disappear altogether, but is left in a state where you can build on the successful parts and rectify the less successful sections in the hazy images remaining on the paper. When drawing in charcoal as part of the academic process, the drawing is often partially erased at one point (generally after the initial sketch and the first blocking in of light and shade), after which the real study of light and shade begins, working the charcoal with fingers, torchons, and rags, as well as the rubber eraser—an important tool when using this technique.

It is hard to sharpen a stick of charcoal (even if it were possible, the point would not last), so it should not be used for small-scale work; it is not intended for miniatures. It is a technique much better suited to modeling form by means of chiaroscuro than to describing outline in minute detail.

The instability of charcoal as a medium is easy to demonstrate: Blowing hard removes all surface dust; if the paper is shaken, any pigment which has not penetrated the grain of the paper will fall off and, if a cloth is then applied, almost *all* the charcoal will be removed. However, you should not rely on this; in spite of its instability, to erase every trace of charcoal is an arduous, if not impossible, task. The darkest lines always leave a mark that not even the plastic eraser can completely eliminate.

Charcoal drawings need to be fixed with a liquid fixative applied with a mouth atomizer or using a special aerosol can.

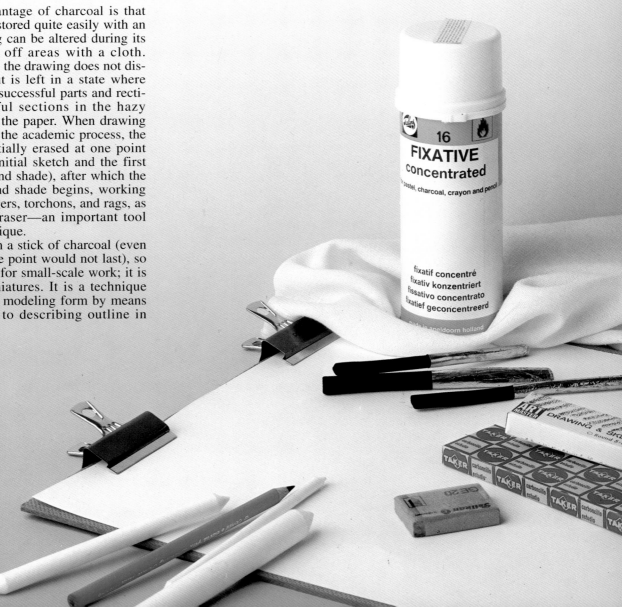

Characteristics and techniques of charcoal

The application and fixing of charcoal
Charcoal is a very unstable medium and the slightest touch can remove the top layer of pigment. As a consequence, you must not work with your hand resting on the paper.

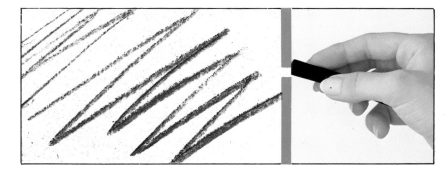

For blackening, shading or gradating, it is best to work with a little piece of charcoal rather than with a long "stick." Try to form a wedge shape on the edge in contact with the paper so you can produce wide, even strokes.

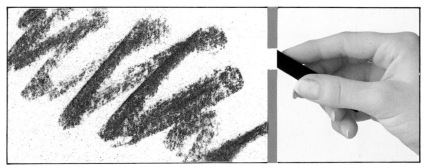

When covering large areas, the charcoal (or a piece cut to a convenient size) can be applied "flat" onto the paper. By varying the pressure applied, gradated strips of gray can be produced to great effect.

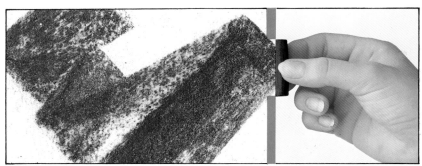

Charcoal drawings must be fixed. To do this, place your drawing on a board and cover it with liquid fixative applied with an atomizer. You'll need a good pair of lungs to use the mouth atomizer.

Aerosol cans of fixative are more expensive but much more practical and reliable, allowing for a more even distribution of the liquid. Whichever method you use, several layers of fixative must be applied, each time waiting for the previous layer to dry. The number of layers required will depend on the amount of black pigment in your drawing. Normally, three layers are sufficient.

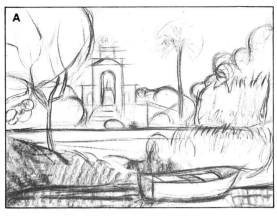

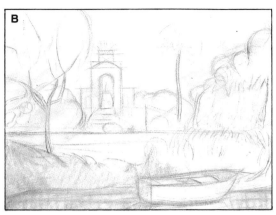

The instability of charcoal
A good part of the charcoal dust present in the sketch (A) has disappeared after being rubbed with a cloth (B). However, the lively strokes remain, enshrouded in a "mist," and they can be used as a base.

The instability of charcoal can be seen when you run your finger across a patch of black, turning it into a blended gray (A). If you blow hard on a black patch, part of the dust will be removed. This changes the tone to a dark gray (B).

Using the eraser
If you use an eraser instead of your fingers, the width of stroke and the tone of the highlighted area can be more easily controlled (A). In B, an even lighter area has been created by two applications of the eraser.

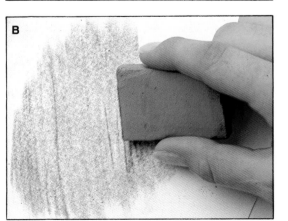

By molding a rubber eraser into a conical shape (like the tip of a pencil) or a wedge shape, it is quite easy to create "negative" details (A) by removing charcoal dust. However hard we rub with a plastic eraser, the dust that has adhered to the paper will never completely disappear.

Gradations using a charcoal pencil and a torchon

Notice (A) that a charcoal pencil gradation darkens considerably when it is blended. To achieve a gradation that goes from black to a fairly pale gray in a short space (B), start with the pencil (1) and then work on this initial area with the torchon (2).

Drawing a sphere in charcoal

Drawing a sphere using charcoal and your fingers is a good way of exploring the subtle effects of light and shade that this medium offers.

1. With firm strokes, draw the outline and the areas of shade and projected shadow.

2. Using your finger, spread the black pigment, molding the shape of the sphere and lightening the tone towards its brightest area. Try not to darken this point too much. Also blend and soften the shadow of the sphere.

3. Reinforce the darkest area with more charcoal and soften the outer edges of this new tone. With a clean finger, take out some pigment from the areas around the brightest spot and also around the darkest part of the sphere, so as to convey the faint strip of reflected light. Clean up the background.

1. Figure study by Juan Sabater, based on the subtle manipulation of large areas of charcoal.

2. A mixed media drawing by J. Juan Aguera, in which charcoal was used in part.

3. Another drawing by Sabater, in which again he builds up structure in large planes of pigment.

4. Classic preliminary sketch for a study of a moving figure: Drawing by Ester Serra.

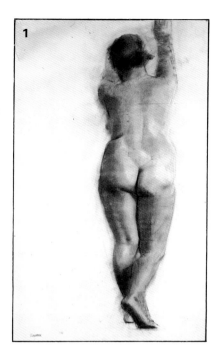

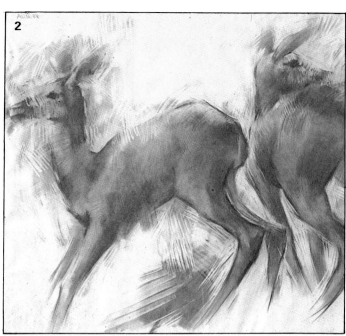

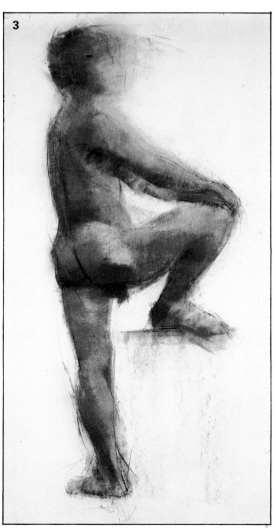

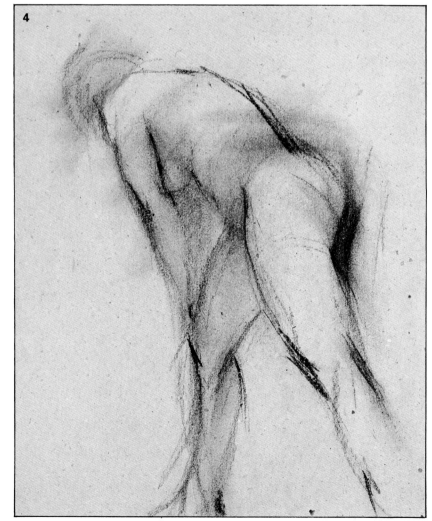

Charcoal drawing using a plaster-cast model

This art school exercise is initially concerned with the lighting of the model. How should it fall on the figure? In our example, natural light comes from the left; it hits the model very much from one side and produces a wide range of tonalities. When a powerful spotlight is used, the contrasts are accentuated but many subtleties of tone are lost, so we have decided to work with natural light.

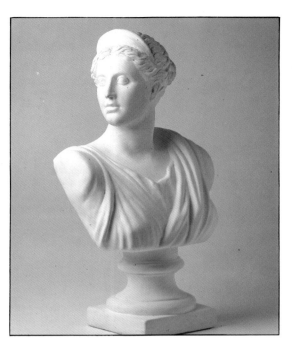

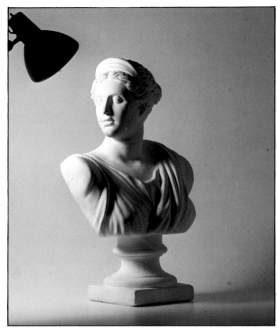

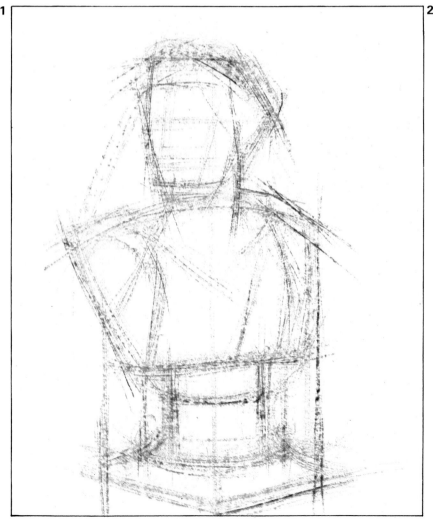

1. We begin by outlining the figure, in charcoal, reducing the lines to the bare essentials. Although nothing has been described specifically, everything we need to continue the drawing is there such as volume and proportions.
2. Once we are satisfied with our outline drawing, we can rub over it with a cloth to get rid of the dust, leaving just the basic lines on the paper. From these, the definitive outlines will be built up.

Charcoal drawing using a plaster-cast model

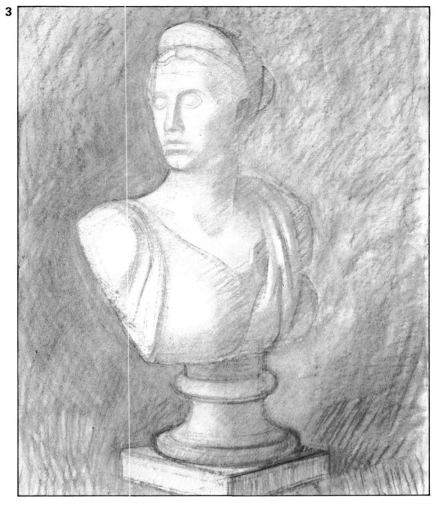

3. At this stage, a first layer of tone is added to clearly establish the areas of light and shade, but using only intermediate tints. We move from the white of the paper and half-tone shadows through various transitional shades. We will be able to add the more vigorous tones later, but at this point it is important to build up the structure of the model perfectly without resorting to the darkest tonal values. Remember that it may be necessary to make corrections, either to lines or shading, something that is no problem if you have not used heavy or dark lines that are impossible to erase.

4. We are now entering the final stage, which consists entirely of introducing the areas of light and shade. It is assumed that, by now, the basic lines and shadows of the drawing will all be in place. From the moment we have completed the initial blocking in of tone (stage 3), we should regard the drawing as unalterable. The final stage involves four aspects of charcoal technique that we have summed up for you in the photographs below:

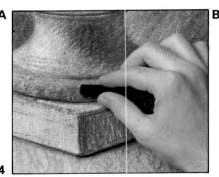

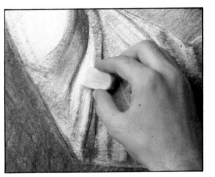

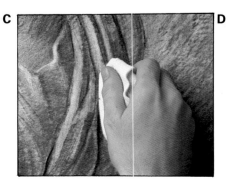

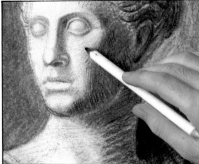

A. The dark areas are intensified using nothing but charcoal.

B. The highlights are cleaned up and sharpened with an eraser.

C. A cloth is used to smooth over the gray areas that require a uniform, medium tone. If necessary, the areas that look too black can be lightened in this way.

D. The areas of transition between light and shade are blended with the finger or a torchon. As we began this exercise without blending the background areas, we will try not to use this technique excessively at this point, either.

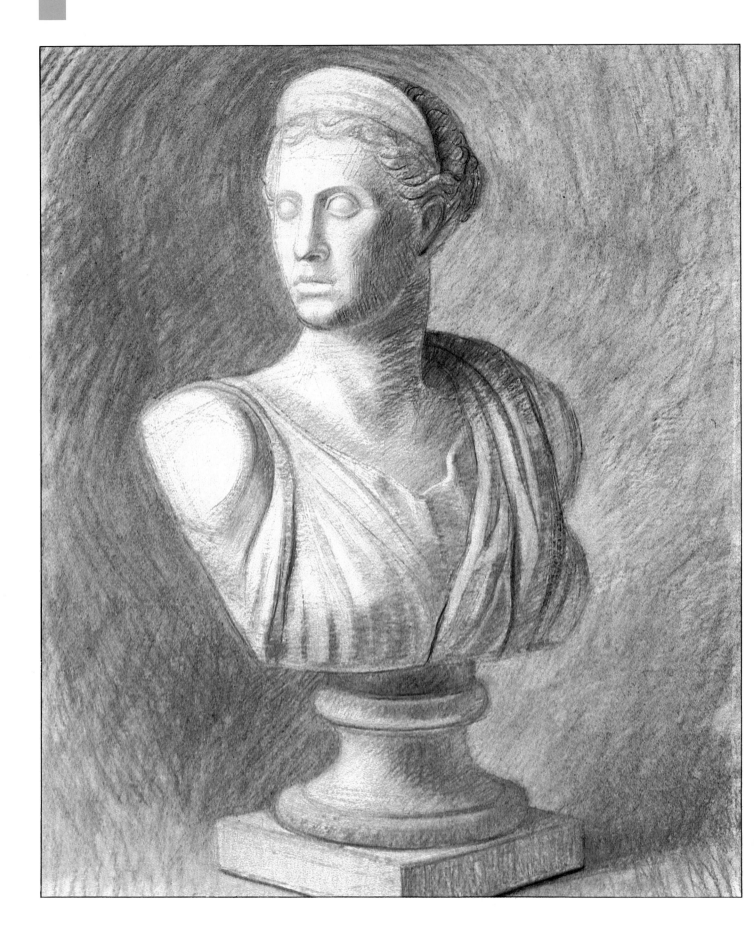

Pen and ink drawing ◼

rawing with pen and ink is one of the most ancient techniques known to man. The original implements used were basic compared with the metal pens we use today, and even more so in comparison with the reservoir pens and felt-tips that have become so popular in the last few decades. For many centuries, great artists used reed pens and goose, swan, or crow feathers. The metallic nib appeared at the end of the eighteenth century, and is still widely used.

In modern times, what we call pen and ink drawing comprises no fewer than twelve techniques that involve drawing with line and patches of ink or dark color, without half-tone or even gradations.

The traditional pen and ink nib is narrow and flexible and can be fitted inside a wooden holder. There are, of course, many other nibs (flat, blunt-ended, round-ended) that can also be used in the holder. Many people like to draw with fountain or reservoir pens and ballpoints, which are very useful for producing even lines of uniform thickness.

Reservoir pens that take cartridges are useful in that they offer a great variety of interchangeable tubular nibs.

Felt and fiber tip pens, with their variety of textures and thicknesses, have some characteristics in common with their more traditional counterparts.

Although we begin by looking at drawing with different types of pens, we should not forget that brushes are very useful for blacking out large areas.

However, in spite of the considerable advantages of reservoir pens and felt tips, the techniques that to this day offer the greatest expressive possibilities continue to be the classic ones: Drawing with a dip or mapping pen, or a reed pen, all of which produce extremely fine and sensitive strokes as well as bold, dark strokes of high quality.

As for ink, the most widely used is black Chinese or Indian ink, available in little pots that make it easier to load the pen, without needing to transfer ink from one container to another. If you wish to work with diluted ink, buy ink sticks that can be dissolved in water. However, this is moving more towards the technique of line and wash as opposed to traditional pen and ink drawing.

Four examples of pen and ink

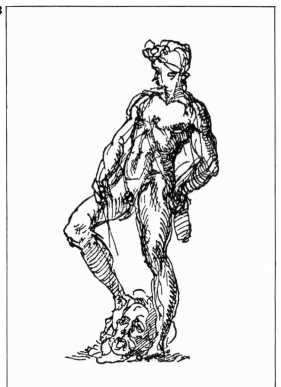

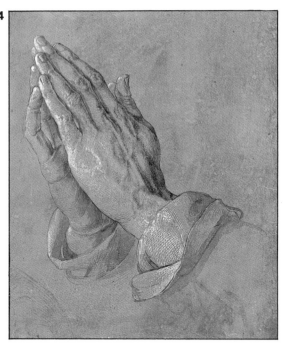

1. Drawing produced with a metallic nib. There is no complicated network of strokes; the contrasts are provided by a series of lines and black areas.

2. Detailed pen and ink drawing. This is a technique that requires, as well as great drawing skills, a good deal of patience.

3. The great Renaissance masters, like many other artists, used pen and ink. This is a "David" sketch by Michelangelo.

4. "Hands at prayer," a famous pen and ink drawing by Albrecht Durer, using black and white ink on blue paper. It seems incredible that this wonderful work was drawn with a reed pen or goose feather.

Closely look at the works on this page. Notice the wide variety of effects the pen and ink technique can create. In the landscape in Figure 1 the artist drew lines and black areas to subtly contrast light and dark. In Figure 2, volume is built up by using only black lines—in some places light and thin and in others dark and dense—which represent dark and light shades perfectly throughout the entire drawing. This is called the English technique, a modern technique that is inspired from the stamped-leather technique. In Figure 3 Miguel Ángel created a model with simple lines in his sketch David. Finally, in Figure 4 Albrecht Durero's hands are perfectly represented with precise anatomy in Hands at Prayer (Manos rezando). All of these drawing are excellent examples to copy in order to practice your drawing skills.

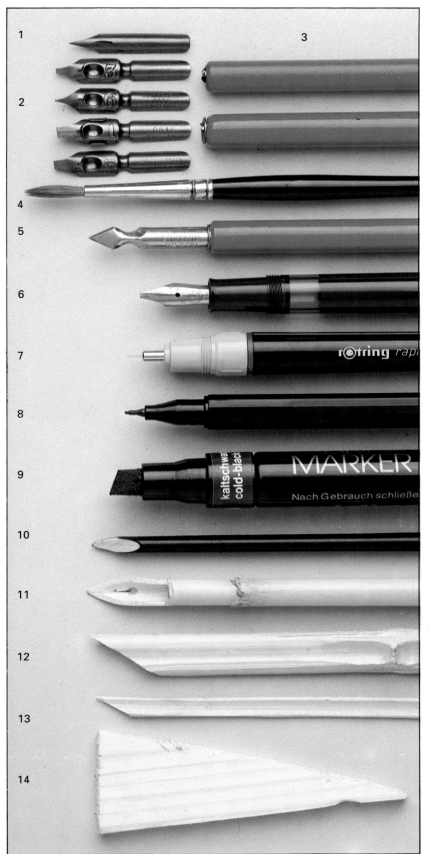

In our introduction we referred to the different implements used today for drawing with Chinese or Indian ink and that can be described generally as tools for pen and ink drawing: These include traditional dip pens, felt tips, fountain or reservoir pens, reed pens and the like. The following list refers to the selections illustrated on this page.

Right
1. Nib for dip or mapping pen.
2. Nibs of various thicknesses.
3. Wooden pen holders.
4. No. 6 sable brush.
5. Scraper-board nib for working on coated paper.
6. Fountain pen.
7. Reservoir pen with tubular nib.
8. Fine felt tip pen.
9. Wedge-nibbed marker pen.
10. Brush handle adapted for use as a pen and ink tool.
11. Bamboo cane shaped into a nib.
12. Cane cut into a wedge shape.
13. Small reed cut into a wedge.
14. Wedge of wood.

Below. *Turning a piece of bamboo cane into a tool for pen and ink drawing.*
a) Creating a point.
b) A longitudinal cut gives the nib flexibility.

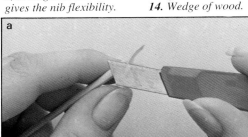

Sample strokes

Black lines produced with a dip pen and Chinese ink.

White lines drawn in white ink with a dip pen on a black background.

a) Individual strokes drawn with a fine nib and b) with a blunt-ended nib. The thickness of line varies according to the angle of the nib.

1 a

 b

a) Brush strokes of varying thickness and intensity. b) White lines drawn with a scalpel on coated paper previously covered with black ink.

2 a

 b

a) Wavy lines drawn with a fountain pen. b) Fine, regular lines drawn with a reservoir pen.

3 a

 b

a) Lines of different thicknesses produced by a wedge-shaped marker pen and b) cross hatched lines made by a fine felt tip pen.

4 a

 b

a) Thick, black lines and semi dry strokes drawn with a nib cut from a piece of cane. b) Fine lines and semi dry strokes drawn with the tip of a brush handle.

5 a

 b

a) On a gray background, thick and fine strokes drawn with a piece of cane cut into a wedge and b) stripes and strokes produced by a wedge of wood.

6 a

 b

Techniques

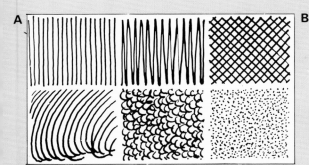

Simple example of how the metal nib can create depth and shade with strokes that carefully describe and define form.

From left to right: Parallel lines, zig-zag lines, cross hatching, curved lines, circular strokes and pointillistic shading.

A. Different strokes using a dip or reservoir pen.
B. Drawing produced with a dip pen.

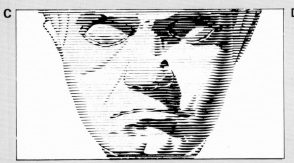

First a pencil drawing carefully maps out the shading. The dots, made all the same size with a reservoir pen, are more densely applied in the darker areas.

First a pencil drawing is made paying attention to tonal values. The reservoir pen draws a pattern of fine parallel lines. With a metal nib, the shading is added.

C. Pen and ink drawing carried out with a reservoir pen and a mapping pen.
D. Drawing using the pointillistic technique. Reservoir pen on coated paper.

This technique is carried out on black card or previously tinted paper. White ink, applied with a pen or brush, is used to situate highlights and describe form.

Pure line drawing, without shading, requires exceptional mastery of form. This technique has been used by great artists such as Picasso, Matisse, Renoir, and Dali, among others.

E. Line drawing. Dip pen, ball point, reservoir pen, or fine felt tip.
F. Drawing with white ink on a black background.

The block style does not allow for half-tones. The forms are described by means of blocked, black areas (shadows and dark tones) that contrast with the white of the paper.

Drawing in negative can be done on a strong piece of card; the card is painted with Chinese or Indian ink and whites are opened up using a scalpel or sharp pointed blade.

G. Negative drawing imitating the style of a woodcut.
H. Block style pen drawing.

Pen and ink exercise

A suggestion

Choose a photograph you like—perhaps showing a corner of one of these little villages that seems to have been designed especially for pen and ink artists to show off their skills. Make a study of this photograph in pen and ink. But, how...? Well, however you think best: By means of a variety of strokes, or perhaps by putting your patience to the test with the pointillistic style, or by using the parallel line technique, by combining pen and paintbrush (for large, black areas), and so on. To inspire you, we are going to show you a drawing by Sabater, produced using the materials you can see on the left: A bottle of Chinese ink, a metallic nib, a clutch pencil, a No. 4 brush, water, and, of course, a sheet of good quality coated paper, not too large—7 × 9 in. (18 × 23 cm) is big enough.

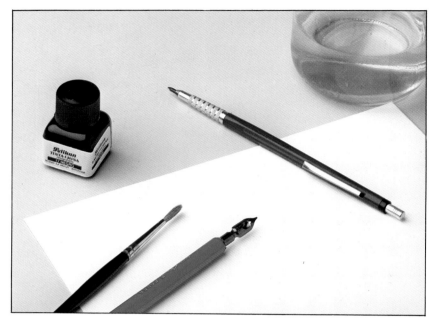

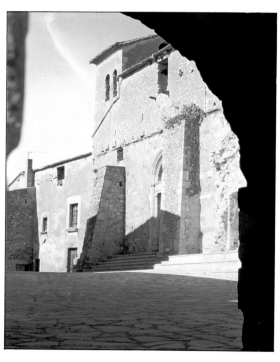

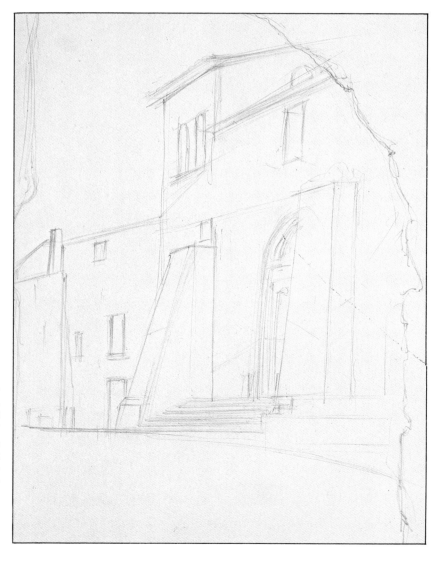

1. Pencil sketch

From his chosen photograph (which you can see above), the artist has made a pencil sketch, using just lines, in which he has resolved the proportions and perspective of the subject. By the time he starts to apply the ink, all doubts concerning these aspects of the drawing must have disappeared. From now on, the only obstacles to contend with should be purely technical ones.

Pen and ink exercise

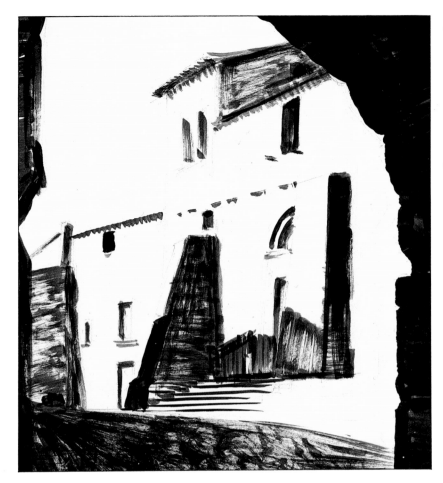

2. The darkest areas.

Sabater has worked mainly with a pen, but he has consigned to the paintbrush the task of covering the largest areas with their base tone. With the brush well-loaded with ink, the part of the arch in the extreme foreground has been blocked in. The brush has applied a layer of intense black in this area, going on to other parts of the drawing with slightly drier ink, so that in these subsequent areas there is still room for work with the pen.

3. Using the pen.

With purposeful strokes, the metallic nib has defined the different areas of the drawing, including the sky. The darkest areas have been worked on (on top of the shading of the previous stage) with a pattern of strokes that have created texture and contrasts. Through a balance of the tonal values and texture of the individual facades of the buildings, Sabater has achieved two things: Enriching the drawing and also bringing out the luminous quality of the building in the background, which, in the finished drawing, contrasts clearly with the foreground and middle ground, both of which have been more intensively worked and, therefore, darkened.

"Focusing" the light on a background area does nothing to detract from the feeling of depth in the drawing. The black areas are strong enough to project the foremost planes; and the strip of light that flashes across the ground plain carries the eye from the foreground on the right to the deepest background of the picture.

Right. Appearance of the drawing after the first pen strokes and detail of the action of the pen on the church steps.

Opposite page. The finished drawing, after the facade of the church, the ground and the dark areas framing the background building have been strengthened.

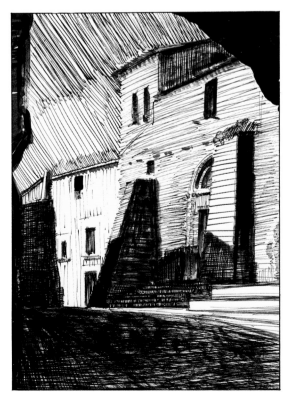

Drawing in ink with a paintbrush

A sable, or similar type of brush, used skillfully, can be an extraordinarily sensitive and versatile drawing implement. Many illustrators and strip cartoonists prefer the brush to the pen; it is more flexible and allows for a freer style. The versatility of the brush as a drawing tool is a direct consequence of the quality and shape of the hairs. For instance, round brushes of sable, squirrel, or synthetic hair can produce an incredibly fine line or a stroke as wide as the thickness of the brush.

It is also possible to take advantage of the ever-decreasing strength of the stroke, as the brush uses up its load of ink. The total black produced by a heavily loaded brush gradually becomes a paler and paler gray, until it is no longer sufficient to slide the brush across the paper; to keep making an impression, considerable pressure must be applied, creating some really subtle and transparent grays. This technique, properly executed, is sometimes known as the dry brush technique and, as we will see shortly, offers a wide range of possibilities. When using the brush (especially if it is heavily loaded with ink), it is impossible to hesitate. As soon as it touches the paper, there is no going back. You will discover this as soon as you try it out for the first time. In view of this, it is not surprising that aficionados of this medium are usually skillful draftsmen, especially those who apply it to figure drawing.

Each of us knows our own limitations, but our recommendation is to avoid the human figure as a subject when first using a brush and Chinese ink. It is better to go for a landscape or simple themes: Rustic buildings, for example, without too many complicated forms and with clearly defined contrasts of light and shade. Although a landscape, like any subject, must be drawn correctly, it never requires the same precision as the human figure. Another useful subject is the still-life, in which the most unlikely objects can be combined: Fruit, vases, books, metal and glass objects, and so on.

Materials and techniques

Brushes

Right. *Four types of brushes suitable for ink drawing. With the exception of the hogs' hair brush (useful for covering large areas and for obtaining uniform grays when using the dry brush technique), these are all extremely versatile, producing fine lines and even or variable strokes, depending on the pressure exerted. For normal work, two round, pointed brushes (preferably sable) are generally enough, the size of which should depend on the size of the work; in addition, a flat hogs' hair brush of the appropriate size is useful for feathery, dry brush effects.*

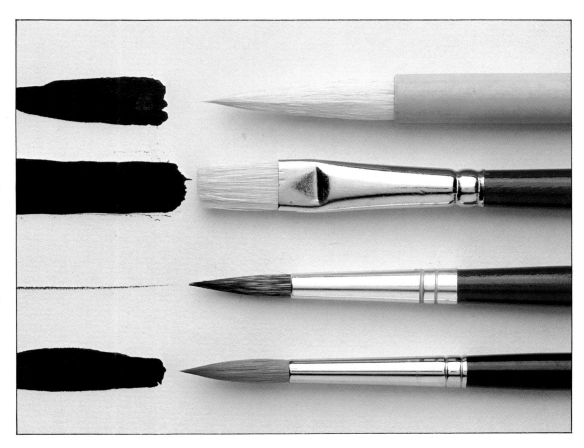

Mixing wells, palette, and bottles of ink

Right. *Mixing well, china palette, and three of the different ways in which Chinese ink is sold by one manufacturer, Pelikan. Container **A** is used mainly by the technical artist, container **B** being the most popular in general use. It is easy to dip the brush in it: Its only real disadvantage is its limited capacity—for professionals it is not economical. The best solution is to buy container **C**, which is much more economical, and to decant from it the amount of ink you need for a particular piece of work. A mixing well can be the ideal receptacle for small quantities of ink. The palette is rarely used—only for working with diluted ink.*

3

A B C

1 2 3

Paper

From left to right.
Very fine cartridge paper. This is the usual paper for ink drawing when using a brush. Rough (watercolor) paper can produce some interesting textured surfaces. Coated paper produces shiny black areas and allows for the surface to be scraped away.

Techniques

1. Fine lines, straight and parallel, drawn freehand on cartridge paper, with a No. 4 squirrel brush.

2. Thick, irregular lines on cartridge paper, obtained with the same brush but varying the pressure.

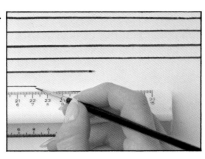

3. Freehand loops on cartridge paper with a No. 4 brush. Care must be taken to maintain the same thickness of line with each loop. Try, also, to keep an even intensity of black.

4. Fine straight lines drawn on a piece of coated paper with a No. 2 brush; the hand guides the ferrule of the brush along the edge of the ruler.

5. Cross hatched lines on cartridge or coated paper, drawn in three stages. The first series was drawn with an almost dry brush, the second with a semi dry brush and the third with a fully loaded brush.

6. Textured effect on rough paper, achieved by rubbing the surface with a lightly loaded hogs' hair brush, leaving hardly any mark, to obtain the gray shading.

7. An experiment on coated paper, consisting of scraping across a series of black lines (No. 2 brush) with a razor blade, scalpel, or craft knife.

8. The coated paper is ideal for negative work; white lines can be traced (scraped) across an area previously covered with black ink. Depending on the type of knife used, thinner or thicker lines can be created.

Line and color technique

Right. For this demonstration, Juan Sabater has chosen an architectural theme that because of its intricacy, may seem excessively complicated. However, as you will see, the technique applied will allow us to merely suggest the decorative detail. The most important objective is to represent the structure of the architectural elements and the way the light falls on them, using the limited means that we are happy to accept as part of drawing with brush and ink.

1. Outline drawing

Once the limits of the drawing have been established (notice that Sabater has left out part of the cornice), the artist has made a meticulous sketch of his subject. This must be accurate in line and perspective, because it will be very hard to alter anything later.

2. The first strokes

Following absolutely the lines of the sketch, the darkest areas have been blacked in with the brush. Notice that the moments in which the brush was drying up have been used to indicate the half-tone areas around the base of the fountain, for instance. The lines of the arches have also been drawn in with a fairly dry brush.

3. Laying the overall tone

Using the tip of the brush, Sabater has indicated tonal values that give the picture a more descriptive quality than you might expect, given the intrinsic harshness of black and white contrasts. Notice the direction of the strokes: In the columns and arches, they tend towards their respective vanishing points (this also enhances the feeling of depth), while elsewhere, vertical lines separate visually the different architectural elements.

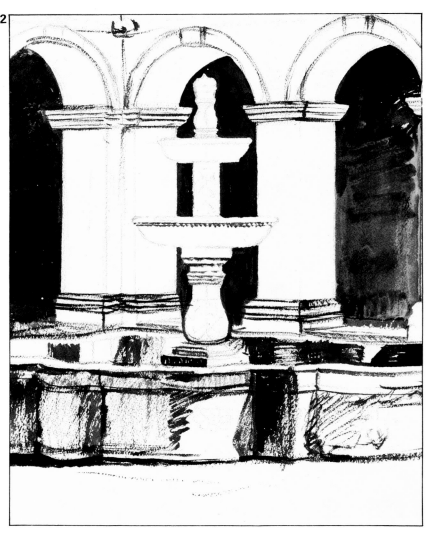

Top, right. Outline drawing of the theme, indicating areas of light and shade.

Right. The drawing after the first few strokes and areas of ink have been applied.

3

Left. Close-ups of two areas of the drawing after a general laying in of tone (stage 3), in which the artist has varied the direction of his strokes.

4

4. Final stage

On top of the previous stage (see the details shown above), the artist has tried to build up texture by cross hatching over strokes he has already drawn. Then, using free brush strokes, he has indicated the floral designs around the base of the fountain and finally, with even more random brush work, he has barely suggested the decorative work on the columns, walls, and arches.

As you can see, although in this case the intention was not to use the dry brush technique, there are inevitably moments in which the drier brush produces less intense strokes. It is precisely these irregularities that give this type of drawing a softness rather like that of an etching.

Left. The finished work: Juan Sabater's drawing using a brush with Chinese ink.

■ Dry brush technique

Some initial advice

The dry brush technique requires patience for one very simple reason: It is very difficult to know exactly what gray will result from a brush that has been allowed to dry. If, before starting on your drawing, you wish to know which tone of gray your brush will produce at any given moment, the only way to find out is to try it on the same type of paper.

You will have to do this with every new loading of the brush. Sometimes you will need to dry the brush by rubbing it on a piece of paper until you achieve the desired tone. In other words, patience is a virtue.

An example from Juan Sabater

Working from the photograph on this page, our friend Sabater has created the drawing on the next page, by means of the stages we are about to show you.

1. Outline drawing

The basic outline has been drawn with faint pencil strokes (2B) on a medium textured watercolor paper so as not to impede the application of the ink.

2. Laying the overall tone

A wide, flat ox-hair brush (No. 14) is loaded with ink and then rubbed over a piece of scrap paper; with the lightly loaded brush, a soft background tone is laid in. In the same way, with varying strengths of gray, the main areas of the drawing are indicated (except for the tree in the foreground) and the overall tones are established.

3. Detailed work and completion of the picture

Sabater has used two paintbrushes for this final stage: A round brush (No. 6) with a good point for the blackest linear work and a flat brush for the gray tones. Because it is almost impossible to make alterations with this technique (there is always the last resort of removing pigment with the razor blade, but you risk damaging the paper), the artist has carefully regulated the tone of every brush stroke used in his drawing. Only through this patient, diligent approach can the perfect balance of tones in the landscape be maintained, ranging from the intense blacks of the foreground to the subtle grays of the sky and the background hills.

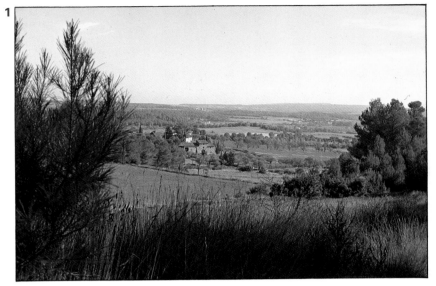

Left. Close-ups showing a well-loaded brush drawing black lines of varying thicknesses and a flat brush working on the wooded area to the right of the picture, applying a variety of tones.

Below. The completed drawing. It is a good example of what the dry brush technique has to offer.

4

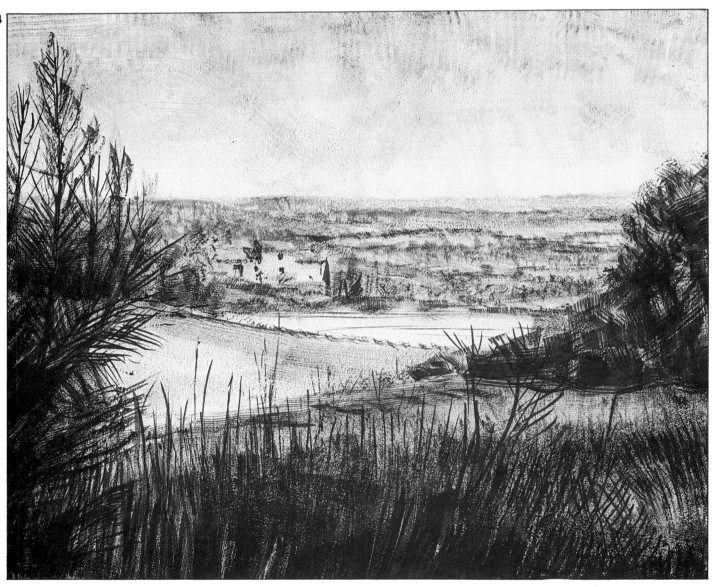

Three examples

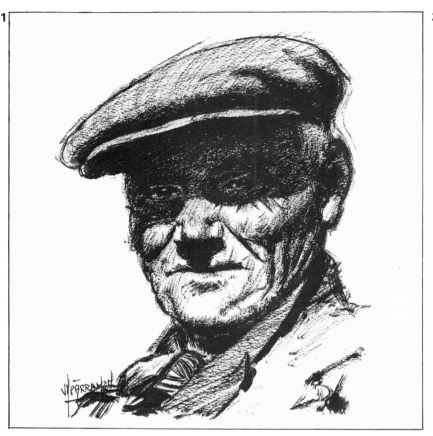

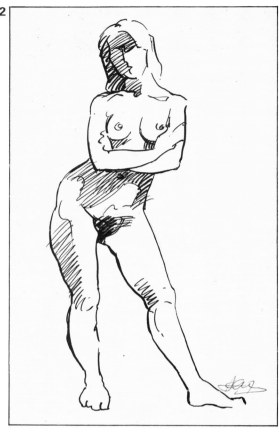

1. "Head of an old man" by J.M. Parramón. In this portrait, the artist shows his mastery of the dry brush technique, in the intermediate gray tones as well as in the strokes that soften the outline and lend atmosphere to the drawing.

2. "Nude study" by M. Ferrón. In this quick sketch, using continuous brush strokes, Ferrón shows his great skill in figure drawing.

3. "Rural theme" This landscape, drawn in ink with a brush by Juan Sabater, is reminiscent of an etching in its subtlety.

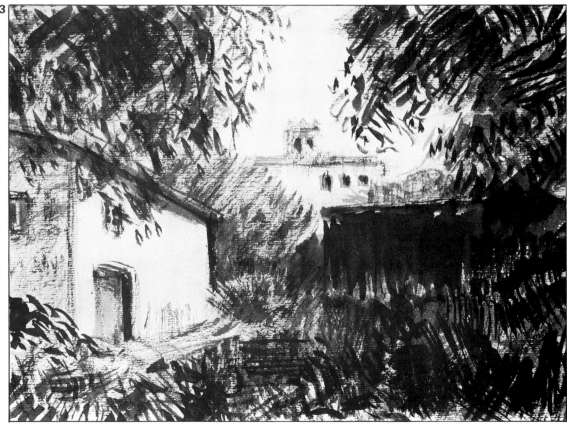

Sanguine crayons and colored chalks ■

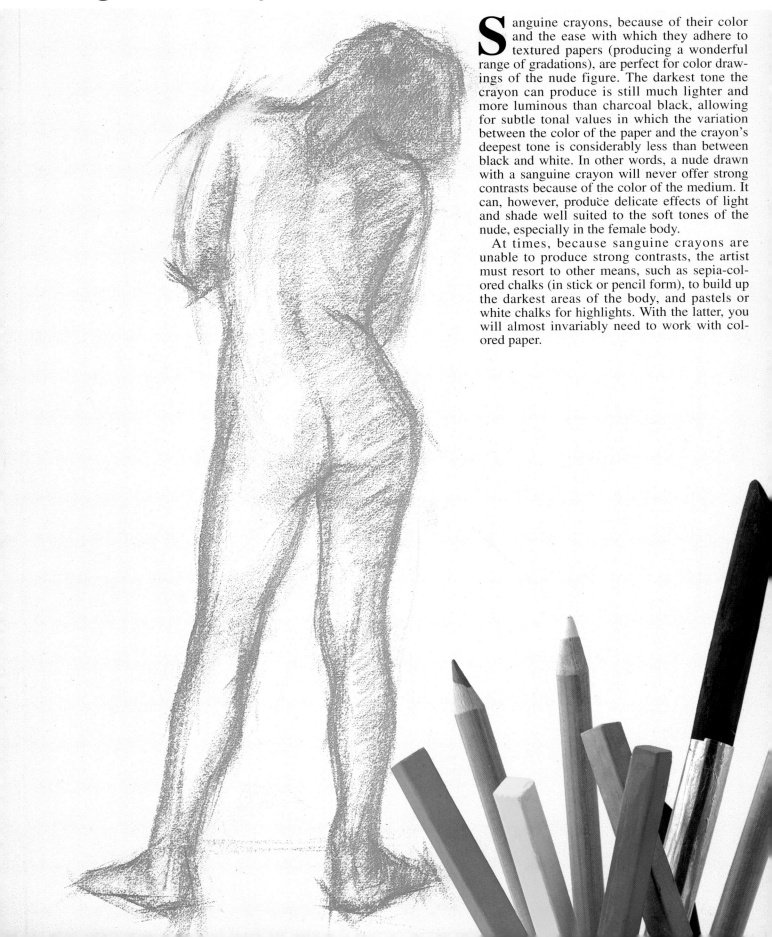

Sanguine crayons, because of their color and the ease with which they adhere to textured papers (producing a wonderful range of gradations), are perfect for color drawings of the nude figure. The darkest tone the crayon can produce is still much lighter and more luminous than charcoal black, allowing for subtle tonal values in which the variation between the color of the paper and the crayon's deepest tone is considerably less than between black and white. In other words, a nude drawn with a sanguine crayon will never offer strong contrasts because of the color of the medium. It can, however, produce delicate effects of light and shade well suited to the soft tones of the nude, especially in the female body.

At times, because sanguine crayons are unable to produce strong contrasts, the artist must resort to other means, such as sepia-colored chalks (in stick or pencil form), to build up the darkest areas of the body, and pastels or white chalks for highlights. With the latter, you will almost invariably need to work with colored paper.

Female nude

Choosing the pose

We will follow the step-by-step development of a study of the female nude drawn by Juan Sabater on Ingres paper, using sanguine crayon and sepia-colored chalk. Naturally, the eraser can also be added to the list of materials used by the artist.

We will start by looking at four sketches made using just sanguine crayon, based on four different poses. Each of the poses (all seen from behind) is interesting in its own way; however, Sabater chose the first one, feeling it was the richest in rhythm. It certainly does offer the greatest variety of curves, angles, and empty spaces. The artist felt that, of the four poses, it was the most striking.

Below. In the artist's study, the model poses against a backdrop of white paper. Lateral illumination prevents the figure from projecting a shadow so it stands out sharply against the paper background.

Upper, right. The equipment used in this exercise.

Right. Four sketches of the same model in different poses. The main intention has been to capture the rhythmic lines of the body with broad, loose strokes and by suggesting light and shade.

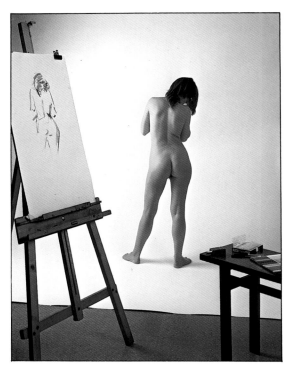

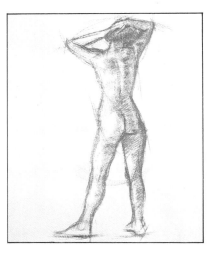

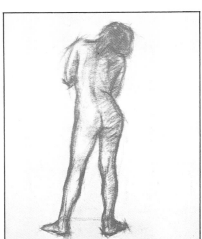

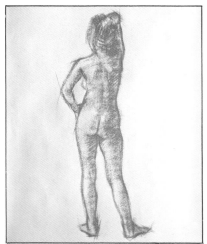

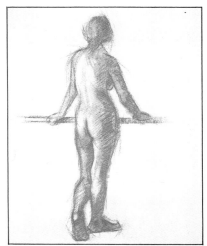

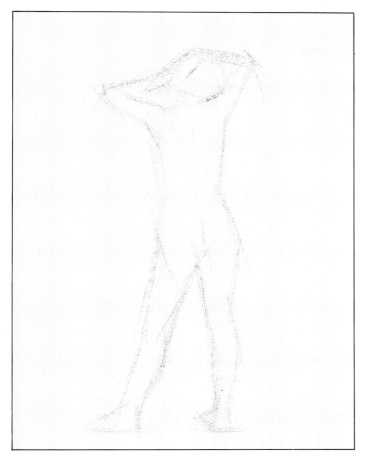

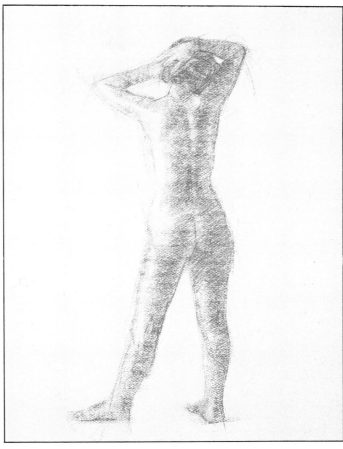

Outline sketch and first strokes

Notice that the sketch of the figure has been traced with very light charcoal strokes. It is important to produce such a sketch to guarantee easy removal of the black line and, above all, so that the sanguine color is not dirtied by an excess of charcoal dust. However, this light touch should not detract from the accuracy of rhythm and proportion.

Once satisfied with this initial sketch, Sabater proceeds to block in all the parts of the figure in shadow. Without pressing too hard, he has created a fairly uniform layer of base tone through which the texture of the paper can be clearly seen. However, even in this general tone, certain shades already suggest the most visible muscular forms.

Left. In this close-up you can see that, in spite of the simplicity of the first layer of tone, the artist *has hinted at the forms of the deltoid muscles, the brachial biceps, and the shoulder blades.*

Initial blending of the pigment

The objective is to work on areas of the sanguine crayon to draw out the characteristic qualities of the medium, and the delicate effect obtained when the material is engrained in the paper. To achieve this, there is no better method than using your finger as a kind of torchon. In this series of six close-ups notice the difference between areas of the picture before blending with the finger and then after the sanguine has become engrained.

In the examples on the right you see the velvety effect characteristic of the technique Sabater is demonstrating. When you proceed to this stage in your own picture, remember that the contours of the figure must not be lost. Always have the sanguine crayon handy to touch up any lines blurred by your finger.

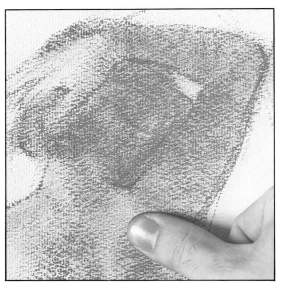 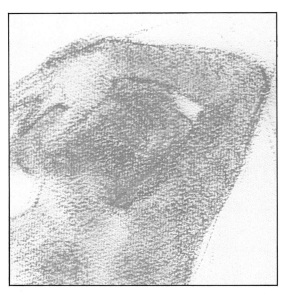

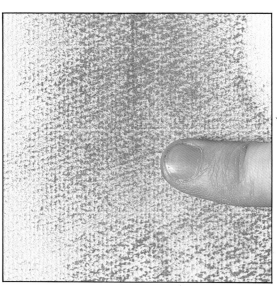

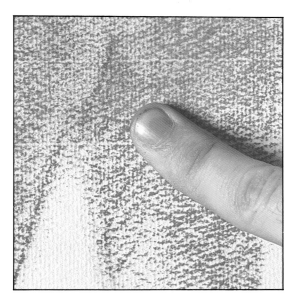

Right. Close-ups in which you see the velvety effect achieved when the finger is used as a torchon.

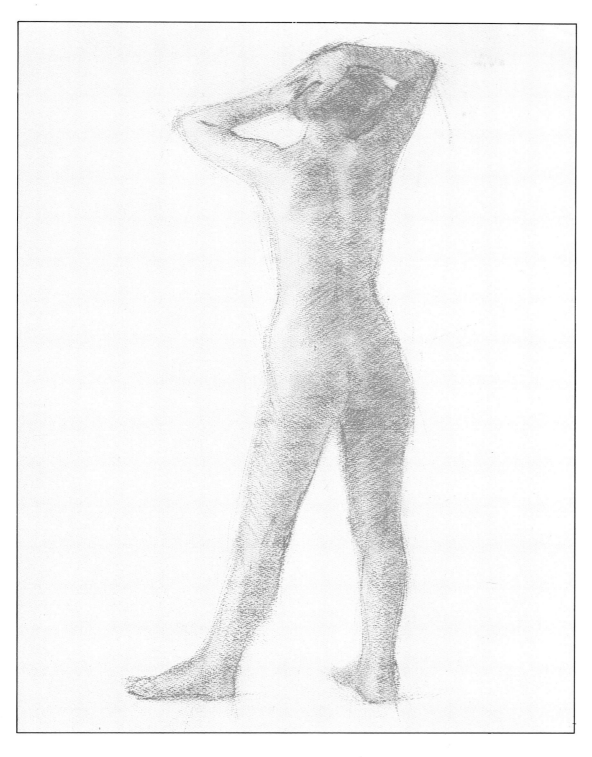

Left. *Appearance of Sabater's picture after the stage described on the previous page. The darkest spots resulting from the grainy surface combine with the fainter tones created by the blending process to produce a more delicate effect, without completely losing the original texture of the paper.*

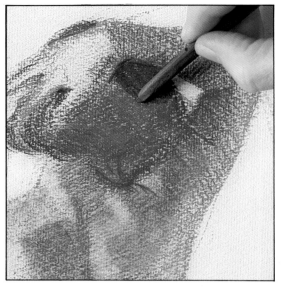

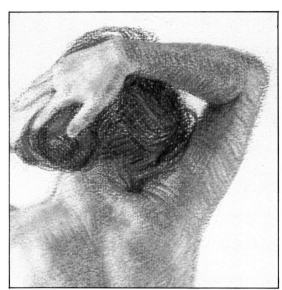

Final tonal evaluation

The previous stage prepared the way for the final process of using sanguine, chalk and the eraser to bring the work to completion. Sabater demonstrates here that sanguine and chalk, besides being perfect for conveying the color of the skin, can combine to produce finished work of high quality. Notice in this series of double closeups that charcoal, sanguine crayon, chalk pencil, and the eraser were applied one at a time. The eraser was used not only for rubbing out, but also for drawing negative lines essential to form, and for giving sensitivity and vibrancy to the finished work. Also of great importance is the direction of the lines, which follow the curve of each of the surfaces they represent.

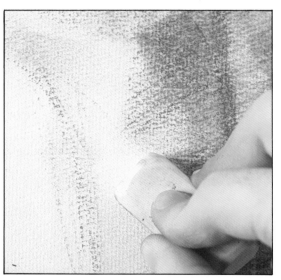

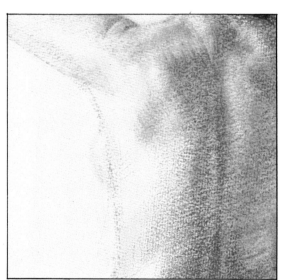

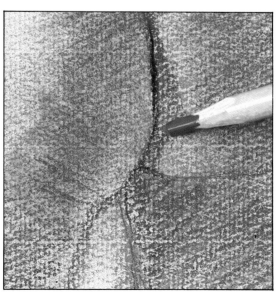

Left. Look at these three sections of the nude, before and after receiving the final touches. Sanguine crayon, chalk, and an eraser all contributed to the definitive appearance of each of the forms shown here.

Right. Notice in the finished work the importance of the direction of the strokes produced by the eraser.

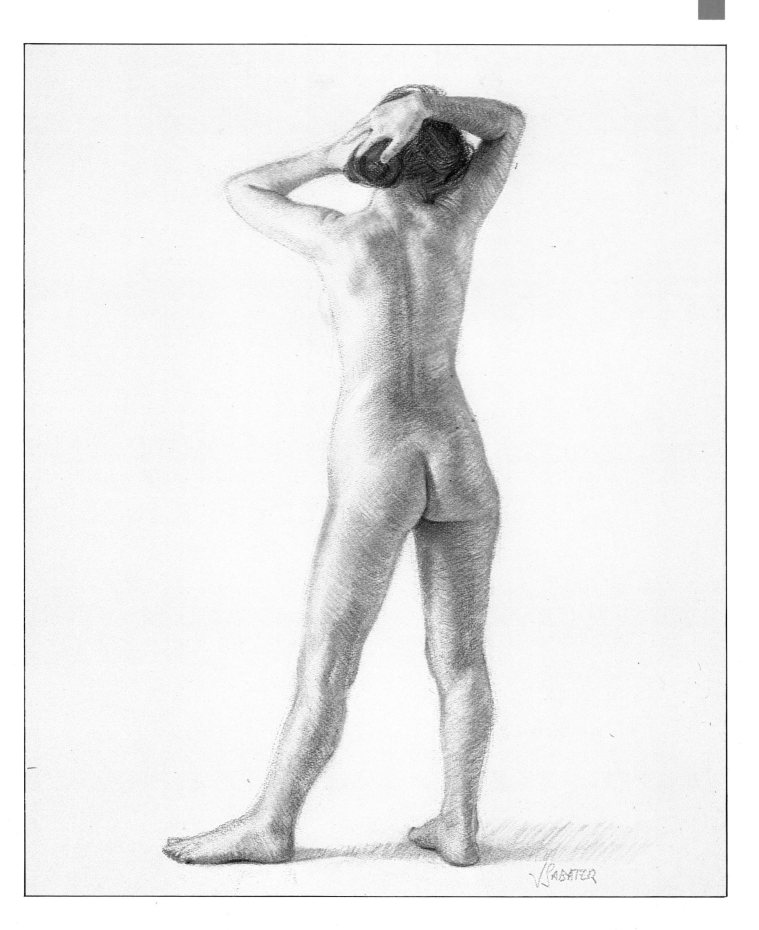

Three examples

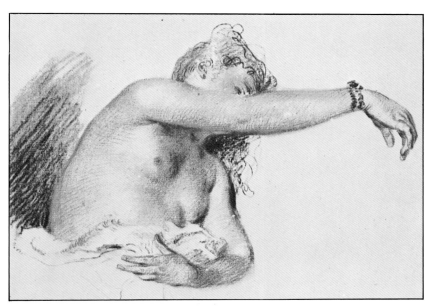

Some of the great masters of painting have found sanguine crayons (and other related materials) to be an excellent medium for their figure studies. Michelangelo, Leonardo da Vinci, Raphael, Rubens, Watteau, François Boucher, to name just a few of the great artists of the Renaissance and Baroque periods, made frequent use of sanguine crayons in their wonderful studies, many of which, thankfully, have been preserved for posterity. Innumerable famous artists, ancient and modern, used the sanguine crayon in their drawings of the nude. Here we will confine ourselves to just three masterly examples.

Left. "Nude study," by Jean-Antoine Watteau. Sanguine and sepia- colored chalk on cream-colored paper.

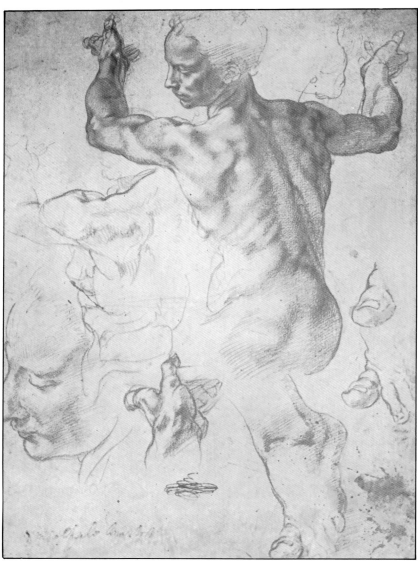

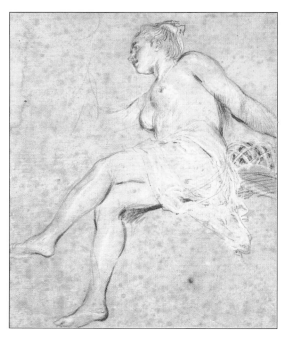

Left. Impressive study in sanguine crayon of "The Sibyl of Lybia" by Michelangelo (Metropolitan Museum of Art, New York). In fact, this is a collection of studies on a single sheet of paper, in which the great artist made preparatory drawings before embarking on the definitive fresco painting.

Above. "Springtime figure," by Jean-Antoine Watteau. Sanguine, charcoal and white chalk on cream-colored paper. This is a very old technique that Watteau described as a dessin a trois crayons (drawing with three pencils).

Reflecting on the art of portraiture

The most appropriate tribute to Diego Rodriguez de Silva Velázquez, one of the greatest painters and portraitists of all time, was to describe him as "The Painter of Truth." Truth is essential. Velázquez always painted the essence of his subject. Stated more philosophically, we could say his portraits revealed the essential personality, that quality without which his subject would not have been the person he or she was.

Those of us less familiar with painting might reply that Velázquez also included much detail in his portraits and compositions: The embroidery and lace of the clothing, the molding and carving of the furniture, and so on. This is, indeed, true.

But *how* he painted them is important. You must get close to the original works to realize that everything in them (even in what seems at a distance to be incredibly detailed work) is essential.

Veláquez's painting of Philip IV was, and continues to be, the ideal for portrait specialists: Paint the truth that is the very essence of each model's personality. The aim is not just to create a photograph with a paintbrush, although the student must initially work to represent what he sees. When you manage to recreate the physiognomy of your model on paper, you will be well on the way to following in the footsteps of masters such as Velázquez, Goya, and Tiépolo.

The history of art is full of masterly portraits and we recommend that you take an interest in this area of painting, if only through studying quality reproductions.

Perhaps it is time to start building a basic art library. This is necessary, even indispensable, not only to satisfy the natural thirst for knowledge of every cultured person, but also to justify one's own work. Naturally, this last consideration becomes important at a higher level of mastery of the medium. The beginner, though, has other, more immediate preoccupations.

On these pages we reproduced five impressive portraits and would like you to notice in each the interest the artist showed in the real person—even when the social standing of his subject must have created a dilemma for the painter.

King Philip IV. Full-length portrait painted by Velázquez in 1632. Oil on canvas, National Gallery, London. Notice the extraordinary skill with which the details of the intricately patterned costume have been treated.

Four examples from the masters

Far left. The Infanta Maria. Detailed sketch for a larger scale portrait completed by Velázquez in 1630. Oil on canvas, Prado Museum, Madrid.

Near left. Head of oriental man, by Giambattista Tiépolo. Oil on canvas, San Diego Fine Arts Gallery.

Below left. The Infanta Dona Maria Luísa. Francisco de Goya. Oil on canvas, Prado Museum, Madrid.

Below right. Don Juan Antonia Llorente. Francisco de Goya. Oil on canvas, Sao Paolo Art Museum.

1

2

3

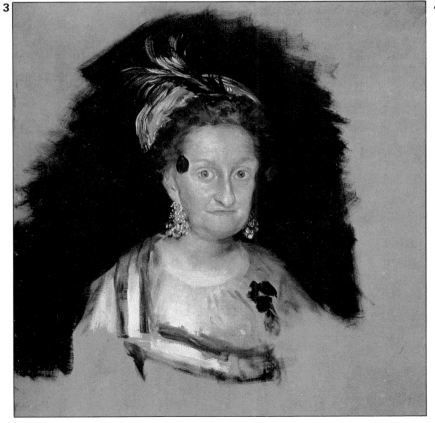

4

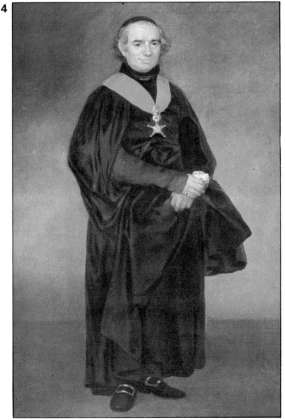

Composition in the portrait

a b c

 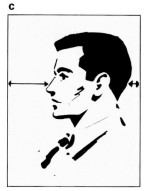

Before beginning a portrait from life, the artist must deal with an initial problem: Composition. This can be divided into two elements: Positioning the model within the picture and establishing the pose. Positioning the head, even with the neck and shoulders, is not difficult. Follow these basic rules:

• When the model faces directly forwards, the head should be centered on the vertical axis of the picture (**a**).

• When the model is seen in profile or at an angle, the head should be positioned off-center, with more space in front than behind the nape of the neck (**b** and **c**).

Another thing to consider is whether to incline the head to one side, or upward or downward. On this point it is best to let the model adopt the position that comes naturally and spontaneously. In fact, the question of composition really begins only when making a half-length portrait. Composition is so important that most masters make a preliminary study of the pose, always guided by the individual characteristics of the model. Of course, doing a portrait of a politician or businessperson, will be a different exercise than portraying a teenager or a society matron. Finding the right pose is, as the artist Francesc Serra will demonstrate, a significant part of the process. Let's follow his train of thought:

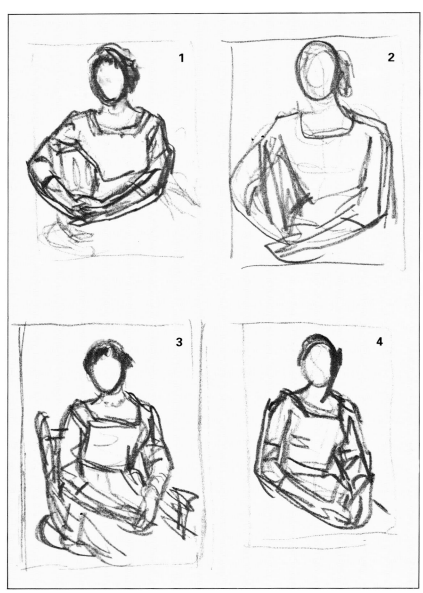

1. Putting a young woman in a seated position, with one arm resting on the back of the chair, gives an air of langor to the pose, but creates a gap that focuses too much attention on the chair.

2. Moving the body closer to the chair back may solve this—but, no, that doesn't look right either.

3. By making the pose more natural, with her hands in her lap, we keep the oval rhythm of the arms, which works well. But now the right shoulder slopes the same way as the tilted head, and too much skirt shows in front of the hands.

4. That's it! Now the figure fills the picture: The left shoulder slopes, accentuating the rhythmic line of the neck; the oval shape formed by the arms, although visible, is less obvious because the left arm has been drawn back a bit. And the chair has disappeared completely. Now nothing distracts the viewer's eye. The languid pose remains, but within a more convincing composition.

Portrait in sanguine crayon and charcoal

The materials

Remember that in art the medium determines the style. It is important to know the limitations of each material and not to demand what it cannot deliver—and vice versa. To achieve the results we want, we must identify the most appropriate medium. It is pointless to try to obtain intense grays with an HB pencil. If you are after strong contrasts, go for a 6B pencil or even charcoal. Remember that any idea you want to express visually has a medium best suited to it. It is absurd to show no interest in new materials. Discovering new techniques should be one of your regular pastimes. To inspire you in this respect, we propose a step-by-step exercise in which you interpret a photographic model. In your interpretation we would like you to combine all the materials you see in the photograph on the left.

Before starting, it would be a good idea to become familiar with these materials.

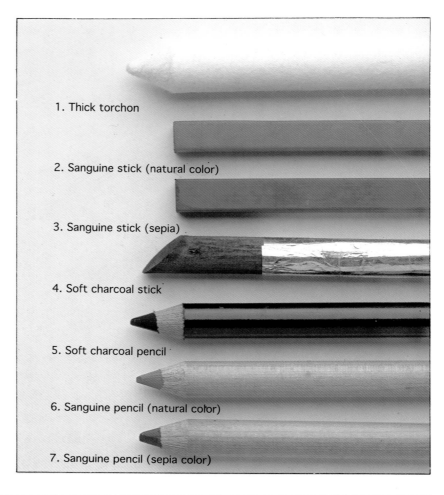

1. Thick torchon

2. Sanguine stick (natural color)

3. Sanguine stick (sepia)

4. Soft charcoal stick

5. Soft charcoal pencil

6. Sanguine pencil (natural color)

7. Sanguine pencil (sepia color)

On a piece of fine-textured Canson water-color paper, experiment a little as we have done here. Explore the potential of each material separately and try for new effects and tones by superimposing two or more of them. Try blending pigment with the torchon and your fingers, or leaving the strokes unblended. Cover areas of the paper with vigorous cross-hatching. You will probably discover other methods of enriching a drawing with different pictorial qualities.

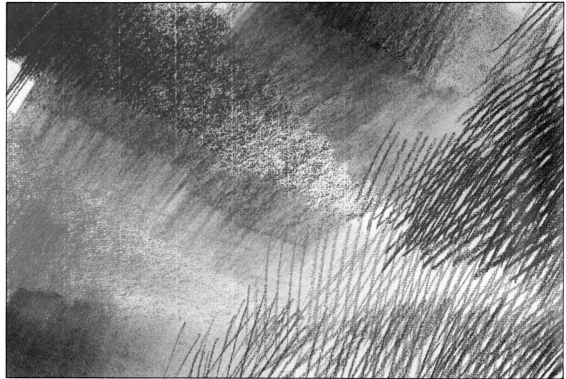

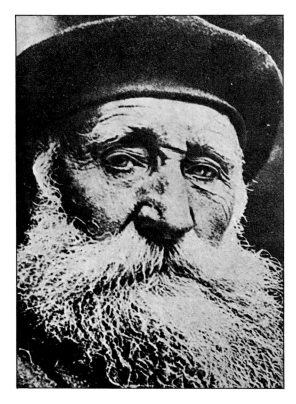

The model

This is a photograph of the great sculptor Aristides Maillol (1861–1944). We thought it was a good subject because of the combination of dark areas in his beret, the background and the shaded parts of his face, and the other two-thirds of the picture comprising the pale tones of his face and his white beard.

Sanguine crayons and charcoal soften the general aspect of the portrait, without sacrificing the possibility of an intense black where necessary. Let's see how it's done.

The process

1. Use fine-textured Canson watercolor paper of a pale, warm tone—a pale sienna, for instance, works well with sanguine. The idea is to find a background color that provides a medium tone to guard against excessive contrasts.

With a charcoal stick, start your outline sketch. Use very light strokes at the beginning to avoid damage to the paper. Only when you are sure of the features should you make them definitive, as shown in the close-up on the right. Notice that, even in the definitive sketch, we have avoided vigorous strokes. We do not want an excess of charcoal dirtying the sanguine we are about to add.

2. Using the sepia sanguine crayon stick, cover the surface of the face with soft, slanting strokes. You can also hint at the shading of the eyebrows, the nose and the darkest areas of the cheek and temple. Black in the background and the beret. Notice that in the beret and in the bottom left-hand corner a background tone has been established. Dark, directional strokes have been applied on top of this to help describe form. With the charcoal pencil, go over the outlines of the eyes, adding some shadow beneath the eyebrows. On the cheek, indicate the division between the beard and the chin, and draw in the lines of the mouth beneath the great moustache. Using the sienna sanguine pencil, trace the short wavy lines that suggest the hair and beard. Pay particular attention to the direction of these little strokes.

To help you see more clearly the application of the crayon sticks and pencils, we have added close-ups of the cheek and the left eye.

The torchon has been used to soften the gray of the background.

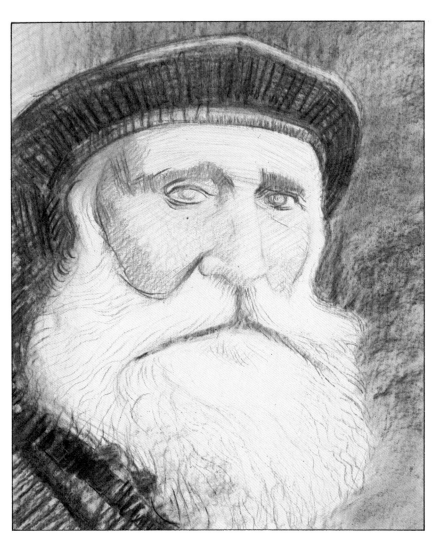

Notice only a tiny bit of sanguine was used to give just a hint of color. You want to progressively build up color. If you begin with a dark shade, you will later have to go over it with an eraser, which is always difficult and which usually ends with bad results.

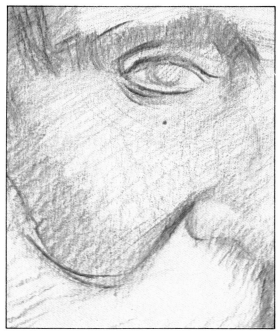

3. The final stage begins. The background is worked on with the sepia sanguine stick, so that, when mixed with the gray of the charcoal, we achieve a medium tone with tinges of violet. Then the natural-colored sanguine stick is used to draw strokes across the entire beret. These lines tone down the contrast between the beret and the face.

After this stage, the natural-colored sanguine is used extensively to define the various forms of the face. Notice that the artist has paid careful attention to the direction of the strokes. The beard has been enriched with strokes of sepia (and some of charcoal on the lower parts) except in the areas where the light falls directly. In these areas the pure color of the paper is allowed to show through. At this point we embark on the final stages of the picture.

4. Look at the close-up photos showing the last stages: The eyes have been outlined in black with the charcoal pencil; the charcoal stick has reinforced the contrast at the base of the beard between the white hair and the dark clothing; and sanguine and charcoal have been used together on the beret, to achieve a balanced tone. You can also see where the eraser has been used: For instance, as shown in the fourth close-up on this page, to blur the charcoal line at the base of the beard which had been too sharply defined.

The natural-colored sanguine pencil was used in conjunction with the charcoal pencil to sharpen up the profiles and contrasts of the eyes and nose. Try to imitate this in your own version of the drawing.

The left side of the head has been built up with the charcoal pencil and, following Leonardo's example, the background has been darkened adjacent to the lightest part of the picture on the right side. All these touches help to make the face and beard the center of interest in the composition. As you can see in the finished work (opposite page), our gaze goes instinctively toward the eyes, which is appropriate in a portrait showing only the subject's head.

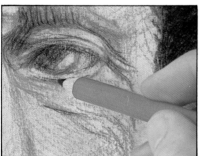

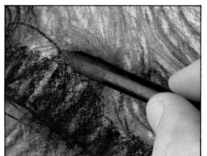

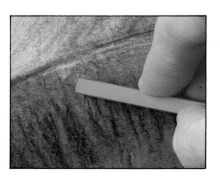

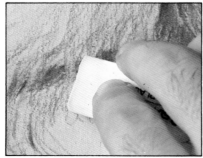

On the following page is the final result. Study it carefully and review each step. Follow the explanations and try to draw it yourself.

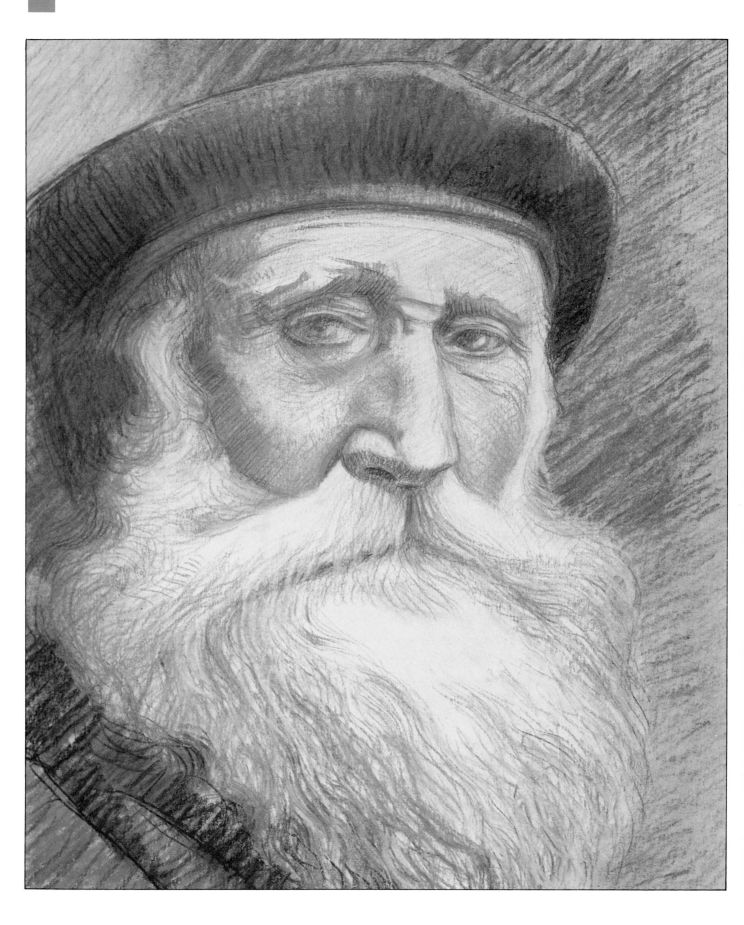

Sanguine crayons and colored chalks ■

In this section, we continue to work with sanguine, colored chalks, and charcoal used in combination. We are going to explore further the possibilities offered by these media by creating a colorful theme: This time a landscape.

Sanguine crayon, which we earlier saw used in the magnificent figure studies of some great Renaissance and Baroque artists, was also greatly valued by many artists inspired by the Baroque and Neoclassical periods (end of the 16th century and beginning of the 20th). In their studies of landscapes, real or imaginary, there always appeared some ruin reminiscent of the Roman era. In these works, we can see that sanguine (sometimes in combination with chalks of a darker tone) is a medium that, thanks to its high quality and flexibility, can produce landscape drawings of considerable sensitivity. We hope that, by following the exercise, you will reach the same conclusion and that, as a result, you will count it among the techniques you readily use when interpreting a landscape.

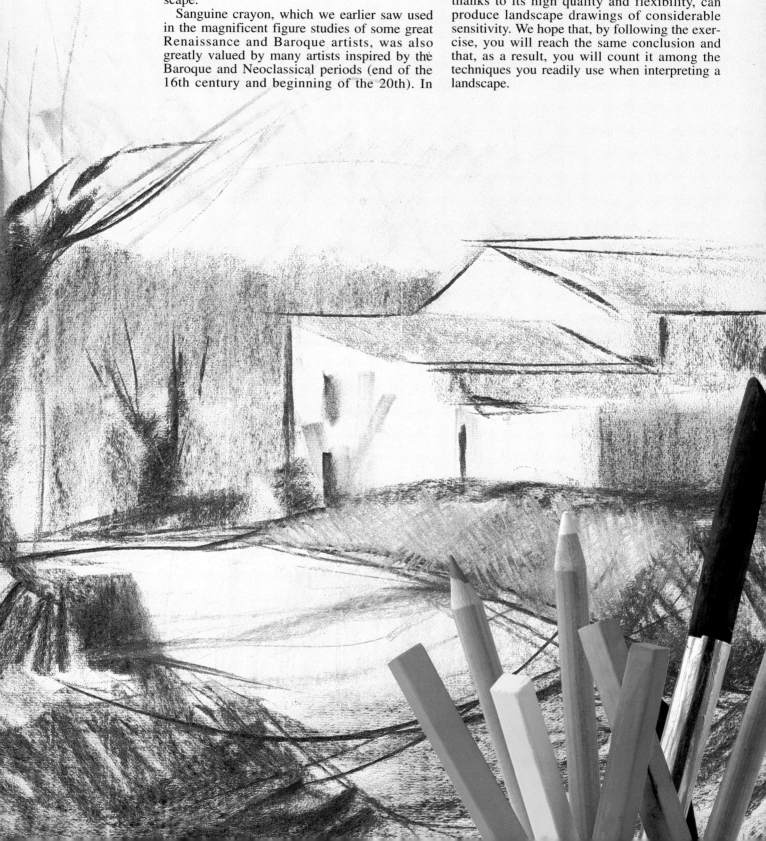

Landscape in full color

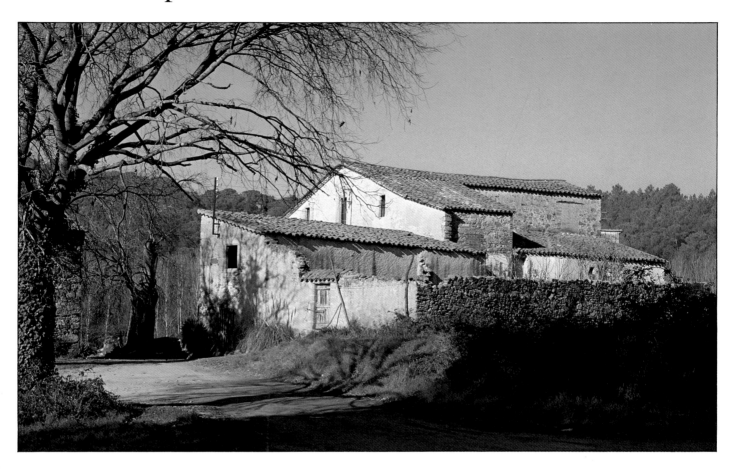

The photograph

This time, Juan Sabater proposes that you work from a color photograph. This is not because he thinks this is the ideal way to paint a landscape but because he is sure that a color photograph need not be just something to copy (such an exercise could hardly be called artistic creation). The photograph is a starting point for seeing something from a fresh perspective, for adapting form, composition and color to convey an aesthetic idea, or to compensate for deficiencies in the original photograph. We should state right away that Sabater's only objective on this occasion was to create a traditional landscape drawing without any intellectual overtones. However, if we analyze the photograph with the eye of an artist, it quickly becomes obvious that Sabater will have to make some major modifications in the area of color. A cold tone in the photo completely dominates every part of the composition and gives it a rather unappealing monotony of color.

We recommend that you follow Sabater's example and, using this photograph or another of your choice, create an individual artistic interpretation, with the photo as a reference.

Introduction

In this next exercise you will see how the mixed media technique, which we will be using, can create pictorial results. Therefore, although we are going to use media that are traditionally associated with drawing, you must pretend that you are not drawing but rather painting with sanguine, colored chalks, and charcoal.

Right (opposite page). Sketch of the subject. Notice the sharp lines Sabater drew to define the edges of the planes of the building and also how he has outlined the shadows of the tree in the foreground. There is nothing unnecessary in this sketch—and yet nothing is missing either. Everything is where it should be.

Right and below (opposite page). Sabater's picture with the first areas of color have been blocked in. Note the division between the totally cold area of shadow in the foreground and the receding planes in which, apart from brilliant white, warm tones have appeared.

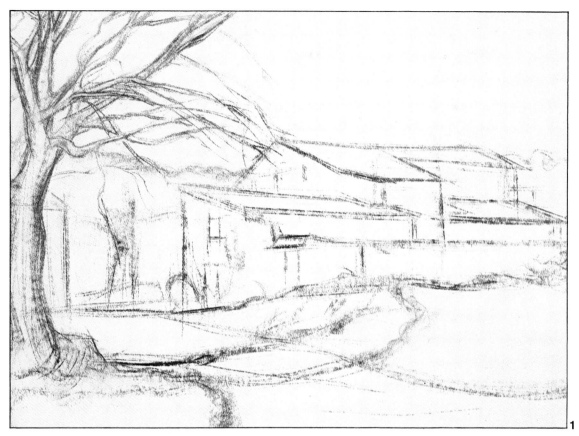

1. The sketch

On Ingres paper about 14 × 19 in. (35 × 50 cm), make an initial charcoal sketch, paying careful attention not only to the proportions and perspective of the main forms, but also to the direction of the shadows projected onto the different surfaces. In this picture, as indeed in many landscape paintings, shadows are often a vital part of the composition.

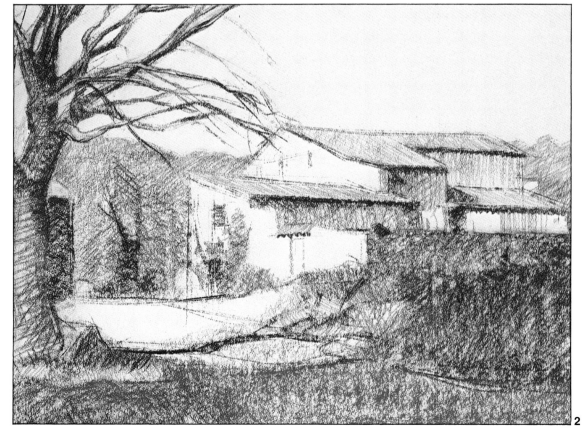

2. Initial color

Using dark tones, indicate the areas of the drawing where cool color will dominate, separating them by use of tonal contrast from the more luminous zones (the white walls of the old country house). This helps establish at an early stage the general appearance of the picture.

3. Warm-cool contrasts and contrasts of texture

This example will demonstrate how to use the texture of the paper in conjuction with the torchon to produce areas where the grain of the paper is visible and others where the pigment has completely penetrated the rough surface. On the left (previous page) are three pairs of photographs; in the classic "before and after" style you can see close-ups of the picture.

A. Part of the sky and the roof of the house with no color blending. The vibrancy afforded by the white of the paper showing through the pigment is evident. In this area there are no contrasts other than those caused by the impact of a cool tonal value beside a warm one.

B. Close-up of the foreground where Sabater combined the texture produced by the grain of the paper with that obtained by blending the bluest part of the shadow, causing the pigment to sink into the grain and completely cover the surface. Another kind of contrast has been created here: That of two different textures in juxtaposition.

C. In this part of the road, there are two types of contrast: A marked contrast between warm and cool (warm light and cool shadow) and the background (which has been worked with the torchon) with its ochre plane for the road itself and where the grain of the paper is still revealed. At the end of this third stage of Sabater's picture, you can see that the artist has begun to introduce warmer colors into areas that are cool in the photograph, such as the background, or the tree in the foreground.

Below. The picture after the introduction of warmer tone and after establishing both those areas that will show the texture of the paper and those in which the pigment will be blended.

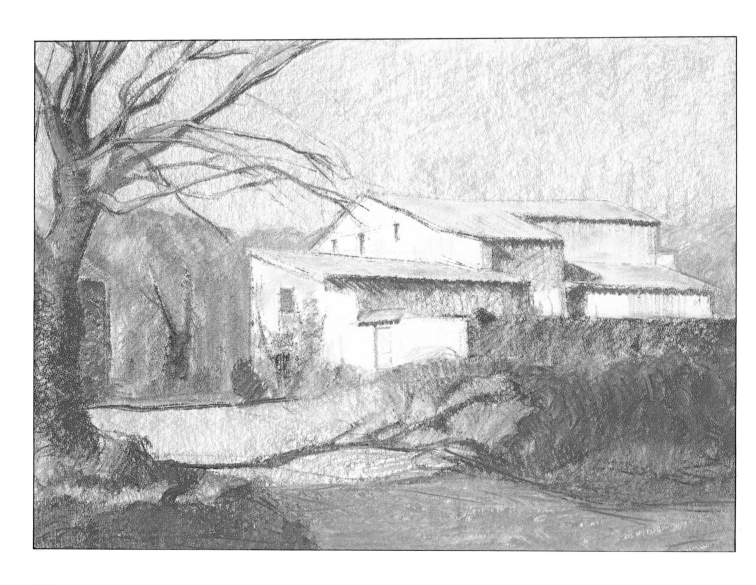

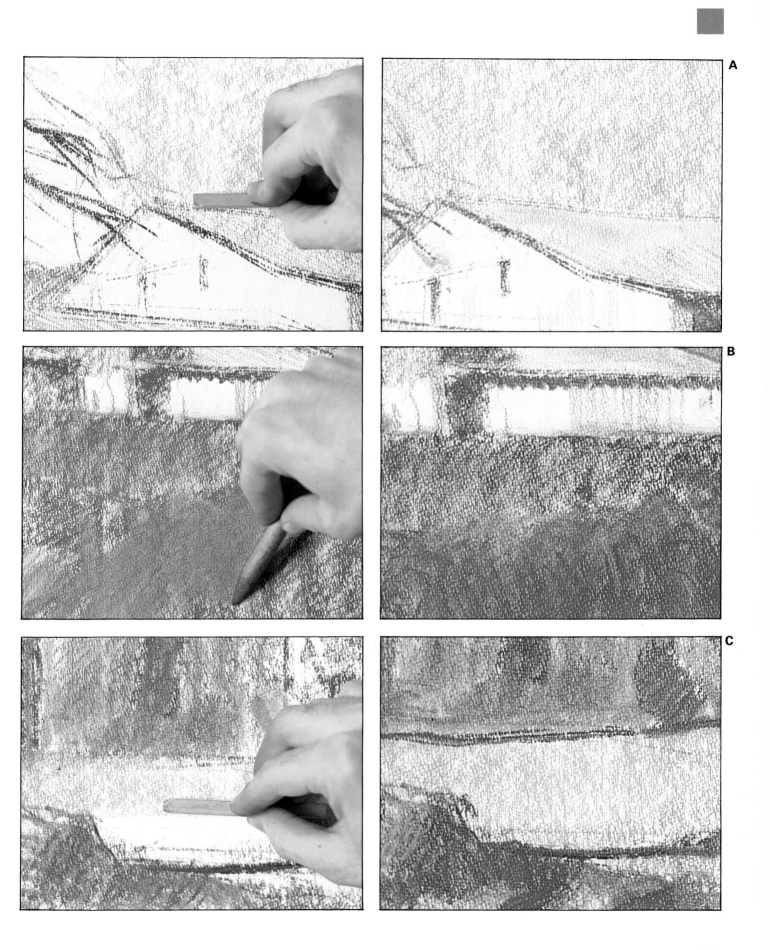

4. Final stage of the picture

After completing the stage shown on the previous page, you must, as Sabater has, work on building up the color and tonal values of each part of the landscape. Decide whether, as in our example, you need to accentuate the warmer tones or if the colder hues should be intensified. Obviously, the latter will apply if reds and yellows are too dominant in the photograph you have chosen.

Note how, for example, in close-up **A** on this page, the clearly greenish tone of the branches on the big tree (look again at the original photograph on page 24) has become a much warmer color.

The same thing has happened with the background (see close-up **B**), which has taken on a color somewhere between blood red and sepia, considerably altering the coolness of this area in the photograph. Looking at the shadows, in close-ups **B** and **C**, you can see that the artist has put a lot more into his picture than he could see in the photograph. In the photo, the shadows are a flat, uniform color. In the artist's version, although the prevailing coolness of tone remains, the shadows appear to be more luminous because they contain more color or, to be precise, warmer pigments.

Analyze the way Sabater treated the roofs; he started with an even ground, predominantly ochre in color. On top of this he drew short, wavy lines with sepia-colored chalk and a few lines of white chalk, managing to give a convincing impression of an Arab-tiled roof, without introducing unnecessary details. The roof glows with colors ranging from yellow ochre to luminous orange, reflecting the radiant, golden light of the Mediterranean sun.

Notice also, in the photo of the finished picture (on the next page), the difference between the broad area of shade in the foreground, as seen by the artist, and its appearance in the photograph. What was a uniform patch of shade in the photo, became one of the most interesting parts of the picture. The warm colors of the sunlit ground are flecked with a complementary dark blue, which in turn is enriched by splashes of black and more luminous strokes of green and white that suggest the tufts of grass on the edges of the road.

Finally, look at close-up **D**, on the next page, and observe how to use white chalk pencil to highlight indistinct details in a more or less uniformly colored background. In this case, the white pencil defined the old trunk of a dead tree and the shapes of those in the thicket in the background.

A

B
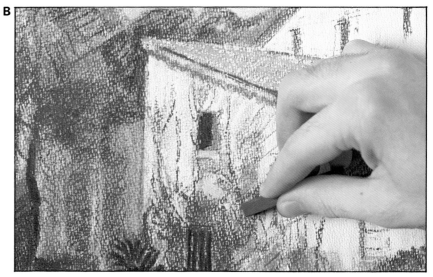

C
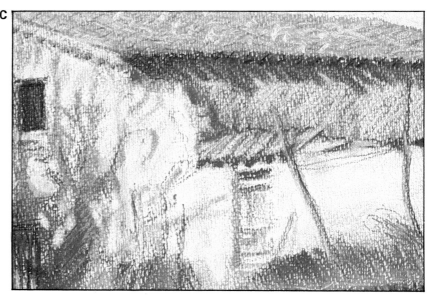

D

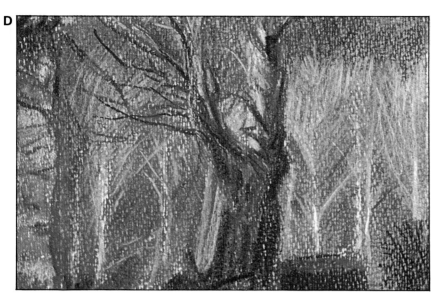

Also note how white chalk was used to illuminate the upper or left sides of the branches on the tree in the foreground, taking into account the position of the sun.

Left. *Close-up showing how the white chalk pencil was used to highlight the trunk of the dead tree and to define the trunks of the trees in the thicket.*

Below. *Juan Sabater's picture is offered to you as an example, in the hope that you will be inspired to produce your own landscape using sanguine crayons and chalks.*

E

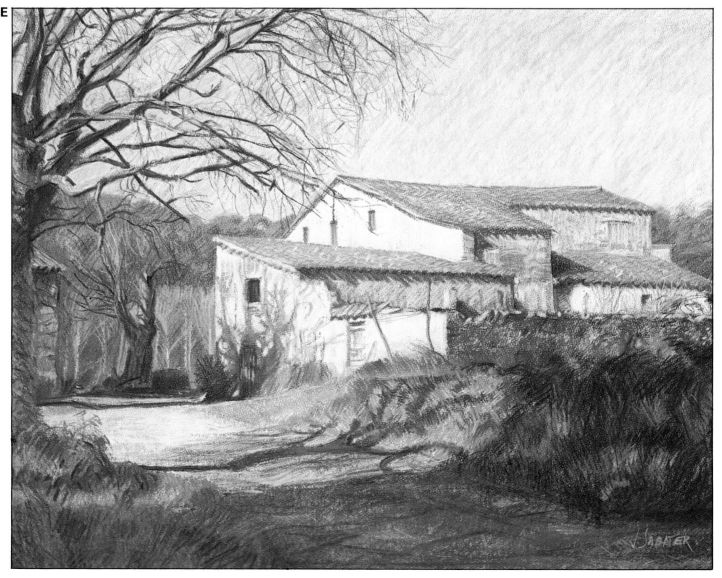

Three examples

Left. Landscape study, very typical of its time, showing the allegorical ruins of a bygone age. Drawn in sanguine by Hubert Robert (1733–1808), Boymansvan Benmingen Museum, Rotterdam.

Below. This is a sanguine drawing by Jean Honoré Fragonard (1732–1806). It shows "The great Tivoli waterfall, seen from beneath the bridge," which is held by the Musée des Beaux Arts, Besançon.

Above. Let's leave the 18th century behind and return to our times, when mixed media techniques seem to be fashionable. Here is a landscape drawn with sanguine, chalks, and colored inks by the artist Ester Serra.

This leap in time and technique demonstrates the extreme versatility of the medium we are studying when it is used to interpret aesthetic concepts of an avant-garde nature.

The ink wash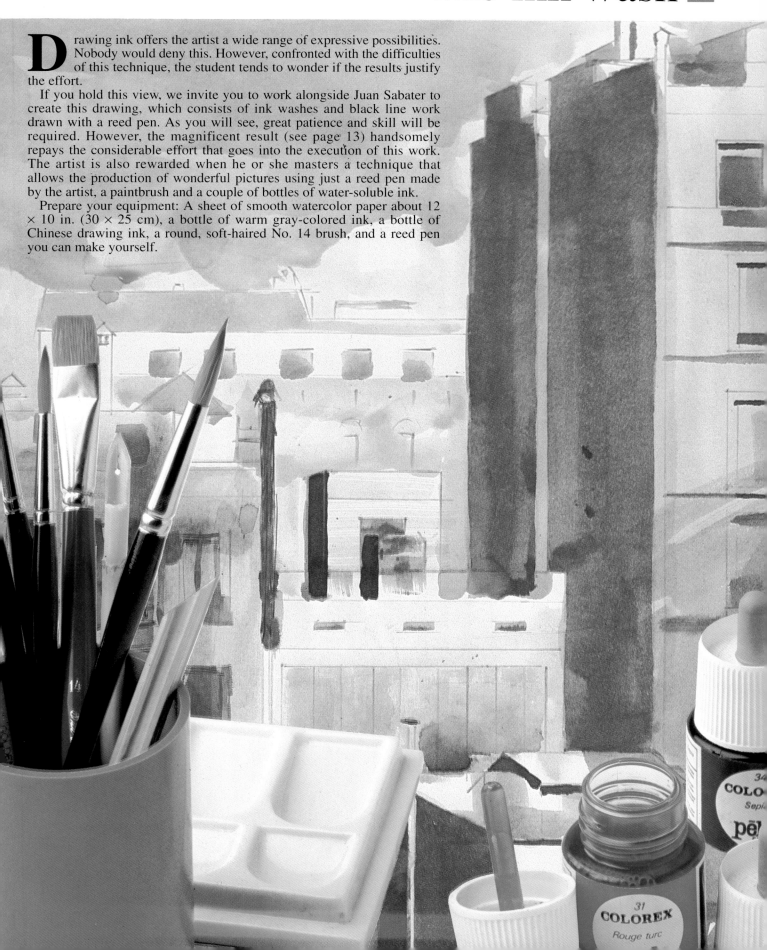

Drawing ink offers the artist a wide range of expressive possibilities. Nobody would deny this. However, confronted with the difficulties of this technique, the student tends to wonder if the results justify the effort.

If you hold this view, we invite you to work alongside Juan Sabater to create this drawing, which consists of ink washes and black line work drawn with a reed pen. As you will see, great patience and skill will be required. However, the magnificent result (see page 13) handsomely repays the considerable effort that goes into the execution of this work. The artist is also rewarded when he or she masters a technique that allows the production of wonderful pictures using just a reed pen made by the artist, a paintbrush and a couple of bottles of water-soluble ink.

Prepare your equipment: A sheet of smooth watercolor paper about 12 × 10 in. (30 × 25 cm), a bottle of warm gray-colored ink, a bottle of Chinese drawing ink, a round, soft-haired No. 14 brush, and a reed pen you can make yourself.

Ink wash with reed pen line work

Step 1
Introduction of the subject and outline drawing

When contemplating this rear view of apartments in the suburbs of Barcelona, Sabater said he first thought of the human phenomena underlying this architectural arrangement: Family, intimacy, the struggles of daily life, human warmth, and so on. Conveying this human equation is not an easy task, especially because the only way to express it is through suggestion of an atmosphere that, to a certain extent, dissolves the rigidity of the structures designed to contain human life. To start, Sabater produces the outline sketch (with HB pencil) you can see on the right. The artist tells us: "I am not embarrassed to admit that I used the ruler for added speed and accuracy in drawing so many straight lines. Rembrandt himself did the same thing without the slightest pang of guilt."

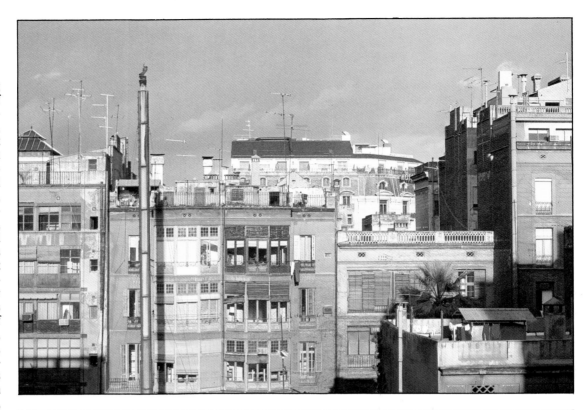

Right. Outline sketch of the subject, drawn with the aid of a ruler. The artist has tried only to define the basic areas of the drawing. Note that, at this stage, Sabater decided to leave out the chimney on the left of the photo.

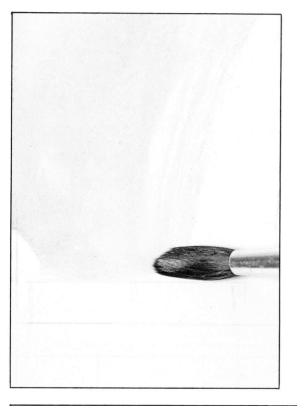

Step 2
Background wash

Sabater knew that if he produced a good initial sketch, with all the elements of the composition in correct proportion, he would have no problems with the linear aspects of his drawing—that is, with the parts reserved for the reed pen. Using a No. 14 sable brush and fairly diluted gray ink, Sabater covers his outline drawing with a background wash that (in his words) "gives me a first idea of atmosphere."

He has been preoccupied with conveying atmosphere from the moment he decided to undertake the picture, as if everything depended upon achieving this goal. Now he can strive to create the "mood" he requires, by laying down successive washes in the traditional way.

Notice how, even at this early stage, a play between light and shade has been introduced that will carry through to the completed picture. It contributes greatly to the interest and the feeling of depth in the drawing.

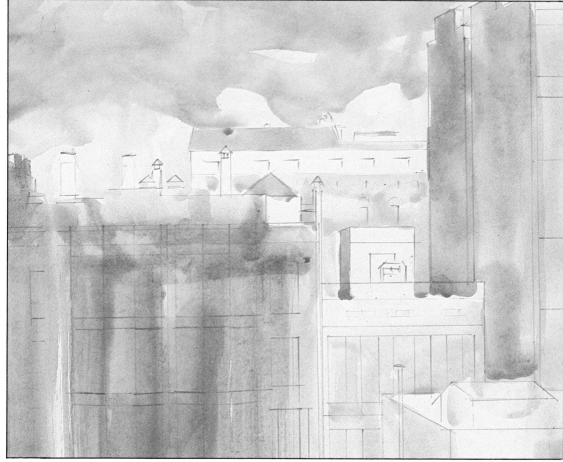

Above. Action of the brush, applying two washes of different intensity. Note that the darker the wash, the greater the warmth of the gray color.

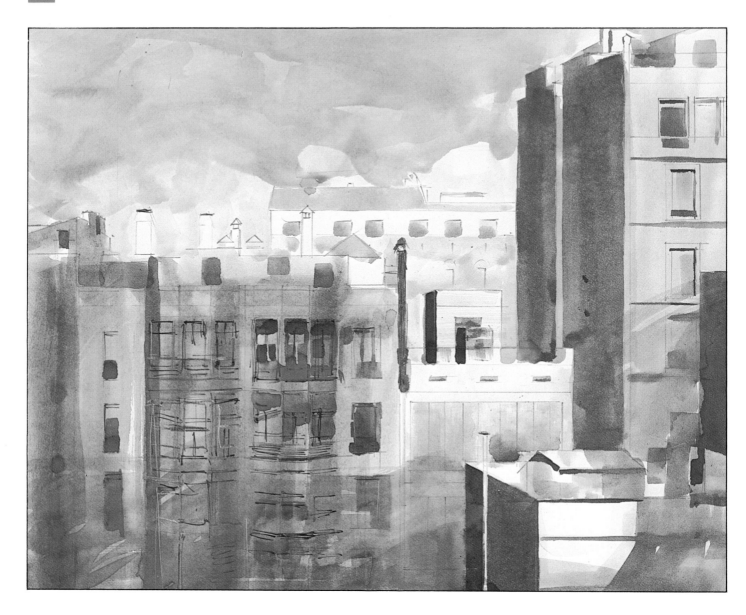

Step 3
Tonal evaluation

At this stage we can confirm a comment made earlier: Atmosphere is an important feature of this picture and must be conveyed, almost exclusively, by the washes of ink.

In fact, if you carefully study the photograph of Juan Sabater's drawing taken on completion of this third stage, you will find no fewer than five different tones, achieved by successive layers of a single wash or (in the darker areas) by brushstrokes of another, much less diluted wash.

You will undoubtedly notice also the greater purity of the white areas compared to the last stage, and perhaps will wonder how these were created, in view of the permanence of ink wash.

Some areas have been whitened with a 50% solution of bleach. Inks that are water soluble are generally also soluble in chloride solutions such as bleach. Experiment a little and you will find that bleach is a powerful ink solvent and that it also whitens the surface of the paper itself.

To open up white areas in a layer of ink wash, the bleach solution must be applied to a damp surface. If the wash is completely dry, this process will not work as well.

Look closely at the verandas of the buildings in the left half of the picture and you will see the first few linear details.

Above. Sabater's drawing after the completion of step 3. Notice two things: The atmosphere is created by the washes and, secondly, a technical detail—the negative lines on the facades of the buildings have been drawn with a dry tool (such as an unloaded pen nib) on top of the damp wash.

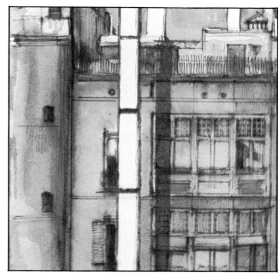

Close-ups

To help you appreciate the successive use of different techniques and the use Sabater made of each one, we laid out this series of close-up photographs in pairs. The pictures on the left show you a section of the drawing during the application of the washes; on the right, the finished picture with all the whites opened up and the black lines superimposed with the reed pen. Remember that whites are produced by using bleach on damp paper, while the black pen strokes must be applied on a dry surface to prevent the ink from running.

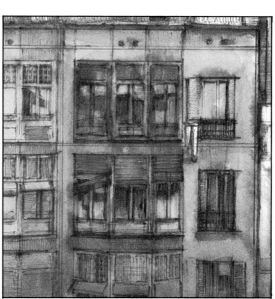

Above. Area centering on the chimney created by the skillful use of the whiting-out process.

Middle. Part of the veranda area during the application of the black tone using the reed pen and then in the finished drawing.

Below. Part of the building on the extreme right of the drawing, photographed during the whiting-out of one area, and in its completed state.

179

Step 4
Reed pen work, whiting out and touching up with the brush

This is, undoubtedly, the longest and most laborious stage, but also the most gratifying. It is during this final stage that the most creative aspects of the drawing must be resolved. On top of the washes created in step 3, Sabater drew in details using black ink applied with the reed pen. At the same time, he opened up whites wherever he thought it necessary and blended shades of gray, where he perceived one area to be too harsh or cold. Notice that in the walls seen from the side, the ink lines were not applied in just any direction, but always toward the corresponding vanishing point. These strokes contribute to a feeling of depth that, in a drawing consisting predominantly of facades, is not easy to achieve.

Finally, the white chimney appears. Sabater says: "I deliberated for a long time before deciding to give the chimney an important role. I even thought about getting rid of it and adjusting the entire layout of the picture. But in the end, its inclusion has provided a frame for the veranda area that, because of its dark tone, was previously a bit overpowered by the whites immediately to the right."

Below. Sabater considered getting rid of the chimney and changing the framework of the picture to focus more attention on the verandas, which present a range of medium tones.

Two examples

[top legend] Mountain Village (Pueblo de montaña) by F. Florensà. The simplicity of this drawing comes from the treatment. Its pictorial values come from the layers of light washes. The drawing creates the contrast, not the colors.

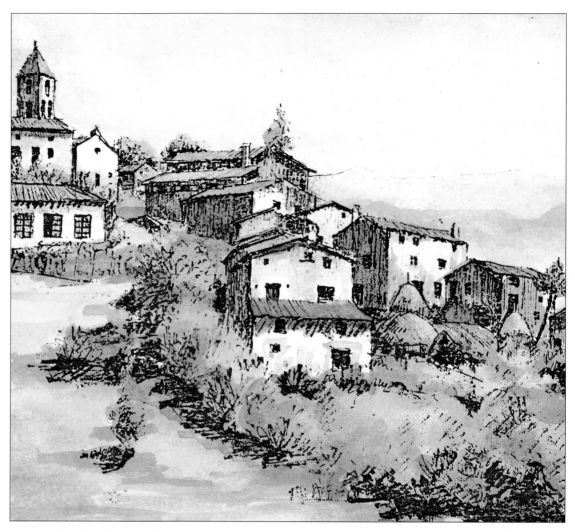

We close this lesson with two examples that combine ink wash and reed pen line work. However, we are going to do the opposite of what we previously did. Previously we applied an ink wash and then outlined the details with the reed pen; now we are going to draw with the reed pen first and then add color.

Although all the drawings in this section have pictorial motifs, the two examples on this page have a much more drawing conception in their themes. They appear to be illuminated drawings that are commonly found in English and French illustrations from the 18th and 19th centuries.

Here is another example by the same painter, using the same technique. Notice the precise outlines and the light and shade contrast of the old, rotted boards of the door. The ink washes give the drawing character. The mold on the door, created with greenish gray and burnt sienna colors, makes the drawing even more realistic.

182

Drawing with pastels

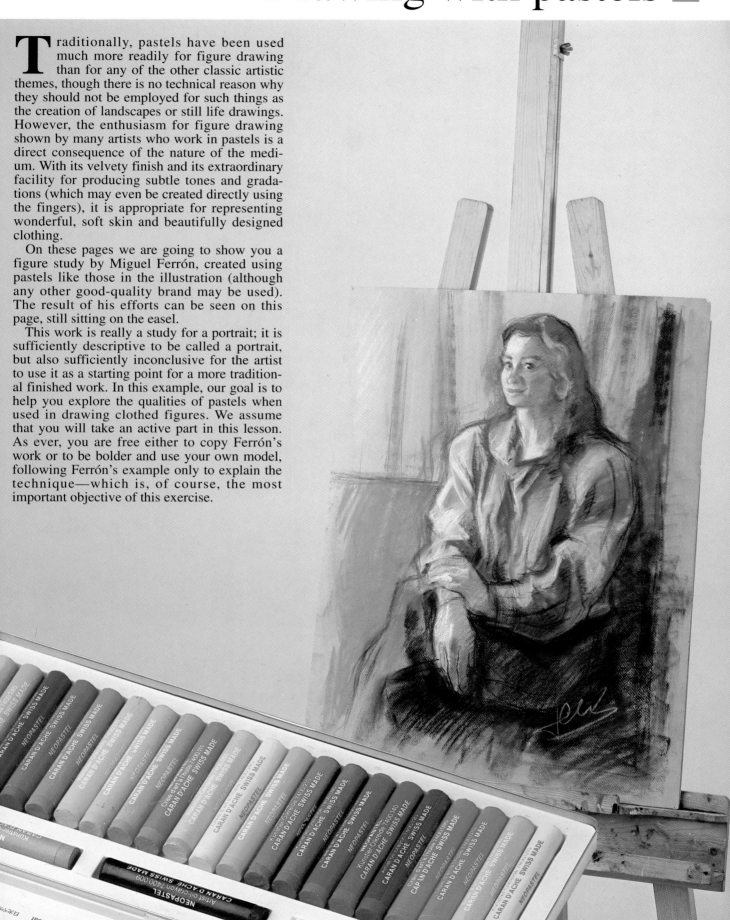

Traditionally, pastels have been used much more readily for figure drawing than for any of the other classic artistic themes, though there is no technical reason why they should not be employed for such things as the creation of landscapes or still life drawings. However, the enthusiasm for figure drawing shown by many artists who work in pastels is a direct consequence of the nature of the medium. With its velvety finish and its extraordinary facility for producing subtle tones and gradations (which may even be created directly using the fingers), it is appropriate for representing wonderful, soft skin and beautifully designed clothing.

On these pages we are going to show you a figure study by Miguel Ferrón, created using pastels like those in the illustration (although any other good-quality brand may be used). The result of his efforts can be seen on this page, still sitting on the easel.

This work is really a study for a portrait; it is sufficiently descriptive to be called a portrait, but also sufficiently inconclusive for the artist to use it as a starting point for a more traditional finished work. In this example, our goal is to help you explore the qualities of pastels when used in drawing clothed figures. We assume that you will take an active part in this lesson. As ever, you are free either to copy Ferrón's work or to be bolder and use your own model, following Ferrón's example only to explain the technique—which is, of course, the most important objective of this exercise.

Study for a portrait

1. Initial decisions

Once the artist knows who the model will be, then the artist must make two preliminary decisions: Which pose the model will adopt and which paper will be used. In the first case, it is a question of finding the most appropriate pose for that particular model. With regard to paper, it is a matter of knowing how to choose the texture and color best suited to the vision (mainly of the color scheme) each artist has before starting to work. Experience will have taught the artist that a work of art originates from the image the artist forms in his or her mind.

Look at the model who posed for Ferrón, her clothing and the surrounding atmosphere, and you will see why he chose a paper from the warm range of colors. The artist decided on a dark beige, medium-textured Canson watercolor paper.

Above. Sample of papers in the warm color range. They are medium-textured Canson watercolor papers sold in sheets of 19¹/₂ × 27¹/₂ in. (50 × 70 cm).

Right. Here is the model posing for the artist; his viewpoint is that of the camera. Notice that the figure, like everything surrounding her, is bathed in warm light. This warmth is clear in the skin and the clothing but also, although to a lesser extent, in the tones that modify the green of the sofa and the curtain in the background. Far from creating a strong contrast to the model, they are in harmony with her.

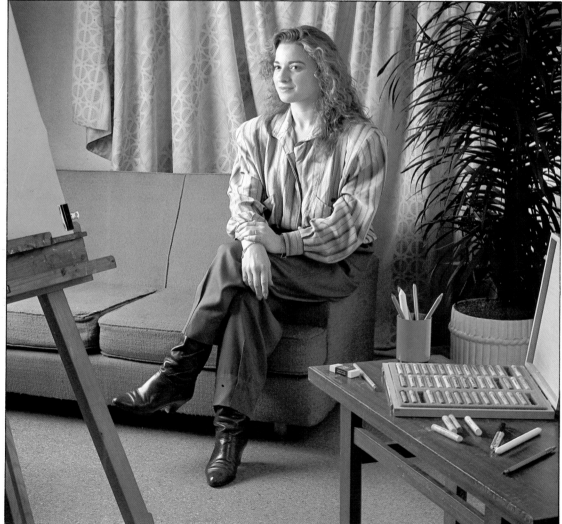

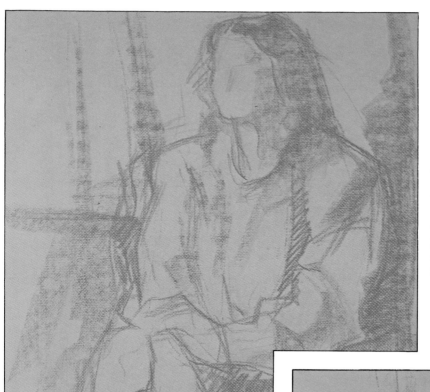

2. Initial sketch and adjusting the drawing

The initial sketch (left), in which Ferrón established the layout of the picture, was drawn with a burnt sienna pastel. Note how even in these early stages the artist considers form and depth in the drawing, immediately locating the most significant areas of shadow. From this point, Ferrón adjusts the drawing, defining different areas with lines and patches of Prussian blue that contrast with the pale violet highlights of the blouse and the whites and yellowish tones of the skin. The skin tones are subtly enhanced by touches of burnt sienna and orange.

Below is a photograph of Ferrón's work after the second stage. As you can see, while adjusting the initial sketch, the artist was also laying down a first layer of color using strokes that reinforced the drawing at the same time.

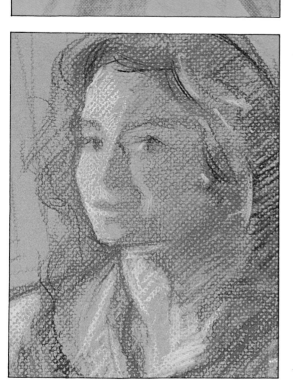

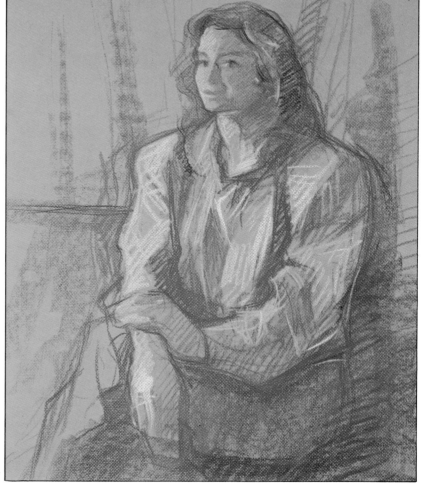

3. Building up color

Through these six close-up photographs you can see how the artist builds up the color in each part of the picture.

A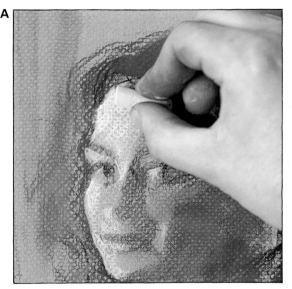

A. Light, shade and half tone on the face and in the hair are created using violet, yellow, orange, and burnt sienna.

B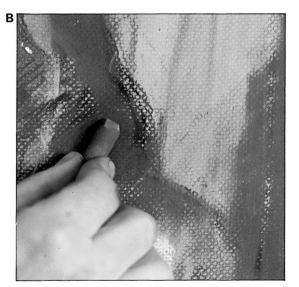

B. Sutble tints in the hair, using Prussian blue for the darkest tones and burnt sienna for areas of half tone.

C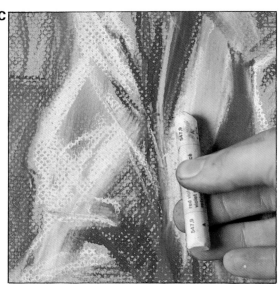

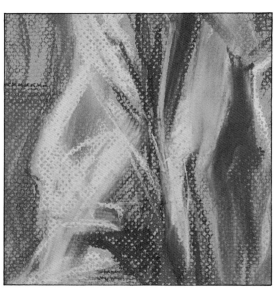

C. Highlights and reflected light on the blouse, using firm strokes of pale violet to contrast with the shadowy background color of burnt sienna and the blue outlines.

Do not confuse blending with gradating color. Gradation implies fading out or darkening of a single color, whereas blending involves mixing two or more adjacent areas of different color.

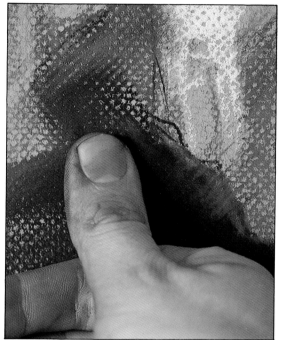

4. Blending of color

When you work in pastels, even though your intention may be to produce a simple study, it is hard not to blend pigment given the wonderful results it produces. In the three close-up pictures on this page, you see a few more areas in which adjacent colors have been blended with the fingers.

5. The final touches

On the right you see Ferrón's work after the blending stage, an indispensable step in achieving the velvet-like finish of some areas of the composition.

At this point it is time to put in the final touches of detail, light, and form wherever the skill and instinct of the artist deem them necessary.

Look at the two close-ups at the bottom of this page showing the left eye and part of the hair, in which the outline of the eye has been defined and the pupil built up (black pastel pencil). A few wisps of gold have been added on top of the dark mass of hair (yellow pencil).

You should also note that the blending of pigment has not been overworked; the color has not been forced too deeply into the texture of the paper so a shimmering effect is maintained.

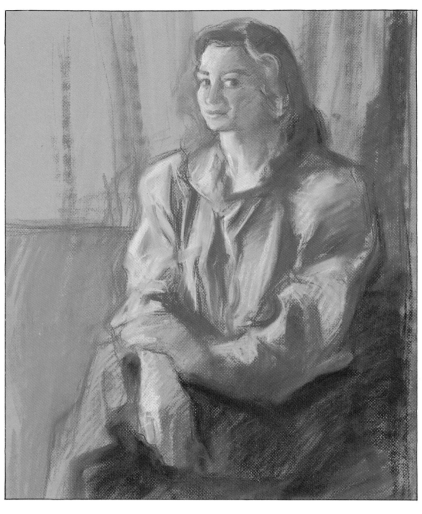

Below. Two close-ups showing the texture and color of the paper. Don't overlook the little splash of green on the eyelid that lightens it up.

Right. "Study for a portrait," by Miguel Ferrón. Normally, a study implies a piece of work that is more than a sketch, but not as elaborately worked as a finished picture.

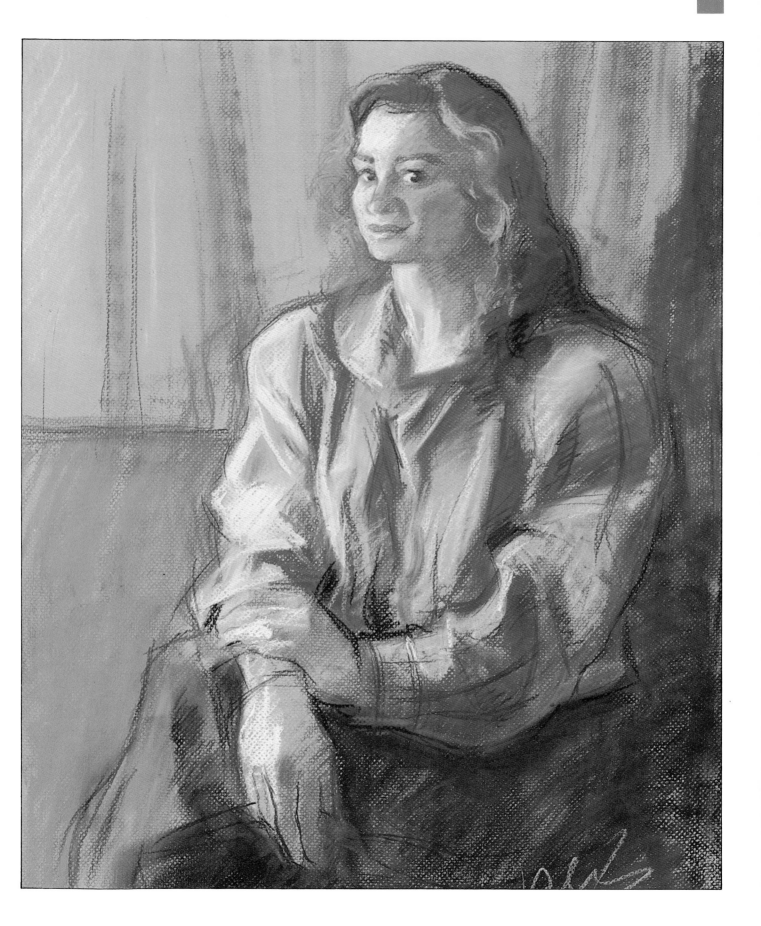

Three examples

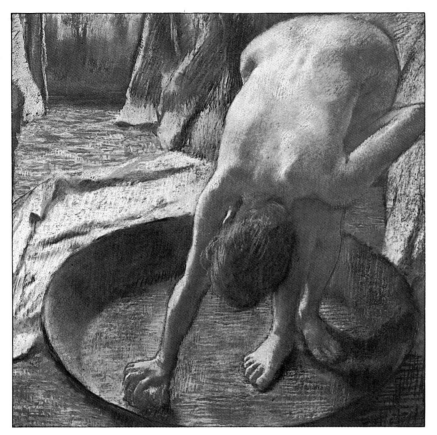

On this page we have reproduced three examples of pastel drawings of the human figure that are undoubtedly supreme works in this genre. Looking at these pictures you can see that pastel is a pictorial medium and not just for drawing. If certain works do not have the same build-up of color and are described as drawings, then one should study the results obtained by great masters of the medium to assess the pictorial qualities this technique can produce.

1. "The bather." An extraordinary pastel painting signed by Degas about 1886. This is an exceptional work, as much for its technical skill as for its originality of composition, which gives the picture an intense dynamism through rhythm and light.

2. "Portrait of Miss Laverque," by Jean-Etienne Liotard (1702–1789), in which the delicate colors and soft gradations lend a feeling of intimacy to the picture and give the figure its pleasant look of youthfulness and innocence. It has an atmosphere of carefully chosen warm tones.

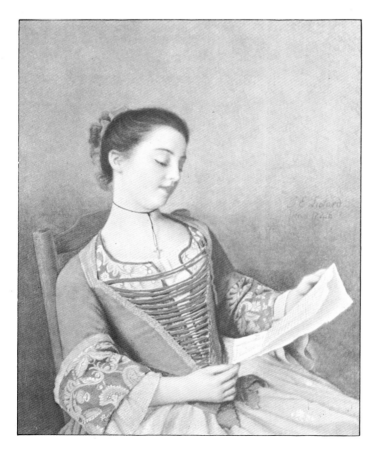

3. "The star." Ballet scene drawn in pastel by Degas, a work in which the rich superimposition of color created the delicate transparency of the lace costume of the ballerina.

Wax crayons

The technique of using wax crayons is probably not new to you. As a medium, they are sometimes compared with oil pastels because of certain characteristics they have in common. You will find this out for yourself by following this step-by-step exercise, in which Ester Serra, who just gave us her personal interpretation of a floral theme in oil pastels, will explore a similar subject using wax crayons.

Let's take a look at the main characteristics of this medium:

• Crayons are applied directly to the support and may be blended (though only to a limited extent) using the fingertips, a torchon or a cloth.

• Wax crayon is very difficult to erase. The best method of removal is to scrape as much as you can from the surface and then to use a plastic eraser. However, some pigment will always remain.

• Wax crayons may be dissolved in turpentine essence. It is always best to work with the most refined product, although everyday materials will also give good results.

• Crayons are extremely opaque colors and may be superimposed.

• When you use a blade or pointed implement to scrape the surface of a superimposed color, the underlying color will appear. This feature offers a wide range of possibilities as far as texture is concerned.

• Normal fixative may be used on wax crayon drawings.

We will assume you are familiar with this information, and that you can now follow without difficulty the practical demonstration Ester Serra has drawn as an example.

A floral subject in wax crayon

A composition study

Before starting work on the actual picture, Ester Serra made a few preliminary studies based on the subject you see in the photograph on the right. Her intention was to find a viewpoint that offered her the most balanced composition within a square area. She decided to work from the viewpoint from which the photograph was taken. The compositional study not only helped to establish a balance between the different planes and volumes, but also defined certain areas of tone and color. In this floral theme, the shapes described by the various elements approximately determine the main areas of color.

Right. Preliminary study carried out by Ester Serra, on which the compositional construction has been indicated. Notice that the arrangement of the elements revolves around dividing the square into different triangles. You will see that each triangle corresponds, more or less, to one of the main colors.

Zone A: Background triangles, predominantly pale gray.

Zone B: Triangle containing the color green.

Zone C: Triangle containing most of the flowers. Red.

Zone D: This corresponds to a more stable element—a square—which is predominantly white.

Zone E: Dark gray triangle corresponding to the drapery beneath the flower pot.

Zone F: Small triangular area at the base, pale gray in color.

Layout sketch

On a textured paper, similar to Ingres paper, our artist made a layout sketch of her subject, using an earth-colored pastel stick. The fact that she has used a pastel and not charcoal allows her to apply wax crayon on top of a subtle base color that will breathe through without dirtying later color applications.

Left. Sketch of the subject made by Ester Serra using a burnt sienna pastel. Observe the simplicity with which she interpreted the compositional layout of the previous page.

Bottom left. Close-up photographs taken during the application of the first areas of color (step 1). See how the wax crayons are applied, flat against the paper, so that their whole length is used. The intention is to block in color, rather than to define form.

Step 1

Ester Serra has started by blocking in the gray of the basecloth and the red of the flowers on top of the previous sketch. These form a link through color between two of the main triangular areas of the composition. The method of working is illustrated in the two close-up photographs on the previous page.

Right. How the picture looks after the color of the two main areas of the composition were blocked in. At this point the advantage of having made the base sketch in sienna pastel rather than charcoal becomes clear.

Bottom right. In these two close-ups (which correspond to the second stage of the picture's development) you can see how the colors were blended after being applied directly with wax crayon. A hog's hair brush loaded with turpentine was used to produce this effect. The tip of the crayon is applied (far right) to build up tone and define form.

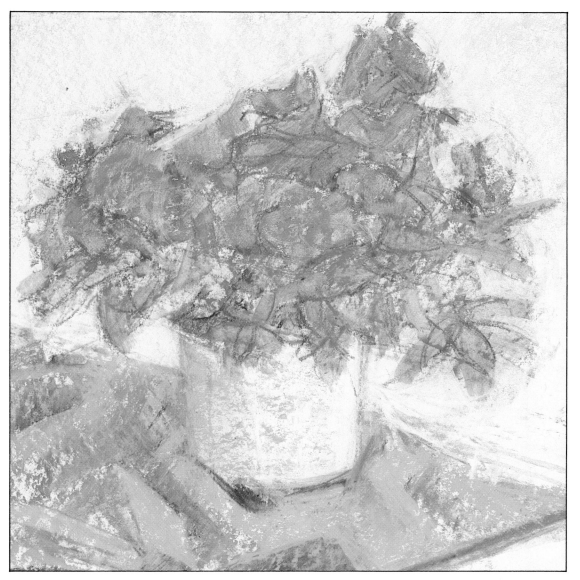

Step 2

The artist began the second stage of her demonstration by coloring in all the leaves around the flowers in bright green. She then reinforced in reddish brown the folds in the drapery that appear in shadow. After working directly on the picture in wax crayon, she blended the color using the methods described in the two close-ups on the previous page.

This technique of blending the pigment has been used extensively on the leaves and flowers where there is a greater variety of shades and where the forms are more complex and irregular.

Ester Serra gave the background a brown base color on top of which she applied a thick layer of white wax crayon. This superimposition of color created the warm gray seen in the photograph. The brown she used for the background is the same as the one used for the shaded areas in the folds of the drapery and also in the first touches of color applied to the vase.

Left. Close-up photographs taken during the blending, with the help of plenty of turpentine, of the white and brown colors of the background, after which neither the texture of the paper nor that of the wax pigment remain visible.

Step 3

This shows a transition stage during which the artist worked on making the drapery beneath the vase more substantial and on defining more sharply the different parts of the plant. She outlined in white the edges of those parts that stand against a white background, and in violet those in shadow. Notice in the illustration directly above that the vase has been given greater volume through a subtle gradation of grays around its surface, with the brown of the background breathing through.

Step 4. Final stage

In the final step of Ester Serra's picture she enriched the color and clarified some of the forms that, until now, were still a little vague. Look at the three close-up pictures on the right and in the finished picture on the opposite page, and observe the colors used in the different areas of the composition:

In the flowers: On a base of uniform red, the artist worked with ochre, deep carmine, gray, and orange. *On the leaves:* On top of a green base there are touches of Prussian blue, ochre, violet, and deep green. *On the drapery:* Over the brownish-gray of the darkest areas, touches of violet have been added. Prussian blue has been used to outline the edges of some of the folds. More pigment has been added to build up the highlighted areas of the folds in the cloth over the base gray color and white. The colors were applied directly with the crayons and then a torchon was used to even out the color of certain areas: Look at the second of the three close-ups.

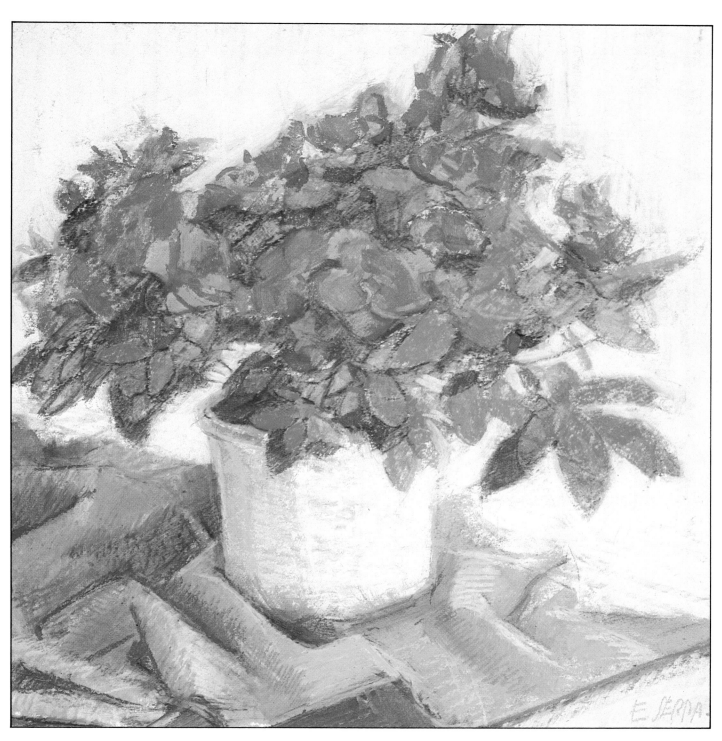

In the finished work the harmony of color is easy to see. Throughout the picture the background brown breathes through (this in itself is a harmonizing influence) and there are no violent contrasts. The carmine color in the drapery represents a visual link between the violets on the leaves and the reds and ochres of the flowers, preventing any feeling of a sudden impact between the two.

Left, opposite page, from top to bottom. Working in ochre on some of the flowers to suggest a fore-shortened view of many of the petals. Notice how the light falls differently on them. The torchon being used on the leaves is to give a greater feeling of depth. *Prussian blue being applied on top of one of the violet-colored leaves. Deepening the color brings the viewer closer to the picture. In contrast, those parts softened with the torchon tend to recede.*

Above. *The finished work. Each area of the composition has been treated in a differrent way.*

Three examples

Left. *Detail from a study by Miguel Ferrón, demonstrating in a single work most of the techniques of wax crayon drawing. The white areas have been reserved with masking fluid and the background has been painted with a brush, using wax crayon dissolved in turpentine. The carmines, greens, and yellows have been applied directly in wax crayon. You can see that, after the masking fluid was removed, new shades (basically blue and green) were introduced using a brush with dissolved pigment; these overlapped the reserved whites in a few places.*

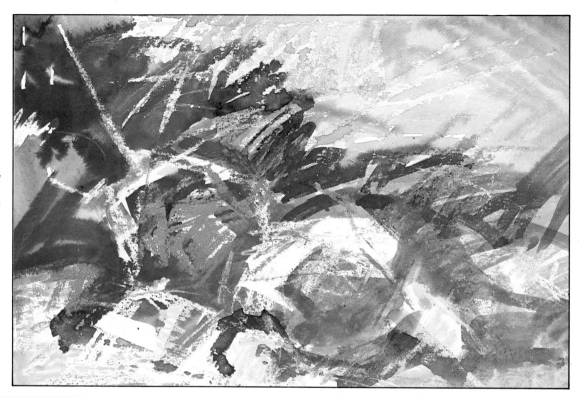

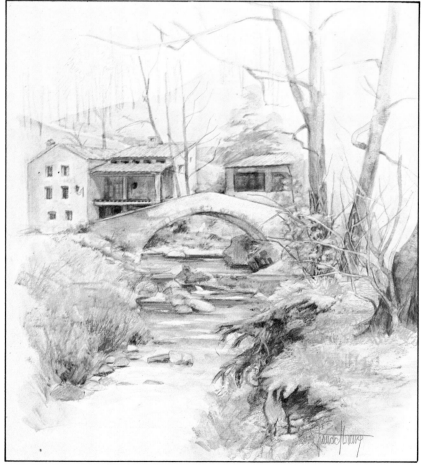

Above and left. *Two good examples by Francesc Florensa, showing the quality wax crayons are capable of producing when they are applied directly to the paper and then diluted with turpentine using a soft-haired brush. The middle range of tones look similar to those produced by water-soluble colored pencils, although wax crayon color is perhaps more luminous.*

Above.
"The story of Adam and Eve," from a manuscript of the Gospel-book by Alcuin or Moutier Grandval, produced between 834 and 843 (at the height of the Carolingian period), watercolor on parchment. (British Museum, London.)

Below.
"Hare" by Albrecht Dürer, watercolor on paper (Albertina Museum, Vienna). Durer (1471–1528), the greatest German painter and engraver of the 16th Century, painted many watercolors of animals.

It was more than 3,500 years ago that man started to write and illustrate books, never imagining that he was building the foundations of the art of watercolor painting.

The Egyptians took the first step when they discovered a plant called *cyperus papirus*—the famous papyrus—the bark of which became paper used for illustrating and writing about history, science, religion, and magic. These elementary volumes were buried with their authors, so these eminent people could show what they had achieved in this world when they reached judgment day in the next.

The colors used to paint these books were transparent, made with earth pigments for the ochres and siennas, minerals such as cinnabar for red, burnt willow for black, and gypsum for white. These pigments were bound together using gum arabic and egg white, and were used diluted in water. In other words, they were watercolors. Another thousand years passed before, in AD 170, the properties of parchment were discovered—goat or sheepskin treated with lime and rubbed down with pumice stone—as a suitable material for preparing "codices," the individual sections of manuscripts. The man responsible for this development was Eumenes II, King of Pergamon.

The illustrations, which we call *miniatures*, that accompanied the text of these manuscripts were painted with watercolor mixed with white lead, resembling the *gouache*, or opaque watercolor, we use today. In the 9th Century, during the reign of Charlemagne, Emperor of the Carolingians, these illustrations began to take on a greater importance and painters were commissioned who alternated the use of transparent watercolor with the opaque mixture already mentioned.

This was the most widely used medium from the Early Middle Ages until the Renaissance; by the height of the Renaissance, the use of watercolor was widespread. More than ten centuries of constant development and discovery separate this time from the sophisticated techniques available today. The spread of literature was really the significant force and ally in the development of this important painting medium.

The watercolor wash

In the last year of his life alone, Van Gogh painted about 850 pictures and made more than 1,000 sketches and pencil studies. Van Gogh, like many great painters, was a tireless worker. Like Van Gogh, you or anyone else who decides to enter the world of painting pictures will have to accept this simple fact: Hard work, and the constant search for progress and professionalism are unavoidable. With watercolors, the effort is even greater. Beginning to paint, as with any intellectual activity, always represents an effort we try to postpone with excuses of every kind. Knowing how to use watercolors is not something that can be learned in half a dozen lessons. It takes technique, skill, a great deal of patience, and an infinite number of sketches and preliminary studies—many to be discarded because they were not successful. With any type of wash, if the goal is not achieved first time around, there is no possibility of going back and redoing what has already been done. But we mustn't give up when we've barely started! We took the first step a little while ago, with the preliminary monochrome exercises in wash technique. Now we are going to look at the two-tone watercolor wash, as a threshold to the unrestricted glories of watercolor. And before long, when you discover for yourself through a watercolor painted by your own hand, all the spontaneity, freshness, delicacy, and character of this almost magical medium, you will see that this initial effort was more than justified.

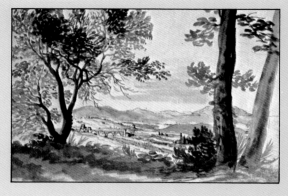

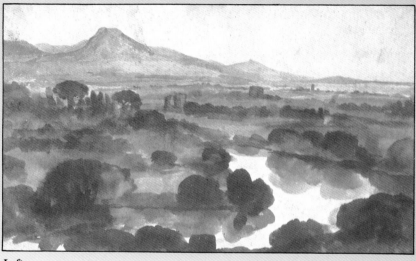

Left.
"The Moller Bridge near Rome" by Nicolas Poussin. (Albertina Museum, Vienna.)

Below.
"Landscape with a river; view of the Tiber from Monte Mario, Rome," by Claude Lorrain. (British Museum, London.) Two classic examples of painting with wash.

Paper

One of the elements that most influences the quality of a watercolor is the paper. There are various qualities of paper available on the market, ranging from student quality to high quality, handmade papers. Within the superior or professional quality range, there are three main types of paper:

- **Hot-pressed (fairly smooth) paper**
- **Cold-pressed (semi-rough) paper**
- **Rough (heavily grained or "toothed") paper**

These papers are easily recognized by their watermarks, which will be visible if you hold them up to the light. They come as loose sheets in a variety of different sizes.

All good-quality papers have a front and back. The front generally has a better finish and has been sized. For sketches and preparatory studies, a medium-quality paper with a medium "tooth" will do fine.

Watercolors

Watercolors of professional quality come in small pastilles of dry pigment, in pans of semi-moist paint, or in tubes or bottles of liquid watercolor.

Above, left.
When you go to buy watercolor paper, remember that you will find loose sheets, sheets on backing board, and pads of paper. The highest-quality papers often have characteristic uneven edges to show that they have been made by hand. The pads are very practical for sketches and quick color notes.

Pans of semi-moist watercolors, professional quality. The colors dissolve easily and give excellent results. They are sold singly and in little boxes (which double as palettes) containing 6, 12, 14, or 24 colors.

Professional quality watercolors in tube form; this paint has a similar consistency to that of oil paint, with the advantage that it dissolves immediately in water. These tubes may be bought in sizes of 2 to 5½ oz. (8, 21 ml).

Bottles of professional quality liquid watercolor. These are widely used in the field of illustration. Similar to dyes, very concentrated, they are sold singly and in sets of 12 or 16 bottles.

PRINCIPAL MANUFACTURERS OF WATERCOLOR PAPERS

Arches	France
Canson	France
Fabriano	Italy
Grumbacher	United States
Guarro	Spain
RWS	United States
Schoeller	Germany
Whatman	United Kingdom
Winsor & Newton	United Kingdom

■ More about equipment

Color ranges and boxed sets

Sets of watercolor paints are available in lacquered metal boxes with various divisions painted white so that the box doubles as a palette. The number of color pans depends on the requirements of the purchaser; they come in ranges of 6, 12, or 24 colors.

A set like this is not essential: Many a professional mixes paints on a large white china plate or on a piece of thick, white watercolor paper, allowing him or her to see what a certain mix will look like before applying it to the painting.

Almost all the boxed sets have a little hole or ring on the case so you can hold it with the thumb of one hand while mixing color with the other.

Many watercolor sets contain white. You have probably heard a thousand times that it is a sin to use white in watercolor painting; you should use the white of the paper in predetermined areas of your picture. For some reason, manufacturers insist on including this color, which is similar in character to a white tempera or gouache. We would like to state as a basis for all future lessons, that there are dozens of ways to open up or protect white areas in a painting without resorting to white paint. So, from now on, its use is strictly forbidden!

A big boxed set of twenty-four semi-moist watercolors. The tray of colors can be separated from the metal box, allowing more space to mix paint. The fastening of the box at the bottom attaches to the ring for holding the set while you work.

Left.
The minimum selection of brushes for the beginner: Three sable brushes, Nos. 8, 12, and 14 and a No. 24 ox-hair brush.

Below.
A color chart from the Rembrandt range published by courtesy of the firm Talens. The chart does not include Chinese White.

The watercolor chart below produced by the firm Talens shows thirty-five colors. Some manufacturers offer an even greater range of tones; Winsor & Newton, for instance, produce eighty-six different colors. Of course, you don't need this number of blues, reds and yellows, but every artist has his or her own preferences and usually chooses a basic range from which to work. When you are starting out, it is useful to have a range like this so you can experiment and decide on your preferences.

Bear in mind that all watercolors lose about 10 or 20% of their color intensity in the drying process. This color is restored if you glaze or varnish your painting.

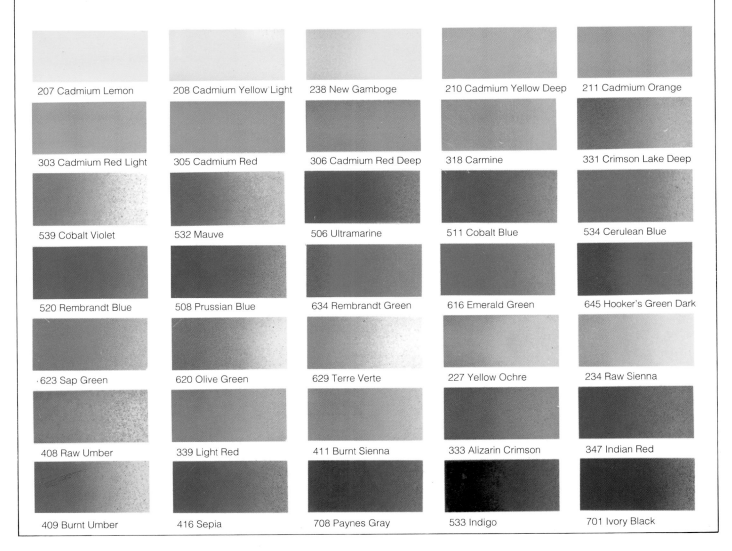

207 Cadmium Lemon	208 Cadmium Yellow Light	238 New Gamboge	210 Cadmium Yellow Deep	211 Cadmium Orange
303 Cadmium Red Light	305 Cadmium Red	306 Cadmium Red Deep	318 Carmine	331 Crimson Lake Deep
539 Cobalt Violet	532 Mauve	506 Ultramarine	511 Cobalt Blue	534 Cerulean Blue
520 Rembrandt Blue	508 Prussian Blue	634 Rembrandt Green	616 Emerald Green	645 Hooker's Green Dark
623 Sap Green	620 Olive Green	629 Terre Verte	227 Yellow Ochre	234 Raw Sienna
408 Raw Umber	339 Light Red	411 Burnt Sienna	333 Alizarin Crimson	347 Indian Red
409 Burnt Umber	416 Sepia	708 Paynes Gray	533 Indigo	701 Ivory Black

Above. Essential to a good composition are the direction of the light (from the side in this case) and the position of the subject. As you can see, for the purpose of the exercise on the following pages, the light was provided by a table lamp.

Right. A cube, a cylinder, a sphere, and the necessary background drapery, form the basic elements of the subject. The sphere could be replaced by a tennis or ping-pong ball.

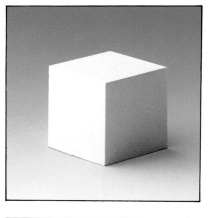

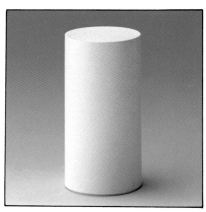

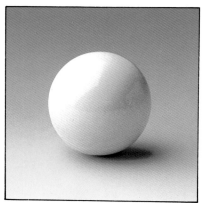

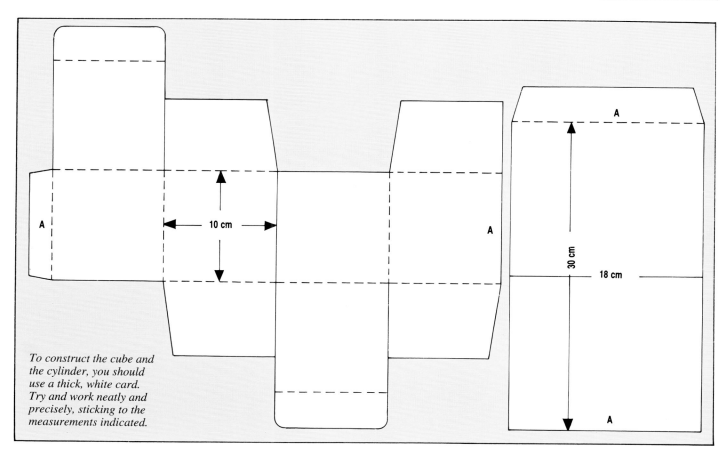

10 cm

30 cm

18 cm

A

A

A

A

To construct the cube and the cylinder, you should use a thick, white card. Try and work neatly and precisely, sticking to the measurements indicated.

Two-tone study

A two-tone watercolor study is the subject of our next practical exercise. Our subject will be a cylinder, a cube, and a sphere, arranged as a still life on an attractive piece of drapery. And, we repeat, we are only going to use two colors. These two colors will actually become four: The Prussian blue and the carmine we intend to use, when mixed, become black (see the illustration on the right) and, if you add to the equation the white of the paper, you can see that we have four colors with which to work.

In fact, as shown in the illustration at the bottom of this page, the variety of tones obtained by mixing these two basic colors—Prussian blue and carmine—is extensive, so it would be fair to say that we are not going to be hampered by color limitations.

These are the materials we have used in carrying out this exercise:

- The colors Prussian blue and carmine.
- 10 oz. hot-pressed paper.
- Lead pencil No. 2.
- A soft eraser.
- Sable brushes, Nos. 8 and 12.
- Two water holders.

But before starting on the practical side of the exercise, let's study a few of the unavoidable preliminaries.

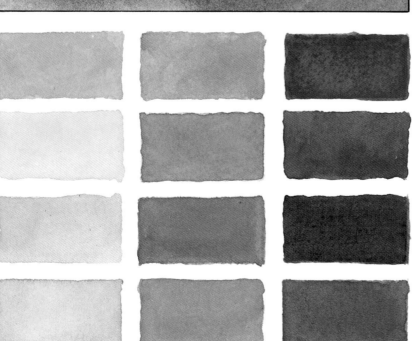

*Above, the two colors we are going to use: Prussian blue and carmine. In the middle picture you can see that by mixing the two colors you make black. **Below**, the range of possible colors if you mix the two in question.*

Besides the arrangement we have chosen, and that you can see at the bottom of this page, the variety of possible compositions is as unlimited as the imagination of the painter. On the left we have shown you two possible alternatives, as valid as the one you are going to begin shortly.

It is worth repeating that it is best to work from nature, studying directly the idiosyncracies of the subject. With this in mind, we are offering you the opportunity to construct these geometric shapes for yourself (the following page) and, therefore, to adapt the arrangement of these elements to suit your own preferred composition.

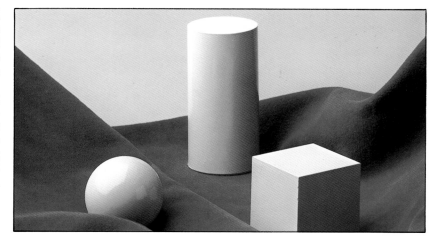

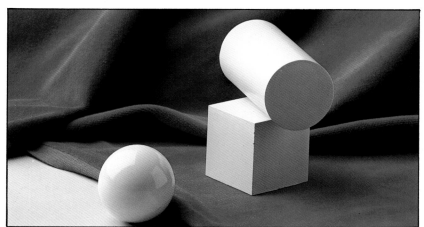

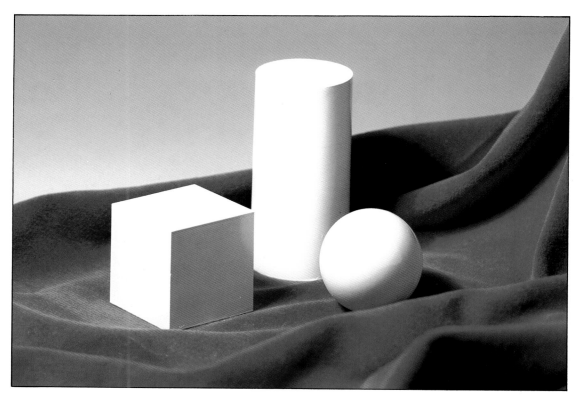

Here is the subject we are going to work on. Assess the balance of volume and the number of objects that make up the subject, the direction of the light, and the composition, trying to avoid excessive space between the objects as well as a feeling of ordinariness.

Construction of figures for the exercise

Using a fairly thick, white card, draw the plans illustrated on the previous page and, with a knife, cut out the shapes, following the measurements as accurately as possible. It is not a difficult job and it will allow you to create your own subject and to work from it directly.

First stage: Initial layout

Draw the subject without any shadow, as a simple line drawing, so that later there will not be any problems with proportion and perspective. Pay particular attention to the cylinder, the dimensions of which will serve as a guide for the other elements.

Second stage: General background

Dampen the surface of the paper and, when it has dried, dampen it again with the brush, avoiding the cube, the cylinder, and the sphere. Try not to go inside the outline of the geometric shapes, because otherwise the background color might filter in later on, making subsequent stages of the work more difficult. Without waiting for this layer to dry, paint in the general background with a wash of carmine and blue, using a little more carmine so that the color is warmer.

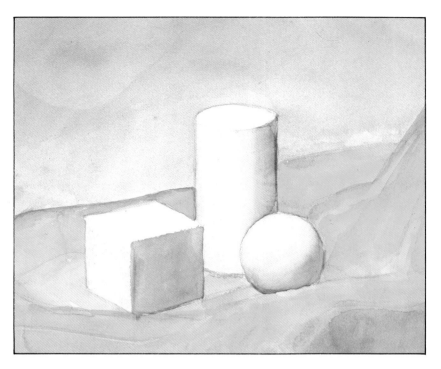

We have already mentioned one way of opening up white areas in a watercolor. However, it is more useful to determine these areas in advance, especially with small highlights. There are many ways of whiting out areas ranging from the application of masking fluid, which is removed when the picture is finished, to using sandpaper, synthetic brushes, a scalpel, bleach, the handle of the brush, or even a fingernail. We will go into some of these later on.

Third stage: Adding tone to the figures

Lay a light wash over the shape of the cylinder and then the cube and the sphere, leaving out the areas to be shaded. Then apply a darker wash to the areas in shade. If you tilt your drawing board, the excess color will accumulate at the bottom of the paper; take some of it up with your brush and then use it to gradate the shaded areas. We will turn later to the shadows cast by the objects across the folds of the drapery.

Fourth stage: Completing the picture

Concentrate now on the drapery, laying deep shadow in the folds of the cloth, generally darkening its color, opening up whites on the figures where you want to show highlights. Enrich the overall color of the painting, making subtle alterations of tone, adding a little more blue to the shade on the figures and the drapery. Sometimes it helps to apply just a few lines with a ballpoint pen to emphasize some of the sharper outlines. You will become familiar with little tricks, like protecting the white areas with masking fluid during the sketching stage.

So that's all there is to the two-tone technique. Practice whenever you can because in the next exercise we are moving on to painting with no color limitations whatsoever.

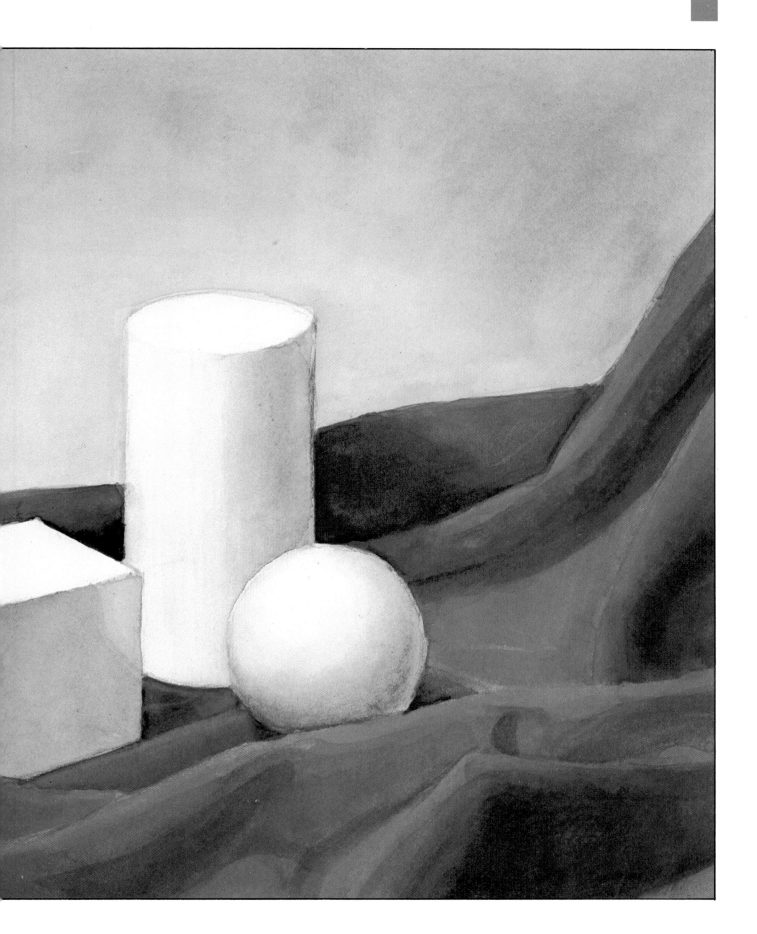

Watercolor painting in all its glory

Watercolor painting on dry and damp paper

Watercolor painting on a dry surface is simply a matter of painting with transparent color, defining the shapes of each part of the subject and using the white of the paper. Of course, this does not mean dispensing with gradation or softening of spherical shapes, or creating a strictly defined background area, which would rob a painting completely of any atmosphere.

Taking into account that watercolor applied to dry paper is easily absorbed, we have to work from light to dark, first of all filling in the pale areas—often more extensive—and going on to the darker ones. Really, describing this technique as painting on dry paper is just a way of distinguishing it from that of painting on a damp surface, which has some special characteristics. "Dry" watercolor painting is considered the traditional form.

To employ the "wet into wet" technique, we have to use damp paper, so outlines appear blurred or hazy. Naturally, all areas will be blurred using this method, even the background.

The damper the paper, the more the color will run and the greater the lack of definition. We are, therefore, obliged to control carefully the degree of dampness using the paintbrush or absorbent paper. Remember that when we talk about painting on *damp* paper, we are not referring to a surface covered with puddles of water.

The examples shown on this page represent the two styles. If you compare them, you will understand more clearly what we have been discussing.

Below.
"Marsh," by Aida Corina (First Prize at the 17th Autumn Salon in Madrid). Here is a good example of the wet-into-wet technique. The subject—marshes and mud-flats—lends itself to this technique, in which the blurred outlines combine perfectly with the sharply defined lines in the foreground.

Above, right.
A wash on dry paper shows a "seam" where the painting was not carried out quickly enough; and a wash on damp paper that has been worked on from light to dark. Unwanted "seams" are a problem when working on dry paper. Water is an essential ingredient when using watercolors.

"Dead Nature," Guillermo Fresquet, private collection. Fresquet, one of the best Spanish watercolor painters, presents this superb example of classic dry watercolor in which all of the subjects are delineated.

A still life in watercolors

At last you are going to paint using any color you like; no more restrictions. You can use your complete palette without having to stick to two or three primary colors as on previous occasions.

We have chosen the still life you see on the left, but this subject should not put you off doing this exercise. As long as you follow the basic procedure you can choose any subject you like.

First stage: Layout drawing

We have arranged the elements of the still life in a triangular composition. We have used dry paper and a range of warm colors, as you can see from the finished painting.

Being able to use any color does not oblige you to use them all. On the contrary, it is best not to go overboard with color and to restrict yourself to the range within which you are going to work.

First, make a rough sketch, then draw in the outlines in pencil, without any shadows. At this initial stage, establish which areas are to remain white.

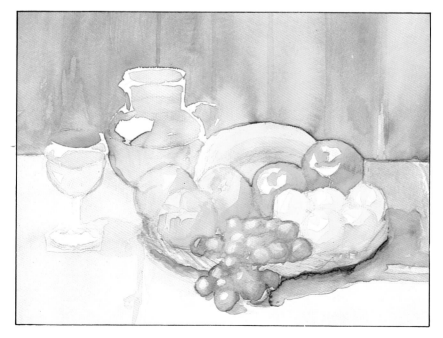

Second stage: Laying the tone in the main areas and the background

Using a No. 12 sable brush and with your working surface at 60 degrees (for those of you with an adjustable drawing board), fill in the background color and, varying the tone a little, the surface of the tablecloth and some of the larger areas of the fruit. It is worth deriving the tones of the other elements of the picture from the background color to produce a harmonious and uniform effect within a warm tonal range.

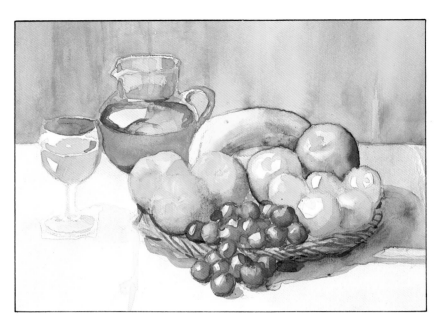

Third stage: Building up the picture
Paint in the rich colors of the fruit, flat and without shading, and the colors of the glass and the jug. Build up these areas, remembering to avoid the white areas. Soon the excessive contrast of the whites with the color around them will involve you in some touching up, softening of edges, and addition of further washes of color.

Fourth and final stage: Adjusting the tone and completing the picture
Tone in some of the whites by adding further washes. Strengthen the colors of the fruit and the basket and make any other necessary tonal adjustments. Sharpen the edges of the different elements, but not too severely, allowing some outlines to blend with the objects beneath them.

Before adding your signature, leave the painting for a day; you will always find some little detail that needs polishing up.

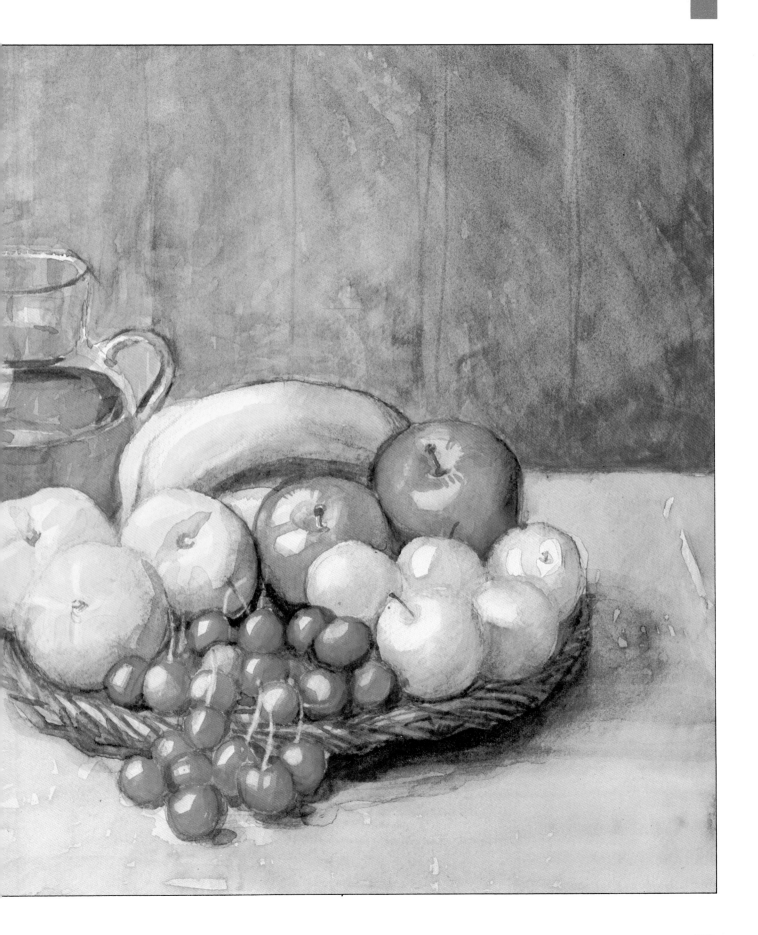

■ Two examples

Between the earliest watercolor painting described on the previous page, and the work of contemporary artists like that shown on this page, inevitable changes in the form, color and idiom of this type of painting have taken place, but the fundamental properties of watercolor have remained constant. The subject matter is the same: Landscapes, seascapes, portraits, figure studies, still life, and the artist's personal vision—impressionist or expressionist—of a subject, knowing that watercolor provides solutions to even the most technical demands of his work.

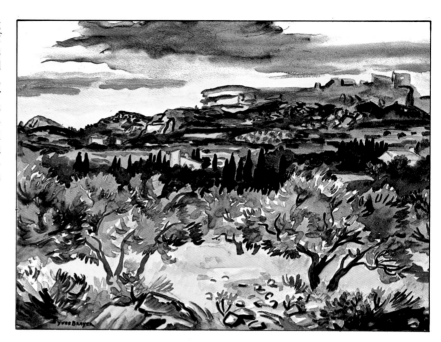

Right.
"Backlight in Baux-de-Provence," by Yves Brayer, private collection. Watercolor using a conventional color range.

Below.
"Landscape," by Julio Quesada, private collection. This Spanish watercolorist limits his palette to create a harmonious whole.

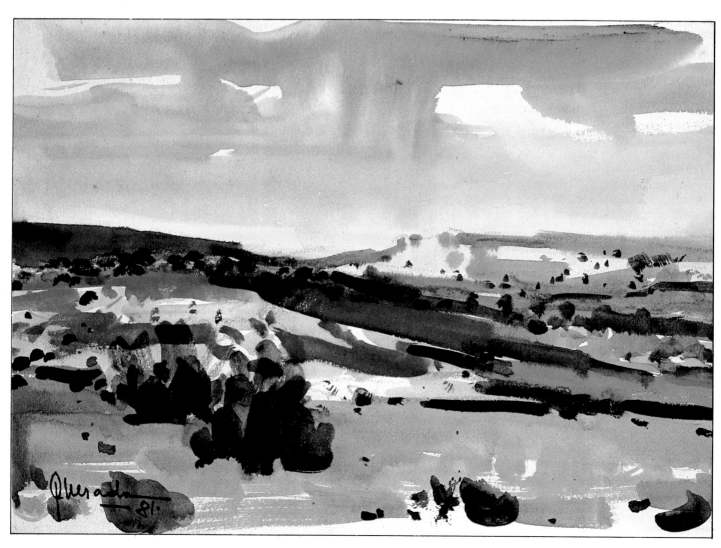

Watercolor painting. A seascape ■

In principle it must be assumed that every pictorial process is versatile. That process should be equally capable of expressing, in artistic terms, any subject: The human figure, landscape, seascape, still life, and abstract images. Generally, this is true. However, some media seem to have been invented with a certain subject in mind. This could be said in relation to pastels (considered by many to be the ideal medium for depicting the female nude) and something similar to watercolors, which seem to have been designed especially for painting seascapes. It is possible that this arises because the artist, without realizing it, associates the transparency of the medium with the transparency of water. By seascape we mean every kind of landscape in which water plays a prominent part: sea scenes, lake and river views, and so on.

If you paint with watercolors, however infrequently, the chances are that sooner or later you will find yourself painting a seascape.

So why not start right now? We invite you, by way of an introductory exercise, to follow the practical demonstration provided by Juan Sabater.

Preliminary studies

Looking at this scene, it is tempting to create from it a picture full of detail. However, the abundance of vertical planes and the strong contrasts created by the light inspired Ester Serra to consider an abstract vision of this subject, in terms of form and color. Because departing from detail to arrive at the essence of a subject is never a casual exercise, our artist made two preliminary studies: A monochrome drawing as a study of the basic structure and the contrasts between the various planes, and a watercolor study to try to achieve synthesis of color.

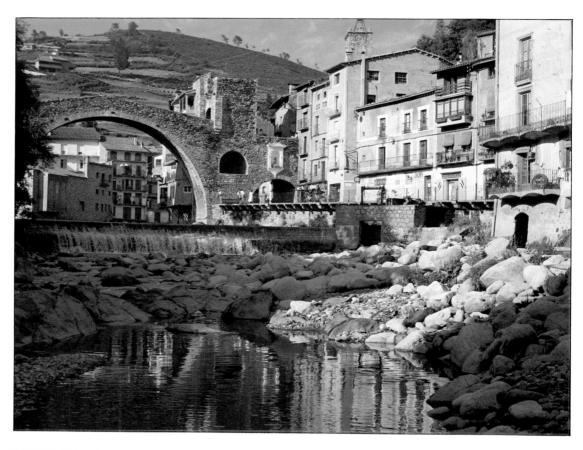

Right. These studies were produced by Ester Serra before she began the definitive version.
1. A magnificent study in which the basic forms have been described as simply as possible using marker pens and ink wash.
2. Close-up of the same study.
3. Watercolor study in which the artist worked out the main areas of cool and warm tones that constitute an abstraction from the real colors.
4. Close-up from the same study.

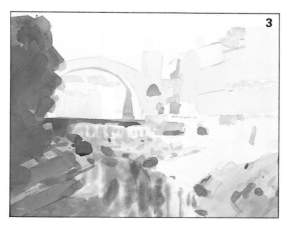

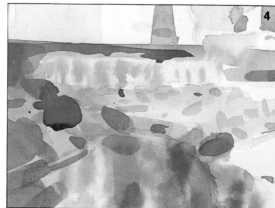

The outline drawing

On watercolor paper with a fine-grained texture, Ester Serra produced an initial sketch with a blue water-soluble pencil. Notice that, even at this stage, the objective is to reduce the drawing to the bare essentials, ignoring any unnecessary details—that is, anything that does not contribute to the fundamental structure of the subject. It is not by chance that a blue water-soluble pencil is used for the sketch. Blue being the predominant color of the subject, the fine lines and the soft tone applied in areas of shadow provide a good base color, once water is applied, and will not cause problems later. Apart from this, the pencil lines are water soluble, guaranteeing that the marks of the initial sketch will disappear once water color is applied on top.

Left. *Four close-up photographs of Ester Serra's work show the first washes being applied, and the effect of the water-soluble pencil marks on the sienna wash, which takes on a richer tone. Merely by applying clean water, a background wash is created. On the next page, you will see how to make the most of this possibility.*

The first washes

Using a lot of water and very little color, the artist blocked in the first washes. She used just two colors: Prussian blue and raw sienna. The blue wash contained hardly any color because, once applied on top of the water-soluble pencil lines, its color would be intensified. Although this is considered just the first stage of the painting process, note that the three main areas of tone have already been defined: Shadow (the blue areas), half-light (sienna), and sunlight, represented by the areas left white.

Right. These four close-ups demonstrate the process described on the next page, in which the artist accentuates contrasts through a two-color operation. The right hand pictures correspond to the stage just completed, in which the pencil markings are still visible, and the other two show the same areas of the painting after more color has been added.

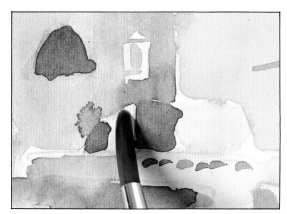

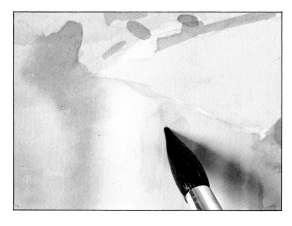

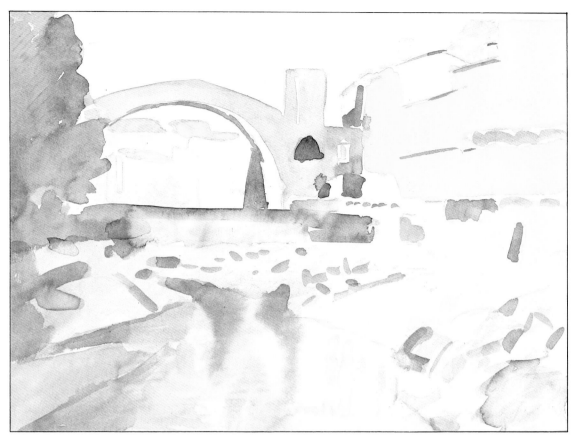

Emphasizing contrasts

The decision to include nothing but bare essentials led the artist to concentrate on tone and volume. She thought, quite rightly, that this would make the later job of introducing a more descriptive element much easier. If you turn back a couple of pages and look again at the first watercolor study the artist produced, you will see that she has returned to her point of departure, in which the most illuminated areas are not left white (as in the previous stage) but have taken on a shade of yellow ochre, giving them a more luminous quality.

Left. From the stage just described, Ester Serra used the wet into wet technique to develop her painting, as you can see in these four photographs. In one of them you can see her soaking up color with a piece of absorbent paper towel.

Richness of color

Working wet into wet, Ester has enriched the color in each part of her painting, thinking always about the intention of every brushstroke. However, it is important to realize that in this landscape, which we have described as abstract, the brushstrokes enrich the color but do not actually describe form. You can see in the close-ups below, as well as in the finished picture, that these strokes of color are abstract forms located within previously drawn limits (either spreading beyond them or not quite covering them completely). Their only purpose is to create a series of visual effects or impressions of color that, seen as a whole, suggest what they represent in reality. What we have here is not *that* landscape; it is an image of it, an abstraction from what we actually see with our eyes.

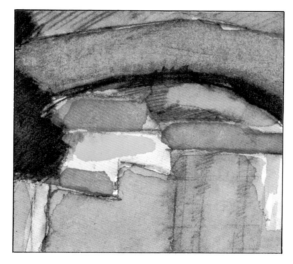

Right. Close-ups showing clearly the purely chromatic value of certain areas of color. They have been treated as abstract forms that, within the unique context of this painting, suggest the color of light on a wall or a roof . . . or (in the second close-up) mobile reflections and their relationship, in terms of color, with the objects that create them.

220

Three examples

On this page we reproduced three watercolors that represent different levels of abstraction.

1. There is practically nothing linear in this watercolor by Ceferino Olivér. Light stands out above all from this vision of reality.

2. The ability to convey a great deal with few resources is a sign of a great master. The watercolorist Fresquet is able to go beyond material reality and paint pure atmosphere: It's hard to be more abstract than that!

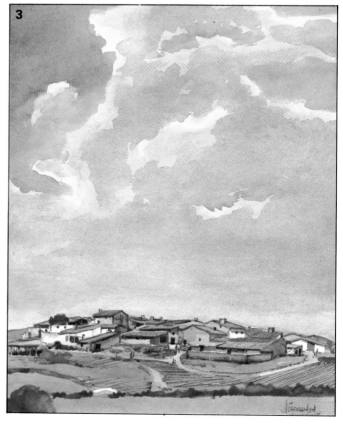

3. José M. Parramón gives us a lesson in his highly personal style on how to achieve synthesis and harmony. Take away the pen strokes and white areas from this landscape and there would be nothing left.

Watercolor. An abstract landscape

Some people who enjoy *looking* at works of art, as opposed to creating them, tend to be disdainful of any work whose main characteristic is simplicity and economy or harmony of style. They say things like: "A child could have done that" or, "Since when is the sky *that* color?" and again, "Anything is called painting these days; four blobs on a piece of paper and they tell you it's a landscape." Words like these suggest that the speaker has a very narrow idea of what a work of art should be; or perhaps it would be fairer to say that people like this have not reached an intuitive sense of what Art (with a capital "A") really is and what it means to our society.

In case you are not convinced, we have asked Ester Serra to show us, by means of a watercolor painting (a landscape, to be specific) that it is not easy to synthesize artistic expression, to achieve an abstract vision of the chromatic and formal values of any subject. It requires skill, and understanding abstraction should be considered an essential ingredient of true artistic creativity.

The color range

Sabater tends to use few colors in his work, although he does explore every possibility afforded by his limited palette. Watercolors, with their characteristic luminosity and transparency, are perfect for this style of painting. By mixing them on the palette, or by laying successive washes on the paper itself, working in dry or wet, our artist found that the four colors shown below were all he needed for his interpretation of the subject.

Range of four colors chosen by Sabater and the possibilities offered by different color mixes, by working wet into wet, or by going over dry areas of color.

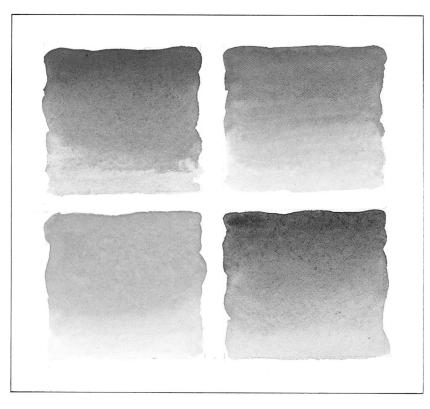

Charcoal sketch

On a sheet of water-color paper, Sabater has drawn a charcoal sketch, using stronger lines than usual to distinguish the forms very clearly. Once he is satisfied that the sketch is accurate, he dusts the surface of the paper with a cloth so that only the faintest guidelines remain. They provide a reliable guide to the outline of each form for when he starts to apply color.

Two close-up photographs showing the faint guidelines of the charcoal sketch and the first application of the Prussian blue wash. These pictures correspond to stage 2, which is described on the next page.

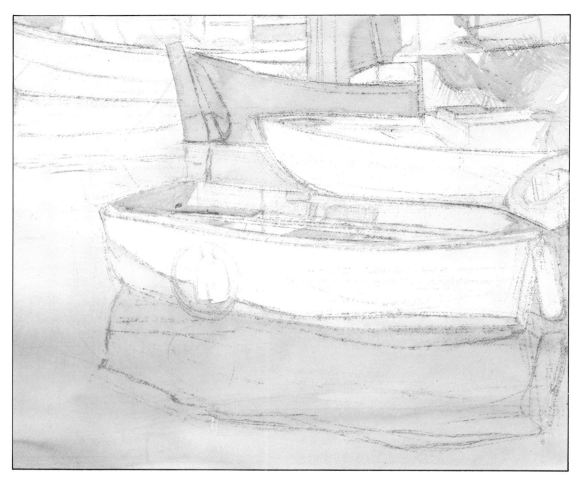

The first wash

With masking fluid, Sabater has masked out the main areas to be left white (mainly on the boats), so that he can freely apply the first washes of color. The initial wash is a general layer of Prussian blue, deeper towards the foreground and on the boat near the back of the picture.

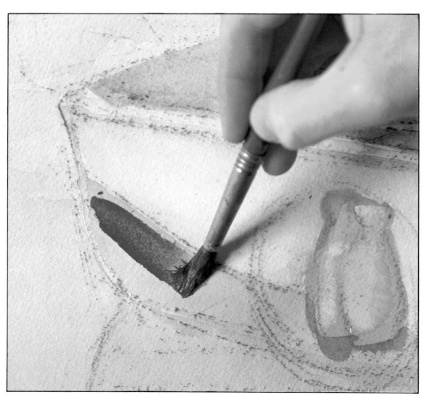

Building up color

Describing the various actions of the artist during the execution of a painting is very difficult, not only for him but also for anyone trying to translate his thoughts into the written word.

We will try to sum it up: After completing the previous stage, Sabater began to define the tones (especially the reds and blues) of the most important parts of the picture, either by filling these areas with color, or by containing them within surrounding areas of color. On top of the first blue wash, several new layers have been applied, adapting the initial color to indicate reflections in the water.

Where the reflections are, the colors of the boats have been added to the basic blue, creating earthier, less pure tones.

These stages are shown in the close-up photographs on this and the next page, where you can also see an overall view of the painting at the end of this stage of its development.

 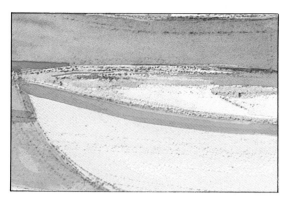

Outlining in red the upper edge of one of the boats. This is just to establish the color that will be built up at a later stage.

Thin layer of sepia applied beneath the boat in the foreground, indicating its reflection. This area has been applied with a large, flat brush on top of the blue background, which by now is almost dry.

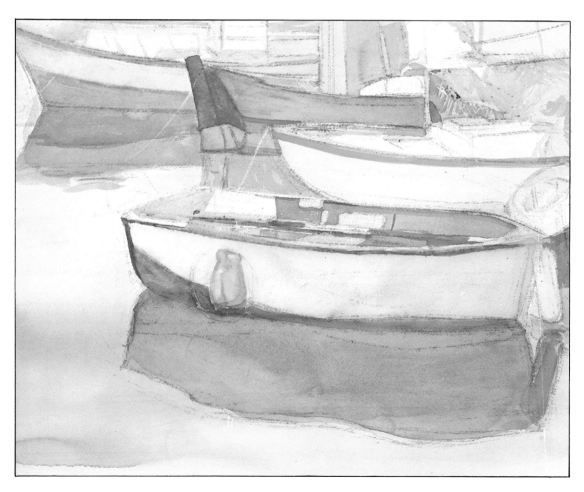

This picture shows the watercolor at the end of the stage we just described. Notice that the first layers of color are intended to define the basic colors of the boats and their reflections, and to locate and define the various forms. Now that everything is in its place and the main areas of color have been blocked in, it is time for the completion. Let's turn to the next page.

Completing the picture

Further layers of color have been added on top of the basic tone to emphasize the darker areas. Sabater, remembering the technique of the great masters of the baroque era, has worked patiently and subtly, altering shades and tonal values with successive applications of delicate color. This enabled him to create nuances of tone within each of these dark areas, so that when seen as a whole, they lend a vibrancy to the painting that areas of uniform color would not achieve.

At this stage, the artist has removed, using an eraser, the areas protected by masking fluid. Sabater subsequently ran a delicate wash over these areas to make them less harsh. If you compare the finished work with the last photograph on the previous page, you will see that the colors of the objects themselves have been intensified and the reflections have been built up with brushstrokes of cool color, taking care not to destroy the luminosity of the few warm patches.

Close-up showing the flat brush applying a layer of deep carmine on top of the previous tone in one of the reflections.

Using an eraser, remove the sticky gum formed by the masking fluid you applied earlier to preserve the whiteness of certain areas from the successive color washes.

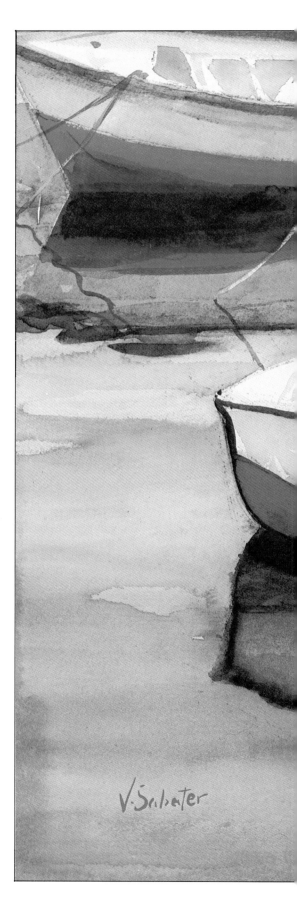

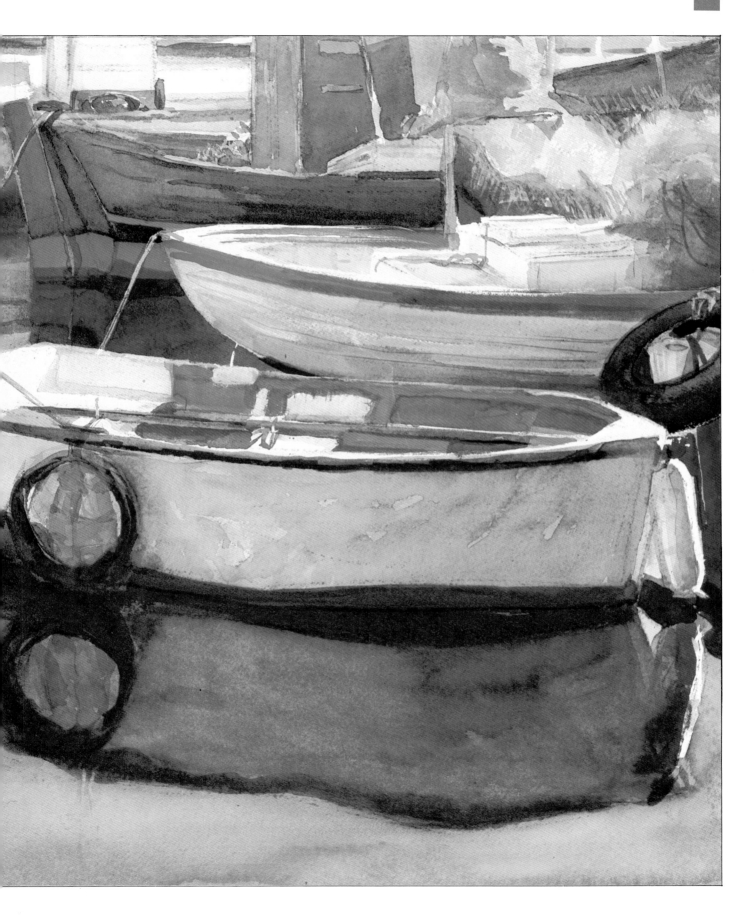

Two examples from masters of the medium

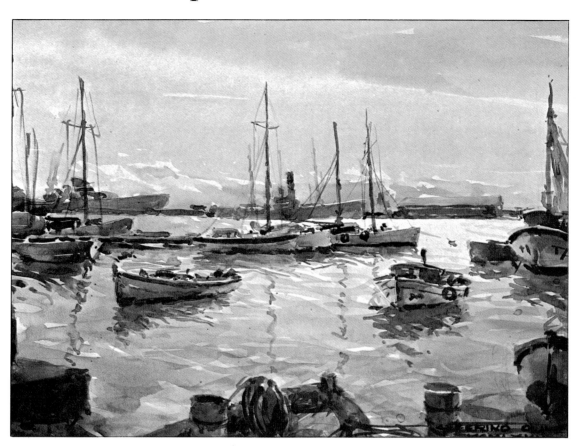

Study and admire these two seascapes. Though separated in time, both offer important lessons in the masterly exploitation of the transparency of watercolor.

Left. "Light (in Castellon)," painted by Ceferino Olivér in 1978.

Below. "St. Paul's Cathedral" by John Sell Cotman (1782–1842), one of the greatest English watercolorists of the 19th Century. In both examples, all the qualities of watercolor have been exploited in order to convey to perfection the transparency of water.

Painting in oils ■

The moment has arrived to turn our attention to oil painting. For the remainder of this book we will concentrate on introducing you to oils. You will find many more detailed analyses in other volumes dedicated exclusively to this pictorial medium. Why are oils often considered the highest form of painting? At least, artists who have mastered the medium tend to hold this view; they say that there is nothing as gratifying and complete as oil painting for expressing feeling and reflecting all aspects of nature. Of course, watercolorists put forward a few solid arguments contradicting this theory.

What is certain is that oil painting offers an almost infinite range of possibilities; the majority of the greatest painters since oils were first used have worked in this medium and many novices to the world of painting have started out in oils.

We are going to look especially at the practical aspects of oils, sharing some of the information gleaned from the experience of experts. For us, the practicalities include such things for example, as knowing that no other blue has the same luminous quality as cobalt blue; and that today you can buy synthetic brushes worthy of comparison with traditional hogs' hair ones, at considerably lower prices. But theories and tricks of the trade are meaningless if you do not follow the advice of the old saying:

Practice makes perfect

In other words, you have to get out there and work. Paint, set up your easel and canvas, and learn about the consistency of the colors and their combinations; discover which is the best frame for that seascape or this portrait; make mistakes and start again as many times as is necessary. It's the only way. We can promise you that the satisfaction you will gain from this fascinating medium, once you have come to grips with some of its techniques, will repay you with interest for the inevitable frustrations of the learning process.

Materials

SURFACES FOR OIL PAINTING

1. Cotton duck (notice the knots in the weave).
2. Linen, darker than cotton and with a more uneven weave. This is the best surface for oil painting.
3. Coarse hessian. Some painters still use this, in spite of its disadvantages.
4. Primed cotton duck.
5. Standard quality primed linen.
6. Fine artists' linen, an inspiring surface.
7. Cotton-duck mounted onto board.
8. Hardboard (rear).
9. Plywood.
10. Oak wood (other types of wood may be used).
11. Primed board or card.
12. Cotton-duck mounted onto board with acrylic primer.
13. Thick cardboard (prepared with a single coat of glue size or by rubbing with a garlic clove).
14. Colored drawing paper.

No.	Portrait	Landscape	Seascape
1	22 × 16	22 × 14	22 × 12
2	11 × 19	24 × 16	24 × 14
3	27 × 19	27 × 16	27 × 16
4	33 × 24	33 × 22	33 × 19
5	35 × 27	35 × 24	35 × 22
6	41 × 33	41 × 27	41 × 24
8	46 × 38	46 × 33	46 × 27
10	55 × 46	55 × 38	55 × 33
12	61 × 50	61 × 46	61 × 38
15	65 × 54	65 × 50	65 × 46
20	73 × 60	73 × 54	73 × 50
25	81 × 65	81 × 60	81 × 54
30	92 × 73	92 × 65	92 × 60
40	100 × 81	100 × 73	100 × 65
50	116 × 89	116 × 81	116 × 73
60	130 × 97	130 × 89	130 × 81
80	146 × 114	146 × 97	146 × 90
100	162 × 130	162 × 114	162 × 97
120	195 × 130	195 × 114	195 × 97

STANDARD INTERNATIONAL MEASUREMENTS OF CANVAS STRETCHERS (IN CM.)

Above. *The horizontal and vertical proportions of stretchers of the standard formats, Figure (F), Landscape (L), and Seascape (S).*
Left. *Canvas mounted on a number 12, figure-format wooden stretcher.*

Below. *Complete range of hogs' hair brushes, from numbers 0 to 24. The real size of the brushes has been reduced in this illustration, so a No. 16 brush would, in reality, be approximately the size of a No. 24 shown here.*

Left. *Palette knives have wooden handles and steel blades. The blade is flexible, round-ended, and has no cutting edge. These tools are used for erasing (scraping paint off the canvas), for cleaning the palette, and also for painting, in the place of brushes. The mahl stick (top of picture) is a length of wood with a little ball at one end that is placed gently on the picture and used as a rest for the hand when painting small details.*

0 1 2 4 6 8 10 12 14 16 18 20 22 24

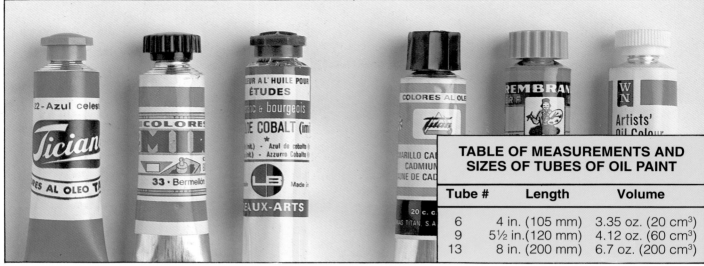

TABLE OF MEASUREMENTS AND SIZES OF TUBES OF OIL PAINT		
Tube #	Length	Volume
6	4 in. (105 mm)	3.35 oz. (20 cm³)
9	5½ in.(120 mm)	4.12 oz. (60 cm³)
13	8 in. (200 mm)	6.7 oz. (200 cm³)

Most frequently used oil colors

You will probably have seen some of the extensive color charts offered by manufacturers. You will have seen them and been confused by the number of colors and tones to choose from.

Each artist has his or her preferred range of colors—there will always be someone who will not use any but Naples yellow—but the fact is that most professionals since painting began have worked with no more than ten or twelve basic colors, as well as black and white. On the left is a fairly typical selection.

From this range, if we had to leave out four, we would opt for cadmium yellow, burnt sienna, permanent green, and black. Black can easily be made from Prussian blue, alizarin crimson, and burnt umber.

Depending on the dominant tone of his subject, the artist can put together his palette using one of these ranges: Cool colors, warm colors, or subdued colors. We will look at these in more detail in the following pages.

Above. Tubes of oil paint from different manufacturers. The three on the right are professional quality and those on the left are from the students' range.

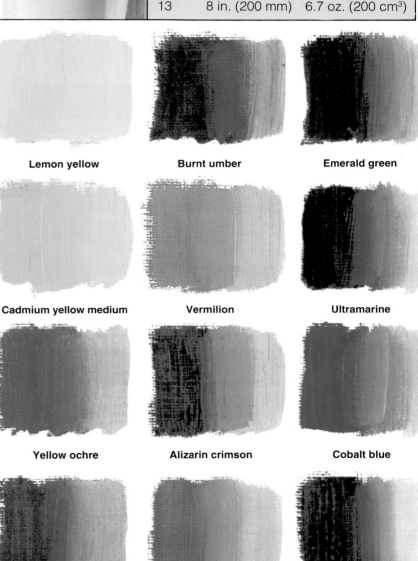

Lemon yellow	Burnt umber	Emerald green
Cadmium yellow medium	Vermilion	Ultramarine
Yellow ochre	Alizarin crimson	Cobalt blue
Burnt sienna	Permanent green	Prussian blue

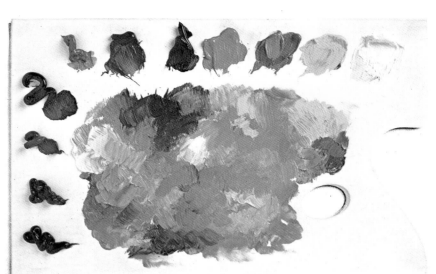

Warm color scale

This consists of yellow, ochre, red, burnt umber, alizarin crimson, permanent green, emerald green, and ultramarine blue.

We have left cobalt blue and Prussian blue out of this range, although these, or any other color, may be introduced into a warm color scale. By warm colors we mean all those with a chromatic tendency towards red, yellow, orange, ochre, and sienna. But these colors may be mixed with blues, greens, and violets to darken tones or to paint shadows and half-light—to "dirty" the picture, as Titian put it.

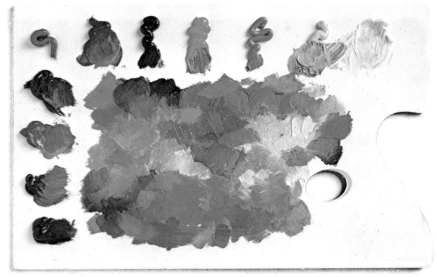

Cool color scale

Basically, this consists of Prussian blue, ultramarine, cobalt blue, emerald green, permanent green, alizarin crimson, raw umber, and yellow ochre.

A cool scale need not necessarily be blue, as Degas and other great artists have demonstrated in their works. However, the overall tendency in the painting must be bluish, even in flesh tints.

On the next page you can see some examples of famous paintings in which the chromatic tendency is quite obvious.

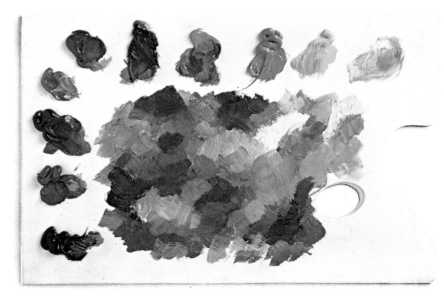

Subdued color scale

Subdued colors are the result of mixing complementary colors with white. For example, a green and an intense red. The result can be a brown, a khaki, an ochre, a green all toned down, or "dirty" colors.

The more equal the proportions of each complementary color, the darker the mixture will be, and the more white added, the grayer the result. Subdued colors may be predominantly cool or warm. No shade is excluded from this palette.

The method to follow

It is logical that, before starting on a painting, the artist will spend some time (though this is never wasted) contemplating the subject at some length, discovering the nature of it, deciding which details to explore and which to ignore, which contrasts to emphasize, how to interpret forms and colors; in short, seeing in his mind's eye the finished painting.

Normally, this stage is complemented by a preparatory sketch, although the controversy surrounding this point is as old as painting itself. Is it better to start with a sketch, or to go straight into the painting itself? The "colorist" school (painters who use very little shadow, differentiating between objects purely by color) tend to work directly, while the "tonalists" (those who work with light and shade) begin with a sketch.

If we may offer some advice, we suggest an intermediate course between the two extremes—make a very quick sketch, just as a pointer. Of course, a lot will depend on how confident you are in your own ability. Perhaps Van Gogh, Cézanne, or Manet would not have restricted themselves in this way, but as beginners they undoubtedly took similar precautions before beginning a painting.

First stage: Layout sketch
Start with a charcoal sketch, keeping the lines simple because if the sketch is too detailed, you will need to use fixative. Charcoal will dirty the color and it is worth fixing if you have been liberal with it in your initial sketch.

Second stage: Setting the tone
The color is blocked in, without any detail. The objective, at this stage, is to cover the surface to obtain an overall picture.

Third stage: Building up color and form
Once the general tone has been blocked in, the third and longest phase begins. Gradually, and working on all parts of the picture simultaneously, the color is adjusted and the contrasts of light and shade are clearly established. This stage is really about the artist creating the "atmosphere" he wants in his painting (illustration at top of next page).

1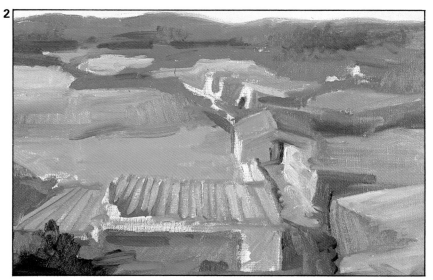

2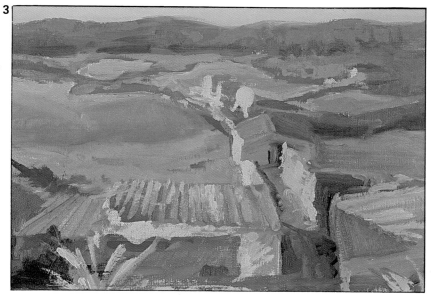

3

4

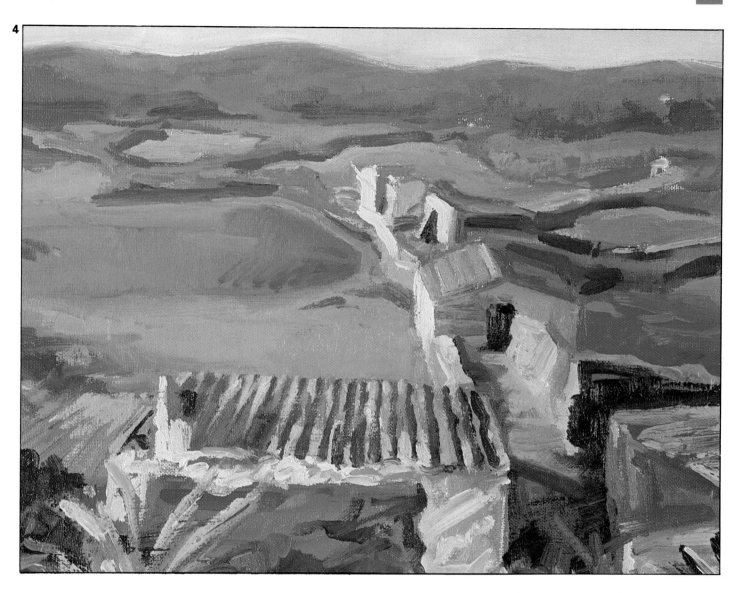

Cleaning is basic in oil painting. Get accustomed to cleaning your brushes and palette frequently with the help of a solvent, old newspapers, and rags. Wipe the brush various times over the newspapers, soak it in a solvent, and clean it with a dry rag. Repeat this process until the brush is paint-free.

Fourth stage: Completing the picture

Finishing a painting is always a compromise between the artist and the work itself. It is difficult to pinpoint the moment when you feel that a particular brushstroke is one too many. In general, the last touches should merely accentuate a color or contrast in the foreground of the picture. Each artist has his own style and, in the case of our example, it is clear that the final, vigorous strokes have considerably enriched the foreground of this landscape.

Three examples

"Field with reaper" by Van Gogh (1889), oil on canvas. This superb painting uses a warm range of colors; it paints more than a thousand words.

THE WARM COLOR SCALE
Greenish-yellow, yellow, orange, red, carmine, purple, and violet.

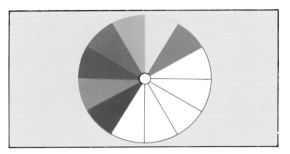

"The Soler family" by Pablo Picasso (1903), oil on canvas. It would be hard to find a more masterly use of the cool color scale than in this work by Picasso.

THE COOL COLOR SCALE
Greenish-yellow, green, emerald green, cyan blue, blue, ultramarine blue, violet.

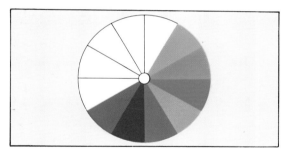

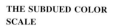

"The bridge over Calle Marina" by José María Parramón (1973), oil on canvas. A gray day and a gray subject, captured with exceptional skill by Parramón; this provides an excellent lesson in the use of subdued colors.

THE SUBDUED COLOR SCALE
This consists of a mixture of complementary colors in varying proportions in combination with white.

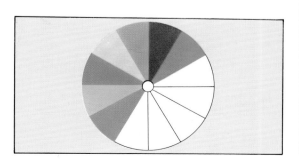

238

Oil painting

Probably one of the easiest questions about oil painting to answer relates to the usefulness of still life painting as part of the learning process. There are many excellent reasons why great painters through the ages, right up to and including the present, have chosen the still life over and over again as a theme for their works. Here are some of them:

• Van Gogh once described the still life as one of the best methods of learning and teaching the art of painting. Cézanne went further, describing it as an ideal vehicle for trying out various combinations and compositions of everyday things—fruit, comestibles, commonplace objects—using them to develop visual perception, an awareness of composition and of how to construct a painting as a harmonious whole.

• Painting a still life involves choosing the subject for oneself as well as the objects or elements contained within it.

• It also involves arranging those elements to form an agreeable and original composition, taking into account lighting, contrasts, harmony of tone (by varying the objects and their color and positioning), the intensity of the light, and so on.

• Painting at home, in the studio or workshop, without an audience and with all the creature comforts, allows the artist to concentrate and experiment, to look at all the effects and possibilities of form, color, style, and execution—in a word, to develop his potential.

• Once the artist has passed through this apprenticeship as a still life painter, he is able to take on any other subject with every likelihood of success.

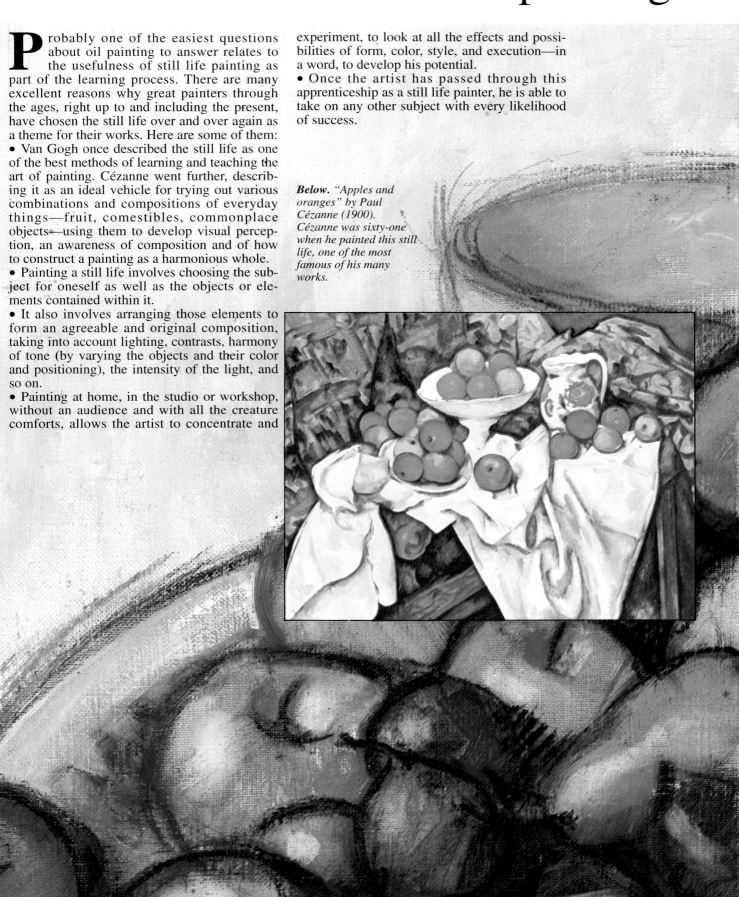

Below. "Apples and oranges" by Paul Cézanne (1900). Cézanne was sixty-one when he painted this still life, one of the most famous of his many works.

A still life. A little bit of history

Caravaggio, father of the still life

It was the year 1596 when a twenty-three-year old Italian painter called Michelangelo Merisi "da Caravaggio" (his native village) arranged a few bunches of grapes, an apple past its best, some figs, some pears, and a peach in a wicker basket.

Caravaggio made history when he painted this subject: It was the first true still life recorded in the history of painting. After Caravaggio, the still life was frequently used as a theme by many great masters: Velasquez, Rembrandt, Rubens, Ribera, Zurbarán, Murillo, Chardin, Delacroix, Renoir, Van Gogh, Manet, Monet, Picasso, Dalí.

And Cézanne.

Cézanne deserves a separate mention; it is not without reason that he is considered the most important still life painter of modern times. It is worth making a long, almost religious study of Cézanne's still life paintings— any of them—to learn from the apparent disorder of the elements in each picture. It is only apparent disorder, for, in fact, Cézanne spent hours and hours of study on each work before he arrived at the perfect composition.

Cézanne and the Impressionists, just like Picasso, Velasquez, Murillo, and all the others, based their work on an idea hit upon in 1596 by the young "da Caravaggio" when he arranged a few pieces of fruit in a little wicker basket.

*"**Basket of fruit**" by Caravaggio (1573–1610), Pinacoteca Ambrosiana, Milan. This is the first recorded still life in the history of painting. There may have been other earlier attempts, but never with the intention of making the pieces of fruit themselves the theme or reason for the painting.*

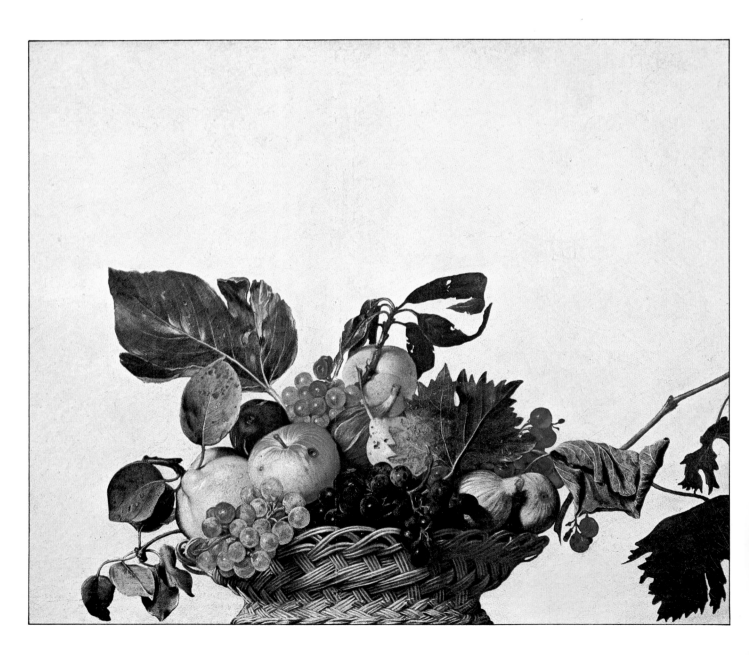

The still life. Preparatory steps

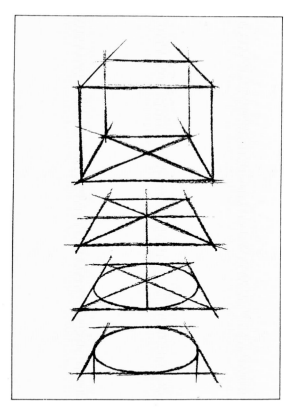

Get used to reducing figures to geometrical shapes. They will be extremely helpful when you create an outline for your painting later. Continue to practice drawing freehand, without a ruler or T-square, the perspectives of a square, a cube, and a circle. The illustration to the left shows the first step our artist took to create the basic form of the pitcher.

The diagram below is the pitcher and cup's form in the still life we are about to paint. Both objects are objects of revolution that are first broken down into various circles placed at different heights within a square prism. Again, do not draw them with exact geometrical precision, but rather freely and according to how you think their perspective should be represented. The layout's perspective (the blue pencil lines) determine not only the pitcher and cup's outlines (the brown pencil lines) but also where their projected shading should be.

The construction of shapes

Be patient. The day will come when you are able to change and distort the laws of perspective, dispense with horizons, view-points, and vanishing points. Modern painting tolerates such bold moves; they are acceptable as long as the artist departs from a basis of proven and traditional experience. Then it is possible to start playing with the idea of a personal style, to get around the occasional rule.

But until that day arrives, keep asking yourself if you can draw a cube, a cylinder, or a sphere from memory. Do you think you can? Let's give it a try.

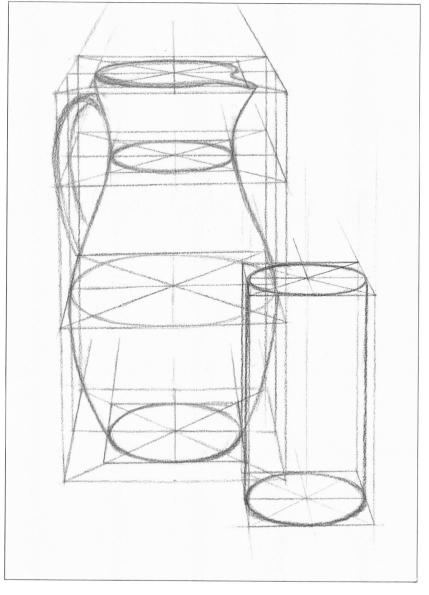

Evaluation of light and shade

We could describe light as drawing and painting objects, while shade explores their form and volume. To represent this volume, we draw or paint using color of varying tonal value and intensity. This evaluation is a fundamental part of drawing and painting.

The illustrations on this page may clarify these concepts. The objective is to see and understand, simply by observation and comparison, the different tonal qualities that make up any object. In fact, with just five shades of gray, plus black and white, it is possible to represent the entire tonal scale of our subject.

The depth or volume of any object is conveyed by a series of elements indicated in our illustration: 1. Light; 2. Reflections; 3. The "fade-out" of the shaded area; 4. Reflected light; 5. Half-light; 6. Shade on the object; 7. The projected shadow.

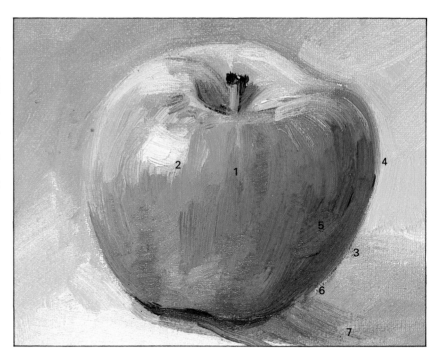

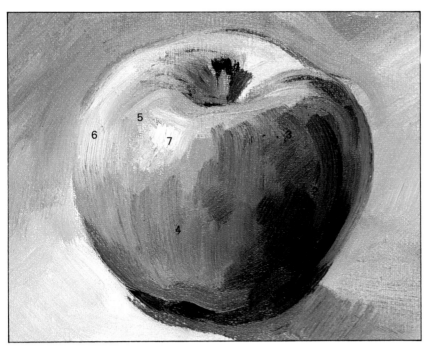

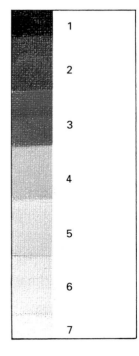

In this illustration you can see the variety of tones used to describe the volume of the object (look at the numbered scale). Try the same exercise using another subject, creating a tone scale similar to ours. Instead of an apple you could work with a different colored fruit, an orange, for example. It is likely that the darkest tone of an orange might correspond to number three on our apple.

242

The still life. Preliminary steps

Creating a pleasing composition that you are ready to paint requires nothing, in principle, other than undivided attention and a taste for hard work.

Composing a still life demands total dedication, trying out, looking at and comparing different combinations, arranging and rearranging until you are happy with the result.

Cézanne, for example, used to go back and forth from table to easel, looking at the model from every possible angle, moving elements from left to right, adding new ones, arranging folds in the backcloth, raising up objects in the central plane on boxes hidden beneath the drapery. This process could take hours, but when he finally decided he was ready to paint, nothing would induce him to change his composition.

We could learn a great deal from Cézanne's example.

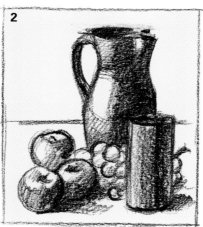

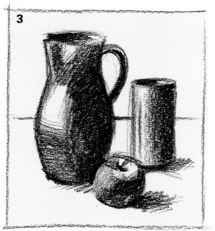

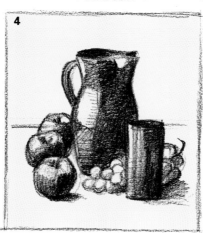

Above, left. *This first composition suffers from excessive uniformity (the elements are too close together).*

Above, right. *This time the jug is too far to the right and all the elements are too close to the edges of the picture.*

Below, left. *The third option is well-balanced, but too simple.*

Below, right. *Undoubtedly the best composition. It combines all the necessary qualities, providing interesting content while balancing effectively the rhythms of the composition and the volume of the objects.*

Using two set-squares made from black card, it is possible to frame and study the composition of your subject. It is also useful to make a couple of preliminary sketches in charcoal, sanguine crayon or with a soft, lead pencil (4 or 6B), working on paper of approximately 5 x 7 in. (12 x 17 cm).

In these sketches you can study the arrangement and proportion of the elements with respect to the picture area, the tone of the background, the light source, and so on.

Painting a still life in oils

The moment has arrived to leave the learning process behind. Have your palette, your canvas, and your brushes at the ready. We are going to start painting! Here is a photograph of the composition we have set up and, as you can see, the light is coming from the left-hand side.

Now stop thinking about the subject and prepare to copy our exercise, which we will describe in four stages.

First stage: Initial sketch
This layout sketch is made in charcoal. It should be a quick, loose drawing, outlining the composition, the shapes and proportions. Once it is finished, the drawing should be fixed to prevent the black dust from dirtying the colored pigment.

Second stage: Background color
This subject does not offer a wide range of colors, with the result that depth and tone take priority. It is especially useful here to block in the first layer of color by means of the rapid application of complementary tones, diluted in a lot of turpentine; a few minutes later, and using slightly thicker paint, it will be possible to build up a light layer of tone all over the picture as shown in our photograph. This color brings life and vibrancy to the picture, at a stage in which we are experimenting with the tonal values which will be built upon later.

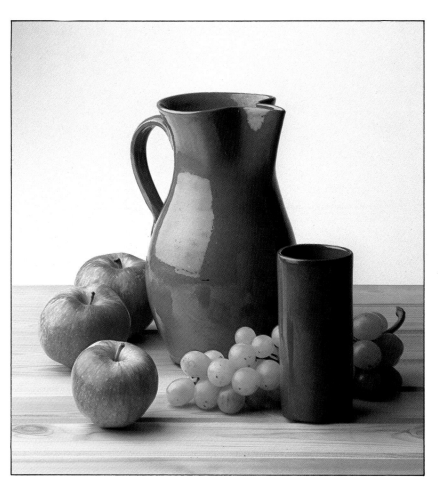

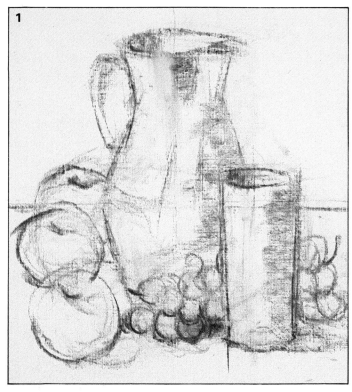

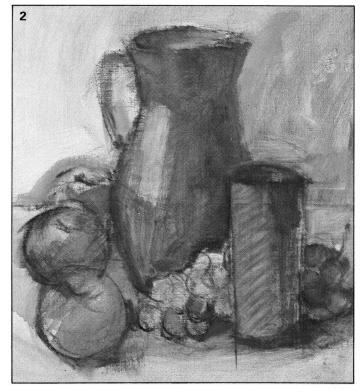

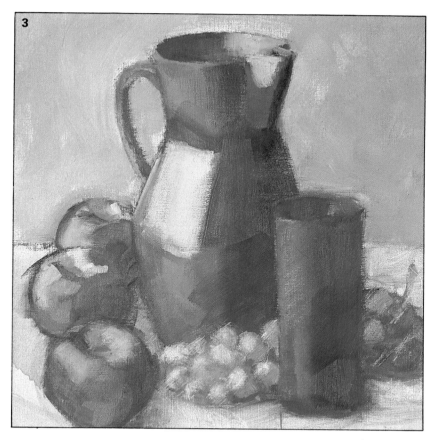

Third stage: Evaluation of light and color

By now the surface of the painting is totally covered with paint. Here we have attempted, without too many tonal variations and in a fresh and uninhibited way, to resolve color and tonal contrasts, emphasizing the sense of depth without detracting from the chromatic richness. Patches of almost pure color have been applied to the canvas, some mixed on the palette and some on the painting itself using light brushwork—see the apples, the bottom of the jug and the shading on the vase. In the close-up picture (below), you can see the contrast created by just a few touches of green and yellow on the reds, crimsons, pinks, and siennas of the apples. These touches also enhance the feeling of depth.

Fourth stage: Completing the picture

At this point it is important not to overdo the tonal variation or the general brushwork or the picture will end up looking contrived. During the third phase some parts of the painting were almost completed. Now, it is just a question of subtly refining outlines and the color of the background, the table and the fruit, making sure that no areas are left unpainted. Reflections are sharpened, some of the darker tones are strengthened, the harshness of the area of light on the jug is softened by making it pinker; finally, we take a look at the whole painting and decide that it is just right. We have achieved our objective.

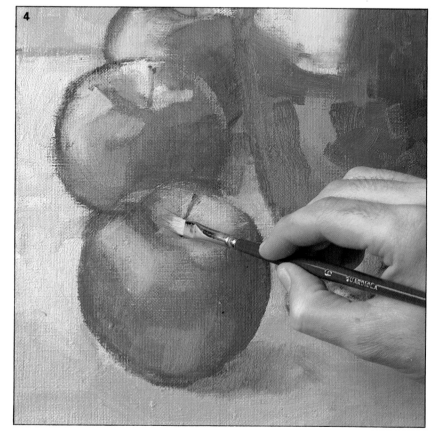

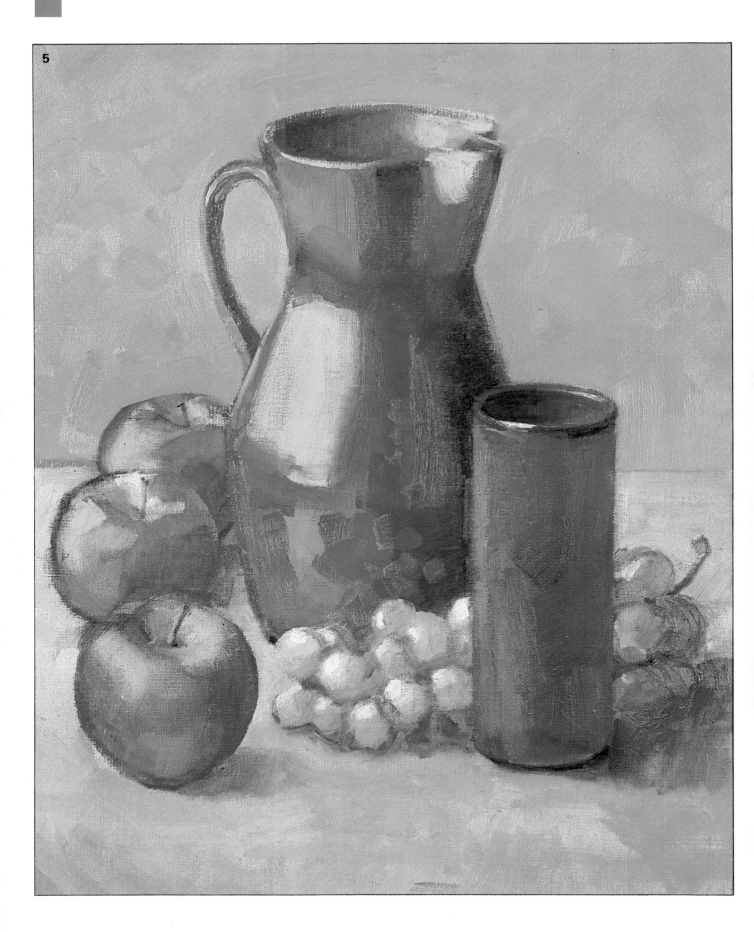

Landscape painting in oils

Methods and techniques

At this stage of our course, with a lot of knowledge and experience under our belt, we can begin to look at landcape painting. We are going to show you how one particular artist interprets this theme using oils. It is useful to study the work of artists who do not conform to the aesthetic principles some of us consider sacred.

We will be looking at a work by Juan Sabater to see "one" method of painting a mountain landscape.

"One" method of painting? Does this mean that "my" method is as valid as anyone else's?

It certainly does.

Nobody can deny the existence of many ways of perceiving a landscape (as a subject for painting) and nobody can dispute that the quality of a painting has nothing to do with the style of the painter.

But, however little you know about the history of landscape painting, you will surely acknowledge that the aesthetic principles that have dominated this century find their roots in the work of the Impressionists. So, although we cannot define a unique tendency in contemporary landscape painting, it seems fair and even necessary to point to their works when trying to orientate the novice painter. Put another way, any modern method of interpreting landscape that follows fundamentally traditional lines of approach can be useful to the student who wants to learn technically correct forms of expression. With time, and increasing artistic maturity, he will undoubtedly develop a much more personal style and technique through which to express himself.

Painting a landscape in oils

1. An example to follow

Our intention with this exercise is to offer you the opportunity to study an individual approach to a subject. With this in mind, take a canvas no larger than 18 × 13 in. (46 × 33 cm) and follow the steps taken by Juan Sabater in creating his painting, which we will call "Winter Landscape."

2. Layout drawing

With panoramic scenes in which there is no clearly-defined foregound, the initial sketch is, perhaps, more important than in other cases. Because there are no distinct forms, if the different areas of terrain are not mapped out at the very beginning it is easy to lose your way after a few brushstrokes. So trace out an initial charcoal drawing that will tell you, at any given moment, which area of the landscape you are working on. You can go over these lines with a fine brush using Prussian blue.

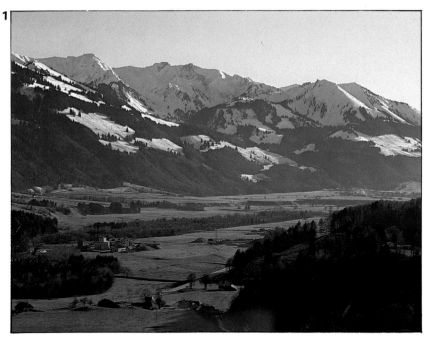

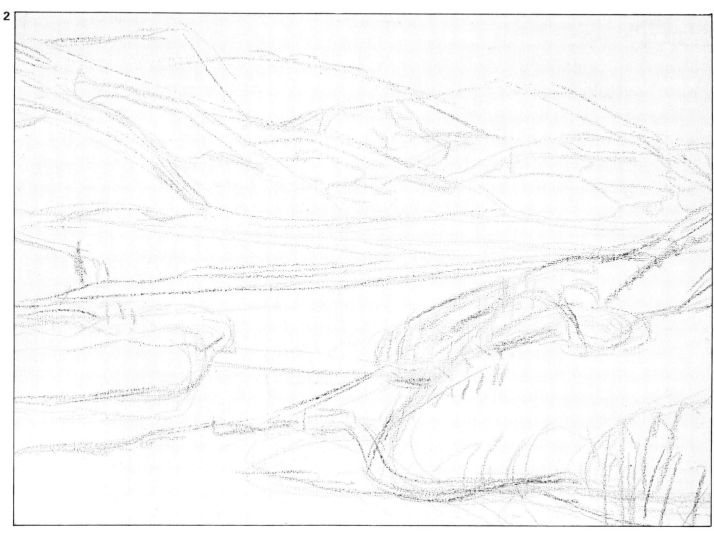

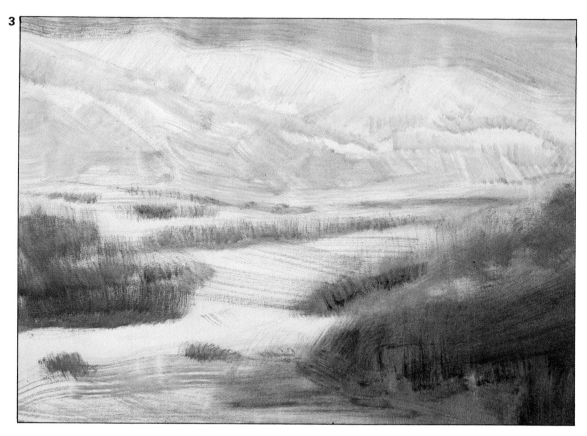

3. Initial color

Using a lot of turpentine and cool colors, begin, as Juan Sabater has done, to block in the darkest areas in the foreground. Although at this stage the exact color is not too important, you should try to maintain harmony of tone, more or less within the sap green or cinnabar green range, with traces of ochre and black. As for the mountains in the background, any muddy gray will do to suggest their initial structure.

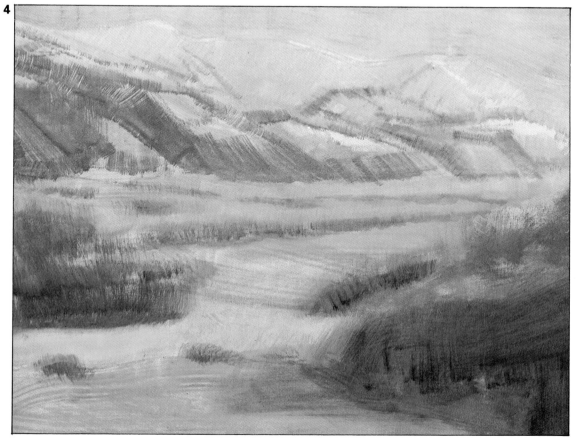

4. The first contrasts

On top of the previous stage, almost without touching the foreground areas, Sabater has introduced the warmer colors that provide the majority of chromatic contrasts in this winter landscape with its predominantly cool color scheme. Notice how atmospheric conditions begin to affect perspective: Cold tones become bluer as they recede from the foreground. The mountains, although without any clearly-defined color, have been described with a few structural brushstrokes, the direction of which is very important in Sabater's painting.

5. The build-up of color

Throughout this fourth stage, the color for each part of the picture has been mixed on the palette and transferred to the canvas with decisive brushstrokes. This part of the process has been divided into three close-ups and an overall view (following page). This is so you can see exactly how Sabater tones down the greens with black paint and, above all, the care he takes to ensure that each brushstroke follows the direction appropriate to the depth and form of the area he is working on.

5a. Close-up of the copse in the foreground, defined with dark, vertical brushstrokes, applied on top of the initial greens. See, to the left of the close-up, the diagram showing the proposed direction of the brushstrokes in each area.

5b. Now we move to the central foreground area. The trees continue to be painted with vertical brushstrokes, while the greenish ochres and other colors of the fields have been applied with horizontal strokes. Look at the diagram on the left of the illustration.

5c. The first undulations of the mountainous area, in which predominantly slanting brushstrokes are used (following the slopes of the hills). Notice how the colors become less and less intense as they fade into the distance.

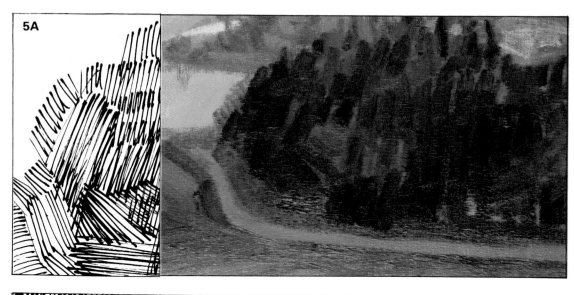

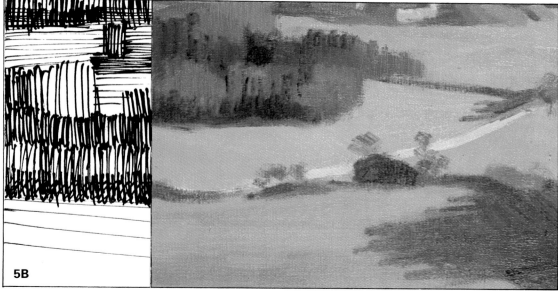

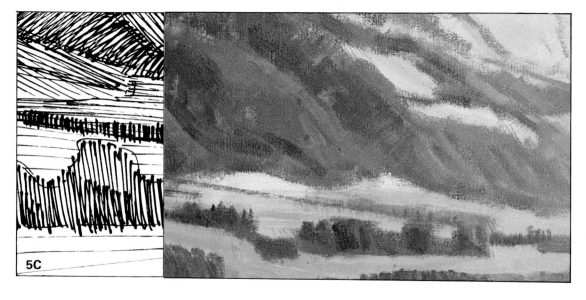

5

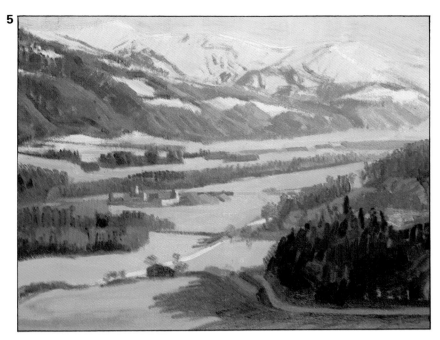

6. Final stage

If you compare the finished picture (below) with the smaller reproduction showing how it was left after the previous stage, you will find few, but significant, differences. Before allowing himself to feel completely satisfied with his picture, Sabater built up further layers of color on the brightest areas of the mountains to give a sense of depth; he also added a veil of cool color over the most distant meadows and, using white with a hint of blue, he brought out the sunlight sparkling on the snowy mountains.

Left.
Reproduction of Sabater's landscape before he decided to finish it off with a few touches to give it greater depth and luminosity.

Below.
The landscape completed to the personal satisfaction of our artist who is well-known for suggesting forms rather than going into minute detail.

6

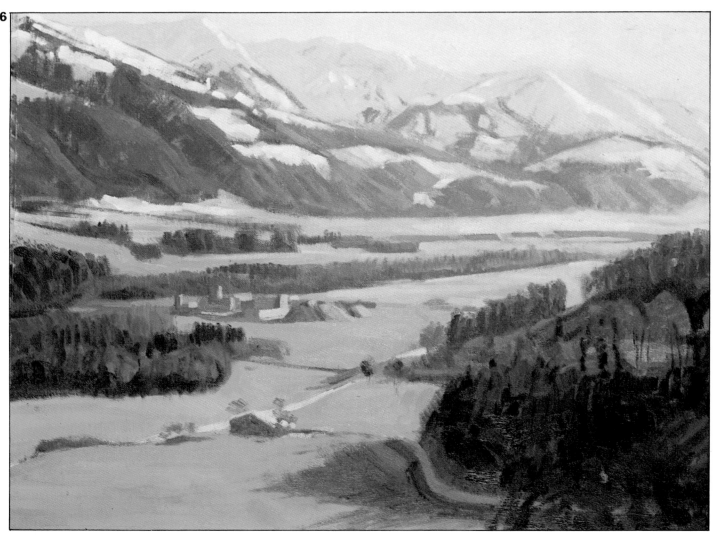

Landscape painting in oils. Study of trees

Pencil studies

In a landscape there are often trees and, frequently, one of them emerges as the focal point of the painting.

The problem for the inexperienced landscape painter lies not in painting *a* tree; it lies in painting *that* particular tree. As with all living things, no two trees are alike; this means that each one has its own personality, an individual character that the artist must be able to capture. The "personality" of a tree depends, basically, on its structure. It is the same with trees as with animals: There are certain characteristics common to each species, quite apart from which every individual has its own peculiarities that we must attempt to draw.

You will have to make dozens of pencil sketches like those on this page—or thousands, even, if you do not want to settle for mediocrity. Bare trees with intertwining branches, leafy trees with welcoming areas of shade, old, tortured trunks, and implausible root structures—you will need to study all of these and more.

Right. In your sketches try to establish the overall structure of the tree. Analyze its branch formation, which will determine the logical distribution of the various leafy areas.

Below. An old Mediterranean pine, clinging to a rocky slope.

Oil study

Alternating with your practice of pencil studies, it is beneficial to use bits of canvas or cardboard covered with latex primer in order to make lots of oil studies of trees. The process is summarized in these illustrations.

Dark areas

Assuming you have first made a good outline drawing in charcoal, block in, using diluted paint, the areas corresponding to the different groups of leaves as well as the trunk and the branches. Leave a few blank spaces to allow the sky to "filter" through the leaves. Use a mixture of Prussian blue and burnt umber, which will give you a very dark green.

Finishing the picture

On top of the previous stage, once the paint is almost dry, fill in the sky areas with a mixture of ultramarine and white. By adding yellow and ochre to the dark green used for the first stage, you can create a scale of three new greens that will allow you to define the different areas of foliage.

Left. Study of a tree by Juan Sabater, following the process described.

Above. Scale of three greens made with Prussian blue, burnt umber, ochre, and yellow.

Notice, in the close-up, the apparently carefree way of applying the brushstrokes—something the artist revels in. If you prefer a little more precision, that's fine too.

Three examples

Three examples illustrate some of the techniques developed by 20th century landscape painters.

1. "Harvest at La Crau" by Vincent van Gogh. Painted in 1888, this painting is considered a departure point for modern landscape painting.

2. "The big pine tree" by Paul Cézanne, painted around 1882. The shimmering pattern of superimposed brush-strokes remains a feature of contemporary landscape painting.

3. "Lady in a wood" by Giovanni Fattori, 1875. These "atmospheric" effects appeared in European landscape painting towards the end of the 19th Century.

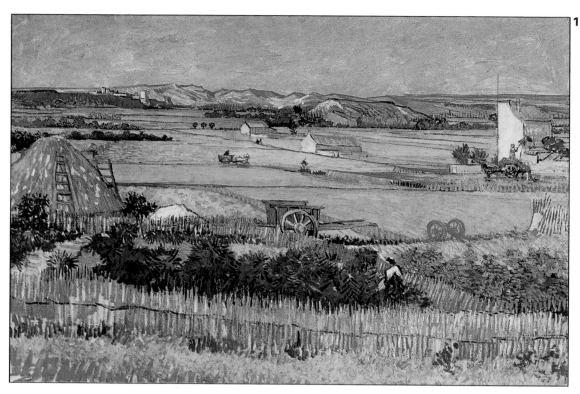

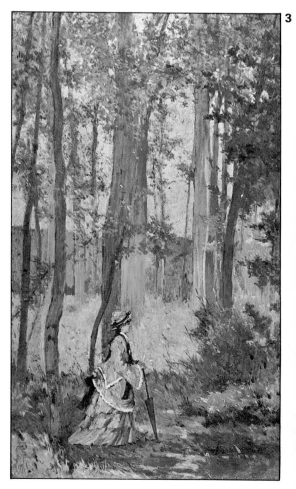

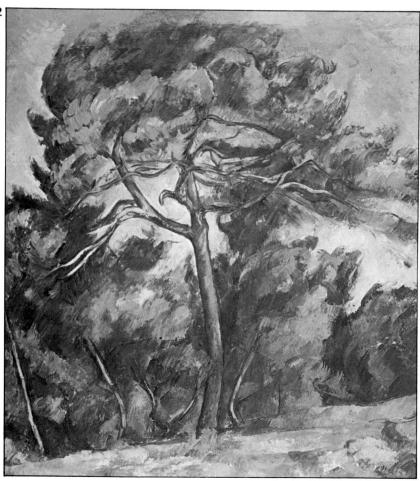

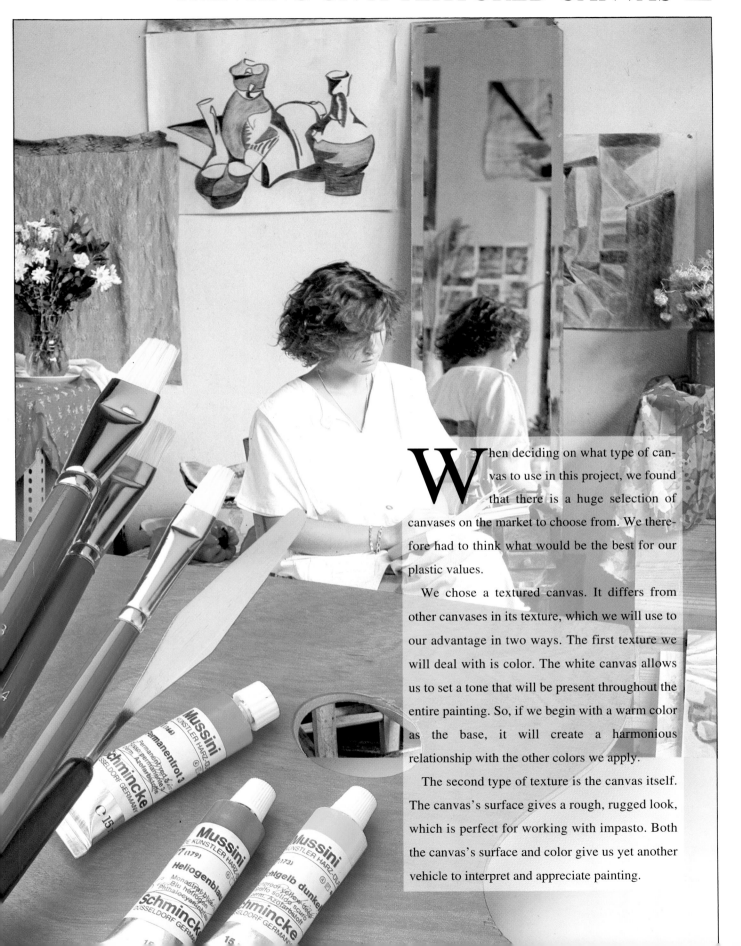

When deciding on what type of canvas to use in this project, we found that there is a huge selection of canvases on the market to choose from. We therefore had to think what would be the best for our plastic values.

We chose a textured canvas. It differs from other canvases in its texture, which we will use to our advantage in two ways. The first texture we will deal with is color. The white canvas allows us to set a tone that will be present throughout the entire painting. So, if we begin with a warm color as the base, it will create a harmonious relationship with the other colors we apply.

The second type of texture is the canvas itself. The canvas's surface gives a rough, rugged look, which is perfect for working with impasto. Both the canvas's surface and color give us yet another vehicle to interpret and appreciate painting.

■ A figure

1. Figure sketched directly on the canvas with a bristle brush and well-diluted paint.
2. Background color rubbed on with a rag dipped in turpentine.

Below. *A view of the initial sketch with the background colors that establish the main chromatic zones of the painting: a warm area in the lower right balancing the cool tones of the rest of the picture.*

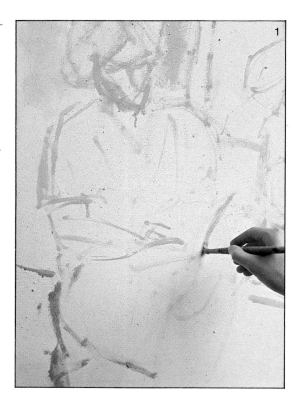

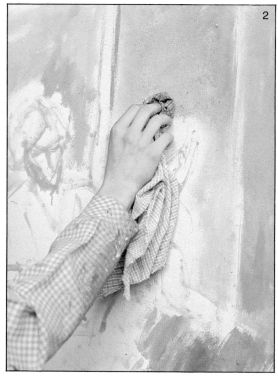

Texture

Muntsa Calbó, our artist in this example, says that for her, the subject is just an excuse to paint, or a starting point, a stimulus for her imagination.

Calbó, in her paintings, creates an abstraction of reality, excluding all that is incidental to retain what is essential—the essence of form, the essence of color. When she paints clothing, for example, there are no wrinkles, only the great planes that define the underlying solid form. This work of abstraction means ignoring detail. To this end, Muntsa Calbó paints on canvas that she has textured with modeling paste, rather like stucco.

For this, she mixes white acrylic with finely ground marble (or alabaster or fine sand) to make a paste, which she applies to the canvas with a palette knife or with a large old bristle brush.

In the photographs on this page you can see the grainy texture given to the surface, which in this case is a stretched canvas, but could as easily be a wooden board or even cardboard.

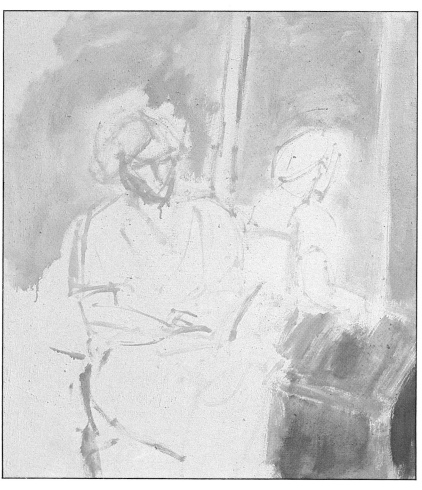

1. The artist's palette, idiosyncratic but well organized.

2. A line is added to delineate a form or modify a contour whenever the artist feels this is needed.

3. Applying the paste to the left shoulder of the figure with a small bristle brush. The artist does not use soft brushes because this technique would ruin them.

4. The figure now shows areas of tone and contrast.

5. An application of burnt sienna brightens the reflection of the figure's hair in the mirror. Notice that the flat side of the bristle brush is used to deposit paint without rubbing.

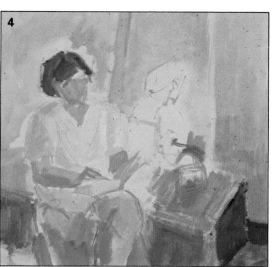

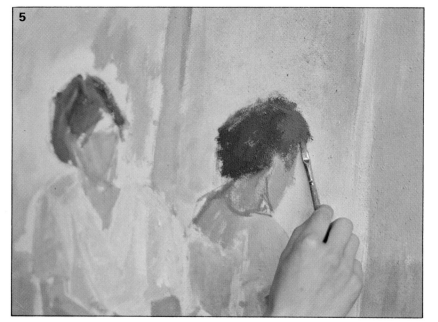

General color

The photographs on these two pages follow Muntsa Calbó's progress as she establishes the general tones of the picture. Each area of the composition is covered with its basic tone, and within these areas the obvious tonal contrasts have also been put in. All this follows Calbó's emphasis on the "volume" of the subject, almost as if it were a clay figure, as a matter of large structural planes. As the artist works, lines appear sporadically to restructure a shape or modify its limits, but almost all disappear as the work progresses.

Right. In these two details
you can see that the
artist has no objection to
leaving part of an area
uncovered when she
applies color.

Right. Here is Muntsa
Calbó's work at the end
of the phase we have
called "general color."
Notice that both the
direction of the brush
strokes and the changes
in tone serve to build the
forms into geometric
shapes.

Impasto and details

Considering the general color complete, Calbó's next step was to add to the picture enough surrounding detail to provide a clear context for the central figure. We could already tell that the figure was a woman, seated indoors and reflected in a mirror. With the addition of a few details (see the following page), we can deduce that it is not just any interior, but a painter's studio. Notice the difference between the detail to the right and the one below, in which you can see the greater richness in the color of the blouse and the head. This richness has two sources: the texture of the impasto itself, and the tonal quality given by the impasto.

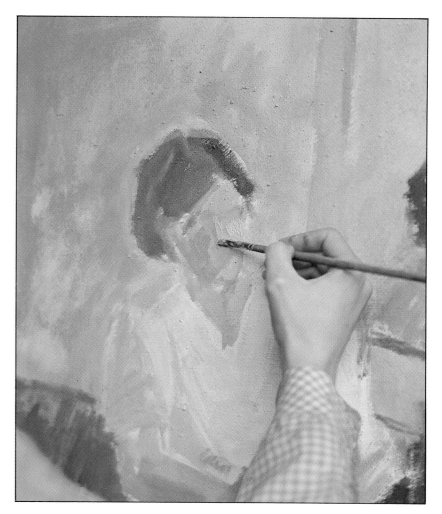

Left. Thick, fleshy brush strokes establish the lighter planes of the woman's face. In this stage, the structure begins to be created by the contrasting colors.

Below. In this detail of the head, you can see the various tones of the hair and the suggestion of facial features with no attempt at portraiture.

Below, right. The tip of the palette knife is used to suggest the pages of a book.

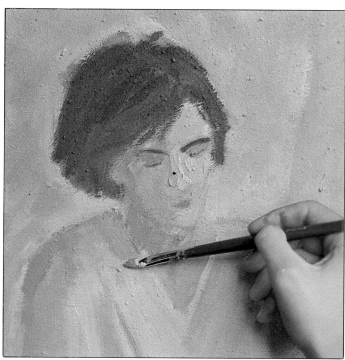

Right. *Our artist is working in the throes of creativity, surrounded by the varied items in her studio. The line sketch in the painting suggests the still life we saw hanging behind the model in the original scene.*

Right. *The painting is nearing completion. This is the time for the artist to take a break, while she waits for the impasto to dry almost completely.*

The final touches

Now look at your work with a critical eye. Whatever subject you started with, you should now have an image that resembles it in shape and color.

If you see that, despite the textured canvas, you have allowed details to dominate your painting, take a cloth dipped in turpentine and rub it thoroughly over the entire surface of your painting. Wait until this dries completely. Now give it a fresh coat of white acrylic and start all over again, ready to get into the spirit of this exercise.

If, as we hope, you are at least partially satisfied with your progress, follow Calbó's example and add the final touches. At this point, it is only a matter of adding some touches of color—strokes of purer color and perhaps a bit of impasto—to give vibrancy and atmosphere to the work.

This page. These are a few of the final brush strokes Muntsa Calbó added to finish her work. Notice that they are aimed more at enriching the color in some areas than at delineating forms.

Following page. The finished work. Think of it as an abstraction in which shapes and planes of color combine to create the forms.

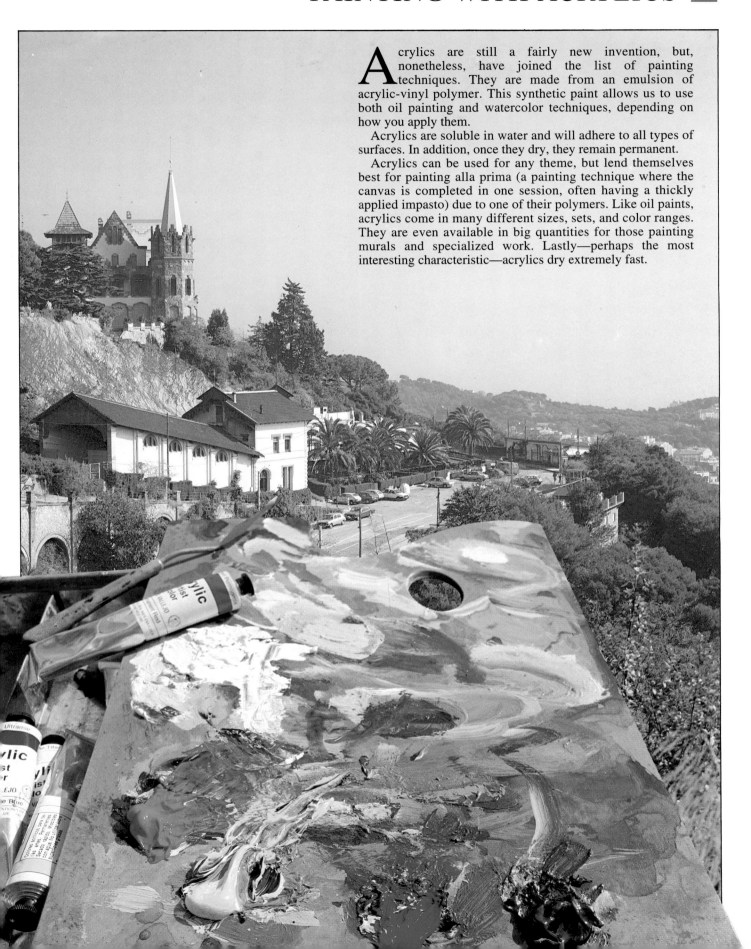

Acrylics are still a fairly new invention, but, nonetheless, have joined the list of painting techniques. They are made from an emulsion of acrylic-vinyl polymer. This synthetic paint allows us to use both oil painting and watercolor techniques, depending on how you apply them.

Acrylics are soluble in water and will adhere to all types of surfaces. In addition, once they dry, they remain permanent.

Acrylics can be used for any theme, but lend themselves best for painting alla prima (a painting technique where the canvas is completed in one session, often having a thickly applied impasto) due to one of their polymers. Like oil paints, acrylics come in many different sizes, sets, and color ranges. They are even available in big quantities for those painting murals and specialized work. Lastly—perhaps the most interesting characteristic—acrylics dry extremely fast.

A rapid sketch with acrylics

Often an artist can be on his way home after a session of painting in the open air, in the country or in town, when he chances upon something he finds interesting: A little corner of the town, a particular view of the landscape, the appeal of which he had not noticed before. Or perhaps some aspect of human life—a market, the excitement of a fair or carnival, or the atmosphere of a village square, captures his imagination. If it were not for lack of time and the inconvenience of transporting a second, recently painted canvas, he would want to record the moment immediately. What a shame to let that moment of inspiration go unexploited!

For times like these, it is a good idea to always carry a second, small canvas (one that fits inside the paint box) and five tubes of acrylic paint: The three primary colors, plus black and white. Add to this a piece of charcoal or a soft pencil, the brushes you normally use and some water, and you have all you need to produce a rapid sketch in color. First, working with only five colors allows you to have the palette ready in no time. And working with acrylics is a guarantee that, five minutes after the sketch is finished it will be dry enough for you to carry home, uncovered if there is no other solution, and without covering yourself with paint (or, for that matter, any other innocent soul who might be passing).

Above, left. *Charcoal sketch of the subject. The main elements of this landscape have been included.*

Left. *Application of a gray wash with which the artist, Pere Mon, dulls the surface of a canvas that he finds excessively white. This wash is, of course, optional. You may decide to do without it and go straight into the process described on the following pages.*

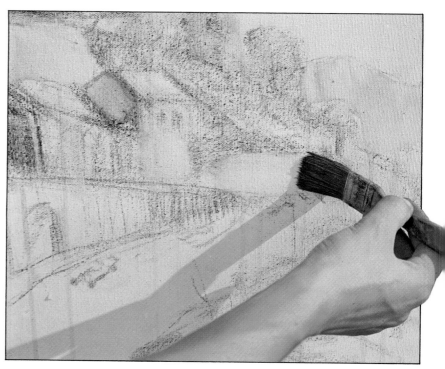

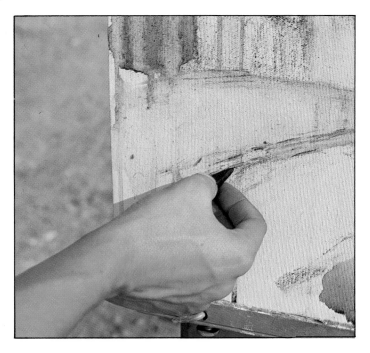

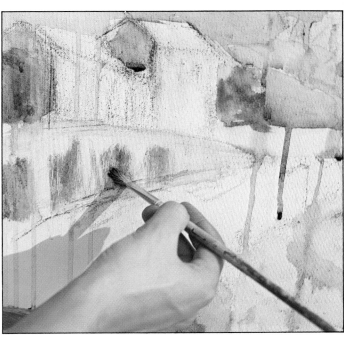

Working with a medium that dries quickly is very useful when making color sketches because it enables you to superimpose new colors without wasting time waiting for the first layer to dry. This means that you can work much more quickly than with other slow-drying techniques, with which you have to think about blending and mixing on the canvas or consider using thick applications of color.

Pere's example

On this occasion we have invited our friend, the excellent painter Pere Mon, to demonstrate how to produce a rapid sketch using just the three primary colors (as well as black and white) without sacrificing any purity of color.

With this aim in mind, we accompanied him to a spot at the foot of the Tibidabo mountain in Barcelona (which you can see on page 94), where he set up his easel and began the task summed up in the photographs and explained in the accompanying captions.

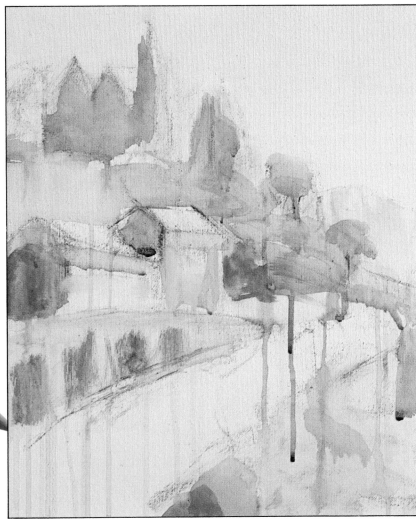

Top, left and right.
Reinforcing some of the charcoal lines that disappeared under the gray wash. Blocking in the dark areas of the subject with a black wash.

Your contribution

This time we would like you to imitate Pere Mon's approach, but not to copy his work. In this exercise you should imagine yourself in the circumstances we described at the beginning of this section. Find a subject that interests you and, using acrylics in only the three primaries, with black and white, jot down on a canvas no bigger than 16 × 10 in. (41 × 27 cm) the essential elements of your picture. Work as quickly as you can. This does not mean that you should work with a stopwatch beside you. Our intention is not to reduce you to a state of nervous anxiety (in which case it would be hard for you to produce anything worthwhile), but rather to make you think about what is essential when trying to make a simple sketch of a subject.

Previous page, below.
Overall view of the sketch after the black wash has been applied.

Above. Two close-ups showing the application of opaque color with wide brushstrokes in different areas of the sketch. The artist's aim was efficiency in covering as much of the surface as possible with a few brushstrokes, as illustrated in the second picture.

Right. The sketch after the first color was blocked in.

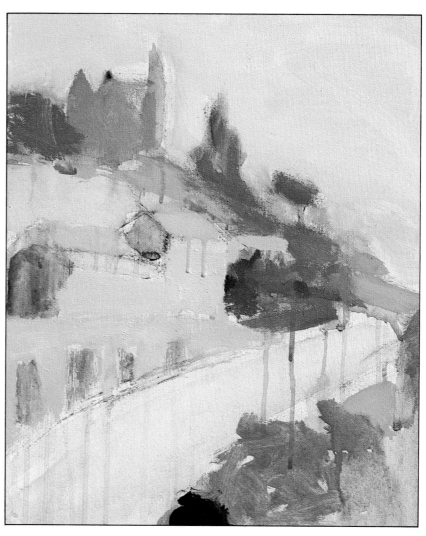

266

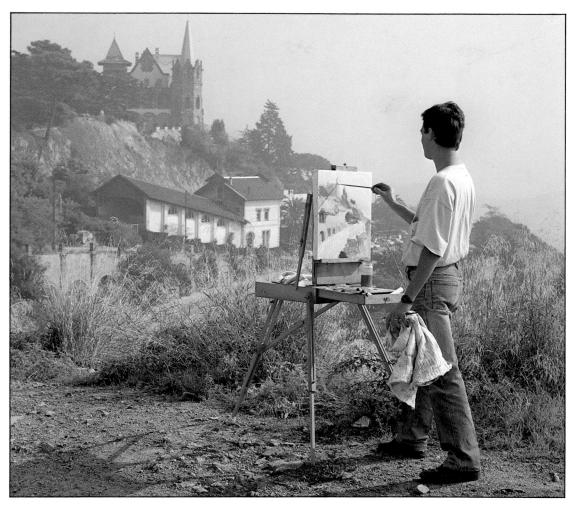

Left. The artist at work.

Below. Two close-ups that capture two of the few occasions on which Pere Mon used a small brush. Even here, a single brushstroke has been enough to suggest the existence of the buttress-like structures on the containing wall seen in the left foreground of the painting. The same goes for the windows: Just one stroke with a fine brush and that's all there is to it!

Next page, top. Overall view of the sketch after the first, rapid blocking-in of color; a few more greens have been added in the lower right-hand corner of the picture.

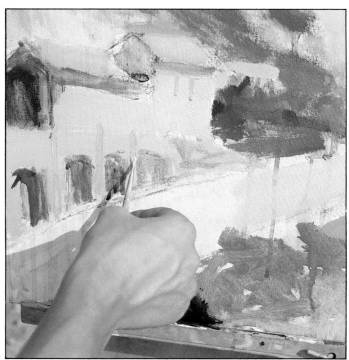

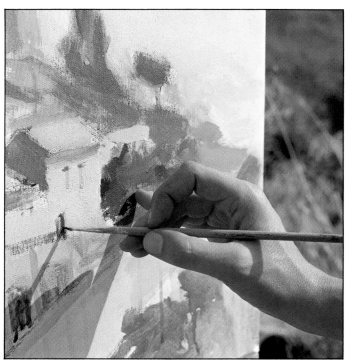

The saving in time does not result from the speed with which the brushstrokes are applied, but rather from the fact that there are fewer of them. Forms and colors are suggested with a minimum of effort. If something can be described with a single brushstroke, then we should make sure that we do not allow ourselves two. If a single color is sufficient for two or more areas of similar tone, there is no point in searching the palette for an almost identical shade within the same tonal range. When one stroke with a wide brush can cover a particular area, why waste time with a fine brush that will take three or four times the effort?

The art of the rapid sketch, contrary to what many people think, is not something for those who act without thinking, relying entirely on their intuition. As with writing, it is more difficult and requires greater concentration to say a great deal with a few words than to say little with enormous verbosity.

Think for a while about the comments we have made and then start painting—directly from nature if you can.

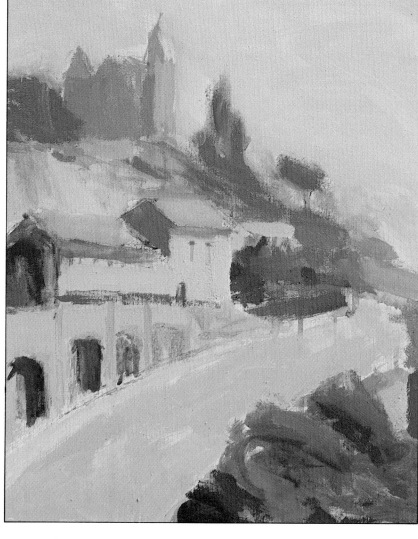

Below. Close-up showing how the green paint left on the brush can be used to reinforce the line between the road and the containing wall. The second illustration shows how the same brush and the same color that painted the wall of the building can be used to suggest a patch of light on the embankment in the bottom right-hand corner.

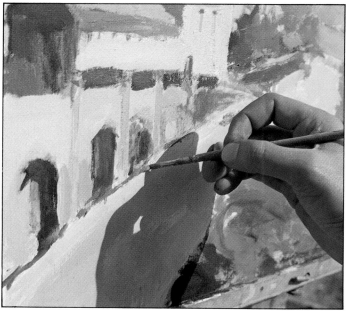

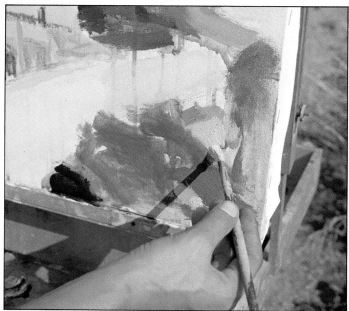

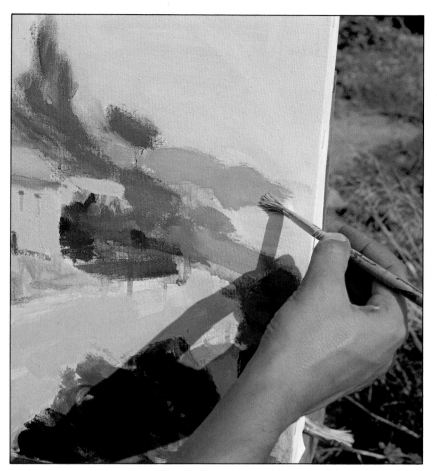

How do you know when to stop?

Deciding when a quick sketch may be considered finished is a difficult matter. Inevitably, ideas concerning what is a sketch and what is a rapidly produced painting differ. In principle, we can say that everything depends on the amount of time available.

It is obvious that if the artist had been able to take longer to produce the picture in our example, it would have had the more finished look of a painting, as nuances of tone were added and further details introduced. This would have occurred even if he did not lose the atmosphere of a sketch, or resort to colors other than those initially used.

There is no time limit. However, it is true that the initial approach to producing a rapid sketch using just the primary colors cannot be the same as when undertaking a premeditated work on which you are prepared to spend as much time as necessary. So, in principle, once a sketch has brought together enough elements to define the subject, we can say that it has accomplished its objective and may be considered a finished piece.

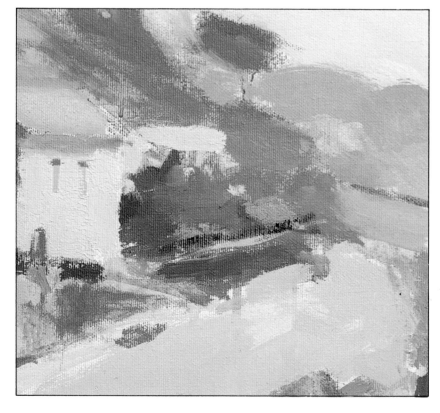

Left, above. Covering the mountains in the background with uniform color; this same color has been used for the palace facade (see top, opposite) and the roofs of the other building. The artist has applied the principle of minimum effort.

Left. Close-up showing the purity of the apparently formless strokes in this rapid sketch.

Next page. The completed sketch. A good example of how to convey a great deal with just a few brushstrokes.

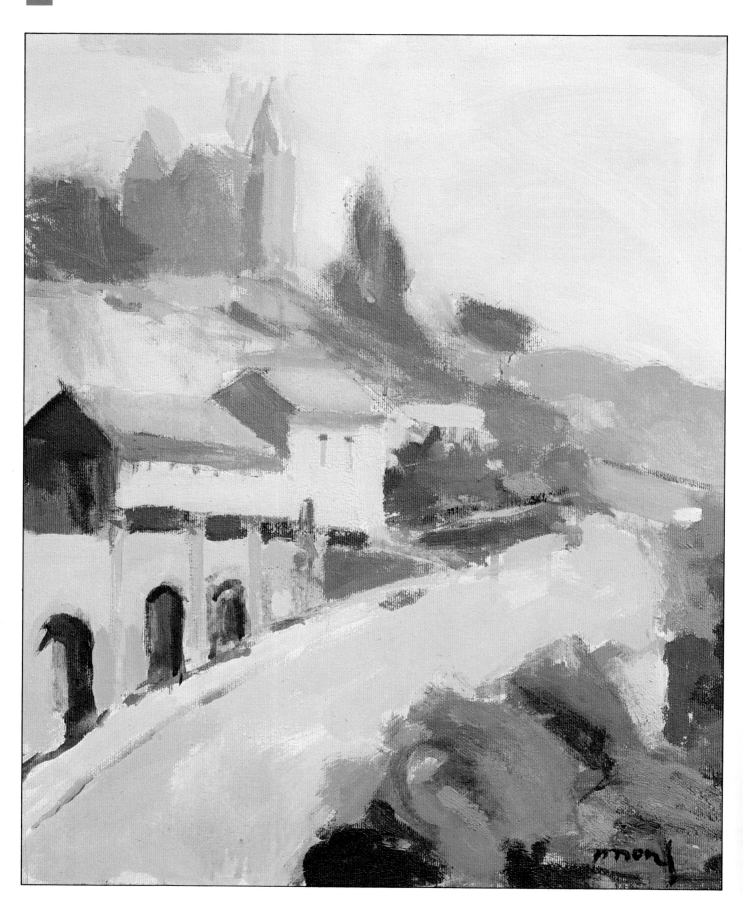

Using homemade acrylic paints ■

Although it is not a common practice, some artists, instead of using commercially produced paints, prefer to emulate the old master and prepare their own colors. We are not going to enter into a discussion of the relative merits of making your own at this point. However, we would say that every artist should, at least once, have the experience of painting a picture with colors he prepared himself. The process of choosing the pigments, mixing them with the appropriate binding agent, finding the right consistency and, finally, using the mixture to create a painting, is an experience that, like no other, gives us an intimate understanding of the medium. It develops our sensitivity to color, encouraging us to create our own range, different from those made by commercial manufacturers. This can undoubtedly give real character to our work. It is worth remembering some of the great artists who have distinguished themselves, among other reasons, for the originality of their colors. Think of El Greco's yellows, for instance, or Van Dyck's browns, or the greens of Veronese. Besides, the process we are recommending is no longer a difficult one, thanks to the existence of practical binding agents such as acrylics. This is why the next exercise we propose involves preparing your own acrylics, rather than any other type of paint. The raw acrylic medium will allow you to experiment with pigments easily and without a lot of mess.

To make your own acrylic paints, you will need:

• Powdered pigment found in any specialty art store. The price of these pigments varies. Pigments obtained from salts of chromium, for instance, are more expensive than the earth pigments, including ochre.

As for which pigments to buy, you will have to invest in the basics: A blue (ultramarine), vermilion, and cadmium yellow. White is also essential, although black is an optional extra. You might extend your range with a green (or several, such as emerald and cinnabar green), an ochre, raw and burnt sienna, raw umber, and so on.

• Raw acrylic medium, also found in art stores. The binding capacity of this substance depends on how much water it contains.

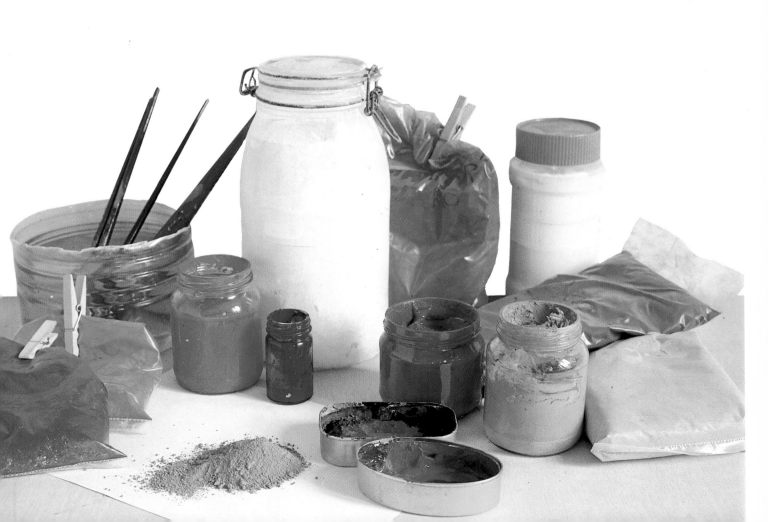

Logically, its effectiveness as a binding agent will disappear if there is too much water in the mixture. As a general rule, the relationship between acrylic medium and pigment, in volume, should be 50/50.

• Spatulas. You should have two or three wide, strong spatulas to make mixing pigment and acrylic medium an easy job.

• A varnished wooden board or a thick sheet of glass on which to mix your paints. If you opt for the wooden board, varnish it so that it loses its porousness.

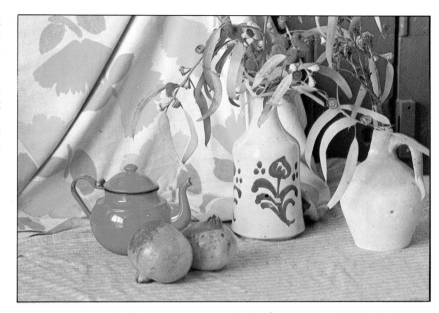

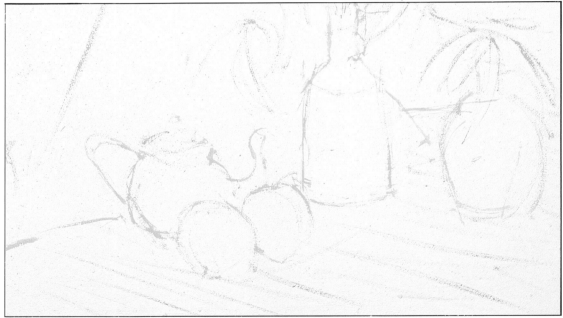

Right. Sketch of the subject that Muntsa Calbó has painted for us using acrylic colors she has mixed herself. She has painted the sketch directly onto the canvas in a yellow-orange color, complementary to the tone that will be dominant in the painting (violet-blue). Because it is a light color, the paint applied later will cover it easily.

Below. Close-up pictures showing the first areas of color being applied. Strokes with a wide brush block in the ochres, violets, and pinks of the patterned cloth in the background. Muntsa Calbó told us she always has to make a mental effort not to launch into the picture with very bright colors (those that attract her most) but to restrain herself, first applying the pale shades that become a guide to the intensity of color to be added later to the canvas.

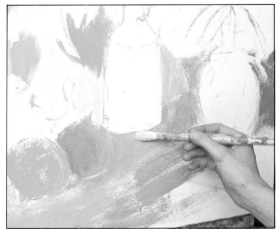

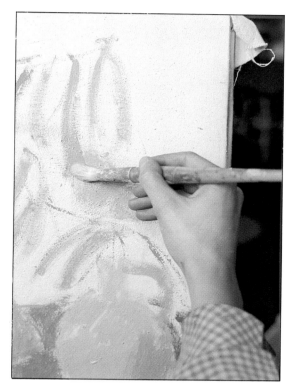

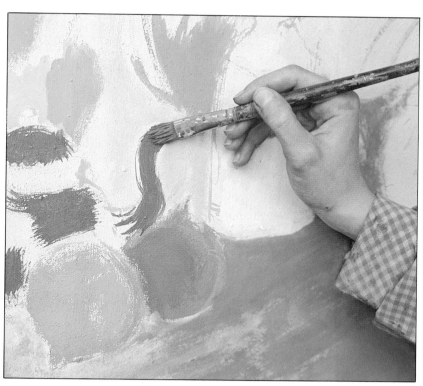

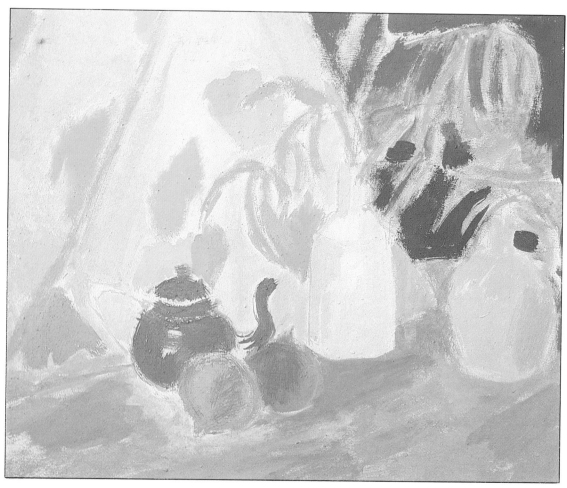

This page. *Photos showing the restraint the artist used in developing the color scheme.*
Except for the luminous red of the tea pot, which is an uncompromising vermilion, the violets, blues, and ochres have been softened through the addition of white, giving them a greater opacity. In the large photograph, the vases are described in just a few, muted brushstrokes, with no strong contrasts. They show subtle variations of tone, similar to those of the drapery, which prevents them from stealing the limelight.

• Glass jars with hermetic seals for storing the paints you have made up. It is much more practical to prepare a reasonable amount of paint and to keep it, than to be constantly mixing small quantities. We recommend you make up a fairly thick mixture that you can cover with a little water to protect it from contact with the air. If the jar is tightly sealed, your acrylics should last a long time.

Preparation

Pour a little acrylic medium (tablespoonful) onto your wooden or glass surface. Beside it, place an equal amount of your chosen pigment.

Slowly, to avoid spilling the powder, carry a little of it to the acrylic medium and press it in with the spatula. Then pick up the medium that has spread out and press it into the pigment again. The idea is to mix the pigment until you have a thick, uniform paint of a regular consistency. While using the spatula to blend the mixture, and whenever it starts to become too thick, add a few drops of water to make it more fluid.

When you have prepared the first spoonful of paint, add another spoonful of acrylic medium and another of pigment, and continue to mix it using the spatula. It is quite difficult to mix large quantities all at once, so it is easier to do it in stages. Gradually add ingredients until you have the amount you need. As this is a trial run, don't prepare too much.

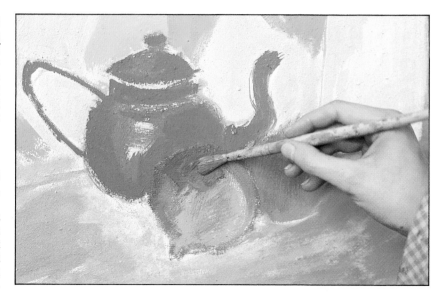

Right. Close-ups showing some luminous strokes that stand out strongly from the other more subtle colors (of the eucalyptus leaves, for instance); the quieter colors form a halo of diffused light around the more dominant tones.

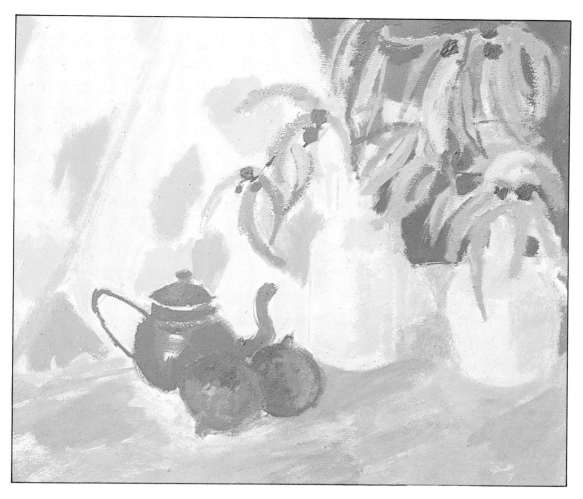

Left. *The picture after the main areas of color have been established. In spite of the chromatic impact of the teapot, the curved lines of its handle and spout lead the eye toward the two vases.*

Below, and next page. *Four close-ups showing a few aspects of the artist's work that speak for themselves.*

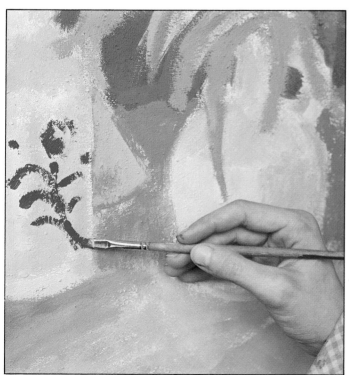

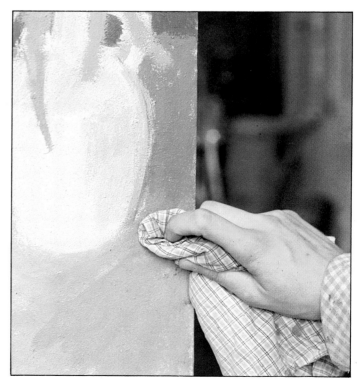

275

A few final tips

In general, the pigments produced by commercial manufacturers are finely ground enough to be mixed without any kind of preparation, especially if the binding medium is acrylic. If you wish to make oil paints rather than acrylics, the technique is more or less the same, although it becomes more important that the pigment be finely ground.

The best binder for oil colors is refined linseed oil. The pigment is mixed with the oil (using, in volume, half as much pigment as linseed oil, or even less). Blend patiently until you achieve the consistency you require. As linseed oil dries very slowly, it is common to add a little cobalt pigment and oil of turpentine to accelerate the process. The proportions in which these components are added depends greatly on the tastes of the individual artist. It is best to experiment until you achieve the right drying time for your style.

However, remember that oil painting is intended to be a slow-drying process. An excess of drying pigment or turpentine can lead you to produce very low-quality, thin, and lifeless paint that cracks easily.

Do make the effort to prepare your own colors; it is a constructive exercise that, we should emphasize, does much for your understanding of, and sensitivity toward, color.

Below. Close-up showing Muntsa Calbó's last few brushstrokes on her painting. She felt that the fruit located nearest to the foreground did not stand out enough, so she emphasized its contours with a broad outline of cobalt blue.

Right. The finished picture. Note how the subtle harmony of the dominant shades (violet-blues) is exploded by the color of the teapot and the yellow patches near to it. However, because they do not take up much of the overall volume of the picture, they provide an effective contrast within the chromatic uniformity of the composition.

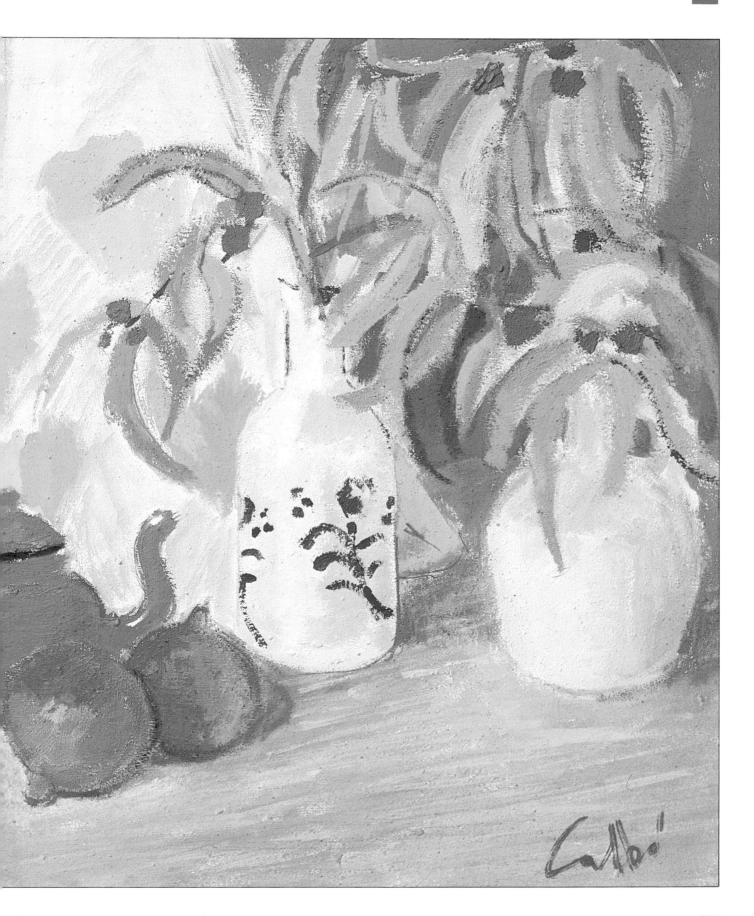

Using homemade oil paints

Throughout history many different types of oils have been used to make *oil paints,* hence the name oil paint. Due to its purity and the color it creates when mixed, the most common is refined linseed oil. You can buy linseed oil in any fine art or craft store, along with the other components you will need. There are many brands to choose from, but we have found that it is cheaper to buy a large quantity since linseed oil can be rather expensive. However, if you only need a small amount, then it is better—and cheaper—to buy a small bottle. Some recommended brands are Talens, Lefranc & Bourgeois, Titan, and Windsord & Newton. Experiment with different products and techniques before you begin painting; this way you will learn not only about oil paints, but also about color. Pigment is the other indispensable component needed to make oil paints. Again, as with linseed oil, there is a large selection to choose from, ranging from organic to synthetic pigments. The qualities of both the powdered pigment and linseed oil are extremely important since they will determine the final characteristics of the paint.

You will also need the following items: a glass panel—being the most ideal surface—on which to mix the different components; a wide, flexible palette knife; essence of turpentine; Cobalt Siccative Drier; Damar varnish; and pure bees wax.

The first step is to make sure the pigment is a fine powder. If it is granulated, grind it using a mortar and pestle until it becomes extremely fine. Place a small amount of pigment onto the glass surface and add the linseed oil little by little, mixing the pigment with the palette knife until it becomes smooth. The more you mix the smoother the paint will become, thus creating a better final result. Repeat this step each time you mix a part in. After you make the amount you need, add a couple drops of the Cobalt Siccative Drier and the essence of turpentine. Pay special attention when adding the Cobalt Siccative Drier, as too much will create bad paint and too little make the paint thin, which will make the paint crack more easily. It is optional at this point to dissolve some pure bees wax in Damar varnish and then add the mixture to the paint in order to make the paint even smoother.

Below is our artist in her studio. Notice the different materials she uses to make her oil paint. Instead of glass, she uses a slab of polished marble to mix her colors on.

Glossary

Acrylics. Acrylic paints are made from synthetic resins that are soluble in water. They dry within minutes and will not rot, discolor, or crack—unlike watercolors and gouache.

Advancing colors. Colors that appear to come toward the front of the picture. These are usually the warm colors such as reds and yellows or any particularly vivid colors.

Aerial perspective. The effect of tones and colors becoming paler as they recede, with diminishing light/dark contrasts. Aerial perspective is important in creating a sense of space, particularly in landscape drawings.

Alla Prima. Literally translated, this Italian term means "at first," and refers to paintings completed in one session, with each color laid on more or less as it will appear in the final painting. The Impressionists worked in this way, in contrast to the academic painters of the 19th century.

Backruns. In watercolor painting, jagged-edged blotches will sometimes occur when new paint is added into a wash that has not fully dried. Backruns can look unsightly if the color area is intended to be flat, but they can be an attractive feature of a painting and are often induced deliberately by watercolorists who paint wet-into-wet.

Base. A layer of glue size, gesso primer, impasto, or acrylic primer that is applied to the canvas first. A layer of white paint or a thin, diluted color tone is usually then applied.

Binder. The liquid medium that is mixed with pigment to form paint or pastel sticks. The binder used for watercolor is gum arabic. Oil paints are bound with oil, acrylics with a synthetic resin, and pastels with gum tragacanth.

Blending. Achieving a gradual transition from light to dark, or merging one color into another. Pastels are often blended by rubbing two colors together with the finger, a rag, or a torchon.

Blocking in. The first stage of a painting in which the main areas of tone and color are laid in broadly to be refined in later stages.

Body color. A term exclusive to watercolor painting meaning opaque water-based paint. It sometimes refers to watercolor mixed with Chinese white, but is also used as an alternative term for gouache paints.

Broken color. A slightly imprecise term, sometimes used as a synonym for optical mixing. In fact, broken color simply means color that is not laid as a flat area and does not completely cover another color below, or the color of the canvas or paper.

Burnishing. A technique used in colored pencil drawings in which colors are rubbed into one another and into the paper with a torchon, plastic eraser, or white pencil. Because burnishing irons out the grain of the paper and compresses the pigment, it imparts a slight sheen to the surface and increases the brilliance of the colors.

Canvas. A heavy woven fabric, it is the most commonly used SUPPORT for oil painting. It is also frequently used for acrylics.

Chalk. Material used for drawing since prehistoric times. It is made from various soft stones or earth pigments. The term is a rather imprecise one, and is often used as another name for conte crayon or soft pastel. Leonardo da Vinci made many drawings in red and black chalk.

Charcoal. Charred twigs or sticks used for drawing that are particularly good for broad, bold effects.

Chiaroscuro. An Italian word meaning "bright-dark," used to describe the strong light and shade in a painting.

Chroma. The term used to describe and measure the purity of a color. Pure red or blue, for example, are high on the chromatic scale, while neutral gray contains no chroma.

Color harmony. The agreement of colors that the artist uses in his or her painting.

Colored Ground. Artists working in the opaque paints (which includes pastel) often color their ground before painting. In oil and acrylic painting, a thin layer of paint is usually applied over a white primer, although some artists mix pigment into the primer itself. (See also Imprimatura) Pastel painters either work on one of the colored papers specially sold for the purpose or prepare watercolor paper by laying a light wash of color.

Complementary colors. Pairs of colors that are opposite one another on the chromatic color wheel, such as red and green, or violet and yellow. When juxtaposed in a painting they create powerful effects.

Conte crayon. A hard, square-sectioned crayon stick available in black, two browns, white, and sanguine. The crayon takes its name from Nicolas-Jacques Conte, who invented both it and the graphite pencil in the late 18th century.

Crayon. An imprecise term, but one that usually refers to sticks of color made with an oily or waxy binder. A conte crayon is not really a crayon in this sense of the word because it is not oily.

Crosshatching. A method of building up the tones or colors in a drawing with crisscrossing parallel lines. (See also hatching)

Depth. The illusion of space in a painting.

Diluent. Liquids used to thin down paint, such as turpentine or white spirit for oils.

Dry brush. A technique of applying a minimum amount of paint to the surface, usually with the bristles of the brush slightly splayed out. The method can be used in any of the painting media, but is perhaps best known in watercolor, where it provides a means of describing textures such as hair or grass.

Easel. A stand or frame for supporting or displaying the canvas at an angle. There are many different types of easels for painting both indoors and outdoors.

Fat over lean. The traditional way of building up an oil painting by beginning with thin, non-oily paint (lean) and increasing the thickness and oil content as the painting proceeds. For any painting built up in a series of layers, this is very important. Thick, oily paint takes a long time to dry and shrinks slightly in the process. If lean paint is laid over this, the top layer will dry first and may crack as the lower layer shrinks.

Figurative drawing. A painting of something actual, as opposed to an abstract painting. The word does not imply the presence of human figures.

Fixative. Thin varnish sprayed onto a pastel or charcoal drawing or painting to prevent the pigment smudging and slipping off the surface. Some artists use a fixative throughout working while others never use it at all. It has a tendency to darken the colors.

Foreshortening. The optical illusion of diminishing length or size as an object recedes from you.

Genre. (1) A term used to describe paintings depicting scenes from domestic life, most commonly associated with 17th-century Dutch painters. (2) A category of art; for example, landscape, portraiture, and still life are all genres of painting.

Gesso. Traditionally, it is the brilliant white ground used to prepare a surface for painting and gilding. It is also chalky pigment mixed with glue and applied to a panel in several successive layers. Gesso grounds are still used by artists who paint in Tempera. The preparation known as acrylic gesso, sold for preparing canvases and boards for oil and acrylic painting, is not true gesso, and seldom requires more than one or two coats.

Glazing. A technique of applying oil or acrylic color in thin, transparent layers so that the color beneath shows through, modifying the color of the glaze. Overlaid washes in watercolor are sometimes described as glazes, but this is misleading since all watercolors are transparent.

Golden rule. A system of organizing the geometrical proportions of a composition to create a harmonious effect. It has been around since Classical times, and is defined as a line (or rectangle) that is divided in such a way that the smaller part is to the larger what the larger is to the whole.

Graphite. A form of carbon that is compressed with fine clay and used in pencils.

Ground. A layer of paint or other substance that isolates the SUPPORT from the paint placed on top. A ground is necessary for oil painting because without it, the oil from the paint sinks into the surface of the canvas or board and eventually causes the fibers to rot. (See also colored ground)

Gum arabic. The medium used as a binder for watercolor pigment. Mixed with water, the gum can also be used as a painting medium. It enriches the colors and makes the paint less fluid.

Harmonious colors. Colors that are close together on the color wheel (i.e. blues and violets, reds and yellows) and so do create sharp contrasts.

Hatching. Building up tones or colors by means of closely spaced parallel lines; the closer they are, the more solid the tone or color. When a further set of lines is laid on top, going in the other direction, the technique is called crosshatching.

Horizon line. An imaginary line that stretches across the subject at your eye level where the vanishing point or points are located. The horizon line in perspective should not be confused with the line where the land meets the sky, which may be considerably higher or lower than your eye level.

Hue. The type of color on a scale through red, yellow, green, and blue.

Image. A term used to describe either the particular subject being painted, the painting itself, or a specific part of the painting.

Impasto. Paint applied thickly to stand proud of the painting surface. Impastos can be put on either with a brush or a knife. Special mediums are sold for bulking out paint for this kind of work.

Imprimatura. A layer of color applied to a ground, often used as a middle tone in a painting. (See also colored ground).

Lead pencil. This is a misnomer, but graphite pencils are still sometimes referred to in this way. The term comes from the metal points that were originally used for drawing.

Lifting out. This method is most used in painting, particularly with watercolor, but is also a well-known charcoal technique. The darks are laid first, and the highlights and mid-tones achieved by removing areas of charcoal with a kneaded eraser.

Linear perspective. The method of creating the effect of recession through the use of converging lines and vanishing points.

Linseed oil. Made from hot- or cold-pressed flaxseeds, linseed oil is a thick, brown oil that is mixed with oil paints. It dries to a glossy finish that is resistant to cracking. It is the most common mixing medium for oil paints, usually mixed with turpentine in a ratio of 60% oil and 40% turpentine.

Local color. The actual color of an object regardless of the lighting conditions. The local color of a lemon is yellow, but the shadowed side may be dark green or brown.

Mahlstick. A piece of bamboo or dowel rod with a pad at one end that is used for steadying the hand when painting fine details or in pastel work to prevent the hand resting on already laid pastel color.

Masking. Masking methods are often used for reserving highlights in watercolor work. The most common is masking fluid, a rubbery substance painted onto the paper before paint is laid. It is then removed after the paint has dried. For clear, straight edges, masking tape can be used.

Medium. (1) The material used for drawing or painting, for example pencil, pen, or ink. (2) Substance added to paint, or used in its manufacture, to bind the pigment and provide good handling qualities. To avoid confusion, the plural is usually given as "media," for the first meaning and "mediums" for the second.

Optical mixing. Placing small areas of color side by side so that when seen from a distance they appear to make a third color. Color printing is based on the same system. In painting, the best effects are achieved by keeping the colors close together in tone, for example a very light yellow and a deep blue will not mix optically to make green.

Paintbrush. Traditionally the term was used for only oil paint brushes, while "brushes" was used for gouache or watercolor brushes. Nowadays it applies to all types of brushes.

Palette. (1) The object on which paints are mixed. The traditional oil-painting palette is a flat-shaped piece of wood. A wide variety of palettes are sold for watercolor work, from small, deep dishes to a rimmed plastic version of the oil palette. (2) The kind of colors used in a painting or those an artist habitually uses, for example a "limited palette;" a "palette of primaries;" a "cool palette."

Pastel. Sticks of color, either cylindrical or square-sectioned, made by mixing pure pigment with gum tragacanth. Pastels are available in soft and hard versions, the former being also known as chalk pastels. There are also oil pastels in which the binding medium is a mixture of oils and waxes.

Picture plane. The plane occupied by the physical surface of the drawing. In a figurative drawing, most of the elements appear to recede from this plane.

Pigment. Finely ground particles of color that form the basis of all paints, pastels, and colored pencils. Most pigments are now synthetically made, but in the past they were derived from a wide range of plant, animal, and mineral sources.

Primary colors. Colors that cannot be made from mixtures of other colors. The primaries are red, yellow, and blue.

Primer (priming). Priming a canvas, board, or other support-simply means laying a ground. The paints specifically made for this purpose are sometimes called primers. The most commonly used nowadays is acrylic gesso, which provides a suitable ground for both oil and acrylic work.

Receding colors. "Cool" or muted colors that appear to recede to the back of the picture plane. They allow bright, warm colors come forward. (See also advancing colors)

Rough outline. A first, rough sketch that defines the composition lines of a work. Often, it helps the artist perfect his or her drawing technique and train the eye.

Saturated color. Pure, intense color that is not mixed with black or white.

Scraping back. Small, linear highlights are often made by scratching into dry watercolor or wet oil paint with the point of a knife or similar utensil. When used for oils, the technique is usually referred to as sgraffito. Broader effects can also be achieved in oil paintings by scraping off whole areas of wet paint with a palette knife to give a misty, veil-like impression.

Secondary colors. The colors made by a mixture of two primary colors. Green, orange, and purple are all secondary colors.

Sepia. Traditional drawing color. Brownish pigment, originally obtained from the ink of a cuttlefish.

Sgraffito. Scraping back one layer of color to reveal another color—or the color of the paper—below. The method is often used in oil and acrylic painting; but in drawing, the only really suitable medium is oil pastel.

Shading. Graded areas of tone describing light and shade in a drawing.

Size. A form of glue, traditionally made from animal skins, used for sealing canvas or unprimed board before an oil ground is put on. Size should not be used with acrylic primer, since this is applied directly to the surface.

Sketching. This has taken on an outdoor connotation, but a sketch can be any drawing that is done quickly and not taken to a high stage of completion.

Spray fixative. Thin varnish sprayed onto charcoal or pastel drawings to prevent them from smudging. Spray fixative is often used at various stages in a drawing. It has a tendency to darken pastel colors.

Squaring up. The traditional method of enlarging and transferring a working drawing to the painting surface. A grid of squares is ruled over the drawing and a similar grid, with larger squares, on the painting surface. The information is then transferred from one to the other.

Still life. The drawing and painting of inanimate objects such as flowers, fruit, vessels, utensils, etc.

Support. The term applied to any material, whether paper, canva, or board, that is used as a surface on which to draw or paint. The word is more common in the context of painting than drawing.

Tempera. Originally, all water-based paint "tempered" with some form of gum was known as tempera, which was the main painting medium before the development of oil paints. Tempera is a tricky medium to use but can achieve beautiful effects. Now after centuries of neglect, it is now enjoying a revival.

Tertiary colors. The colors made by mixing the three primary colors or one primary and one secondary, for example green (blue + yellow) and red.

Tone. The lightness or darkness of any area of the subject regardless of its color. Tone is only related to color in that some colors are naturally lighter than others. Yellow is always light in tone and purple always dark.

Toned ground. Another name for colored ground , particularly where the tone rather than the color is the important factor.

Tooth. The term for the grain of textured papers that "bites" the colored pigment or pastel dust and helps to hold it in place.

Torchon. A rolled paper stomp used for blending.

Turpentine. A colorless liquid derived from petroleum that is used to clean oil paint brushes. It is also a good diluent for oil colors.

Underdrawing. A drawing made on the painting surface with a pencil, charcoal, or brush, to act as a guide for the color.

Value. Another word for tone.

Vanishing point. In linear perspective, it is the point on the horizon line at which receding parallel lines meet.

Varnish. Liquid that is applied over the final painting to form a protective layer.

Wash. A transparent or very thin first coat of color that is applied to the painting's surface.

Watercolor. A painting technique that uses colors made from ground pigments and gum arabic. Watercolors are soluble in water. They differ from gouache in that their colors are transparent.

Wet-into-wet. Laying a new color before the previous one has dried. In watercolor this creates a variety of effects, from softly blended colors to color "bleeds" and backruns. In oils the effects are less dramatic, but each new color is slightly modified by those below and adjacent, making forms and colors merge into one another without hard boundaries.

Wet-on-dry. Laying new (wet) color over a dried layer.

Working drawing. A drawing made specifically as a basis for a painting, usually from earlier studies and/or photographs. Unlike a sketch, a working drawing establishes the entire composition, and is usually transferred to the painting surface by squaring up or other similar method.

Index